Studies in the History of Art
Published by the National Gallery of Art,
Washington

This series includes: Studies in the History of
Art, collected papers on objects in the Gallery's
collections and other art historical studies
(formerly Report and Studies in the History of
Art); Monograph Series I, a catalogue of stained
glass in the United States; Monograph Series II,
on conservation topics; and Symposium Papers
(formerly Symposium Series), the proceedings
of symposia sponsored by the Center for
Advanced Study in the Visual Arts at the
National Gallery of Art.

*Forthcoming

New Perspectives in Early Greek Art

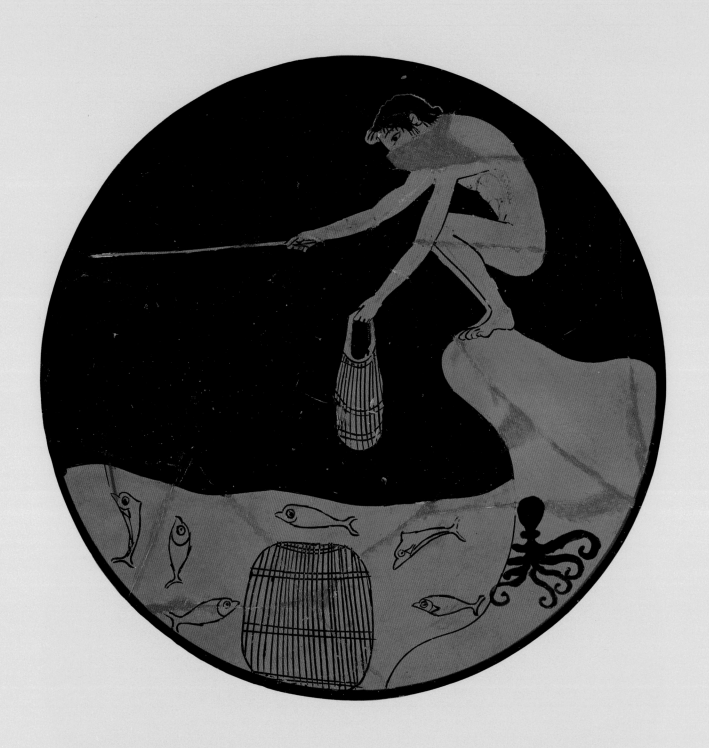

STUDIES IN THE HISTORY OF ART · 32 ·

Center for Advanced Study in the Visual Arts
Symposium Papers XVI

New Perspectives in Early Greek Art

Edited by Diana Buitron-Oliver

National Gallery of Art, Washington

Distributed by the University Press of New England
Hanover and London 1991

This publication was produced by the Editors Office, National Gallery of Art, Washington Editor-in-Chief, Frances P. Smyth

Printed by Schneidereith & Sons, Baltimore, Maryland
The text paper is 80 pound LOE Dull
The type is Trump Medieval, set by Maryland Composition Company, Inc., Glen Burnie, Maryland

Distributed by the University Press of New England, 17½ Lebanon Street, Hanover, New Hampshire 03755

Abstracted by RILA (International Repertory of the Literature of Art), Williamstown, Massachusetts 01267

Proceedings of the symposium, "New Perspectives in Early Greek Art," sponsored by the Center for Advanced Study in the Visual Arts, 27–28 May 1988

ISSN 0091-7338
ISBN 089468-177-x

Frontispiece: Attic red-figure kylix by Ambrosios Painter, c. 500–490 B.C. Museum of Fine Arts, Boston, H. L. Pierce Fund

Frontispiece, page 14: Attic clay vase in the shape of a kneeling boy, 540–530 B.C. Agora Museum, Athens. *Human Figure,* 48

Frontispiece, page 22: Attic clay loutrophoros, attributed to the KX Painter, beginning of the sixth century B.C. *Human Figure,* 33

Frontispiece, page 80: Attic red-figure kylix, detail, c. 500 B.C. Agora Museum, Athens. *Human Figure,* 51

Frontispiece, page 92: Attic red-figure kylix, detail, c. 500 B.C. Agora Museum, Athens. *Human Figure,* 51

Frontispiece, page 140: Fragment of a clay relief pithos, second quarter of the seventh century B.C. Archaeological Museum, Tenos. *Human Figure,* 26

Contents

Preface

This volume of Studies in the History of Art comprises the proceedings of a symposium on "New Perspectives in Early Greek Art," sponsored by the Center for Advanced Study in the Visual Arts in May 1988 and held in conjunction with the exhibition *The Human Figure in Early Greek Art* at the National Gallery of Art. The gathering was intended to present current research in various aspects of Greek culture, including literature, mythology, archaeology, art, and architecture. An initial idea of the diversity of subjects and themes addressed by the sixteen presentations may be gained from the titles of the four sessions: "A New View of the World," "Myth and Man," "Sacred Spaces," and "Man in the Visual Record." The Center for Advanced Study is extremely grateful to Leon Levy and Shelby White for the generous support that made this symposium possible.

The symposium was planned in consultation with Diana Buitron-Oliver, curator of the early Greek art exhibition, who also kindly agreed to edit the symposium papers for publication and to write an introduction to the volume. The Center for Advanced Study is pleased to acknowledge these important contributions here. The Center would like to express its appreciation also to Andrew Oliver, Carol Mattusch, and Richard Mason for their advice and assistance in the formulation of the program, and especially to Yannis Tzedakis, Martin Robertson, and James McCredie who, in addition to Diana Buitron-Oliver, served as moderators of the symposium sessions.

The Center for Advanced Study in the Visual Arts was founded in 1979, as part of the National Gallery of Art, to promote the study of history, theory, and criticism of art, architecture, and urbanism through programs of fellowships, meetings, research, and publication. This publication forms part of a separate series of Studies in the History of Art designed to document scholarly meetings held under the auspices of the Center and to stimulate further research. Coincidentally, the first volume within the symposium series, published almost a decade ago, concerned a culturally-related theme: *Macedonia and Greece in Late Classical and Early Hellenistic Times*, edited by Beryl Barr-Sharrar and Eugene N. Borza (Studies in the History of Art, volume 10).

HENRY A. MILLON
Dean, Center for Advanced Study in the Visual Arts

Introduction

The exhibition *The Human Figure in Early Greek Art*, which opened at the National Gallery of Art in January 1988, sought to draw attention to the changes in the representation of the human figure during the four centuries that preceded the emergence of the Classical style in art, that is, the period from the tenth to the beginning of the fifth century B.C. This was a critical period in Greek history, during which Greece emerged from the Dark Ages and developed a culture that is recognized as the basis of western civilization. American museums have presented many exhibitions of Greek art in the last decade, among them *Greek Art of the Aegean Islands* (1979–1980), *The Search for Alexander* (1980), *Vases from Magna Graecia* (1982–1983), *The Amasis Painter and His World* (1985–1986), *The Gods Delight, the Human Figure in Classical Bronze* (1988–1989). None, however, had so broad a scope as this one, which considered the human figure throughout Greek lands over a period of four hundred years. During the exhibition's preparation many questions arose, some of them basic, such as what role these objects were made to play, what kind of spaces they inhabited, and how the styles evolved. Other questions were more philosophical and abstract, such as that of the relationship between gods and men, and men and heroes. All these issues are still under debate, and many of them are addressed in the symposium papers that complemented the exhibition.

In examining some of these topics, the contributors presented new material as well as new perceptions about familiar material. We are most grateful to our colleagues from Greece for publishing recent archaeological discoveries and objects excavated long ago but not well known to audiences outside Greece. The directors of two major museums in Athens present objects previously unpublished. Evi Touloupa, former director of the Acropolis Museum, discusses bronze fittings from the Athenian Acropolis that include early versions of several popular myths: the suicide of Ajax, Herakles and the Ketos, Perseus and Medusa. Olga Tzahou-Alexandri of the National Archaeological Museum, Athens, contributes an interpretation of the Painter of Acropolis 606, a major figure in early black-figure painting, augmenting his oeuvre with a vase recently brought to light on the Acropolis, which increases our understanding of his artistic personality.

Recent archaeological excavation enhances understanding of the nature of early monumental architecture in sanctuaries, giving us an idea of the setting in which objects such as those in the exhibition were used or displayed. Vassilis Lambrinoudakis describes the temple he excavated on Naxos in the Cyclades, and Richard V. Nicholls provides an interpretation of a sequence of early temples at Old Smyrna in northern Ionia. Bernard C. Dietrich investigates the origins of the Greek sanctuary and the role of the cult image.

An exhibition or symposium dealing with the early phases of the mainland Greek artistic achievement must address the problem of continuity—whether Bronze Age Crete and

Classical Athens form part of the same continuum. Emily Vermeule provides new insights into the debate in her discussion of a previously unpublished head vase with funerary significance.

The undoubted continuity of language from Bronze Age to Iron Age leads to questions about the date of the appearance of the Greek alphabet. Mabel L. Lang argues for an eighth-century B.C. date for literacy in Greece, taking into account recent theories that would place transmission of the alphabet from Phoenicians to Greeks as far back as the eleventh or even the fourteenth century.

What kind of society produced these objects? Alan Boegehold shows that it was one with an enduring impulse toward sociability, and that this same characteristic informed developments in politics and warfare. Oswyn Murray asks us to consider how art was used in antiquity, and how its uses affected artistic production. Jeffrey M. Hurwit discusses the Greek experience of nature, pointing to the scarcity of landscape representation until the end of the sixth century B.C. and suggesting a possible reason for increased interest in nature in late Archaic Athens.

What is the significance of these objects? What do they reveal about the Greek view of gods, heroes, and men? Bernard Knox and Walter Burkert both address the Homeric view of man, from Homer's specific physical descriptions, or lack thereof, to the anthropomorphism of the gods, the Greeks having been among the first to create gods in the image of man. Alan Shapiro investigates the character and development of the Athenian national hero Theseus, reinterpreting several well-known representations.

Some traditional ways of looking at objects are given a new perspective in these essays. Evelyn Harrison does this for women's dress, focusing on the Archaic korai, but surveying the evidence from the Bronze Age onward. Dyfri Williams shows how vase painters came to understand the mechanism behind the human body and mastered technical devices usually attributed to much later periods. Mando Oeconomides examines the human figure in the period covered by the exhibition through a survey of coins marked with human figures.

As well as adding to the corpus of material with which we interpret antiquity, these essays reveal several trends in current scholarship. One is the increasing importance given to the Near East as a source of inspiration and of craftsmen. We see this in the development of monumental architecture in sanctuaries, the way in which the gods are conceived and depicted in literature and art, and the nature of the dominant religious rituals. Another trend is expressed by Oswyn Murray, who asks us to forego the developmental model in art history by considering objects of art in the social context that produced them. In general the symposium confirmed the fruitfulness of many different approaches to the study of classical antiquity, by demonstrating the scholarly rewards achieved in departing from the customary and traditional models.

DIANA BUITRON-OLIVER
Georgetown University

New Perspectives in Early Greek Art

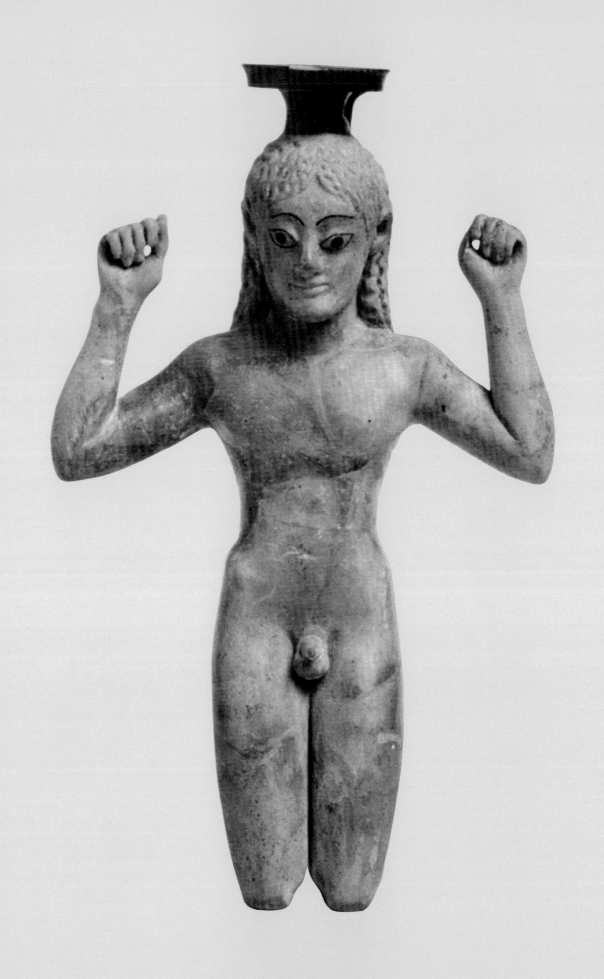

ALAN L. BOEGEHOLD
Brown University

Archaic Greece: An Era of Discovery

When historians make their categories of Greek civilization, they distinguish a Mycenaean Era, a Dark Age, and Archaic and Classical eras. Throughout those eras, which is to say (roughly) the twelve hundred years from the sixteenth century B.C. to the late fourth century B.C., Greeks were recognizably Greeks in that they spoke Greek. They lived in mainland Greece, in the Peloponnese, and on Aegean islands, and their lives touched Cyprus, Asia Minor, and Italy. Mostly they buried but sometimes they burned their dead, and they included offerings when they could. They all recognized essentially the same deities. From a time earlier than when the tales of Homer were first written down, they had conceived of an abstraction called "justice," and had entrusted to their neighbors responsibility for its implementation (Homer, *Iliad*, 18, 497–508). They all ate more or less the same food, and they danced to celebrate, mourn, or signify all phases of life. Greeks moreover of Archaic and Classical times looked back to earlier eras; when they had pretensions to nobility, they might identify as their forefathers Herakles and Theseus, Nestor, Aias, and other legendary figures from a millennium before.[1] These heroic figures they also made their exemplars of proper conduct and achievement.

From c. 750 B.C. to 490 B.C., records and reports of an expansive series of developments define the term *Archaic Era*. A new conformation of communal life, namely the *polis*, has evolved among a people who now make explicit their identity as Greeks. They appropriate an alphabet, and they learn to read and write. If they have always been familiar with the sea, they now use it much more, and accordingly learn more from their eastern neighbors. They found colonies east and west. They speculate about the nature of the cosmos, begin to use coins, build bigger and better temples and treasuries, execute more ambitious sculptures, bake and paint ceramics that are exported all over the Mediterranean Basin, create Panhellenic sanctuaries and games, codify and publish laws, develop new tactics of warfare on land and sea, and devise new modes of poetry and song.[2]

A principal factor in this expansion of achievements was the city-state or polis. The polis was a geographical and civic unity, whose borders men usually set in accordance with natural features, such as mountains or valleys or water. The total land area might be modest, even for a powerful state. Within the borders, clusters of dwellings showed where there was access to arable land, or grazing areas, or ground well suited for defense against enemy attacks. Where there were springs of water, there would be settlements. The dwellings could be disposed in various ways: grouped in small hamlets scattered throughout the polis, or as a few larger towns with outlying farms, or as a large walled central town with outlying estates. A chief town was often situated on or with access to high ground, where fortifications and sacred precincts defined an *acropolis*. Somewhere

below the acropolis, an *agora* might be found. This was an area where food and goods were bought and sold, where citizens could meet to gossip and to consider the city's business, where sometimes buildings of civic administration were situated, and within which a space might be designated for dancing.[3] No single organization of space and people, however, presents itself as canonical throughout all the Greek poleis. What determined the nature and quality of a polis was the kind and number of men who had recognition as being responsible for its continuous existence. They established rights and obligations for themselves, and in so doing constituted a citizen body.[4]

To consider a few of the forms of poleis, a unification of Athens, which later Greeks called *synoikismos*, can have been an accomplished condition as early as c. 1300 B.C. Thucydides (2.15) preserves a tradition that in the time of Theseus, kings who had been ruling in various parts of Attica came to agree to having a single bouleuterion, but the full unification that is imputed to historical times may have come about as late as 600 B.C.[5] It is noteworthy, however, that there appears nowhere else in all of Attica during the Mycenaen era any other center that resembles the acropolis as it was in Athens at the time. An old double kingship at Sparta with subsequent modifications, whereby a board of supervisors or *ephors* and a senior council called *gerousia* directed policy, is an instance of another kind of polis, one whose vital center was located in four (and later five) geographically separated villages.[6] At Corinth, whose land extended to the Saronic Gulf on the eastern side of the isthmus and to the Corinthian Gulf on the western side, an oligarchy enclosed a large area of land within a wall. Inside that wall, and outside as well, there may have been hamlets or even great estates belonging to ruling families.[7] A small circle of families, a *dynasteia*, controlled Thebes, whereas at Ozolian Lokris, there was a council, a popular assembly, and something perhaps between the two called *apoklesia*. There were *demiourgoi* and committees formed of aristocrats. There was also an apportionment of public land, our first notice of such a concept.[8] A memory of ruling kings is attested in some states by old stories and by titles such as the Athenian βασιλεύς and φυλοβασιλεῖς, but the kings themselves had

disappeared, to be succeeded by aristocrats, oligarchs, and tyrants, and toward the end of the era by democracies. The incidents by which one charts such changes in forms of government are attested in enough density to certify a generalized phenomenon of change in Archaic Greece. The polis will accordingly be considered here in its aspect of nurturing matrix, out of which a number of new or newly developed arts and skills and ways of thinking emerged.

One difference made by the poleis was that they focused the appetites, energies, and talents of larger concentrations of people than before. In the first days of mutual recognition, if residents of one hamlet ascertained that in another hamlet Greek was spoken, indicating that fellow Greeks lived there, the resulting intercourse was not necessarily fruitful or amicable. It could then (as later) lead to bloody conflict. But the outcome, no matter what it was, did not involve many people. On the other hand, when in later days a number of such settlements agreed to have a common administration and system of settling differences between them, and a common defensive and offensive direction—as happened when poleis were formed—then the sheer resultant increase in number of people involved created a new dimension of effects on the world around them.

To note a few of these effects: Panhellenic centers, such as those at Delphi and Olympia, became large and influential, because poleis used, maintained, and enriched them. Likewise the extraordinarily productive use of forms, skills, and techniques from older civilizations to the east was a result of the polis civilization. Mycenaean Greeks had used the Mediterranean for trade, commerce, and exploitation, and during the so-called Dark Age, ships and sailing continued to be a necessary part of life. But once the polis existed, many more people were on the sea, and they thought of themselves as contributing members of societies that could help and protect them. Exploration and innovation became profitable as eastern goods, services, and culture were put to widespread and imaginative use.

What made it possible for poleis to come into being? Maybe it was increased rainfall after a long drought.[9] The peoples living around the Mediterranean in that case would have been able to grow more food, so that the

population could grow. The numerous colonies sent out by various cities attest population growth that may have surpassed the rate of increase of food production. But in addition to benefits of increased physical capacities—that is, healthier, more numerous citizens—majorities or leaders within geographically defined areas decided somehow to cooperate with their neighbors rather than attempt to exploit all within reach. For the needs and recognitions that made such cooperation desirable or possible, no single, sure explanation presents itself.

It may be interesting, however, in the context of polis and invention and creativity, to consider an enduring impulse among Greeks, namely, that toward sociability. This impulse might in fact be better called appetite—one which, coupled with a strong aesthetic sensibility, may account for some of the innovations of the Archaic Era. For once the comparatively populous community of the polis existed, like-minded spirits could come together and form their own community within it. And within this smaller community, poets and superior artisans could give and receive needed praise and appreciation. More ambitious ways of honoring gods now seemed appropriate to Greeks, who always wanted to compete and excel. Also there was time to make beautiful things, since food production in the Mediterranean area, while subject to natural catastrophes, does not require unremitting, intensive labor. Among the beautiful things that appear now, we find first the Homeric and Hesiodic poems, which were perfected in oral and written form early in the Archaic Era. Archilochos, Tyrtaios, Alkman, Ibykos, Sappho, Alkaios, and others follow, using a Homeric vocabulary but their own experience, dialects, and music, and new rhythms as well.

There was also painting. Out of Corinth and Athens, potters shipped vases whose quality of shape and decoration made them highly valued items of export. In the paintings that appeared on these vases, a central element was the human figure, whether representing a human or immortal being. Architectural elements also were painted and likewise carried representations of human figures. In the seventh century B.C., Greeks began to use stone in large-scale sculpture. They used stone also in their increasingly elaborate temples and treasuries, since a polis

by reason of its numbers of participants gave to planning and execution a stability that was never possible for families, clans, or special interest groups.[10] In sculpture, also, larger visions were actualized: sculptors made not only life-sized bronze and marble figures of men and women, boys and girls, and dogs, horses, lambs, and calves, but colossi as well. And it may be that sculptors working in these larger dimensions apprehended better the strength in a properly nourished and exercised musculature, together with its implicit urgencies.

Artisans who made beautiful things were alert to new possibilities of decoration. At the same time, an artist, poet, or architect, when admired generally for his creations and empowered to claim them as being essentially his own, could regard himself as an extraordinary being. Homer and his successors were both originators and producers of their songs.[11] If we suppose that a spirit of play together with curiosity moves artists and poets toward innovation, we may ask about possible connections between art and poetry and the Greek adaptation of letters of a north Semitic alphabet. For these letters, as they first appear in Greece, were not only used to affirm ownership and identify dedications but also clearly served as elements of decorative design. The earliest surviving examples of Greek writing are statements—in meter more often than not—to the effect that so-and-so owns or will own or made or dedicated this or that object. At the same time, the disposition of the letters often shows a consideration for design rather than a wish for clarity of expression.[12] Whether it was a restless painter in quest of different forms who prompted the initial discovery, or a poet who wanted to fix the words of his song and identify it as his own, we can in any case rationally doubt that the first person to turn Semitic letters into Greek was an accountant or bookkeeper. It was only later, by two or three hundred years perhaps, that Greeks regularly and systematically used letters for practical purposes such as inventories, accountings, and law codes.

A bronze *mitra* or groin guard, flattened to take writing, preserves the conditions of the earliest known Greek appointment of a scribe.[13] The appointment may be dated as early as the end of the sixth century B.C. In an unknown town in Crete, a board called *Da-*

taleis appointed one Spensitheos as scribe and recorder. His work therefore was to record whatever contracts, laws, genealogies, town decisions, and transactions his compatriots wanted to have accessible. Spensitheos was a citizen of the town. His descendants, who are to succeed him, are called "runners" when grown, and the name is taken to show that he and they were citizens.[14] It is noteworthy that in the same decree by which Spensitheos is appointed provisions are made to assure him of continued full citizen status. In some Doric communities and at Athens, citizens had privileges and responsibilities in accordance with a rank established by kind and volume of income, production, or contribution. These privileges and responsibilities, however, could be suspended or even nullified if contributions were in arrears. This could happen, for instance, when a citizen did not pay a debt he owed the state. In the particular case of Spensitheos, the Dataleis stipulate that ten axe-heads (a unit of weight) of dressed meat be given annually in his name to his male dining society (*andreion*). The reason for such a provision may be that a citizen of Spensitheos' rank made such a contribution as a necessary condition of his citizenship and that failure to do so would change his status. So the Dataleis, by providing for Spensitheos' contribution, assured continuity of his full citizen rights.[15] That the board took the trouble to do so permits an inference that citizenship (and perhaps even a certain class of citizenship) was a necessary condition for appointment as scribe in that Cretan town.

To consider briefly other groups whose members might have been citizens to the full extent in Archaic poleis, certain families or tribes obviously had priority, but substance was an inevitable attendant requirement. Pentakosiomedimnoi at Athens were landowners, as were the Spartiatai at Sparta, and the *kosmoi* in various Cretan towns. In most poleis men who could provide horses or armor would have been citizens. At first such citizens as these last would be hard to distinguish from landowners, but later, when a man could get his wealth from manufacturing or trading and not necessarily from land, residents with only small plots of land but who controlled other resources might qualify for citizenship, although they might not qualify for every single right and privilege that came with the highest rank. Potters at Athens are a case in

point. Considered quite apart from any genealogical claims a particular potter might be able to invoke, successful potters had disposable income. They had the use if not ownership of land, and they were employers. But all this may have been beside the point if they were not actually landowners. There was, however, a tradition at Athens that Solon enabled qualified foreign artisans to become citizens.[16]

But to return to Greek sociability and aesthetic sense, music and dancing combined both. Dancing was ubiquitous in Greece and may have been productive in ways one does not immediately consider. Some names of dances have survived, as well as pictures and descriptions of a few.[17] In certain kinds of dancing, possibly in most, choruses of a dozen or more dancers took part at the same time, and it appears from the shorthand notations of vase-painting that sometimes the dancers were in ordered ranks.[18] There is also a connection between dancing and being a good warrior that goes a long way back.[19] It may consequently be appropriate to consider two important innovations in warfare—namely, the hoplite phalanx formation and the trireme—both of which, early in the Archaic Era, may have assumed the form they kept in historical times. Dancing, including the sort that is done naked with a helmet, sword, or spear, was an old and familiar mode of expression long before triremes and phalanxes, so it may be of interest to review the means by which a phalanx and a trireme moved.

In the case of the phalanx,[20] a line of hoplites extends itself opposite to a similar line of enemies. These hoplites were men of property who could have imagined themselves Homeric heroes, each winning his own κλέος ἀνδρῶν, but who instead ordered themselves in disciplined units. Each warrior holds a circular shield on his left arm. With this shield, which is about a meter in diameter, he protects the hoplite on his left. His right arm holds his thrusting spear, or sword if it comes to close work. Behind him there stand in support ranks of hoplites who may be as few as four ranks deep or as many as twelve. Now this line, four to twelve ranks deep, must be able to move forward, back, left, and right, and to expand its wings, contract, and wheel. Its depth in ranks is not necessarily the same throughout its length. In one segment of the line, there may be four ranks, and

in another, five or six. In a long phalanx, there had to be squad leaders. But even so, how did they coordinate their movements? To an extent, they did so by music. They were not a gang of neighbors out on a raid, or a rabble moved forward and back under the whip; they were in a sense participants in a communal dance. The hoplite phalanx became a possible formation when each man knew how to protect the compatriot to his left, and wanted to do so. If we ask how it came about in the first place that such massive deployments were attempted, it seems natural to look to the communal dancing that boys and girls and seasoned veterans performed at festivals and virtually every civic celebration. In such dances, complex movements of twenty, fifty, or a hundred or more dancers could have been explored as refinements of the dance well before anyone realized their strategic uses.

On the sea, an analogous development can be imagined. Toward the end of the eighth century B.C., Ameinokles, a Corinthian, went to Samos and built four triremes for the Samians.[21] A trireme, therefore, was by that time a known and exportable commodity. It differed from previous ships in that it had three banks of rowers. The numbers of rowers came to 170, and they could, when properly coordinated, move the ship faster than those with one bank, and employ more complicated maneuvers as well. The crews, however, not only had to be conditioned physically to endure hard work, they had to execute—all 170 of them—vital maneuvers precisely and as one man.

One such maneuver was the *diekplous*. In order to visualize how a *diekplous* was executed, it is helpful to recognize that the hull of a trireme, like those of other ancient ships, was built as a hollow shell, the planks secured by mortise and tenon joints. Benches and decks were built afterward inside the shell, and a rope contrivance, when tightened, held the whole together. To disable such a ship, one needed to puncture that shell at the waterline. Triremes (like their predecessors) were built with bronze rams at their bows to make that puncture. Once the shell was penetrated, water went in and made the ship unnavigable. Usually a disabled ship would not sink but would sit helpless in the water until towed away.[22]

The ramming, however, needed to be done in certain ways to enable the aggressor to survive the collision he caused. One tactic was to get behind the enemy ship and try to overtake it. If it turned right or left, a pursuing ship was in a position to broach that shell with its ram. But one had to avoid becoming entangled. If for instance ruptured timbers held fast the ship that had done the ramming, then the result was no different than having been immobilized by grapples. Marines from the broached ship could board the aggressor, so that the advantage it should have had was lost. To keep this from happening, oarsmen maintained a certain known ramming speed, fast enough to overtake but not so fast that they could not extricate themselves after ramming. Then at a certain point, they had to suddenly reverse their rowing. This was not only to avoid becoming entangled and grappled, but also to facilitate a second ramming if possible. And this is one reason why rowers needed long hard training to be effective. They not only had to have endurance, they also had to respond in critical instants reflexively as a unit. They may have known they could do this in the first place because they had danced together. That is, dancing gave them confidence in their bodies and in their bodies' responses when required to perform some move all together. Their movements in any case, like those of the phalanx, were given rhythm by the music of a flute.[23]

To conclude, one cannot say, "They danced, therefore they could envision the first hoplite phalanx," or, "They danced, hence the trireme." Nothing is ever so simple.[24] Dancing, warring, and seafaring together had all had important parts in Greek life for a long time. But in fact Greeks, once the nature of their physical world allowed them to do so, formed their poleis, and their appetite for sociability was a factor in those formations. Their concern for beauty, clear enough in the poetry, jewelry, painting, sculpture, and architecture of the time, may also have been a factor in other achievements—seemingly mundane but hugely pregnant—such as writing and tactics of warfare on land and sea.

1. Compare Emily Vermeule, "Baby Aigisthos and the Bronze Age," *PCPS* N.S. 33 (1987), 122: "Greek poets and painters of all archaic and classical stages actively used the Bronze Age as their major medium of expression." On justice, see Hugh Lloyd Jones, *The Justice of Zeus* (Berkeley, Los Angeles, London, 1983), throughout but especially 1–59, 165–251.

2. For general views and assessments of the Archaic Era in Greece, see the following: Jeffery, *Archaic Greece*; Anthony Snodgrass, *Archaic Greece: The Age of Experiment* (Berkeley, Los Angeles, and London, 1980); Oswyn Murray, *Early Greece* (London, 1980); Charles W. Fornara, *Archaic Times to the End of the Peloponnesian War* (Cambridge, 1983).

3. See, for example, Homer A. Thompson and R. E. Wycherley, *Agora*, 14, *The Agora of Athens* (Princeton, 1972), 127.

4. Compare Raphael Sealey, "How Citizenship and the City Began in Athens," *AJAH* 8 (1983), 97–129.

5. If, as Kevin Clinton argues in "The Author of the Homeric Hymn to Demeter," *OpAth* 16 (1986), 43–49, that hymn is simply a restatement of a traditional, pious subject, we shall have to reconsider how one may use the hymn as evidence for a late unification of Attica.

6. Note the difficulty Megillos has in describing Sparta's constitution (Plato, *Laws* 712). There are recent discussions of the Lycurgan rhetra in G. L. Huxley, *Early Sparta* (London and Cambridge, 1962), 22–25; Jeffery 1976, 117–120; K. A. Raaflaub, "Die Anfänge des politischen Denkens bei den Griechen," in *Pipers Handbuch der Politischen Ideen*, 1 (Munich, Zurich, 1988), 251, with bibliography on 271.

7. On the early Corinthian families, see Nicholas Jones, "The Civic Organization of Corinth," *TAPA* 110 (1980), 161–193, with relevant bibliography. Also S. Dow, "Corinthiaca," *HSCP* 53 (1942), 89–119; R. S. Stroud, "Tribal Boundary Markers from Corinth," *CSCA* 1 (1968), 233–242.

8. An archaic inscription written in a Lokrian alphabet preserves these details. See R. Meiggs and D. M. Lewis, *A Selection of Greek Historical Inscriptions to the End of the Fifth Century B.C.* (Oxford, 1969), no. 13 with pages 24–26.

9. John McK. Camp II, "A Drought in the Late Eighth Century B.C.," *Hesperia* 48 (1979), 397–411, presents evidence for a period of drought that lasted some years at Athens. Compare Michael Jameson, "Famine in the Greek World," in *Trade and Famine in Classical Antiquity*, ed. Peter Garnsey and C. R. Whittaker (Cambridge, 1983), 6–16.

10. Evelyn B. Harrison, "Sculpture in Stone," in *Human Figure*, 50, cites the Greek desire to emulate "those richer and more powerful people of earlier times," that is, their Mycenaean ancestors.

11. W. Burkert, "The Making of Homer in the Sixth Century B.C.: Rhapsodes versus Stesichoros," in *Papers on the Amasis Painter and His World* (Malibu, 1987), 49 with note 43.

12. L. H. Jeffery, *The Local Scripts of Archaic Greece* (Oxford, 1960), gives content and appearance of early Greek alphabetic inscriptions. See especially 58–62 on the earliest such inscriptions. Compare M. Guarducci, *Epigrafia Graeca*, 1 (1967), 135–136, 145–146, 196–197, 226–227, 274–276, 328–329, 350–353; 3 (Rome, 1974), 476.

13. L. H. Jeffery and Anna Morpurgo-Davies published the editio princeps "ΠΟΙΝΙΚΑΣΤΑΣ and ΠΟΙΝΙΚΑΖΕΝ: BM 1969. 4-2.1, A New Archaic Inscription from Crete," *Kadmos* 9 (1970), 118–154. Subsequent studies are listed in *SEG* 17 (1977), 157–161.

14. See Jeffery and Morpurgo-Davies 1970, 135, comment on A, line 10.

15. See Catherine Gorlin, "The Spensithios Decree and Archaic Cretan Civil Status," *ZPE* 74 (1988), 159–165.

16. Plutarch, *Solon* 19. See A. Boegehold, "A New Attic Black-Figure Potter," *AJA* 87 (1983), 89–90; A. Boegehold, "Amasis and His Time," in *The Amasis Painter and His World*, Dietrich von Bothmer (Malibu, New York, London, 1985), 30–31; J. Boardman, "Amasis: The Implications of His Name," in *Papers on the Amasis Painter and His World*, 141–152; R. M. Cook, " 'Artful Crafts': A Commentary," *JHS* 107 (1987), 170 with note 12.

17. Names of dances principally in Pollux 4.101–108, Athenaeus 629–631, Lucian, *De Salt.* 10. M. Wegner, "Musik und Tanz," *ArchHom* 3 (1968), U69–U84, lists 189 representations of music and dancing on pottery and in bronze of the eighth and seventh centuries. Most are of women grieving, but some show men in helmets or with spears. Compare Jean-Claude Poursat, "Danse armée dans la céramique attique," *BCH* 92 (1968), 550–615. For a general survey, see L. B. Lawler, *The Dance in Ancient Greece* (London, 1964).

18. See, for example, dancers on a Middle Corinthian aryballos, illustrated in M. C. and C. A. Roebuck, "A Prize Aryballos," *Hesperia* 24 (1955), 158–163, pls. 63–64; A. L. Boegehold, "An Archaic Corinthian Inscription," *AJA* 59 (1965), 259–262, pl. 56; Guarducci 1967, 176. Compare the coordinated leaps of two dancers on a red-figured pelike, in Martin Robertson, "Jumpers," *Burlington Magazine* 119 (February 1977), 77–78, and three pairs of male dancers on a column-krater (Antikenmuseum Basel Inv. BS 415) discussed by J. J. Winkler, "The Ephebes' Song: Tragoedia and Polis," *Representations* 11 (1985), 43–48, fig. 4.

19. Homer, *Iliad*, 16, 617–618. Compare the line assigned to Socrates at Athenaeus 14.628F: "Those who pay honor to the gods with the most beautiful dances are the best in war."

20. On the phalanx, see W. K. Pritchett, *Greek Military Practices*, 1 (Berkeley and London, 1971), "The Marching Paian," 105–108, and 134–154 on the depth of files and width of the phalanx. On dance and its place in military training, see W. K. Pritchett, *The Greek State at War*, 2 (Berkeley and London, 1974), 216–218, 190–207 on the wings of the allied phalanxes and fleets; also W. K. Pritchett, *The Greek State at*

War, 4 (London and Berkeley, 1985), "The Pitched Battle," 1–93. I do not wish to contest Pritchett's convincingly argued view that something like the Archaic hoplite phalanx can be seen in Homeric battle scenes and in accounts of war in earlier civilizations, but at the same time I assume that our sense of something new may come from a development or change in modes of heavy armed infantry fighting.

21. Jeffery, *Archaic Greece,* 146 and 159, note 2, has doubts concerning date and kind of ship after saying (67), "perhaps at the end of the eighth century." Compare J. S. Morrison and R. T. Williams, *Greek Oared Ships, 900–322 B.C.* (Cambridge, 1968), 157–158; W. G. Forrest, *CQ* 19 (1969), 100; and L. Casson, *Ships and Seamanship in the Ancient World* (Princeton, 1971), 80–81. An account of the reconstruction of a trireme is found in J. S. Morrison and J. F. Coates, *The Athenian Trireme: The History and Reconstruction of an Ancient Greek Warship* (Cambridge and New York, 1986).

22. See J. F. Lazenby, "The Diekplous," *Greece and Rome* 34 (1987), 169–177, and Ian Whitehead, "The Periplous," *Greece and Rome* 34 (1987), 178–185, for recent discussion and diagrams. See most recently L. Casson and R. Steffy, eds., *The Athlit Ram* (College Station, Texas, 1991), 76–82.

23. Athenian athletes as represented in vase paintings often have a flute player nearby to provide music for their exercises. Moreover, dancing was widely recognized as being another form of exercise or training. See Plato, *Laws* 797, 814. The same music that made dancing and physical training rhythmic also attended Spartans and Corinthians when they went into battle. See P. Cartledge, "Hoplites and Heroes: Sparta's Contribution to the Technique of Ancient Warfare," *JHS* 97 (1977), 16; John Salmon, "Political Hoplites?" *JHS* 97 (1977), 89–90.

24. See E. L. Wheeler, "*Hoplomachia* and Greek Dances in Arms," *GRBS* 23 (1982), 232–233.

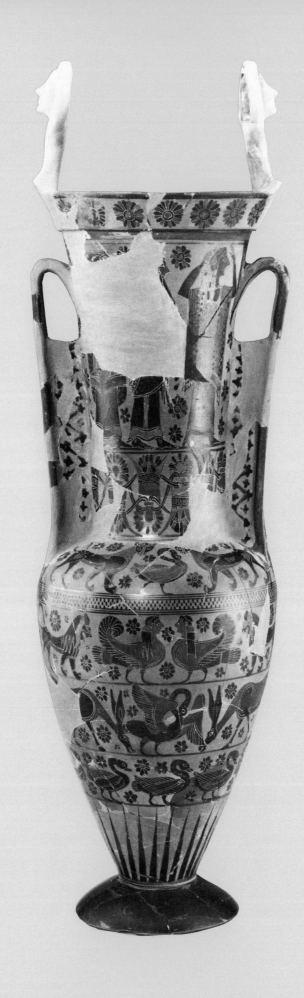

OSWYN MURRAY

University of Oxford

The Social Function of Art in Early Greece

Traditionally the history of classical art has been dominated by a developmental model of the historical process. We seek to analyze artistic production as a progression through time: for each artistic phenomenon, whether it be art form, artistic medium, style of decoration, type of production, or simple motif, we try to trace its formal continuity from its origins onward in a meaningful chain of cause and effect. Such a developmental model is fundamental to the Anglo-Saxon positivist school of history in general, and in terms of results it has proved its worth in art history as in other areas of historical research.

For all its apparent rejection of metaphysical justification, this developmental model rests on a pair of principles of comparatively recent formulation. The first of these is the proposition that the origins of a phenomenon constitute both its essence and a determining factor in the causal chain that is its history: to know how something began is to know that thing, and to be able to understand all its subsequent transformations. Thus the origins of naturalism in Greek art are the explanation of why Greek art developed as a system of naturalistic representations, and the limitations of that development are to be explained by the limitations inherent in its origins in Mesopotamia or Egypt. This principle is clearly a version of that most powerful of all nineteenth-century myths, the Darwinian theory of evolution, which holds the same position in modern western thought as the "Great Chain of Being" did in the Christian and Aristotelian centuries.[1] One important aspect of this principle is its retrospective character: it concentrates attention on the past versions of a phenomenon.

The second principle is prospective. It regards the significant in history as being that which leads forward in the process of development: the forms that have no future may be discarded from the record, for history is the record of success, not of failure: history is dominated by the future. It is such attitudes that seem to account, for instance, for the low esteem in which East Greek art is held, though it is hardly the fault of the East Greeks that their culture was destroyed by the Persians. This ruthlessness in the pursuit of progress is again part of a Darwinian model of natural selection, but it has its roots earlier, in the eighteenth-century Enlightenment. It is what the most intelligent of the English theorists of history, Herbert Butterfield, long ago christened the "whig interpretation of history," in which all is for the best in the best of all possible worlds.[2]

These assumptions have their advantages in the empirical study of history. They serve as principles of selection: only those artistic forms that have a past and a future are significant. The ordering of this evidence in causal chains produces traditions; and, as E. H. Gombrich has taught us, the creative process is best seen as operating within a framework of tradition. Each art form has its traditions handed on through a technical training or apprenticeship, which each successive

artist must master, whether the tradition is one that encourages innovation or conservatism. The phenomenon is the same in literature, where the writer inherits a tradition of generic forms and images, which he or she may alter to a greater or lesser extent: the eye and the hand, being merely extensions of the mind, respond to the external world in terms of inherited forms.[3] These assumptions also help to justify the activity of the art historian or critic, for they bridge the gap between critic and creative process: it is the critic not the artist who can explain for the artist what the artist intended. The balance between tradition and originality is maintained, whether that originality be conceived of as personal or socially determined. Western theories of artistic creativity have in fact oscillated around these three points of reference, tradition, the artist as genius, and art as social expression.

I have two worries about such an approach to the past. The first is that it is too closely bound up with the present: it seeks to explain the present in terms of the past, and to define the past in terms of the present. The history that results is in fact a charter myth, designed to validate the present and to prevent the past from establishing its independence—but surely history should be used to question, not to reinforce present values. Second, such a history shares in the dual character of traditional myth, in being both socially useful and demonstrably false. For we know from our own experience, we who live in history, that history is not like that. History as we experience it is a range of possibilities, some of which will become the future. We may try to predict (especially if we are politicians) which these will be; but we usually fail, even though our attempts at prediction may themselves embody attempts to assist history on the path we desire. We fail especially often where artistic production is concerned, for this is a situation where the unpredictable force of the human imagination is one of the primary causes. Nor do we usually feel for our own age that origin, essence, and cause are fused into a transcendental reality in a world in which change is an unimportant epiphenomenon. This is merely to say that we experience contemporary art as we experience contemporary history, as an aspect of a cultural unity in which past and future are overlaid with the interrelations of the present. If therefore we want to understand the meaning of art for past ages, we must begin by discarding the history of art.

Does this mean that we should espouse a form of idealism, in either the German tradition of *Kulturgeschichte* or the French tradition of collective representations? In my opinion, the answer may ultimately be yes; but that is not what I want to argue here. Instead I want to try to save as much as possible of the positivist approach, in the interests of maintaining the history of art as an intrinsic part of the study of history.

We may begin from a materialist perspective. The social value of art is directly related to its rarity value: often even the material from which the object is made may be scarce, but the skill itself is still scarcer. The laws of supply and demand will therefore ensure that the object created is highly regarded, and that the creator is granted a special status. Early Greece presents a model for such a process. A society with a low basis of material wealth and a lack of artistic skills began by importing objects of beauty: the merchant is the first "artist," whose initially high status diminishes as domestic production rises.[4] In the next stage there is a social problem, as a traditional society has to accommodate itself to the need for a group of privileged craftsmen, or *demiourgoi*, of such value that they must be permitted to stand outside society: the presence of eastern non-Greek craftsmen in Greek cities in the Late Geometric period is now widely accepted, as is the mobility of Greek craftsmen between Greek cities in the Archaic and Early Classical periods. The potters of early Greece, like the sculptors and temple builders of the fifth century, were rich and important men, capable of dedicating on the Acropolis, or of emigrating to Etruria to found a dynasty.[5] The ambivalence of their position in early Greece is expressed in their myths—the lame Hephaistos the divine artificer, who can win but not keep Beauty from the warrior class, and the heroic Daidalos, who is treated like a valued possession by his patrons, honored, imprisoned, and pursued, and who uses his skills to satisfy both their whims and his revenge.[6] Later, once the age of aristocracy has passed, the ambivalent status of the craftsman as outsider can be used against him: in the world of the hoplite bourgeoisie, where all art is state art or subordinate to the democratic concept of uniformity (*homoiotes*), the artist can be rede-

fined as the servant of mass production, a practitioner of a banausic *techne* at the service of his patrons who are the *demos*, and therefore at the bottom of the social scale. The final descent to the Platonic ideal of banausic *techne* is indicated by the descent of the artists from the Acropolis, to carve tombstones for the wealthy *rentiers* of postimperial Athens.

The rarity of art gives rise to a social function; for art may come to operate as a status symbol, differentiating an aristocracy of birth, wealth, or military or religious origins from the rest of the population. This relationship is mediated through patronage, which in turn has its effect on the content, medium, and style of artistic productions. In this social sense art becomes not a question of aesthetic appreciation, but a form of performance or display, serving a more or less public function within the society. Like the literary product, the art object must be considered in its role of performance within a specific social context; that is why art history must be a part of cultural history, and why cultural historians must interest themselves in art.

There seem to be two senses of performance that are relevant here. The first is the primary sense, the direct use of art objects in social, religious, or political rituals; the second is more general and concerns the contribution of art to the history of mentalities. The expenditure of skill or productive labor exemplified in the creation of art is not spread uniformly throughout a culture: it concentrates in certain areas of social life, and therefore serves to indicate the hidden priorities of a cultural system. Thus we should seek to interpret Greek art both directly, in terms of the rituals to which it relates, and indirectly, in the way that it marks out certain areas of human activity as being especially important in Greek culture.

In Classical Greece consideration of the general question seems more profitable: in the developed city-state, civic or institutional patronage and religious patronage indicate clearly where the priorities of the polis lie— in the public festival for the whole citizen body (such as the art of the theater), and in the glorification of specific religious cults adopted by the city and invested with political significance. It is interesting that direct political needs are mediated through these communal and religious forms, rather than being the focus for an independent form of art. Architecture is developed in relation to public buildings that are essentially religious; despite the dominance of the political, purely secular architecture is largely a post-Classical phenomenon. The system of values is well explained in a famous passage of Thucydides, comparing Athens and Sparta:

> For I suppose if Lakedaimon were to become desolate, and the temples and the foundations of the public buildings were left, that as time went on there would be a strong disposition with posterity to refuse to accept her fame as a true exponent of her power. And yet they occupy two-fifths of Peloponnese and lead the whole, not to speak of their numerous allies without. Still, as the city is neither built in a compact form nor adorned with magnificent temples and public edifices, but composed of villages after the old fashion of Hellas, there would be an impression of inadequacy. Whereas if Athens were to suffer the same misfortune, I suppose that any inference from the appearance presented to the eye would make her power to have been twice as great as it is.
>
> *(Thucydides 1, 10,*
> *trans. Richard Crawley,*
> *1876)*

Behind this melancholy vision of the transience of human societies lies the presupposition that religious art is an expression of military power, an idea natural enough in a society where the gods were responsible for victory, and where a tithe of booty from military success was traditionally dedicated to them for the adornment of their sanctuaries: Delphi was, in the memorable words of Jacob Burckhardt, "the monumental museum of Greek hatred for Greeks, of mutually inflicted suffering immortalized in the loftiest works of art."[7] It is from this perspective that Sparta is a paradoxical Greek city, in its combination of attention to military power with neglect of public art.

The question that I want to raise for specific discussion here is this: in what contexts does art perform in pre-Classical Greece, and how do these contexts affect artistic production? In suggesting a number of areas for investigation, I do not intend to imply that these areas are independent of each other. Rather we need to analyze the varieties of early

Greek art and the ways they function, in order to understand the complexity of a society that is itself a cultural unity. In order to avoid the accusation of assuming a differentiated society, I shall therefore try to emphasize especially the points of interaction between the fields that I have singled out.

The use of artistic skills in relation to the worship of the gods and religious rituals is a feature of most societies, but each form of religious art has individual characteristics. In Greece, religious art is centered on the furnishing of the temple building and the sanctuary on the one hand, and on dedications by the worshipers on the other, to the effective exclusion of the interests of a priestly class— a clear indication of the comparative insignificance of a priestly class mediating between worshipers and gods. Interestingly it is not the cult statue itself that is at first a focus of artistic activity, but rather the building that houses it. The traditional interpretation of the temple as derived from the Mycenean long-house of the chieftain has perhaps been reinforced by the ambivalent status of the tenth-century *heroon* at Lefkandi.[8] In an early period we may assume decoration in wood perhaps; but as soon as the skills of large-scale terracotta, and later stone carving, come into use, they are employed on public temples, rather than in the private sphere. Dedications and ex-votos arrange themselves in categories according to the religious needs the cult serves. They represent a considerable input of artistic labor, though the modest level of skill and the fact that they are often in base materials, such as terracotta and lead, demonstrate the wide range of social classes involved, or (to put it another way) show the nature of Greek religion as an expression of communal values, rather than an elite activity.

More lavish dedications raise problems of social propriety. Foreign kings like Gyges, Croesus, and Amasis may dedicate according to their fashion, but Greeks seem to be restricted to a certain code of values. That at least is the conclusion I draw from the importance of tripods, cauldrons, and iron spits in early dedications. The desire for display is regulated through a heroic code, for these are the objects that indicate wealth in the world of mythic value; they are therefore sanctioned by tradition, rather than naked displays of wealth. We may be sure that Rho-dopis, the courtesan of Naucratis, was not paid in iron spits for her services; but when she came to dedicate a tithe of her booty from her feminine conquests, the iron spit was a medium of suitable and traditional respectability (Herodotus 2, 135).[9] Recently, however, the work of N. Valenza Mele has drawn attention to the practical signification of symbolic objects, in relation to changes in tomb furniture in the Archaic necropolis at Cumae. Whether or not we accept her interpretation of the development "from the cauldron to the crater" as implying a change in social customs from feasting to the *symposion*, in a sanctuary context it is worth reflecting on the central importance of the division and cooking of meat in the ritual context of Greek sacrifice: the tripods, cauldrons, and iron spits may not have been intended for actual use within the sanctuary, but they retain a symbolic meaning in relation to the worship of the gods, after their practical social uses have disappeared.[10]

The military applications of art relate to the rituals of war and the demands of a warrior elite. Of course the materials involved— leather, iron, and bronze—are especially liable to decay, and our record is therefore necessarily incomplete. But leaving aside such mythical presentations of military art as the shield of Achilles or the armor of other Homeric heroes, it is clear that the manufacture and decoration of armor were major influences on artistic production in early Greece; they demanded high skills of technology and design, and the patron's pride in his status was expressed in the elaboration of decoration that he demanded from the armorer. The relation between an armaments industry and more general artistic production is well illustrated in the decline of Spartan artistic skills, as the Spartan aristocracy was submerged in the hoplite group of *homoioi* in the Late Archaic period. The artistic production that survived longest was the manufacture of bronze cauldrons, surely an activity carried on in the metal workshops supplying arms to the warrior elite; these cauldrons were apparently no longer in use within the society, but could serve as the symbol of a state diplomacy in relation to the barbarian world.[11]

In the earliest period we may also detect an interesting relationship between religion and the military function, in the way that the evidence of metal working seems often to be as-

sociated with religious shrines that do not belong to one city, as at the eighth-century shrines of Kalapodi in Phokis and Philia in Thessaly. The shrine outside the control of any one polis community may well have served as a focus for production and distribution of military hardware, just as its festivals seem often to have functioned as a hiring fair for mercenaries: hence the lavish dedications at Delphi and Branchidai by those eastern kings most interested in Greek mercenaries.[12]

Compared with such directly functional forms of art, the evidence for the use of art for personal display is more limited. It has not proved easy to substantiate in archaeological terms the claims of Herodotus (5,88) and Thucydides (1,6) about a specific Ionian form of dress intended to display "the easy life of the wealthy"; the gold grasshopper hairpins, mentioned by Thucydides and Aristophanes as worn by older aristocratic Athenians, seem a poor symbol of aristocratic *tryphe*. The dedication of dress pins and fibulae at a number of sanctuaries, especially those connected with women, seems to suggest that they were regarded as status symbols of some value. But these are remarkably modest styles of personal adornment. It may be that our picture of personal display would be substantially altered if we knew more about textiles; perhaps in the Archaic period there was more imported luxury cloth and less homespun than in the Classical age. But at present it does not look as if social class was reflected in significantly distinct styles of dress and personal adornment, among either men or women. In external terms, the move to the deliberately homogeneous Doric mode of dress was not the great revolution that our ancient sources suggest.[13]

Outside the military sphere the rituals of social differentiation emerge most clearly in two areas. The first of these is the funerary. It is often seen as a problem with Greek art, as with most ancient civilizations, that the circumstances of discovery cause our evidence to be heavily weighted toward death rather than life; but even so it is clear that death was an important focus for social rituals in Greece. These rituals did not so much concern the afterlife—even in the Geometric period the *corredo* or tomb furniture never reaches the heights it achieves in, for instance, the Italian peninsula—and there is little evidence in the Greek world for a conception of death requiring physical sustenance for the afterlife. In the Early Archaic period, tomb furnishing if anything becomes less striking, inversely as the level of material culture rises: armor disappears from the graves, and the possessions buried with the dead are limited to objects that have clearly been closely associated with them during life, and perhaps also those used during the preparation of the body and the funeral rites. The social significance of death lies rather in the funerary ritual itself.

This is reflected best in two types of evidence. The first is the series of funeral representations of prothesis, mourning, funeral procession, and perhaps funeral games, portrayed on the monumental Attic Geometric vases used as grave markers. This is an interesting artistic phenomenon, for it is the first clear evidence of functional representation, as the picture seeks to recall the event that the object commemorates; later such self-reference is of course common in sympotic pottery. The funerary vases also reflect the absence of a clear conception of the afterlife, in that their iconography concentrates on the activities of the living at the funeral, rather than the status of the dead; as J.-P. Vernant remarked recently, there is no iconography of death in early and Classical Greece, only rituals concerned with the funeral, and reflections of the iconography of life; that is why, for instance, *kouroi* can have a dual function both as dedications in sanctuaries and as grave markers.[14]

The second sign of the importance of the funeral in early Greek culture lies in the legislation to control expenditure and display at funerals, which has recently been analyzed by C. Ampolo. The most famous example is the legislation of Solon at Athens, which (if the account of Demetrius of Phaleron is to be believed) sought to "restore" the alleged earlier simplicity of funerals by limiting the numbers and the behavior of professional female mourners, the extent of the feast, and probably also the size of the pyre, the elaborateness of the feast, and the numbers present. The uncertainties in the description are introduced by the fact that Demetrius attributes the Athenian legislation on funerals to two successive stages: according to him, the limitations on the size of funeral monuments, and on speeches about the dead, were

enacted later, in the early fifth century. Similar legislation is known from other cities, and is to be connected with the attempt of the emerging hoplite polis to control the specific displays of power and wealth at the funeral by the traditional aristocracies.[15]

It is therefore clear that the funeral was an important social ritual, and we can relate the various types of funerary monument, whether carved stone or pottery, to their function as memorial, perhaps not so much of the individual dead, as of the funeral occasion and the social status displayed there: for until the advent of written epitaphs personal identity is not indicated in any specific way.[16]

The most distinctive and unusual art form of early Greece is of course its painted pottery, and the question of why this evolved as a major art is surely closely bound up with its function. Initially at least (with the exception of monumental funerary ware) the decoration of painted pottery offers no clue as to its use: it follows a stylistic development clearly affected by contact with the east, from geometric patterns to animal motifs, with the infusion of scenes that have been interpreted as related either to heroic myth or to real life—a distinction that (in the context of artistic representation as of life) probably has little meaning.[17] The definition of the function of pottery has at first to be deduced from the shapes involved. Many of these may allow for a range of possibilities—the amphora and the oinochoe are perhaps ambiguous—but two forms are surely significant. These are the drinking cup and the mixing bowl, each in a variety of shapes. The mixing bowl, krater or dinos, can only be associated with the group consumption of wine and water in a ritual context of *symposion* type. The close relationship between a wide variety of pottery shapes and the *symposion* becomes evident from the late seventh century onward, with the evolution of an iconography both specifically of the *symposion* and more generally of the aristocratic life of warfare and leisure. The shapes of sympotic pottery, however, go back at least into the Geometric period, and are reflected in Homeric epic. I shall be arguing elsewhere that the transition from Homeric feast to *symposion* of pleasure begins as early as the eighth century; and I would like to compare the gradual growth of an elaborate sympotic imagery in art with the equally gradual development of sympotic

lyric poetry, whose beginnings can be traced as early as Archilochus, but which is not fully developed until the sixth century.[18]

Again we can find an interesting interrelationship between two aspects in the prevalence of pottery designed for wine consumption in funerary contexts. The habit of placing the ashes of the dead in drinking vessels may have purely practical origins; but when these vessels are the magnificent black-figure and red-figure kraters found at Agrigento, with their total absence of funerary iconography, it is tempting to suppose a reference to the loss of the pleasures of life.[19] And in the Geometric age it seems clear that the use of kraters as tomb markers for male burials in Attica is intended to indicate a social status. The earliest Geometric kraters seem to have been objects used in life; some show signs of internal wear, and on one occasion of ancient mending. They were surely the focal point of a warrior group, and demonstrate the social prestige of the dead individual as leader of such a group. Later, funerary kraters with a specialized iconography were produced, whether for use at the funeral feast or because the functional role of the grave marker had become wholly symbolic.[20]

Finally we may return to remarks made earlier and consider a function of art that is perhaps closer to our own attitudes than any so far mentioned. The notion of value in respect of art objects may reflect a range of variables, from the value of the material and the rarity of the skill embodied in the object, to responses related to cultural identity, aesthetic appreciation, competitive acquisitiveness, or social custom. The ultimate expression of the value of an object is its withdrawal from the world of exchange: as it becomes too valuable to take part in any but symbolic forms of exchange, art may even become "art for art's sake." The "thesaurisation" of art can operate in an absolute form, or in terms of added value. Thus, to take only one example from personal experience of a practice widespread throughout the world, in the tribal areas of Pakistan today the price of gold ornaments is the weight of the gold: the skill of the goldsmith does not increase the value of the material with which he works; it rather transforms it into stored treasure, hung on the necks of women for simultaneous display and safekeeping. Nikolaus Himmelmann has shown how in the Homeric poems attention

is focused on the art object rather than the artist, and the object is primarily conceived of as an adjunct of the aristocratic life-style. It exists to be described with wonder, admired, stored in a treasure house, and used (if at all) in an aristocratic world of gift giving, related to the laws of hospitality and the acquisition of status. Such a world must lie behind many of the practices we have been discussing; for these too often involve the "thesaurisation" of art objects in rituals of social display, whether by burying them in the ground or by dedicating them in sanctuaries. Such activity has its analogues in the modern theory of collectionism, and in practices such as the dedication of works of art in museums: the worlds of the Homeric hero and the modern collector are not as far apart as a strict analysis in terms of ritual and use might suggest.[21]

Of course I do not intend to suggest that considering objects in terms of their functional status is the only way to study art, or even the most profitable for the art historian. But it is a way that possesses many advantages. It enables us to stand outside many traditional controversies, such as the relationship between mythic narrative and natural representation in early Greek art, or the divide between the artist and the craftsman (surely a meaningless distinction before the fifth century, as Coarelli and others have argued). It gives us a comparative viewpoint outside Greek culture, so that we can ask questions about why Greek art developed particular artistic traditions. And it enables us to relate the theory of art to the theory of literature, and to see how developments in these two spheres of human activity complement each other. Finally it enables us to ask questions about the mentality of an age in terms of the totality of its surviving representations, without attributing to any particular art form a privileged metaphysical status.

NOTES

1. Arthur O. Lovejoy, *The Great Chain of Being* (Harvard, 1936); Gertrude Himmelfarb, *Darwin and the Darwinian Revolution* (London, 1959).

2. Herbert Butterfield, *The Whig Interpretation of History* (London, 1931).

3. Ernst H. Gombrich, *Art and Illusion* (London, 1960); Ernst R. Curtius, *European Literature and the Latin Middle Ages*, trans. Willard R. Trask (London, 1953).

4. On the role of the merchant in early Greece, see especially Benedetto Bravo, "Une lettre sur plomb de Berezan: Colonisation et modes de contact dans le Pont," *Dialogues d'histoire ancienne* 1 (1974), 110–187, and B. Bravo, "Remarques sur les assises sociales, les formes d'organisation et le terminologie du commerce maritime grec à l'époque archäique," *Dialogues d'histoire ancienne* 3 (1977), 1–59; Alfonso Mele, *Il Commercio greco arcaico: Prexis ed emporie* (Naples, 1979); my own views on this controversial topic are sketched in *Early Greece* (London, 1980) chaps. 5 and 13.

5. See the excellent collection of the main articles on the status of the artist in early Greece, Filippo Coarelli (ed.), *Artisti e artigiani in Grecia: Guida storica e critica* (Rome, 1980). On the relation between art and function in early Greece, I owe much to Nikolaus Himmelmann, *Über bildende Kunst in der homerischen Gesellschaft, Abhandlungen der Akademie der Wissenschaften und der Literatur* (Mainz, 1969), n. 7.

6. Jean-Pierre Vernant, "Le travail et la pensée technique," in *Mythe et pensée chez les grecs* (Paris, 1965), section 4; Françoise Frontisi-Ducroux, *Dédale: Mythologie de l'artisan en Grèce ancienne* (Paris, 1975).

7. "Vor allem aber war Delphi noch in der Kaiserzeit das grosse monumentale Museum des Hasses von Griechen gegen Griechen, mit höchster künstlerischer Verewigung des gegenseitig angetanen Herzeleids": Jacob Burckhardt, *Griechische Kulturgeschichte* (Leipzig, 1962), vol. 1, 285.

8. Mervyn Popham, E. Touloupa, and L. H. Sackett, "The Hero of Lefkandi," *Antiquity* 56 (1982), 169–174.

9. Louis Gernet, "La notion mythique de la valeur en Grèce" (1948), in *Anthropologie de la Grèce antique* (Paris, 1968), 93–137. On this passage in Herodotus and the related stories of harlots' pyramids, see now the discussion of Alan B. Lloyd, *Herodotus Book II: Commentary 99–182* (Leiden, 1988), 84–87.

10. Nazarena Valenza-Mele, "La necropoli cumana di VI e V a.c. o la crisi di una aristocrazia," in *Nouvelle contribution à l'étude de la société et de la colonisation eubéennes* (Naples, 1981), 97–124; "Da Micene a Omero: Dalla phiale al lebete," *AION* 4 (1982), 97–133; "Dal banchetto al simposio: Dalla comunità arcaica alla polis classica" (forthcoming). On sacrifice see the bibliography of Jesper Svenbro in Marcel Detienne and Jean-Pierre Vernant, *La cuisine du sacrifice*

en pays grec (Paris, 1979), 309–323; trans. Paula Wissing, *The Cuisine of Sacrifice Among the Greeks* (Chicago, 1989), 204–217.

11. A. James Holladay, "Spartan Austerity," *CQ* 27 (1977), 111–126; Claude Rolley, "Bronze Vessels and the Barbarian World," in *Greek Bronzes*, trans. Roger Howell (London, 1986), 141–150.

12. Klaus Kilian, "Weihungen aus Eisen und Eisenverarbeitung im Heiligtum zu Philia (Thessalien)," in Hägg (ed.), *Greek Renaissance*, trans. Roger Howell (London, 1986), 131–147; my remarks in the discussion there (146–147) relate to the views in Murray 1980, 221.

13. On pins in sanctuaries, see Paul Jacobsthal, *Greek Pins* (Oxford, 1956), 96–104; for cicadas see "Four Ornaments in the Form of Cicadas," in Patricia F. Davidson and Andrew Oliver, Jr., *Ancient Greek and Roman Gold Jewelry in the Brooklyn Museum* (Brooklyn, 1984), 13–14; see also in general A. G. Geddes, "Rags and Riches: The Costume of Athenian Men in the Fifth Century," *CQ* 37 (1987), 307–331.

14. Vernant's remark was made in the course of his (unpublished) summing up at the colloquium "La parola, l'immagine, la tomba," Capri, 20–24 April 1988, whose papers appear in *AION* 10 (1988).

15. Carmine Ampolo, "Il lusso funerario e la città arcaica," *AION* 6 (1984), 71–102.

16. For the significance of the funerary epitaph in early Greece, see now Jesper Svenbro, *Phrasikleia: Anthropologie de la lecture en Grèce ancienne* (Paris, 1988).

17. See most recently John Boardman, "Symbol and Story in Geometric Art," in *Ancient Greek Art and Iconography*, ed. Warren G. Moon (Madison, 1983), 15–36.

18. See Oswyn Murray, "The Symposion as Social Organisation," in Hägg (ed.), *Greek Renaissance*, 195–199; Murray, "The Greek Symposion in History," in *Tria Corda: Scritti in onore di Arnaldo Momigliano*, ed. Ettore Gabba (Como, 1983), 257–272; "Nestor's Cup and the Origins of the Symposion" (forthcoming).

19. *Veder greco: Le necropoli di Agrigento* [exh. cat., Mostra Internazionale Agrigento] (Rome, 1988).

20. See Wilhelm Kraiker, "Die Anfänge der Bildkunst in der attischen Malerei des 8. Jahrhunderts vor Christus," *BonnJbb* 161 (1961), 108–120. I owe these points to discussion with Barbara Bohen and John Boardman.

21. Compare the remarks of Himmelmann 1969 with those of Howard S. Becker, *Art Worlds* (Berkeley, 1982).

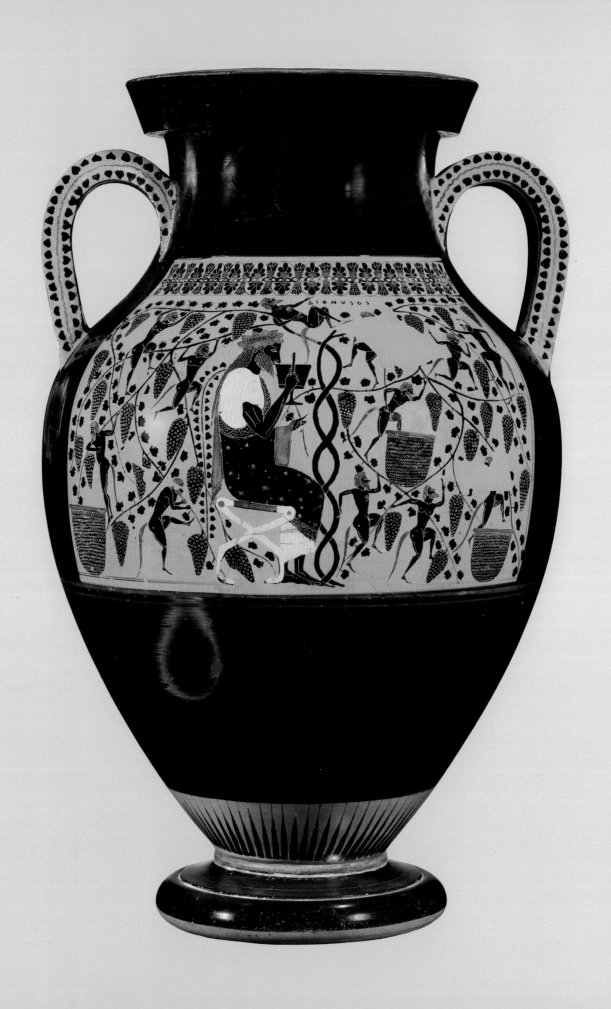

JEFFREY M. HURWIT
University of Oregon

The Representation of Nature in Early Greek Art

The moon has set
And the Pleiades, and the middle
of the night has come. Time goes by
And I lie alone . . .

In this fragmentary lyric often (and rightly) attributed to Sappho,[1] the poet observes the natural world but realizes in her solitude that she is not part of it or its rhythms. The night sky seems almost hostile in its undisturbed, indifferent motion, in its disregard of the poet's feeling. She is isolated and distinct from nature; it is "other." Here, all agree, is Sappho again, and one of the richest descriptions of nature in Archaic poetry:

> She honored you like
> a goddess manifest,
> and in your song delighted most of all.
>
> But now among the ladies of Lydia
> she is pre-eminent, like
> the rosy-fingered moon after sunset,
>
> Surpassing all the stars; its light
> spreads over the salt sea
> alike and the field of flowers,
>
> And the lovely dew is shed,
> and roses bloom, and tender
> chervil and blossoming melilot.
>
> To and fro, wandering,
> She remembers gentle Atthis with
> yearning;
> surely her tender heart is heavy . . .[2]

The same sort of flowery and dewy meadow appears elsewhere in Archaic Greek poetry, and it is an idealized and conventional place, a "meadow of love."[3] But its presence here is not the most interesting thing about the poem. What is striking is the abrupt transition from the lush but imagined landscape (which is itself described in a simile and thus exists only in a world of reference or analogy, in a frame detached from the outer world of the poem) to Atthis' unnamed friend, "wandering to and fro." She is not wandering in the landscape of the simile; we are not told where she is wandering. She is just somewhere in Lydia, yearning and grieving, and the luxuriant, evocative landscape of the simile, like the starry night of "The moon has set," is in stark contrast to her (and to Atthis') isolation. She is a figure—they are both figures—without place.[4] As such they are quintessentially Archaic.

Every culture, society, or people must somehow come to terms with its environment, must somehow structure a set of relationships, more or less complex, with the natural world. But no culture, society, or people is obligated to admire or love its landscape, to find its countryside beautiful or the raw nature beyond the fields and hills, the wilderness at the margins, sublime. Not every landscape excites what the geographer Yi-Fu Tuan has called "topophilia," "the affective bond between people and place or setting."[5] The veneration of landscape, the familiar Romantic impulse to create artistic worlds that are doubles for the worlds of our intellect, ideologies, or emotions, outer worlds that really offer inner, imaginative journeys, have not always or everywhere been components of human desire (that the Romantic attitude toward nature is especially familiar to us should not obscure the fact that it is a particularly extreme position).[6] And the

habit the Romantics had of fusing themselves with nature or of describing themselves wandering through it is one that not many earlier poets shared. Byron's question

> Are not the mountains, waves, and skies,
> a part
> of me and of my soul, as I of them?[7]

would, I think, have mystified an early Greek poet, not to mention a Medieval one. And so might David Hockney's infatuation with southern California: "I'm deeply attracted to the space of this place," he recently told the magazine of United Airlines. "You feel deeply of the earth. It makes you feel small—very good for the soul, I think. It's a spiritual experience in a way."[8] This is topophilia, and it is a feeling that many artists in human history, in their own landscapes, have simply not felt.

We probably perceive nature the way we are taught to perceive it, and cultural expectations may counteract even strong instincts.[9] Certainly, our representations of nature instruct us, conditioning our aesthetic attitudes when we come upon nature itself once again. Thus, topophilia is basically a learned response: it is not universal or innate.[10] And even where it may be genuinely felt, it may not be expressed in literature or art. It may be silent, it may be invisible; undetected, it may nonetheless be real.[11] Or it may be expressed in other ways—in, for example, the placement of a temple upon a precipice (as at Sounion) or on a mountainside (as at Bassae). There, the sympathetic commentary between ordered form and rough nature at first seems the point, though it may also be that the temple, which (in the language of Wallace Stevens) is like nothing else in the landscape, *makes* the landscape surround it, and so, man-made, takes dominion over it—an imposition of culture upon the land, rather than a communion with it.[12] Here, then, are some things at the root of our problem, and a caution as well: the apparent dearth of landscapes in early Greek poetry and art does not necessarily mean that topophilia was utterly absent from the early Greek temperament.[13] Conversely, topophilia and a sensitivity to the beauties of the environment are not the only phenomena that can lead to the depiction of landscape or its elements. Paradoxically, perhaps, topophilia may at times be irrelevant to the representation of nature and place.

Descriptions of the natural world are really not so rare in the poetry of early Greece, though the descriptions are generally of single elements or small sections of nature rather than of comprehensive, picturesque panoramas. Beauty seems to reside mostly in the details—in, for instance, the narcissus with a hundred blooms and sweet smell that Persephone picks in the *Hymn to Demeter* (lines 8–11), a thing of awe (*sebas*) for both gods and mortals—and the Greek view of nature, with the usual exceptions, thus seems myopic, ignoring distances and scale.[14] The problem is that those who have expectantly looked (usually through the hazy filter of romanticism) for expressions of an emotional or sentimental attachment to the natural world in early Greek poetry, and by extension in early Greek art, have not found very many (they have not even found a single Greek word for *landscape*, though not too much should be made of that).[15] Finding the ancient Greeks curiously unlike Wordsworth, Constable, or Heine, they have looked for possible explanations, and they have found plenty.

For Friedrich Schiller, who essentially began the search in 1795 with his essay "Über naive und sentimentalische Dichtung," the ancient Greeks (and he was speaking of them all, not just the Greeks of the Archaic period) failed to respond to or describe the beauty of the natural world because they were too close to nature, too "naive" in their relation to it, too much in accord with it, to conceive of it as a subject for representation. "With them culture had not degenerated so much that nature was abandoned for it. . . . Since, therefore, the Greeks had not lost nature in humanity, they could not be astonished by it outside of humanity and had no such urgent need for objects in which they found it again. . . . They felt in a natural way, we feel the Natural."[16] For Alexander von Humboldt, who devoted a few pages of his monumental work, *Kosmos*, to the problem, the answer was not the naivete but the anthropocentrism of the Greeks, which made of nature a mere accessory: "in Grecian art, all things are centered in the sphere of human life. The description of nature in its manifold richness of form, as a distinct branch of poetic literature, was wholly unknown to the Greeks. The landscape appears among them merely as the back-ground of the picture of which human figures constitute the main

subject."[17] And there is ancient authority for this almost inescapable conclusion as early as Plato's *Critias*: we do not pay much attention to depictions of mountains, rivers, and woods, Critias says (implying, incidentally, that such depictions were not uncommon or remarkable in and of themselves), but paintings of the human figure come under our most intense scrutiny (107C–D). The representational status of the human figure was simply higher. Yet in a famous chapter of his *Modern Painters*, John Ruskin gave four reasons for the apparent failure of the Greeks to respond to nature in addition to the notion that they were just too obsessed with the human form to bother with anything else: (1) they could not distinguish the landscape from all the divinities who occupied it; (2) being inhabitants of Greece, they were so used to the beauties of nature that they became jaded by and indifferent to it; (3) they lived such healthy lives they did not experience the fits of melancholy that the contemplation of nature can relieve; and (4) they, loving symmetry, feared "all that was disorderly, unbalanced, and rugged." "They shrank with dread or hatred from all the ruggedness of lower nature,—from the wrinkled forest bark, the jagged hill-crest, and irregular, inorganic storm of sky." The Greeks took pleasure only in places more "in harmony with the laws of [the human figure's] gentler beauty"—middle landscapes like meadows, fountains, and shady groves, landscapes like those in Sappho's lyrics.[18]

There is enough evidence in early Greek poetry to support some of these views. There is even enough to launch a defense of the Greeks, to argue that they responded to the beauties of nature well enough after all,[19] that varieties of topophilia were not unknown,[20] even that they could feel or describe something like the English Romantic Sublime. In a simile from the *Iliad*, Zeus "removes a dense cloud from the peak of some great mountain, and the lookout points and spurs and clearings are distinctly seen as though pure space had broken through from heaven"—and with that Archaic poetry probably comes as close as it ever gets to Wordsworth.[21] The evidence of Archaic poetry, in other words, is rich and varied enough for us to conclude that there was no single, all-encompassing Archaic Greek attitude toward nature, that it shifts from genre to genre, poet to poet, poem to poem, even, in some cases, from one part of a poem to another. But there is one current in Archaic poetry that, running among others,[22] runs especially strong: the sense of the natural world as "other," as fundamentally distinct from human beings. The source of this current is the *Iliad* itself, where nature not only seems unremittingly hostile—a rainbow, of all things, is considered an omen of war[23]—but where the world of heroic action and the world of nature rarely make contact. The world of the narrative lacks detailed descriptions of places and settings; the spatial relationships among the Achaean camp, the few known features of the Trojan plain, and the citadel itself are unexplored and blurry;[24] and parsimonious Homer only occasionally places a single oak, wild fig, or shrub amid the action, for a landmark or prop. Thus, for example, Odysseus hangs Dolon's weapons and clothing upon a tamarisk at 10, 465–468, turning it into a signpost in the night, and at 21, 18 another narratively useful tamarisk appears so that Achilles can lean his spear against it.[25]

The heroes of the *Iliad* act in a narrative world that, for all we are told of it, is practically barren. But it is not that the landscape is desolate, laid waste by war; it is that the landscape, for the most part, is just not there. As Annie Bonnafé has shown in detail, nature and landscape exist primarily in the world of the simile, in the world of reference. Although nature can be given semihuman aspects, even a will, and although similes sometimes are used to suggest the mood or anxiety of heroes,[26] nature remains distinct, inhuman, even adversarial: its inhuman pitilessness is clear at 16, 34–35, where Patroklos charges that Achilles must have been the child of "the grey sea and steep cliffs, since your mind is so harsh," and the essential antagonism between man and nature is mythologized in the battle between Achilles and the River Xanthos in book 21.[27] And nowhere in the *Iliad*, and only rarely elsewhere in Archaic poetry, are there any concessions that man might actually live in pleasant harmony with a nature untamed and undomesticated.[28] To be sure, there are in Homer, as in Sappho, Alcman, and other early Greek poets, beautiful descriptions of beautiful natural scenes: Calypso's pleasure garden comes to mind. But what dominates Archaic poetry is a process that detaches nature, setting it apart

from human beings, making it an artifact to be seen, not an environment to be experienced: it is "over there," and it needs observers at a distance (like Hermes, in the case of Calypso's wild bower, or Odysseus, in the case of Alkinoos' manicured gardens), rather than occupants.[29] Now, the otherness of nature as perceived by the poets, their reluctance to visualize their figures or themselves in a fully detailed setting, and the distance of human beings from nature do not by themselves explain the absence of landscape from early Greek art. Still, it may not be merely coincidental that the world of Archaic art happens to be essentially the same as the primary world of the *Iliad*—a narrative world that is virtually a natural vacuum.

The Nowhere of early Greek art, the dearth of place and setting, almost goes unnoticed, the Archaic concentration on the human form seems so intense and complete. It is symptomatic that in his *Die Naturwiedergabe in der älteren griechischen Kunst,* Emanuel Loewy could list the absence of landscape as one of seven defining characteristics of the Archaic style: for Loewy the early Greek treatment of "nature" was identical with and limited to its treatment of the human form.[30] And Loewy had a point. There are no more than eight Archaic reliefs with landscape elements preserved (though the series begins rather early with the olive tree incised into the background beside the giant or Titan attacked by Zeus in the angle of the Corfu pediment).[31] And the percentage of Archaic vases that bear the image of even a single tree or rock is, compared to those vases that bear nothing but human figures, very small indeed. If we exclude the plucked and portable nature—the flowers, myrtle branches,[32] ivy, vines, and so forth—that many Archaic figures wear or carry around with them (especially Dionysos and his cohorts, with their proto-*thyrsa*), the percentage is perhaps no higher than 5 percent.[33]

But what is sometimes not appreciated is how rare—and how odd—the Archaic Greek artist's attitude toward the representation of nature seems to be in the history of ancient art as a whole. Even a Neolithic artist could apparently paint his dominolike city against the backdrop of an erupting volcano.[34] In Egypt, paintings and reliefs of men managing the landscape, of gardens and rivers, of marshes and desert, abound; there is even a

scene of a landscape destroyed by the armies of Ramses II.[35] In the art of Mesopotamia and Assyria, emperors and armies ascend mountainous landscapes, attack mountaintop cities, visit grottoes, or cross rivers and marshes in almost maplike settings, and lions await death in luxuriant gardens.[36] Within the Aegean region itself Bronze Age artists depicted *agrimi* cavorting on peaks, warriors defending coastal towns, monkeys hunting for eggs or cats stalking game along lush streams and in ivy thickets, bulls captured on undulating terrain amid olives and palms, ships sailing past richly detailed islands and coasts, and swallows darting through clusters of lilies growing from nearly animate rocks.[37] It is striking that essentially the same environment could apparently excite topophilia in cultures that occupied it early, but not in another that occupied it later on. Even the Etruscans are generally supposed to have displayed a much keener appreciation of nature than the Greeks.

And if there has been one comparison that time and again has been used to prove how different in this respect the Etruscans and the Greeks really were, it is the one between the Tomb of Hunting and Fishing at Tarquinia (figs. 1, 2) and the lid from the Tomb of the Diver at Paestum (fig. 3).[38] In the rear chamber of the Etruscan tomb (dated variously from c. 530 to c. 500), small boys hunt orange, blue, and outlined birds, net and spear fish in a continuous, choppy sea, and dive from a sheer, stratified cliff in an extensive, island-dotted seascape that seems to exult in the joyous (if here unrealistic) colors, freedom, and very scale of the natural world. The Etruscan fresco thus puts human beings and their activities in their proper place and proportion: the boys do not dominate the scene by their size, but act *in* nature.[39] The view of nature is not deep—there is no recession into the distance, and we are reminded of the hard reality of the front plane by the painted garlands hanging from the striped cornice above—but it is nonetheless large, wide, and inclusive. In the Greek panel (c. 500–480),[40] there is another diver, but the view of nature is far different. There are trees here and, like most trees in Archaic Greek art, they are little and spindly ("stark and bare as broomsticks," in Christopher M. Dawson's apt phrase),[41] their small gray leaves hugging the branches tight. Their evocation of nature, moreover, is

1. Tomb of Hunting and
Fishing, Tarquinia, c. 530–
500 B.C., detail
DAI, Rome

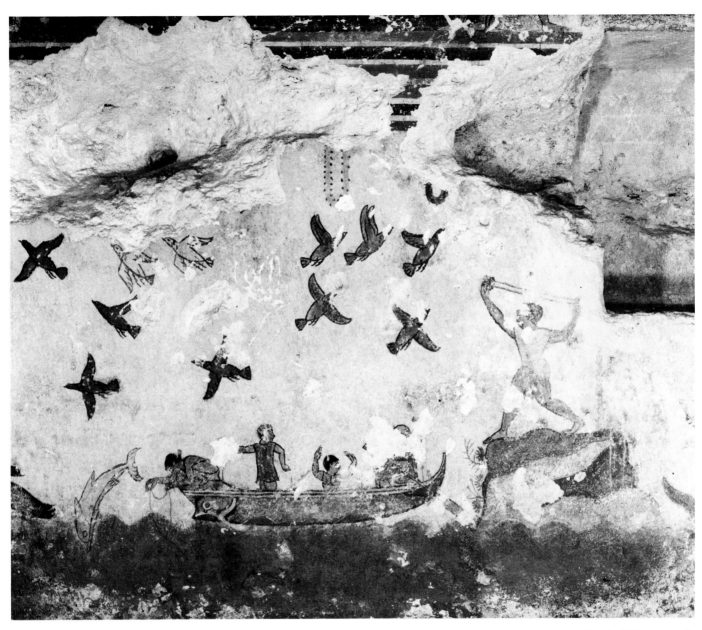

2. Tomb of Hunting and
Fishing, Tarquinia, c. 530–
500 B.C., detail
DAI, Rome

undermined by the prominent decorative pal-mettes at the four corners of the panel: it is as if nature is intentionally subverted by being equated with ornament, or as if there is little difference between them. In fact, many Archaic Greek vases seem to question or wittily blur the distinction between land-scape element and decorative floral pattern that we perhaps take too much for granted; there is a conceit in Archaic art (it is at least as old as the early seventh century) that plays upon the ornamentality of nature and the na-turalistic values of ornament. The status of the trefoil device planted on the groundline of the neck panel on the great Protoattic am-phora from Eleusis, to cite just one oriental-izing example, hovers ambiguously between vegetation and ornament. On the neck of a Leagros Group hydria in the Louvre, birds strut and flap their wings amid subsidiary pal-mettes and tendrils: the decorative florals are thus treated as "real" vegetation.[42] And on an amphora in Boston (MFA 63.952; fig. 4) the

topmost of twelve pygmy satyrs cavorting over and through Dionysos' luxuriant vine pauses, wraps one arm around a branch for support, gazes up at the lotus-palmette band, and probes it with his hand, as if he is himself unsure whether to keep on climbing and so carry the vintage out of nature into ornament. At the same time, the ivy that decorates the handles of the amphora echoes the ivy branch the huge god carries over his left shoulder, and our reading of each of these elements thus oscillates between ornamental device and natural form.[43]

To return to the Paestum diver: the gray-green sea or pool he aims for is not an expanse, but a low mound that rises above the border of the panel—it is a pile of water.[44] And in-stead of a colorful, irregular cliff to jump from, there is a tall masonry platform. The emphasis is not on nature or on the youth's relationship to nature: it is on the youth him-self. Both trees and palmettes point to him, and he is out of all proportion to the landscape

(there just is not enough water for him to dive into without breaking his neck on the border below). The human form and architecture dominate, and natural forms are unconvincing accessories; in the comparison between the two paintings, the *Naturgefühl* of the Greek work seems very much the weaker.

But the Archaic Greek feeling for nature does not come off so badly if, instead of the Paestum panel, we set beside the Etruscan work a scene on the more nearly contemporary vase by the Priam Painter, the Lerici-Marescotti amphora in the Villa Giulia (c. 515–500) (fig. 5).[45] Seven nymphs bathe and swim in a grotto,[46] the sides of the panel having been converted into rocky walls that tower over the scene.[47] Water gushes from natural fountains on each side (two girls wash their hair beneath them, the water cascading over the buttocks of the one on the left). Four nymphs stand on a platform, but the constructed object does not dominate the scene as it does on the slab of Paestum: instead, the natural and built elements have equal status in the composition. And two trees (olives, probably) grow from near the base of the cliffs.[48] Olives or not, they are used as many trees on late-sixth-century vases are—as clothes racks. But the trees are far taller than the human figures, and that alone is remarkable (though hardly unique) for an Archaic work.[49] There is one girl in the water; as Warren Moon has noted, she is slightly smaller than the others on shore, and so seems in the distance. This is a place of some depth. The water, too, is extraordinary: the black glaze has apparently been scraped away to give the impression of a rippling, glistening sea.[50] In short, the nymphs are placed in a coherent and encompassing setting—we feel like voyeurs—and the artist has boldly attempted effects of scale and even light. Now, there are important differences between this scene and the panoramic seascapes in the Etruscan Tomb of Hunting and Fishing. There is, for example, a far stronger sense of closure in the Greek image: the landscape does not open out laterally into a vast natural continuum but is an enclosed vale cut off from the rest of the world, a sheltered and sheltering concavity. It is a different kind of landscape from the Etruscan, but it is no less a landscape. And the sense of closure the grotto offers, though certainly and persistently appealing to early Greeks (the grotto is not unlike the cove of

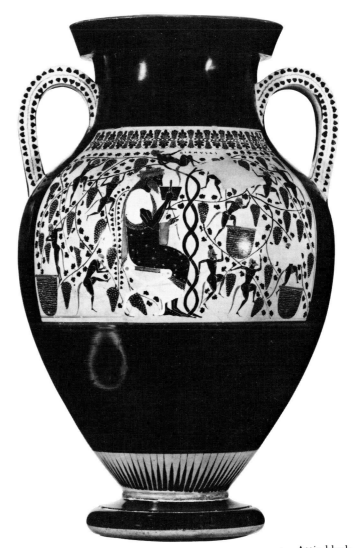

4. Attic black-figure panel amphora (Type A), c. 540–530 B.C. Museum of Fine Arts, Boston, H. L. Pierce Fund

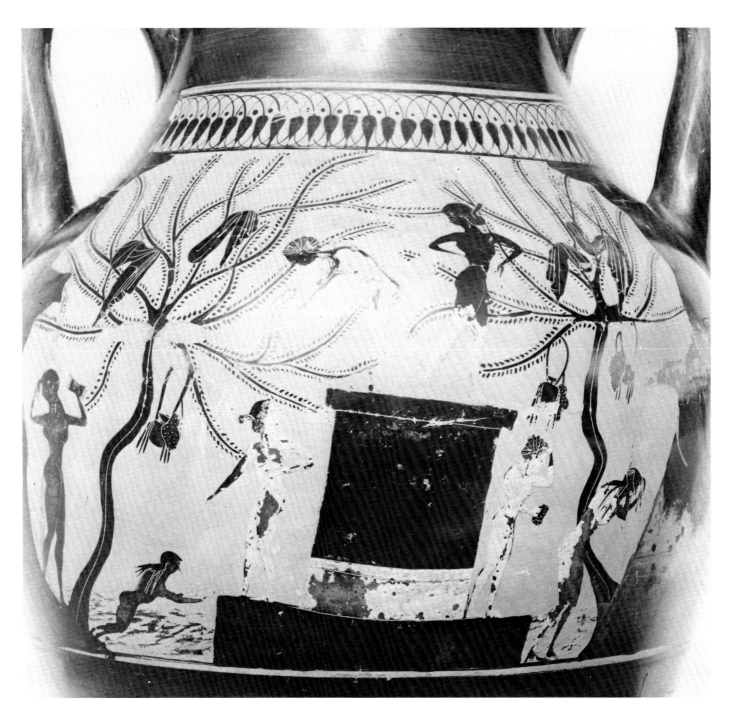

5. Attic black-figure panel amphora by Priam Painter, c. 515–500 B.C., Villa Giulia
DAI, Rome

Phorkys and the Naiads described in the *Odyssey*),[51] may have been here a practical choice: the scene, after all, is painted on a panel amphora.

As for the relationship of this vase-painting to free painting, it is impossible to say whether the Priam Painter was specifically imitating contemporary murals or panels, and it is in any case wrong to assume automatically that the originality of vase-painters was inferior to that of wall- or panel-painters,

their products always and necessarily derivative. Still, it is very difficult to believe that an Athenian vase-painter of the late sixth century could envision and compose a scene like this and that contemporary Greek free painters could not. That is, the Etruscans probably had nothing on them after all: their supposedly stronger *Naturgefühl* is illusory, a matter of medium and evidence. For it goes without saying that the black- or red-figure vase—with the technical limitations of its color

scheme, the absence of green and blue from the palette of added colors, and a curving surface that insists upon planarity—is hardly the ideal vehicle for the representation of vegetation, sea, or land (not to mention atmosphere), and should not be compared to wall-paintings, Greek *or* Etruscan.[52] Given the inherent limitations of the Archaic vase, the wonder is not that there are so few landscape elements in early Greek vase-painting, but so many.

The scene on the Lerici-Marescotti amphora nonetheless comes as something of a particular surprise. For if all the requisites of landscape—rocks and other land forms, trees and other vegetation, and water—had appeared before in Archaic art, they had generally appeared (and would continue to appear long after the end of Archaic art) singly and as accessories. An element of landscape could at times play more than one role in an image, but typically it served as one of the following:

1. A narrative prop. Sisyphos must have a hill to roll his rock up; Sinis needs a pine tree (Munich 8771; fig. 6); Europa, riding to Crete, may actually have the island in sight (Louvre E696; fig. 7); Poseidon may toss (or have tossed) Nisyros at a giant, and so on. Rocks and trees also serve as convenient things for figures, such as the nymphs of the Lerici-Marescotti amphora, the youths of figure 16, and heroes such as Theseus and Herakles, to lay or hang their cloaks, aryballoi, or quivers upon, just as Odysseus hangs Dolon's gear on that tamarisk at *Iliad*, 10, 465–468.[53]

2. A symbol of sexuality, *arete*, immortality, or victory. Palms are particularly useful in this regard, as Helena F. Miller has shown.[54] On the Rycroft Painter's calyx krater in Toledo (Toledo 63.26; fig. 8), for example, the palm behind Achilles has five fronds on each side to four fronds on the tree behind Ajax, the palms serving as signs of Achilles' superiority—as scoreboards, in effect—in place of the inscriptions Exekias used on his seminal version of the dice game in the Vatican.[55]

3. An attribute or symbol of gods, such as Apollo and Artemis (in the case of palms, which may also identify a particular scene as Delos or Delphi) or Dionysos (in the case of vines, which may also place the scene on Naxos).[56] Vines, of course, are particularly appropriate features in scenes of Dionysiac activities, such as symposia.

6. Attic red-figure cup by Elpinikos Painter, c. 500–490 B.C.
Staatliche Antikensammlungen und Glyptothek, Munich

7. Caeretan hydria by Eagle Painter, c. 520 B.C.
Musée du Louvre, Paris

8. Attic black-figure calyx-krater by Rycroft Painter, c. 520–510 B.C. Toledo Museum of Art

4. A more blandly topographic device, setting the scene vaguely outdoors, without any necessarily narrative or symbolic role to play.[57] Trees and rocks, that is, are often the furniture of genre.

At all events, Archaic vases and reliefs typically present a conventional and minimalist nature, where one tree, rock, or bush, like a prop in a play, could have been enough to denote "forest," "grove," "mountain," or "field": the splendid but solitary shrub in the hare hunt on the Chigi vase does the job, and so does a slender tree on the exterior of a cup by Onesimos in Boston, where it simply reinforces the idea that the youths and the horse standing before it are outside somewhere.[58] But things are different on the Priam Painter's masterpiece in the Villa Giulia, for here those props, those accessories, in combination, have very nearly been converted into the subject of representation, or at least there is a balance and proportion between setting and figure that seems absolutely new.

There had been experiments with natural setting before, of course. One striking experiment, in fact, took place near the very beginning of Archaic image-making, on the panel of a mid-eighth-century krater from Argos (Argos Museum C240; fig. 9).[59] Four branch-wielding dancers appear to emerge out of the distance, above; below, a curious horse tamer reins in his animal on a pebbly beach or riverbank; below that, there is the water itself, zigzagged, Egyptian-style.[60] Fit in where there is room are fish and a waterfowl. Men, land, and water are juxtaposed; the creatures are literally fish out of water. But it is precisely the combination of these natural forms, however discrete, that makes the scene, for its time, almost as remarkable as the Priam Painter's grotto.

There would be nothing quite like the Argive scene again for over two centuries, but in the meantime there were other experiments. There are, of course, the rocks on the Argive Polyphemus fragment (Argos Museum C149; fig. 10)—a scene that is usually considered an imitation of a wall- or panel-painting—and a rocky couch becomes a regular feature of the iconography of the myth later.[61] On a Corinthian skyphos in the Louvre the cave of Pholos is shown as a crescentlike overhang,[62] and at Olympia Pausanias saw on the Chest of Kypselos one scene of a man and woman sleeping in a grotto, and another panel with Dionysos "lying down in a cave. . . . Around him [Pausanias says] are vines, apple

trees, and pomegranate trees."[63] Brief indi-
cations of vineyard and setting are found on
many of the early-sixth-century plaques from
Pente Skouphia,[64] but the scene on the clay-
digger plaque (Berlin F871; fig. 11) is more
than summary: the artist has dispensed with
the fixed horizontal baseline, and the irreg-
ular ground supports figures at different
heights. The way the figures are enclosed by
rising ground, in fact, seems to anticipate the
high rock walls of the Priam Painter's
scene—it is another landscape of closure. An-
other familiar example of an atypically ex-
tensive Archaic setting appears on the well-
known name-piece of the Painter of the Vat-
ican Mourner (c. 540–530), where a goddess
(Eos or Europa) mourns her dead son (Mem-
non or Sarpedon) amid four trees—a veritable
forest by Archaic standards.[65] The hero lies
on branches below two firs, his armor is set
against two plane trees. The contrast is be-

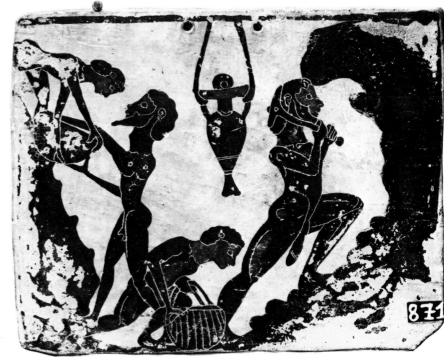

10. Fragment of bowl,
c. 650 B.C.
Argos, Archaeological Museum;
photograph: Ecole française
d'Athènes

tween the state of immortality symbolized by the evergreens and the state of flux the hero leaves behind, as he must leave his armor behind—a state of transience symbolized, very Homerically, by the deciduous trees on the left.[66] This vase is just one of a number of works that suggest that the Archaic repertoire of landscape elements was somewhat richer than we usually think, and that the Archaic artist could from time to time give true value to individual natural forms. The olive tree on the eponymous Acropolis pediment is another example,[67] and so is that eternally controversial East Greek cup in the Louvre—the "Nest Robber" or "Master of the Trees" cup—where, whoever the man is, the supple, large-leafed trees and the variety of creatures found among the branches suggest the lushness of nature.[68]

The Priam Painter's truly remarkable concern for setting did not, then, appear out of nowhere. And it was not unique, either. In the last decades of the sixth century and the first decades of the fifth, the Archaic artist's interest in landscape elements noticeably increases. There are just a lot more rocks, trees, and oceans now, even if it is true that many examples show the same rock—a roughly square or rectangular form with white edges or undulating white and black bands in black-figure (MMA 56.171.33; figs. 12–13),[69] a bulbous outcropping with dilute swirls and hollows in red-figure (figs. 6, 14, J. Paul Getty Museum, 86AE, 607)[70]—and that many vases are so loaded with impossibly elongated branches, floating vines, and desiccated trees that they often lose their evocative value and become elegant filler, there to connect or bracket figures (like the cattle of Geryon on Euphronios' cup in Munich) or to accentuate the lines of composition.[71] But there are also many more scenes that attempt to place figures in a larger, more complex setting. The experiments are not always completely successful, and they are not always Attic. A humorous Caeretan hydria shows Apollo's cattle emerging from one oddly tree-topped grotto while Apollo confronts that coy thief, baby Hermes, in another.[72] On the Chalkidian Phineus Cup in Würzburg (Würzburg L.164; fig. 15), Dionysos and Ariadne ride toward a fountainhouse and grapevine; peeping satyrs approach three nymphs bathing between two palm trees, one of which is set amid thick ivy; and the sons of Boreas chase

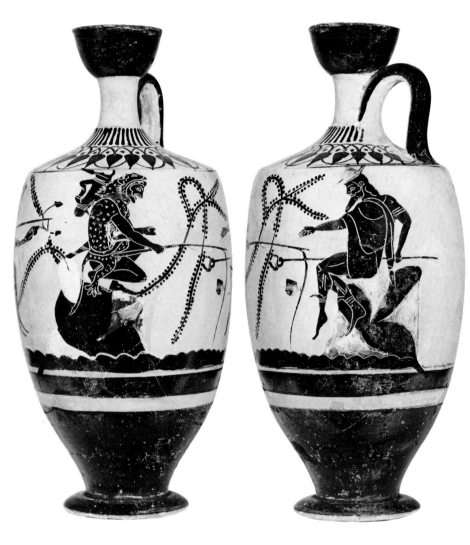

12–13. Attic white-ground lekythos with Poseidon (not shown), Herakles, and Hermes fishing, c. 510 B.C. Metropolitan Museum of Art, New York, Fletcher Fund, 1956

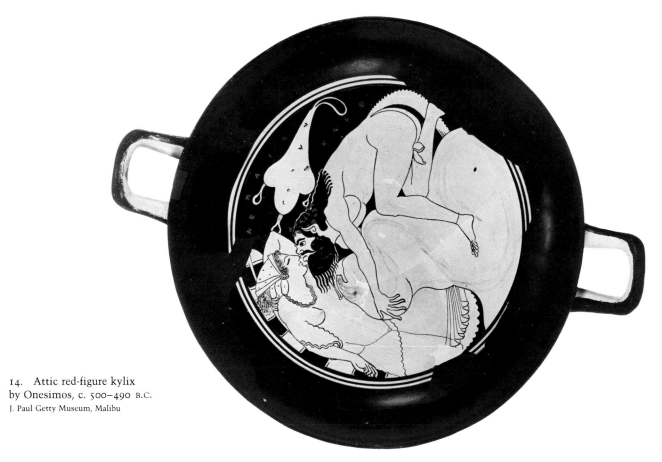

14. Attic red-figure kylix
by Onesimos, c. 500–490 B.C.
J. Paul Getty Museum, Malibu

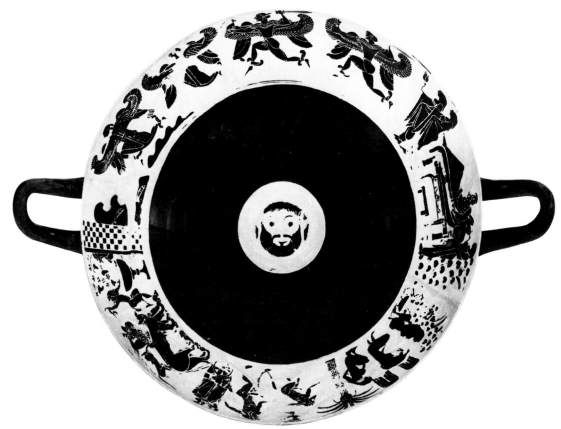

15. Chalkidian cup by
Phineus Painter (name
vase), c. 520 B.C.
Martin von Wagner-Museum der
Universität Würzburg

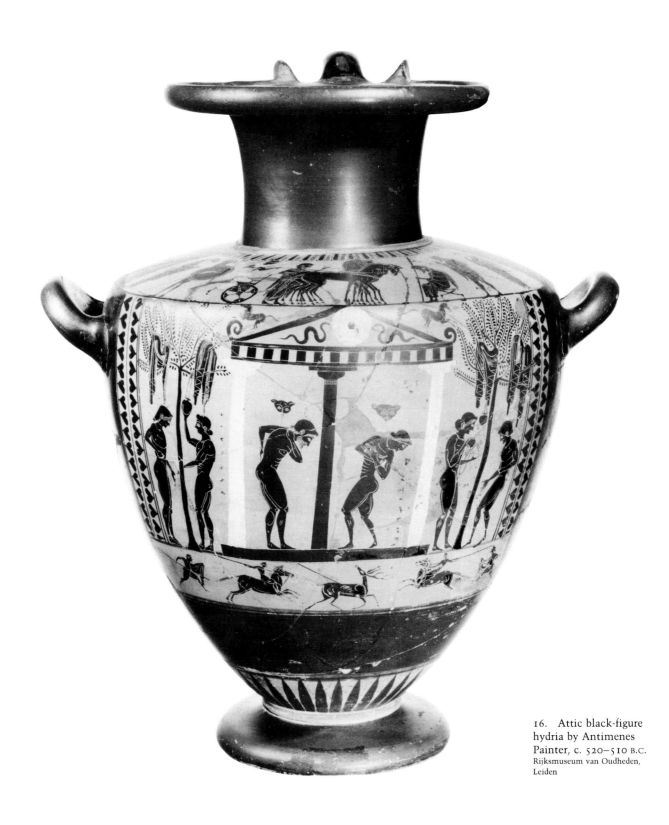

16. Attic black-figure
hydria by Antimenes
Painter, c. 520–510 B.C.
Rijksmuseum van Oudheden,
Leiden

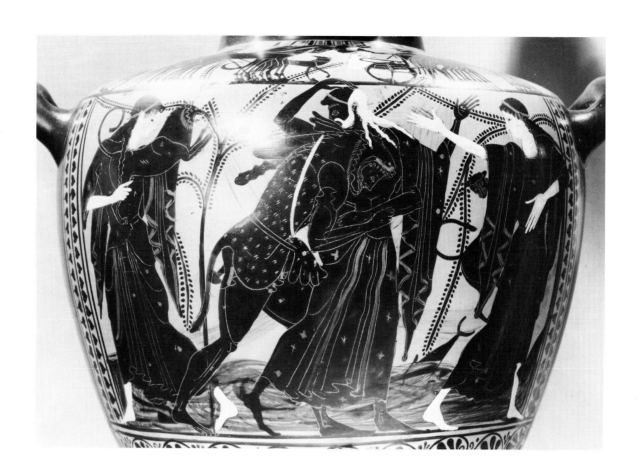

17. Attic black-figure hydria, Leagros Group, c. 515–500 B.C. Bibliothèque Nationale, Paris, Cabinet des Médailles

the Harpies away over a typical wavy sea, incised with fish, that atypically rises like a tidal wave to the left: the impression is that the chase is moving offshore, over deeper water.[73]

It is in Athens, however, that experimentation with setting and landscape seems most vigorous and most successful—in the Antimenes Painter's palaestra scene in Leiden (Leiden XVe28; fig. 16), for example,[74] or in his olive harvest scene in the British Museum, an extraordinary scene of ordinary life, where the relative scale of boys, men, and trees is approximately correct and the air is full of falling fruit—rather, the red background becomes air *because* of the falling fruit.[75] On an oinochoe in the Cabinet des Médailles, a hunter, striding out from behind an olive tree, spears a boar emerging from his cave.[76] On a Leagros Group amphora in London, the spirit of Achilles apparently flies to the Islands of the Blessed over a ship- and fish-filled sea and past a tall rock that may be Cape Sigeum or White Rock (*Odyssey*, 24, 11).[77] The

Priam Painter himself experimented with rural or garden settings: his orchard scene in Munich seems in some ways to anticipate the lithe fruit-pickers in the tondo of the Sotades Painter's Early Classical white-ground (and certainly more atmospheric) cup in London.[78]

Around the time of the Priam Painter and after, a host of late black-figure skyphos and lekythos painters—and some red-figure painters, too—explored the values of rocks, trees, and sea. On a hydria (Cabinet des Médailles 255; fig. 17),[79] a member of the Leagros Group painted Herakles wrestling Nereus at the seashore: dilute brushstrokes suggest the wavy irregularity and highlights of the sea; a leaping fish is painted pure black above the waterline, dilute below, and so seems half immersed in the water; at left, placed incongruously among the figures, is a thin tree that suggests the shore on which the contest takes place (on the right, branches stream in from behind the border). Many vase-painters (such as the Theseus and Sappho Painters) seem inordinately concerned with the myth of Her-

akles and Helios, and experiment with the nature of waves (or are they clouds?) (MMA 41.162.29; fig. 18). The Ambrosios Painter painted a genre scene (MFA 01.8024; fig. 19) that, despite some oddities, compares well enough with the Etruscan image of fishing at Tarquinia.[80] And in the tondo of a cup in Malibu the Brygos Painter gives us our first pebbly beach since the Geometric Argive fragment.[81] We could go on, perhaps, until we reach a semi-outline lekythos in Athens from the Bowdoin Workshop with a hunter chasing hares over a rising, rocky, wooded landscape,[82] or another lekythos in Athens by the Beldam Painter with its puzzling seascape (Athens 487; figs. 20–22): a ship emerges from behind a rocky island or coast on which men torture captives and dunk them in a dilute and turbulent sea.

This vase may well date to the second quarter of the fifth century,[83] but if so it should be taken, I think, not simply as a reflection of contemporary Early Classical developments in free painting but as the culmination of extensive Late Archaic experiment.[84] For still well before the end of the Archaic period, we hear of our first landscape in a Greek panel painting. According to Herodotus (IV.88), Mandrokles of Samos, the architect of Darius' boat-bridge over the Bosporus, took part of his reward and "having a picture painted of the entire bridging of the Bosporus, of King Darius enthroned above, and of the army crossing it, dedicated it in the temple of Hera." The painting must have specified the peculiarities of the setting: the bridge, of course, but also the headlands at either end and "the fish-filled Bosporus" (as Mandrokles himself called it in his dedicatory inscription) in between—probably there was the same compositional principle of sea flanked by tall rocks, the same sense of lateral closure, that we find on the Priam Painter's amphora (fig. 5) or later on the Siren Painter's name-vase in London.[85] It is noteworthy, in any case, that this lost Greek landscape was inspired not by topophilia, but—like Assyrian landscapes, the later painting of Marathon in the Stoa Poikile, and, for that matter, the landscapes on the Column of Trajan—by the historical or documentary impulse, by the desire to commemorate an event in which the landscape itself played a critical role.

The scene on the Priam Painter's Lerici-Marescotti amphora thus is only one—if the

18. Attic white-ground lekythos by Sappho Painter, c. 500–475 B.C. Metropolitan Museum of Art, New York, Rogers Fund, 1941

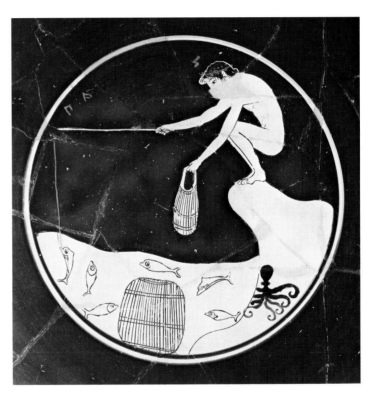

19. Attic red-figure kylix by Ambrosios Painter, c. 500–490 B.C. Museum of Fine Arts, Boston, H. L. Pierce Fund

most successful one—of a series of attempts at describing landscape and setting in Late Archaic art. But two palm trees, one painted by Exekias (Boulogne 558; fig. 23), the other by the Kleophrades Painter (Naples 2422; fig. 24), more or less bracketing the last half-century of the Archaic period,[86] show that something else is happening as well. Like other palms, they may symbolize immortality, *arete*, victory, or Apollo, or even set the scene at Troy (though that is unlikely).[87] But, as I have argued elsewhere, they are stylistically like no other palms in Archaic art (compare figs. 8 and 15), and they do something no other landscape elements ever do: they respond to the heroic or tragic predicament with human feeling.[88] The palm behind Ajax droops its thin, spiritless fronds in sympathy for the hero who is about to die: it weeps like a willow. The palm in the Kleophrades Painter's Ilioupersis arches itself over a mourning Trojan woman, seemingly mourning with her, a grim symbol of despair and brutality, but itself a battered victim, too.[89] These palms are, perhaps, Archaic precedents for the dead tree of the Alexander Mosaic, whose lifelessness sets much of the tone of the violent scene played out beneath it: like our palms

and several other trees in Late Archaic art, it is mood topography.[90] But in any case the palm trees of Exekias and the Kleophrades Painter seem to diminish the distance between human beings and nature that we find in the *Iliad*, in the Sapphic lyrics with which we began, and in the rest of Archaic art.[91] For the first time, the Archaic mind has stopped conceiving of nature as "other" and has begun to imagine that nature may not be indifferent to human beings after all, that it may sympathize. The Late Archaic discovery or invention of the pathetic fallacy is a big step, for it means that nature can now be addressed and invoked, and that prepares for the great apostrophes of Aeschylus' Prometheus and Sophocles' Philoctetes and Ajax.[92]

If responses to nature are more culturally determined than individual or instinctive, it is fair to ask whether the nature of the polis—one of the more powerful of Archaic cultural determinants—had something to do with the absence of landscape from most of Archaic art. Robin Osborne, for example, has recently suggested that it was in the best interests of the polis to "repress" the rural landscape that was so vital to its well-being, that "it was essential to the nature of the city that the

23. Attic black-figure
belly amphora by Exekias,
c. 530 B.C.
After Ernst Pfuhl, *Malerei und
Zeichnung der Griechen* (Munich,
1923), fig. 234

countryside should be . . . unmentioned" in literature and in art unseen, as if the mere representation of rural scenes, by calling to mind the centrality of the country in the life and economy of the polis, would somehow undermine the structure of society.[93] But if Osborne is right about the cultural repression or suppression of the country, it is perhaps curious that there is, at least in earlier Archaic art, no corresponding promotion of the town—so few cityscapes, and no scene (so far as I know) of actual building, no representation of the kind of corporate effort that gave physical expression to the city-state.[94] Where we are told to detect a repression of the countryside on behalf of the town, we find the *asty* itself in art only with difficulty: there is no general promotion of urban life. And if scenes of farming and country life are not particularly bountiful themselves, there are perhaps more of them than we have a right to expect given both the place of production and one of the primary functions of the typical black- or red-figure vase—a luxury item made in the city to display the mythological learning and sophistication of the urban elite and symposiast.[95] The theory of the repression of the countryside makes virtually subversive doc-

uments of the Antimenes Painter's olive harvest in London[96] or the scene of a cow suckling her calf in Brussels,[97] or Nikosthenes' cup in Berlin with scenes of plowing, sowing, and hunting;[98] and I think that unlikely. We must in any case distinguish between scenes of rural life, on the one hand, and the depiction of landscape elements, on the other: the alleged conspiracy against the *actual*, working countryside does not explain the lack of natural setting in the *mythological* narratives the urban elite preferred in order to show off its good taste, at least before the last decades of the sixth century.

Is it possible, then, that *changes* in the polis, especially the Athenian polis, had something to do with the minor eruption of landscape elements, rural genre scenes, and sympathetic palm trees at the end of the Archaic period? Could it be that the growth or concentration of Late Archaic Athens in particular caused a revision in its attitude toward its landscape, encouraging the formation of artificial relationships with nature? Such relationships could be seen, for example, in the emergence of the artificial countrysides and environmental ideals known as *gymnasia* (the Academy, Kynosarges, and the Lykeion

may all have been formalized in the late sixth
century, creating, with their groves and
springs, a kind of "green belt" at Athens' out-
skirts).[99] Did the rising cults of Dionysos and
(at the very end of the period) Pan imagina-
tively supply or invent the pure kind of wil-
derness that no longer existed, if it ever had,
in the actual Archaic landscape of Attica?[100]
Could it be that with an intensification of life
in the Late Archaic city[101] the otherness and
putative distance of nature expressed in Ar-
chaic poetry was no longer affordable, and
that artificial means of making contact with
it—including the first tentative expressions
of the pathetic fallacy—had therefore to be
devised? Heraclitus' theory of contraries
stated, "It is disease that makes health sweet
and good, hunger satiety, weariness rest."[102]
Perhaps he should have added that it is the
city that makes the countryside attractive.[103]

And yet there are problems here, too. The
representation of nature for its own sake still
does not exist in Late Archaic art. Few if any
real places are anywhere depicted.[104] And
landscape per se never becomes the sole ob-
ject of contemplation: it is always subordi-
nate to narrative, and isolated landscape ele-
ments continue to fulfill their traditional nar-
rative, localizing, and symbolic functions
down to the Hellenistic period. Nature is still
no imaginative escape; resentfulness toward
the town is still unfelt. Late Archaic Athens
was not Hellenistic Alexandria, much less
seventeenth-century Amsterdam or nine-
teenth-century London, and the Greeks never
became Romantics. If the ideological de-
mands of the polis cannot be held chiefly re-
sponsible for the neglect of landscape in ear-
lier Archaic art, its changing character cannot
be held chiefly responsible for the somewhat
greater frequency of landscape elements at
the period's end. For an increasing alienation

25. Attic red-figure kylix
by Kleomelos Painter,
c. 500 B.C.
J. Paul Getty Museum, Malibu

of the city from the landscape does not explain why Late Archaic artists now become almost as interested in the depiction of architecture—fountainhouses above all (fig. 16), but other structures, too—as in the depiction of grottoes and seashores.[105] The features of urban environments—the built components of the world—attract them as well. It may be, then, that what we should note in Late Archaic art is not a new interest in landscape as such, but in *setting*, in the placing of the human figure on a larger stage, in larger contexts of various sorts—in complex environments like the one on the Lerici-Marescotti amphora (fig. 5), where, at the center of the large grotto, there is that constructed platform, where natural and human-built elements are complementary.[106]

It is difficult to say why setting should become more important just now—we do not yet find explicit statements, like Xenophon's later, of the smallness of man in relation to the cosmos, a mere bit of earth and moisture out of the mass that exists.[107] Factors such as an increased scientific interest in the physical properties of the phenomenal world and a certain Late Archaic de-deification of nature—all things were no longer quite so full of gods—may have contributed to the increase of landscape elements in art.[108] So may have

the generally greater Late Archaic interest in genre, and so, just possibly, may have the rise of tragedy and scenery in the late sixth century, though, of course, we do not hear specifically of scene-painting until later.[109] But it is perhaps worth noting that although there are a few Late Archaic red-figure images that explore unusual settings for human action (for example, combats taking place before or below citadel walls [J. Paul Getty Museum 84.AE.38; fig. 25]),[110] complex setting—that is, the depiction of environments containing more than a single tree or rock or architectural element—is simply more common in black-figure than in red, and that the representation of *place* (and of places that sometimes extend behind the frame and beyond the limits of the field) was really the only possible response black-figure could make in the face of red-figure's superior ability to show individual figures generating their own three-dimensional space.[111] The response was mimetic, an expression of a broader concern for imitating spatial relationships between figures and between figures and environment. The motivation was not to displace the human figure from the center of representation, or to diminish the status of the figure, but to describe the fields of human activity in greater detail—to create, in effect, humanscapes.

For, in the end, it is still the human figure that counts. If I have here stressed the lesser component of Archaic art, suggesting that the Archaic artist's repertoire and use of landscape elements and setting were more extensive and varied than we normally think, that they were particularly so in the last few decades of the period, and that it was against this background of Late Archaic experiment that Classical developments (however limited *they* still were) must be viewed, landscape never threatens the real subject of Archaic art. And if, over all, the Archaic Greek attitude toward nature still seems exceptional in the ancient Mediterranean, we do well to remember that Greek anthropocentrism was exceptional, too.[112]

NOTES

Many scholars kindly supplied photographs or were instrumental in their acquisition: I am especially indebted to G. Beckel, Helmut Jung, Ursula Kästner, Marion True, Olga Tzahou-Alexandri, and Dietrich von Bothmer. For reading (and improving) an earlier version, I warmly thank Martha Ravits, William G. Thalmann, and especially my colleague Kenneth I. Helphand.

My research into the issues addressed here in a preliminary way was begun under a fellowship from the John Simon Guggenheim Memorial Foundation, and I would like to express my gratitude to the foundation for its generous support.

1. D. L. Page, ed., *Poetae Melici Graeci* (Oxford, 1962), Fr. Adesp. 976. For the authenticity of the lyric, see Diskin Clay, "Fragmentum Adespotum 976," *TAPA* 101 (1970), 119–129.

2. E. Lobel and D. Page, *Poetarum Lesbiorum Fragmenta* (Oxford, 1955), Fr. 96 (trans. D. Page).

3. See J. M. Bremer, "The Meadow of Love and Two Passages in Euripides' *Hippolytus*," *Mnemosyne* 28 (1975), 268–280; and Rebecca Hague, "Sappho's Consolation for Atthis, fr. 96 LP," *AJP* 105 (1984), 29–36.

4. She is, as Hague 1984 has shown, united with Atthis precisely by *being* without place, by being absent from the meadow. Atthis has not been replaced in the landscape of love, and therein lies her consolation.

5. Yi-Fu Tuan, *Topophilia: A Study of Environmental Perception, Attitudes, and Values* (Englewood Cliffs, N.J., 1974), 4. Hesiod, for one, would agree: he reviles Askra (*Works and Days*, 640) and, as if in contempt, never describes his countryside.

6. See Kenneth Clark, *Landscape into Art* (Boston, 1961), xvii–xviii.

7. *Childe Harold's Pilgrimage* III. lxxv.

8. *Vis à Vis* 2.3 (1988), 51.

9. Marjorie H. Nicolson, *Mountain Gloom and Mountain Glory: The Development of the Aesthetics of the Infinite* (Ithaca, N.Y., 1959), 1; Konstantin Bazarov, *Landscape Painting* (New York, 1981), 6. This is why even so powerful an individual as Petrarch, when he heroically climbed Mont Ventoux in 1335 just to see the view and admittedly delighted in its grandeur, stopped, took out his copy of Augustine's *Confessions*, scolded himself, and went down again.

10. It goes without saying as well that not every people finds the same kind of landscape appealing. The Egyptians, for example, found the landscape of Asia unendurable and "wrong"; see Henri Frankfort, Mrs. H. A. Frankfort, John A. Wilson, and Thorkild Jacobsen, *Before Philosophy: The Intellectual Adventure of Ancient Man* (Baltimore, 1973), 47.

11. Moreover, topophilia may be expressed in one artistic form of a culture long before it finds formal expression in another. Chinese poetry, for example, fully evoked the mood of places and settings well before (extant) Chinese painting did; see Tuan 1974, 126–127.

12. The effect has always struck me as similar to the one described in Stevens' dense little poem "Anecdote of the Jar"; see *The Collected Poems of Wallace Stevens* (New York, 1974), 76.

F. de Polignac, *La naissance de la cité grecque* (Paris, 1984), 41–89, has argued that the establishment of a major sanctuary in the countryside, as a kind of polar opposite to a sanctuary in the city, was a common element in the self-definition of the Archaic state, in its marking out of spatial boundaries between nature and culture.

13. See also Rhys Carpenter, *The Esthetic Basis of Greek Art* (Bloomington, Ind., 1959), 24: "From the striking absence of [Greek] landscape scenes, whether of forest or cornland or olive groves or rocky shores or pine-covered heights, no conclusion may be drawn as to the sentiments of the ancient people who lived in that (still today) marvellously beautiful countryside." Anthony M. Snodgrass, *An Archaeology of Greece* (Berkeley, 1987), 69, believes he could make the case that the Greeks lacked any "response to the beauty of rural scenery," but he does not do so.

14. See Annie Bonnafé, *Poésie, nature et sacré, I: Homère, Hésiode et le sentiment grec de la nature* (Lyon, 1984), 158. Exceptions include the vastness of the sea in the *Odyssey* (at 5, 100–101, for example, it is called *aspeton*, "unspeakably large") and the starry heaven in the simile at *Iliad*, 8, 555–561.

15. See Adam Parry, "Landscape in Greek Poetry," *YCS* 15 (1957), 3–29, who notes that ancient Greek has no word for *eloquence*, either. The closest Greek comes to *landscape* is Plato's phrase *khoria kai dendra*, "places and trees" (*Phaedrus* 230d3–5).

16. Johann Christoph Friedrich von Schiller, *Über naive und sentimentalische Dichtung*; trans. Helen Watanabe-O'Kelly, *On the Naive and Sentimental in Literature* (Manchester, 1981), 34. Schiller's point of view essentially survives in, for example, Alfred Zimmern, *The Greek Commonwealth: Politics and Economics in Fifth-Century Athens*, 5th ed., rev. (Oxford, 1931), 19–20, and Parry 1957, 4–7.

17. Alexander von Humboldt, *Kosmos: Entwurf einer physischen Weltbeschreibung*; trans. E. C. Otté, *Cosmos: A Sketch of a Physical Description of the Universe*, 2 (New York, 1844), 22.

18. John Ruskin, *Modern Painters* (London, 1860–1869), 3, chap. 13 ("Of Classical Landscape"), paragraphs 13–16. See also Thomas G. Rosenmeyer, *The Green Cabinet: Theocritus and the European Pastoral Lyric* (Berkeley, 1969), 327 n. 2.

19. Defenders have included Gilbert Murray, *Greek and English Tragedy: A Contrast* (Oxford, 1912), introduction; Henry R. Fairclough, *Love of Nature Among the Greeks and Romans* (New York, 1930); Christopher M. Dawson, "Romano-Campanian Mythological Landscape Painting," *YCS* 9 (1944), 3; Nicolson 1959, 38–39; J. Donald Hughes, *Ecology in Ancient Civilizations* (Albuquerque, 1975), 56; and Vincent Scully, *The Earth, the Temple, and the Gods: Greek Sacred Architecture*, rev. ed. (New Haven, 1979), 2. For a recent general study of Greek poetic attitudes toward nature, see W. Elliger, *Die Darstel-lung der Landschaft in der griechischen Dichtung, Untersuchungen zur antiken Literatur und Geschichte* 15 (Berlin, 1975).

Still, it is surprising how rarely an Archaic poet comes right out and says a landscape or portion of a landscape is "beautiful." It happens in the *Iliad*, where the groves of the nymphs are called *kala* (20, 8); in the *Theogony*, where the haunts of the nymphs are "graceful" or "lovely" (*kharientas*, 129), and where rivers are called "beautiful" or "fair-flowing" (*kallireeth-ron*, 339, *eureitēn*, 343); and in the early Homeric *Hymn to Aphrodite*, where nymphs haunt the "beautiful groves" (*alsea kala*, 97) and the "beautiful mountain" (*kalon oros*, 98) of Ida. And Sappho's word for the apple grove and meadow of Aphrodite (Fr. 2 *LP*) is "lovely" (*kharien*). These may be exceptions that prove some rule or other; at least they prove that nymphs and Aphrodite liked beautiful spots.

20. In Pindar's *Paean 4*, for example, the love of the Keans for their land is clear enough.

21. *Iliad*, 16, 297–302 (trans. Robert Fitzgerald).

22. A powerful cross-current is the quintessentially anthropocentric notion that the only beautiful—or at least only good—landscape is a useful landscape. In the *Odyssey*, that nature is best that mortals exploit. This, I think, is implicit in the *Odyssey*'s contrast between Calypso's and Alkinoos' gardens. The beauty of Calypso's place (5, 63–74), luxuriant but untended, stuns Hermes—its beauty is of a sort to be appreciated by gods—but it is no source of delight to our mortal hero: while Hermes gazes his fill, Odysseus sits on the shore looking seaward, his back to the landscape (5, 151). When, like Hermes, Odysseus gazes *his* fill at a landscape (7, 112–132), it is at the neatly plotted, fenced-in gardens of Alkinoos, the site of human industry (the vintage is under way). It is a landscape that mortals have shaped, and it is the benefits the orchards yield that are the source of his delight. Odysseus admires the deserted island off Cyclopsland (9, 116–141) from this same utilitarian perspective: its "beauty" lies in its untapped potential for exploitation. And this is the root of Odysseus' topophilia toward his own rocky Ithaca itself. It is not so beautiful a place and is fit for goats rather than horses, but it provides the necessities of life, and both Odysseus and Telemachus are inordinately attached to it (4, 601–608; 9, 25–36; 13, 242–249). The sentiment that is topophilia may have practical rather than aesthetic roots; and this utilitarian attitude, which also seems to lie behind Archilochos' preference for the lovely plains of Siris over wild-wooded, ass-backed Thasos (Fr. 18 Diehl; Athenaeus 12.523d), survives at least down to Plato's *Critias*, where the beauty of mountains resides not in their sublimity but in their potential for providing sustenance and raw materials (118B).

23. *Iliad*, 17, 548. The contrast with Genesis 9:12–17 could not be stronger, of course, and it is the Old Testament attitude that prevails—for example, in Wordsworth's poem of 1807 that begins "My heart leaps up when I behold / A rainbow in the sky." See *Wordsworth: Poetical Works*, ed. E. de Selincourt (Oxford, 1969), 62.

24. See Theodore M. Andersson, *Early Epic Scenery:*

Homer, Virgil, and the Medieval Legacy (Ithaca, N.Y., 1976), 17; Bonnafé 1984, 10.

25. See also *Iliad*, 5, 693; 6, 237, 433–434; 7, 22; 22, 145–147.

26. See, for example, *Iliad*, 4, 275–282; 14, 16–22.

27. The similes in general present a nature that is a collection of frightening forces, of death and destruction; see Bonnafé 1984, 37–38, and James M. Redfield, *Nature and Culture in the Iliad: The Tragedy of Hector* (Chicago, 1975), 188–192. Even in the *Odyssey*, where nature emerges from the world of reference to become the setting for the narrative, the sea—one-half of the natural world—is of course the hero's greatest obstacle and source of fear; even the god Hermes is reluctant to cross its bitter and unspeakable expanse (5, 100–101). For the broad Archaic perception of the natural world as mysterious, and of man as helpless before it, see also Charles P. Segal, "Nature and the World of Man in Greek Literature," *Arion* 2 (1963), 19–53, who points out that the idea of nature's essential hostility survives at least down to Sophocles (42).

The general perception of rugged nature as hostile seems explicit in the names the Greeks gave to some of their mountains: Ptoon (Terrifying), Keraunia (Thunder-smitten), Mainalon (Wild or Mad Place), or Tymphrestus (Whirlwind). But, as W. W. Hyde noted, such etymologies do not tell the whole story; see his "Ancient Appreciation of Mountain Scenery," *CJ* 11 (1915), 70–84.

28. Harmony between man and nature exists, for the most part, only after nature has first been submitted to human will through cultivation. Thus Hesiod (who earlier says "the earth is full of evils, and so is the sea") can feel some sympathy for nature when both are buffeted by winter (*Works and Days*, 101 and 504–563), and thus he, as perhaps no other Archaic poet, can think of himself in nature, in a rhetorical (the mood is optative) and rudimentary *locus amoenus* (*Works and Days*, 582–596). The importance of this last passage, however, is the emphasis it places upon the comfort of Hesiod; it is anthropocentric in focus and does not really describe the setting in detail; see Bonnafé 1984, 83 and 246–248.

In his Cologne epode (*PCol* 7511), Archilochos, or his persona, seduces a girl in a flowery meadow, but it is the conventional "meadow of love" found throughout Archaic poetry (above, note 3), and so its reality is called into question.

29. See Paolo Vivante, *Homer* (New Haven, 1985), 176–180.

30. Translation by John Fothergill, *The Rendering of Nature in Early Greek Art* (London, 1907), 6. It is symptomatic, too, that on a well-known pelike in Leningrad (inv. 615; *ARV²*, 1594/48; *Paralipomena*, 509), Spring comes on the wings of a swallow, but there is not so much as a tree, bush, or leaf to suggest its arrival.

Early studies of the representation of landscape in early Greek art include Margret Heinemann's *Landschaftliche Elemente in der griechischen Kunst bis Polygnot* (Bonn, 1910).

31. See Silke Wegener, *Funktion und Bedeutung landschaftlicher Elemente in der griechischen Reliefkunst archaischer bis hellenistischer Zeit* (Frankfurt, 1985), 4–10, and Kat. 1–7. Also, Maureen Carroll-Spillecke, *Landscape Depictions in Greek Relief Sculpture: Development and Conventionalization* (Frankfurt, 1985), and G. B. Waywell, "Landscape Elements in Greek Relief Sculpture" (diss. Cambridge University, 1969).

32. Compare Archilochos, Fr. 25 Diehl.

33. I do not claim a scientific accounting, but a random sample is at least suggestive. A glance, for example, at the 65 vases displayed in the Amasis Painter's recent solo show reveals only 2 vases with any elements of landscape at all—about 3 percent; see Dietrich von Bothmer, *The Amasis Painter and His World: Vase Painting in Sixth-Century B.C. Athens* (Malibu, 1985), Cat. 19 (Würzburg L 265) and 49 (London B 548). So, too, in Mary B. Moore and Mary Z. P. Philippides, *Agora, 23: Attic Black-Figured Pottery* (Princeton, 1986), 1,949 vases and fragments are catalogued. Their index lists 4 works with rocks, 4 with palm trees, and 17 with other sorts of trees (1 or 2 more, such as Cat. 1484, can be added); there are possibly 3 other works with vineyard scenes (Cat. 219, 1071, 1483), for a total of around 29 works with true landscape elements, or about 1.5 percent of the total. Even if one includes the 119 listed pieces with vines (many of them with no discernible connection to the ground and thus probably hand-held), the percentage of the total is still only 7.5 percent. And of the 42 non-Panathenaic amphorae published by von Bothmer in *CVA, USA 12, Metropolitan Museum, fasc. 3: Attic Black-Figured Amphorae*, only two (41.162.176, 17.230.7) depict any landscape elements at all—they are both small rocks—for a percentage of 4.8 percent.

34. See James Mellaart, *Catal Hüyük* (New York, 1967), 176–177, pls. 59–60.

35. See, for example, Kazimierz Michalowski, *Art of Ancient Egypt* (New York, n.d.), figs. 17, 19, 20, 76, 94, 113, and 355–362; and Heinrich Schäfer, *Principles of Egyptian Art*, ed. and trans. Emma Brunner-Traut and John Baines (Oxford, 1974), 44 and n. 95.

36. See, for example, Henri Frankfort, *The Art and Architecture of the Ancient Orient* (Harmondsworth, 1970), figs. 91, 192, 201, 206, and 209. The example of Near Eastern landscapes in particular suggests that topophilia is not a necessary precondition for the representation of the natural world. There may be artistic landscapes that serve primarily a documentary impulse by publicizing, detailing, and glorifying the conquest of foreign territories. The imperial idea fosters the comprehensive depiction of topography or locality, but the landscape is, very often, someone else's. In short, if topophilia may exist in a culture without engendering artistic landscapes, landscapes may exist in the art of a people without necessarily reflecting its own experience or appreciation of topophilia.

37. See, for example, Sinclair Hood, *The Arts in Prehistoric Greece* (Harmondsworth, 1978), figs. 140, 155, 31–33, 34, 179, 160–163, 36, and 47.

This is not the place to examine differences among Minoan, Theran, and Mycenaean attitudes toward na-

ture, and any argument would necessarily hinge on such difficult issues as attribution, patronage, definition, and influence. It is true that detailed landscapes are harder to come by in Mycenaean art (though the corpus of Mycenaean frescoes is smaller, too), and as a result the Mycenaeans are generally supposed to have been less sensitive to nature and less interested in its representation than the Minoans and Therans, who until recently have come across more or less as "flower children" in modern scholarship. To be sure, a comparison between, say, the so-called Spring fresco from Akrotiri or the Partridge frieze from the Caravanserai (see Hood 1978, figs. 40–41), and the (heavily reconstructed) Blue Bird frieze from Pylos (see Mabel L. Lang, *The Palace of Nestor at Pylos in Western Messenia, II: The Frescoes* [Princeton, 1969] pl. R, 9 F nws) does indeed seem to reveal a far different sensibility: the landscape on the mainland work is divided up into outposts or clumps, and the birds dominate by their sheer size and stereotyped pose. The frieze is more an exercise in ornament than in natural depiction: the birds are not placed *in* nature, but *beside* it, juxtaposed to it. But the Mycenaean artist may not have been completely indifferent to the representation of landscape: a carefully rendered olive tree (of which even a Minoan would have been proud) and colorful rockwork that recalls that of the Theran Spring fresco were also painted on the walls of the palace at Pylos (see Lang 1969, pl. Q, 3, 10 N nws). It may be that the Mycenaean had a variety of stylistic options from which to choose. For that matter, not every Minoan or Theran fresco contains lush images of nature, and Minoan/Theran backgrounds can also be nearly abstract.

38. See, for example, Martin Robertson, *A History of Greek Art* (Cambridge, 1975), 240–241; and Larissa Bonfante, ed., *Etruscan Life and Afterlife: A Handbook of Etruscan Studies* (Detroit, 1986), 168.

39. See Otto J. Brendel, *Etruscan Art* (Harmondsworth, 1978), 190, and Maja Sprenger, Gilda Bartoloni, and Max and Albert Hirmer, *The Etruscans: Their History, Art, and Architecture*, trans. Robert Erich Wolf (New York, 1983), 103–104. The first chamber, too, has "naturalistic" scenes of dancers beneath tall trees; see Brendel 1978, fig. 123 and 187–188.

40. For the interpretation of the scene, see R. Ross Holloway, "High Flying at Paestum: A Reply," *AJA* 81 (1977), 554–555, and W. J. Slater, "High Flying at Paestum: Further Comments," *AJA* 81 (1977), 555–557.

41. Dawson 1944, 12.

42. For the Eleusis amphora, see Robertson 1975, pl. 4b. For the Louvre hydria (CA 4716), see Kate Boisse Duplan, "Une Hydrie à col blanc du Groupe de Leagros," *RA* (1972), 127–140. See also D. A. Jackson, *East Greek Influence on Attic Vases* (London, 1976), 76–77, for other examples of East Greek and Attic vases on which subsidiary florals are populated with birds and animals.

43. Similarly, when, as often happens on black-figure vases, large decorative palmettes creep on their tendrils into images that already include representations

of landscape elements such as trees, are we to take them as purely "decorative" after all? Can we so readily accept the "naturalism" of the trees? See, for example, the late black-figure neck-amphora in the J. Paul Getty Museum, S.80.AE.65 (Bareiss 134), illustrated in *Greek Vases in the J. Paul Getty Museum*, 2 (Malibu, 1985), 217 (fig. 36), or the Cactus Painter's lekythos in Berlin (inv. 3261), where decorative tendrils come alive and intertwine with the serpent and the trunk and branches of the apple tree of the Hesperides; see C.H.E. Haspels, *Attic Black-Figured Lekythoi* (Paris, 1936), pl. 18, 1.

44. A similar pile of water appears earlier in the Theseus scene on the neck of the François vase; see John Boardman, *Athenian Black Figure Vases* (New York, 1974), fig. 46.4. This scene, coincidentally perhaps, has something in common with a scene on a bronze band from Balawat, where porters wade ashore from boats; see Frankfort 1970, 165, fig. 191.

45. My debt to Warren G. Moon's fine discussion of this and other vases in "The Priam Painter: Some Iconographic and Stylistic Considerations," in *Ancient Greek Art and Iconography*, ed. Warren G. Moon (Madison, 1983), 97–118, is clear.

One should note, too, that the comparison between the Tarquinian and Paestum paintings ignores the fact that the seascape in the Tomb of Hunting and Fishing is extraordinary even for Etruscan art (and, incidentally, that some scholars have thought it influenced by East Greek styles; see Massimo Pallottino, *Etruscan Painting* [New York, 1952], 52, and Sprenger, Bartoloni, and Hirmer 1983, 104). It is true that trees, bushes, and groves are painted regularly on the walls of Archaic and Early Classical Etruscan tombs, and that figures dance and play joyfully among them. But the typical Etruscan fresco does not do much more than juxtapose or alternate figures and vegetation in what Brendel 1978, 197, calls a "metopic" fashion: the figures are as tall as the trees, and there is rarely any greater attempt to describe environment. There are a few Archaic Greek vase paintings that do as well (Louvre F 162, by the Gela Painter, seems a Greek vase-painter's version of such a scene; see Haspels 1936, pl. 25, 7).

46. That the women are nymphs rather than mortal girls or maenads seems clear on several counts: there is an obvious numerical correspondence between them and the seven midget satyrs on the reverse of the vase (Moon 1983, fig. 7.18a–c); nudity is usually prohibited for mortal women (except courtesans) at this date (the female swimmers on the Andokides Painter's amphora, Louvre F 203, are almost certainly Amazons); maenads are never shown nude; and the clothes and equipment hung on the trees of the scene are not maenadic. For the distinctions between nymphs and maenads, see Mark W. Edwards, "Representation of Maenads on Archaic Red-Figure Vases," *JHS* 80 (1960), 80–81, and Albert Henrichs, "Myth Visualized: Dionysos and His Circle in Sixth-Century Attic Vase-Painting," in *Papers on the Amasis Painter and His World* (Malibu, 1987), 92–124, especially 100–102; also, Sheila McNally, "The Maenad in Early Greek Art," *Arethusa* 11 (1978), 101–135. For the view that the women on the Priam Painter's vase are indeed

mortal, see Claude Bérard et al., *A City of Images: Iconography and Society in Ancient Greece* (Princeton, 1989), 93.

47. The slanted rather than purely vertical right side of the Paestum lid (fig. 3) can also be read as a cliff rising by the sea, with a tree growing outward from its face.

48. The Priam Painter, like many Late Archaic artists, did not bother much about botanical distinctions: the gnarly trunks of the trees are identical to those of the vines painted on the other side of the vase (Moon 1983, fig. 7.18a–c).

49. Among other tall trees are those in figure 16 and the one Peleus has climbed on the white-ground oinochoe by the Painter of London B 620 in New York (Metropolitan Museum 46.11.7); see Boardman 1974, fig. 230.

50. Moon, in "Some New and Little-Known Vases by the Rycroft and Priam Painters," in Malibu 1985, 41–70, especially 63 n. 45, corrects his earlier statement (Moon 1983, 113) that "applied white slip was used to indicate the breeze-blown water." The Priam Painter's treatment of the water is still extraordinary, though there had been earlier "painterly" experiments. On the shoulder of a hydria of the mid-century Kleimachos Group (Louvre E 735; *ABV*, 85/2), for example, a ship sails over a sea rendered in dilute, and the visible brushstrokes suggest the irregularity of the waves; see P. de la Coste-Messelière, *Au Musée de Delphes* (Paris, 1936), pl. 13.

51. *Odyssey*, 13, 96–112, 344–351.

52. So, too, if all we had left of the Archaic Etruscans were their reliefs and painted pots—the principal sources of evidence for Archaic Greek representational attitudes—they would hardly seem more enamored of the natural world than their Greek contemporaries. Would we have guessed they could decorate the Tomb of Hunting and Fishing the way they did even if we had such works as the Micali Painter's amphora in London (Brendel 1978, figs. 129–130) before us? Should we not therefore entertain the possibility that the Archaic Greek depiction of landscape in the virtually lost genre of free painting was fuller than the evidence of the Archaic vase suggests? Now, it is true that the Lerici-Marescotti amphora was exported to Etruria (it was found at Cerveteri), and this raises the possibility that it was decorated with Etruscan tastes or funerary beliefs in mind. But that would not explain why the Priam Painter's scene should be so very different from the vast majority of scenes on other Greek vases that also found their way to Etruria: if the Archaic Greek vase-painter had identified an Etruscan market for landscapes, we should have more of them than we do. In short, I am not convinced that the Etruscan feeling for nature was any more developed than the Archaic Greek or, therefore, that exported vases with extensive landscape elements or rural scenes were decorated that way just to satisfy Etruscan tastes.

53. For Sisyphos and his rock see, for example, Karl Schefold, *Götter- und Heldensagen der Griechen in der spätarchaischen Kunst* (Munich, 1978), 71, fig. 85,

and Boardman 1974, fig. 198; for another Caeretan hydria with Europa but without Crete, see Jaap M. Hemelrijk, *Caeretan Hydriae* (Mainz, 1984), 26–28 (Cat. 13); for Nisyros, see John D. Beazley, *The Development of Attic Black Figure*, rev. ed., eds. Dietrich von Bothmer and Mary B. Moore (Berkeley, 1986), pl. 34, 3 (see also *ARV*², 255/2); for Theseus' and Herakles' use of rocks and trees as clothes racks see, for example, Beazley 1986, pl. 37, 3, and Schefold 1978, fig. 112.

54. See Helena F. Miller, *Iconography of the Palm* (diss., University of California at Berkeley, 1979); also C. Sourvinou-Inwood, "Altars with Palm-Trees, Palm-Trees and *Parthenoi*," *BICS* 32 (1985), 125–146.

55. See Moon 1985, 61–62, and n. 36. For Exekias' Vatican amphora (inv. 344), see Beazley 1986, pl. 64.

56. See Miller 1979, 6–18. I thank Guy M. Hedreen for pointing out to me that many of the vines and arbors on Archaic vases may represent Dionysos' Naxian vineyard; the vine on the Foundry Painter's cup, Tarquinia RC 5291 (*Paralipomena*, 370, 23bis; John Boardman, *Athenian Red Figure Vases: The Archaic Period* [London, 1975], fig. 269), certainly does. See also Guy Michael Hedreen, "The Silens of Naxos," *AJA* 92 (1988), 256–257.

57. The tree before which Herakles so often wrestles the lion might possibly be shorthand for the grove at the sanctuary of Zeus at Nemea, but it is not certain; and the tree depicted in scenes of Theseus fighting the Marathonian bull seems to be there on the Heraklean model, not because it specifies the locale. With Darice Birge, *Sacred Groves in the Ancient Greek World* (diss., University of California at Berkeley, 1982), 4, "we may conclude that depictions of heroes battling wild animals under the open sky included a tree to set the general scene only."

58. MFA 95.29; *ARV*² 324/65.

59. See Paul Courbin, *La Céramique géométrique de l'Argolide* (Paris, 1966), 475–483, and J. Boardman, "Symbol and Story in Geometric Art," in Moon 1983, 19.

60. Water appears much the same way between two waterfowl on the shoulder of a Late Geometric Attic oinochoe in Athens; see *Human Figure*, 66 (Cat. 5). It should be noted that in Egyptian representations of water, the zigzags are usually aligned vertically, not stacked horizontally, as in Geometric Greek images.

61. See, for example, Boardman 1974, fig. 248 (Louvre F 342). Another early polychrome experiment in the representation of nature is (apparently) the dark brown and leafless tree that stands against a lighter brown background on a fragmentary terracotta pinax that may have decorated the interior of the early-seventh-century Temple of Apollo at Corinth. See H. S. Robinson, "Excavations at Corinth: Temple Hill: 1968–72," *Hesperia* 45 (1976), 203–239, pl. 51b (#C-71-285).

62. Louvre MNC 677. J. Charbonneaux, R. Martin, F. Villard, *Archaic Greek Art 620–480 b.c.* (London, 1971), fig. 47.

63. Pausanias 5.19.6.

64. Mary Hamilton Swindler, *Ancient Painting: From*

the Earliest Times to the Period of Christian Art (New Haven, 1929), 119 and fig. 206.

65. Boardman 1974, fig. 134.

66. See *Iliad*, 6, 146–149, and Miller 1979, 32. Joseph C. P. Cotter also made this point in a paper, "Political Symposia and Political Vases," delivered at the annual meeting of the Archaeological Institute of America in 1985; see *AJA* 90 (1986), 187.

67. See Maria S. Brouskari, *The Acropolis Museum: A Descriptive Catalogue* (Athens, 1974), 42–43 and pl. 74.

68. On the cup (Louvre F 68), see Erika Simon, Max Hirmer, and Albert Hirmer, *Die griechischen Vasen* (Munich, 1976), 57 and pl. 35, and, most recently, Henrichs 1987, 107–108, who considers it both a reference to the omen at *Iliad*, 2, 303–320 (in which case it seems odd that the man looks away from the omen) and "an artistic comment on man's place in the natural world."

69. Black-figure rocks often seem like black-and-white versions of the colorfully banded islands of the Etruscan Tomb of Hunting and Fishing (figs. 1–2).

70. The Onesimos kylix in the Getty will be published by Dyfri Williams, and I thank Marion True for permission to illustrate it here. One should note the rock's phallic, almost engorged, character; like the full and phallic wineskin hung in the field above, it seems a party to the (for once, limp) satyr's looming sexual assault, pinning the sleeping and vulnerable maenad beneath it. The rock, in other words, is something more than just a rock for the satyr to creep along: it is innuendo.

71. Munich 2620; *ARV*² 16/17; see Schefold 1978, fig. 148, and L. G. Nelson, *The Rendering of Landscape in Greek and South Italian Vase Painting* (diss., SUNY Binghamton, 1977), 31–32. Also, Beazley 1986, 79: "branches . . . are almost obligatory in late black-figure backgrounds."

72. Louvre E 702; see Hemelrijk 1984, 10–14 (Cat. 3), pls. 29–30. Hermes' cave on Mt. Kyllene is shown later on the exterior of a cup by the Brygos Painter in the Vatican; *ARV*², 369/6, and Alexander Cambitoglou, *The Brygos Painter* (Sydney, 1968), 12–13, and pl. IV, fig. 2.

73. Andreas Rumpf, *Chalkidische Vasen* (Berlin and Leipzig, 1927), 104–115, pls. 40–44 (Cat. 20). The odd configuration of the rising sea may also have been conditioned by the presence of the checkered wall of the fountainhouse in the adjoining Dionysos scene; the wall of water provides a slightly less jarring transition to the next scene than if the sea had been low all the way across. It provides a kind of closure.

On the exterior of an Attic black-figure cup in the British Museum (B 436), merchant vessels and warships sail over a sea that is deeper near the handles than at the sides—an unusual but, I think, successful attempt to suggest sea swells; see Boardman 1974, fig. 180.

74. Beazley 1986, 74, notes, "The figures are comparatively small, and the picture comes a little nearer to being a real landscape than in the many vases where

the figures dwarf the buildings" (or, we might add, the trees).

75. British Museum B 226; Beazley 1986, pl. 83, 5. For the naturalistic proportions of pickers and tree, see the photograph of a modern olive harvest in David Attenborough, *The First Eden: The Mediterranean World and Man* (Boston, 1987), 84. J. Boardman, "A Greek Vase from Egypt," *JHS* 78 (1958), 4–12, believes Egyptian wall-paintings were the direct inspiration for Attic scenes that subordinate the human element to the natural; but see also Jackson 1976, 76 and 79 n. 10.

76. Cabinet des Médailles 274; *ABV*, 530/69 (near the Athena Painter).

77. British Museum B 240. See Schefold 1978, 250 and fig. 335, and Anneliese Kossatz-Deissmann, "Achilleus," *LIMC*, 1, 1, 195 (Cat. 901).

78. Munich 1702 A; see Moon 1983, fig. 7.10. On the interpretation of the Sotades Painter's cup (British Museum D 6), see most recently R. G. Osborne, "Death Revisited; Death Revised: The Death of the Artist in Archaic and Classical Greece," *Art History* 11 (1988), 12–13.

79. *ABV*, 361/18.

80. The exact relationship to the sea of the rock on which the boy squats is not clear: it may be an overhang, but then one would not expect to find the octopus clinging to it below. If the lower portion is meant to be below water, the artist ought to have continued the water line across the rock. The way three tentacles of the typically symmetrical octopus curve out of sight around the rock adds to the spatiality of the scene, but it is the same sort of device often found on shields in Late Archaic vase-painting; see figure 25, and the cup by Phintias (Athens, National Museum 1628) in *Human Figure*, 140–141 (Cat. 50).

81. The J. Paul Getty Museum, *Greek Vases: Molly and Walter Bareiss Collection* (Malibu, 1983), 44 (Cat. 30).

82. Athens, National Museum 1973. See Donna Carol Kurtz, *Athenian White Lekythoi* (Oxford, 1975), 17, 41, 121, pl. 14.2 (dated to the first quarter of the fifth century).

83. See Haspels 1936, 171, where the vase is dated to around 470.

84. Beth Cohen, "Paragone: Sculpture Versus Painting, Kaineus and the Kleophrades Painter," in Moon 1983, 171–192, similarly suggests that the revolution in wall- and panel-painting that we usually associate with Polygnotos and Mikon and usually date to the late 470s may have begun around or even before 480, and that the revolution was really "the final fruit in the evolution of Archaic style" (177–179).

85. British Museum E 440; *ARV*², 289/1; Boardman 1975, fig. 184.

86. There is general agreement that Exekias' vase should date to around 530. The Kleophrades Painter's Vivenzio hydria is now dated by some (and with uncommon precision) to the year or two immediately after the Persian sack of the Acropolis (to which it

would then mythologically refer) in 480. See John Boardman, "The Kleophrades Painter at Troy," *AntK* 19 (1976), 3–18, and Simon, Hirmer, and Hirmer 1976, 105–106.

87. So, Miller 1979, 13, 33–34; Sourvinou-Inwood 1985, 125–126; Nelson 1977, 17, 35; E. Homann-Wedeking, *The Art of Archaic Greece*, trans. J. R. Foster (New York, 1966), 151.

88. Jeffrey M. Hurwit, "Palm Trees and the Pathetic Fallacy in Archaic Greek Poetry and Art," *CJ* 77 (1982), 193–199; but see John D. Madden, "The Palms Do Not Weep: A Reply to Professor Hurwit and a Note on the Death of Priam in Greek Art," *CJ* 78 (1983), 193–199, and my reply, *CJ* 78 (1983), 200–201. A number of similes in the *Iliad* again present natural scenes or phenomena as analogues for human emotion (see above, note 26), and so the steps Exekias and the Kleophrades Painter took were not completely unprepared for in poetry. It is true as well that, once, an Archaic poet actually sympathizes with nature; see above, note 28.

89. See also Robertson 1975, 234.

90. On the name-piece of the Beldam Painter (Athens 1129) there is another unusual palm: satyrs have bound a grotesque woman to it, and proceed to torture her. With its spiky, sharp fronds, the palm almost seems an instrument of torture itself—at least, it suggests the brutality of the scene. See Boardman 1974, fig. 277, and Haspels 1936, pl. 49, and 170–171, where the lekythos is dated "not . . . much earlier than 470"; Miller 1979, 143, dates the vase more broadly to "ca. 490–460." Something similarly moody is going on on the lekythos in Berlin by the Cactus Painter, where the apple tree of the Hesperides helps create a mood of agitation and danger; see above, note 43, and Nelson 1977, 54: "the tree branches reach out toward Herakles in a threatening way, and the frenzied palmettes and tendrils twist around the body of Herakles as if to entrap him."

91. Even on the amphora by the Painter of the Vatican Mourner (above, note 65), the grove, for all its symbolism, stands as a foil to human suffering. It is noteworthy, too, that on the Vatican vase the helmet of the hero looks away, while Ajax's seems a witness to the imminent suicide.

92. Aeschylus, *Prometheus Bound*, 88–92, 1091–1093; Sophocles, *Philoctetes*, 1452–1468; *Ajax*, 412–427.

93. Robin Osborne, *Classical Landscape with Figures: The Ancient Greek City and Its Countryside* (Dobbs Ferry, N.Y., 1987), 16, 197. Osborne quickly rejects the idea that ancient authors "took the countryside for granted because it was so universally important," suggesting that the landscapes of Greece are too varied for that and so "cannot be assumed as a constant known factor" (16). But surely the rhythm of small plain or valley and wall of mountain around it was basic to any Greek conception of landscape; more specifically, the landscape of Athens was surely a constant for Athenians, as that of Corinth for Corinthians. Moreover, I am not sure why even the variety of rural landscapes that Greece as a whole pos-

sesses would preclude perception of them as "universally important." In any case, Old Comedy did not repress the beauties and pleasures of country life; see R. Vischer, *Das einfache Leben* (Göttingen, 1965), 58–59, 131–132, and Rosenmeyer 1969, 208.

94. And just as a single tree may stand for a whole grove, so a single column or two may stand for an entire temple or building. The Archaic artist brought to the depiction of both rural landscape and urban architecture an attitude of abbreviation.

95. See Osborne 1987, 108–112; Oswyn Murray, *Early Greece* (Atlantic Highlands, N.J., 1980), 197–200.

96. See above, note 75.

97. Brussels, Bibliothèque Royale, 5, by Painter of London B 620, *ABV*, 434/4; Charbonneaux, Martin, and Villard 1971, fig. 353.

98. Berlin 1806; see Osborne 1987, fig. 4, and 20, where he notes that Nikosthenes specialized in vases intended for the Italian market, implying that such agricultural scenes were not to the taste of Athenians. But see Jackson 1976, 59–60, 76–77, for the cup's "East Greek spirit" and the Attic response to "the Ionian rustic style," and above, note 52.

99. For the establishment of these *gymnasia*, see John Travlos, *Pictorial Dictionary of Ancient Athens* (New York, 1971), 42, 340, 345, and R. E. Wycherly, *The Stones of Athens* (Princeton, 1978), 141–146; but see also John Patrick Lynch, "Hipparchos' Wall in the Academy at Athens: A Closer Look at the Tradition," in *Studies Presented to Sterling Dow*, ed. Kent J. Rigsby, *GRBS* Monographs, 10 (Durham, N.C., 1984), 173–179.

Tuan 1974, 113–114, notes that we can often come close to the environmental ideal of a people or culture by examining its "idea of the world beyond death." Before the end of the Archaic period, the Greek notion of what Elysium or the Isles of the Blessed looked like is very imprecise. But it is interesting that in Pindar's description, the Isle of the Blessed seems a lot like a *gymnasium*: it is a space before the city, with flowery meadows and fruit trees, where the blessed play games, exercise, make music, and sacrifice; see C. M. Bowra, *Pindari Carmina* (Oxford, 1947), frag. 114.

100. For the rise of the cults of Dionysos and Pan, see Osborne 1987, 189–192.

Homer distinguished between the domesticated plain and the *agrou ep' eskhatien*, "the land beyond the limit of agriculture"; see Redfield 1975, 189–190, and *Odyssey* 4, 517, 5, 489. But the *agrou ep' eskhatien* was not quite "the wild world of nature" that Ian Morris, *Burial and Ancient Society: The Rise of the Greek City-State* (Cambridge, 1987), 192, calls it: it is grazing land, seasonally occupied by herdsmen, and is thus between culture and raw nature. For the absence of Greek wilderness, even on the tops of mountains (where there were many shrines), see Clarence J. Glacken, *Traces on the Rhodian Shore: Nature and Culture in Western Thought from Ancient Times to the End of the Eighteenth Century* (Berkeley, 1967), 119; Snodgrass 1987, 73; and Merle K. Langdon, *A Sanctuary of Zeus on Mount Hymettos*, *Hesperia* supp. vol. 16 (Princeton, 1976).

101. For the problem of population increase at this time, see now Morris 1987, 99–101.

It is interesting as well that Kleisthenes' reforms at the end of the sixth century aimed at artificially eliminating the political distance between city, country, and coast, at completely integrating central *asty* and countryside.

102. Charles H. Kahn, *The Art and Thought of Heraclitus* (Cambridge, 1979), 181–183 (LXVII).

103. This is, of course, the common explanation for the rise of pastoral poetry and landscape art in other cultures and in the Greek Hellenistic period; see Glacken 1967, 25. Also, Karl Woermann, *Über den landschaftlichen Natursinn der Griechen und Römer* (Munich, 1871), 65–66, and Wolfgang Helbig, "Beiträge zur Erklärung der campanischen Wandbilder," *RhM* N.F. 24 (1869), 497–523.

104. Some of the many fountainhouses depicted in late black-figure are labeled Kallirrhoe, apparently after the spring at the Ilissos. But it is unclear whether these can actually be considered "portraits" of Kallirrhoe (or, indeed, whether other vase-paintings actually were supposed to represent the southeast fountainhouse in the Agora). See John Griffiths Pedley, "Reflections of Architecture in Sixth-Century Attic Vase-Painting," in *Papers on the Amasis Painter and His World* (Malibu, 1987), 63–77.

105. On fountainhouse scenes, see Pedley 1987; also, Moon 1983, fig. 7.7a–c.

106. Although there is not much Archaic poetry that can be securely dated at the end of the period, Simonides' poem on Danae (543 *PMG*) seems a poetic expression of a new interest in setting, in placing human figures in a plausible (if in this case threatening) relationship with nature.

107. Xenophon, *Memorabilia* 1.4.8.

108. For Xenophanes, the rainbow, which in the *Iliad* is ominous and "which men call Iris" (17, 548), is simply a colored cloud; see G. S. Kirk, J. E. Raven, and M. Schofield, *The Presocratic Philosophers*, 2d ed. (Cambridge, 1983), 173, fr. 178. See also Sherman E. Lee, *Chinese Landscape Painting*, 2d ed. (New York, 1962), 3: "The preconditions for landscape [painting] include a non-anthropomorphic nature philosophy"; also W. Jaeger, *The Theology of the Early Greek Philosophers* (Oxford, 1947), 169–170, who claims that in the fifth century "nature lost its divine character."

109. See von Humboldt 1844, 84. The Classical painter Agatharchos seems to have been particularly important in the history of *skenographia* (see Vitruvius VII, praef. 11), but he was not likely to have been the very first painter of stage sets.

110. The cup by the Kleomelos Painter in the Getty will be published by William A. P. Childs, and I thank Marion True for permission to illustrate it here; see also the cup by the Foundry Painter in Boston, Museum of Fine Arts, 98.933; *ARV*² 402/23. For a more complex black-figure parallel, see the Leagros Group hydria, Munich 1700, with the walls and gate of Troy, the altar of Apollo, and a tall tree that spreads into the part of the scene on the shoulder; Beazley 1986, pl. 86.

111. See Jeffrey M. Hurwit, *The Art and Culture of Early Greece, 1100–480 B.C.* (Ithaca, N.Y., 1985), 291–292.

112. See Robert Renehan, "The Greek Anthropocentric View of Man," *HSCP* 85 (1981), 239–259.

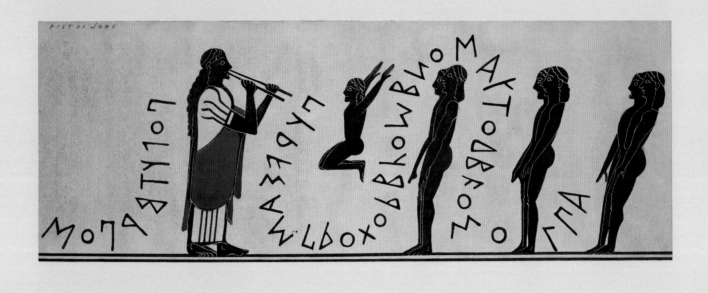

MABEL L. LANG
Bryn Mawr College

The Alphabetic Impact
on Archaic Greece

E arlier in this century a few child psychologists found it amusing to extend the outmoded biogenetic theory of recapitulation to child development, showing how the child passes through various stages toward adulthood that mimic those by which earliest man progressed to some kind of civilized state. The only such stage I remember is tree-climbing, but there was something also about the use of tools and the invention of language, although there the development was not pure "infantasy" but quite literally adulterated by parents and teachers. Even so, children who learn to speak from adults do not, for some time, speak as adults do but use diction and syntax that are very much their own. Similarly, children who are taught to write do not, except under duress, immediately write the sort of things that old hands at alphabetic expression tend to write. What they do write, of course, is often the ABCs, their own names, and words that seem to have some special power (most often, in English, words of four letters).

But it seems likely that the theory of recapitulation might indeed work if we were to compare the newly alphabetic child's initial efforts with an illiterate population's first writings. Thus the Greeks, having lost the Linear B syllabary during the Dark Age when the hand-to-mouth economy did not necessitate record-keeping, were as functionally illiterate as the average preschooler of today. And when they learned the alphabet from the Phoenicians, they, like today's children, for the most part wrote abecedaria, their own names, and obscenities. One piece of earliest writing in Greek[1] (fig. 1), which is both more extensive and different in kind, actually confirms the parallel because its alphas are unique[2] in Greek and most like the Phoenician letters—suggesting that it not only may have been written by a Phoenician but also, like the kindergarten teacher's model, may have been a teaching device incorporating material not of the pupil's making. Written about 725 B.C. on a poor example of Late Geometric ware, it records one dactylic hexameter line and the uncertain and abortive beginning of a second line:

hòc νῦν ὀρχεcτôν πάντον ἀταλότατα
 παίζει
τô τόδε κλλμιν [3]

Whoever of all the dancers now makes sport most gracefully, this is his.

It is as if a foreign visitor, a trader most likely, had said, "Look, I can make a prize for the winner that will be a material reminder and evidence of his prowess—a lot better than your singing him a victory ode." To be sure, in Phoenicia it was not uncommon to write on vessels a notation of their function or purpose, so that there was a very real precedent for a trader showing off his knowledge of writing by proposing such a prize.

Although the Dipylon Jug verse, dated to the second half of the eighth century B.C., is among the earliest extant Greek alphabetic inscriptions, this has still been no bar to re-

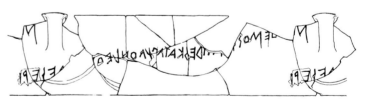

cent efforts to show that the Phoenician alphabet was transmitted to Greece far earlier—about 1100 B.C., according to one authority,[4] and even as early as the fourteenth century B.C., according to the most recent theory.[5] But since the evidence for such transmission remains limited to comparative letter-shapes and Phoenician texts in Greek lands, it provides only possible times and possible means of transmission without any proof that the Greeks got, as it were, the message. And even so, however much earlier the Greek alphabet might have come into being than the time in which our first examples of it appear is a matter of little importance for a consideration of the applications and uses to which it was put, for those we can know only from what has survived. And when Rhys Carpenter pointed to the absence of Greek inscriptions before the late eighth century B.C. as significant, he noted that "the argument *ex silentio* grows every year more formidable, and more conclusive. A negative argument is not valueless if the negative is universal."[6] That was in 1933, and the silence still continues after more than fifty years of intensive excavation in all corners of the Greek world.

Moreover, as with our theory of alphabetic recapitulation, the prominence of abecedaria, of obscenities, and of personal names either alone or as assertions of ownership or pride in "penmanship" in the earliest inscriptions suggests that we must be close to the beginning. Let us then look at a few samples from the latest eighth and earliest seventh centuries B.C. and compare them with some texts typical of what the Phoenician transmitters of the alphabet were writing in the Phoenician texts of the tenth and ninth centuries B.C. An Athenian pyramidal loom weight of the late eighth–early seventh centuries combines a confidently drawn horse and rider on the base with a more tentative and much-worn alphabet on one side (fig. 2).[7] Other similarly dated potsherds with partial abecedaria were found in the shrine of Rainy Zeus on the ridge of Mount Hymettus.[8] There too were many fragmentary inscribed pots asserting that So-and-so himself wrote the inscription, for example (fig. 3): κ]αὶ τάδ αὐτὸς ἔγ⟨ρ⟩αφ[cεν,

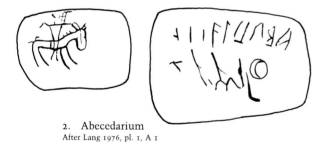

2. Abecedarium
After Lang 1976, pl. 1, A 1

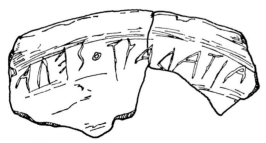

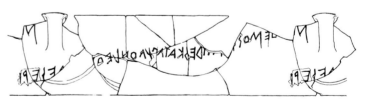

4. Obscene graffito
After C. W. Blegen, "Inscriptions on Geometric Pottery from Hymettus," *AJA* 38 (1934), 11, fig. 1

"And he himself wrote this." Still another (fig. 4) asserts that one Nikodemos is (in the words of Liddell and Scott) "given to unnatural vices": Νι[. .]δεμος φ[ιλ]αιίδεc καταπύγον. Λεο[φρά]δεc [[ἔρι]].[9]

Another kind of alphabetic assertiveness is shown by a late-eighth-century B.C. potter on the western fringes of the Greek world in Pithekoussai (fig. 5):]ῖνος μ' ἐποίεcε[. ". . . inos made me."[10] How different in some ways are earlier Phoenician texts, where there is no need to practice one's letters, nor does the

3. Alphabetic assertion
After Langdon 1976, fig. 8.30

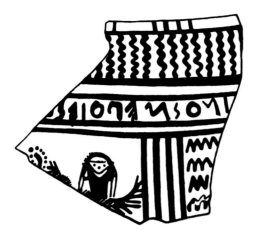

5. Potter's signature
After Jeffery 1982, 829, fig. 2

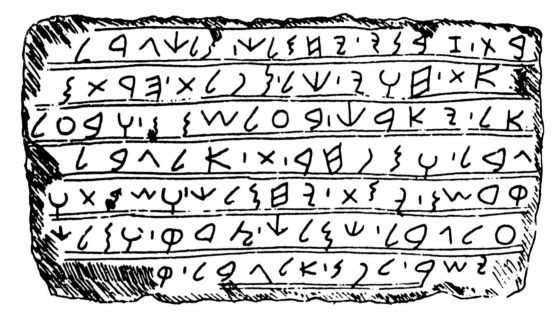

6. Yehimilk inscription
After Naveh 1982, fig. 43

7. Stele of Kilamuwa
After Naveh 1982, fig. 45

awkwardness of exercising a new skill keep one's sentiments brief, but there is the same assertiveness. For example, a tenth-century text from Byblos (fig. 6): "A house built by Yehimilk, king of Byblos, who also has restored all the ruins of the houses here. May Ba'lshamem and the Lord of Byblos and the Assembly of the Holy Gods of Byblos prolong the days and years of Yehimilk in Byblos, for (he is) a righteous king and an upright king before the Holy Gods of Byblos!"[11] And there is a ninth-century text from Zenjirli (fig. 7):

I am Kilamuwa, the son of Hayya. Gabbar became over Y'dy but he was ineffective. There was Bmh but he was ineffective. There was my father Hayya but he was ineffective. There was my brother Sha'il but he was ineffective. But I, Kilamuwa, the son of Tm, what I achieved, the former [kings] did not achieve. My father's house was in the midst of mighty kings. Everybody stretched forth his hand to eat it. But I was in the hands of the kings like a fire that eats the beard, like a fire that eats the hand.[12]

Such Phoenician texts involved not only assertiveness but also a concern for establishing a record and thereby achieving permanence. That the potential for immortality offered by the written word was not long lost on the first Greek users of the alphabet is suggested by the very early appearance of both dedications and epitaphs that manage to combine the personal assertiveness of the "I myself wrote this" with the desire for a kind of permanence even if in name only. But before considering such early inscriptions as are certainly, as it were, for the record and for permanence, let us look at some examples of texts whose chief purpose may have been more immediate and largely ephemeral, like the Dipylon Jug. Such are the very early assertions of ownership, like this late-eighth-century retrograde graffito on a cup from Rhodes (fig. 8): Ϙορά ο ἠμὶ ὑλιχϲ, "I am the kylix of Korakos."[13] Perhaps also a claim of ownership is asserted by one Maion (fig. 9) on an amphora fragment dated by the excavator to 740 B.C.:[14]

(retrograde) ἔ]μι Μαίον[οϲ
Μαίον]όϲ ἐμι
I am Maion's.

A different sort of personal assertiveness may consist in not only making a claim, in modern parlance, to set a new record but also in being able to record that record. Here are involved feats of strength. An early-sixth-century man from Euboea left in Olympia a huge stone (fig. 10) inscribed either, Βύβον τ' ἑτέρει χερὶ ὑπερκεφαλά μ' ὑπερεβάλετο ὁ φόρυ[οϲ], "Bubon, son of Phorys, threw me overhead with one hand," or, Βύβον τ' ἑτέρει χερὶ ὑπὲρ κεφαλᾶϲ ὑπερέβαλε τὸ ὀφό[ρ]α, "With one hand Bubon threw overhead this, which see!"[15] The choice of reading depends largely on a single letter, obliging us to take note of the very great variety of letter-forms in various Greek states. So, for example, lambda may have its hook at top, as here, or at bottom; epsilon may look like an E, as here, or like an angular B; and the M-shaped letter may be a mu if it has both feet on the ground but a sigma if it reclines on one leg. And with this spiraling kind of inscription, one cannot be perfectly sure how the writer was oriented as he turned the corner. Perhaps more noteworthy is the fact that the stone weighs 315 pounds, so that the feat is impossible unless Bubon, having raised the stone with two hands, threw it overhead with one. Even less credible is the boast inscribed on a large black stone (fig. 11) found on the island of Thera that weighs 480 kilos or 10,560 pounds: Εὐμάϲταϲ με ἄηρεν ἀπὸ χθονὸϲ ho Κριτοβόλο, "Eumastas, son of Kritoboulos, raised me from the earth."[16] The boast may be idle but its expression in a perfect dactylic hexameter perhaps grants poetic license.

A less personal boast but one that attests to a craftsman's pride or skill appears on the late seventh-century fragmentary Naxian marble base of the fragmentary colossal Apollo found in Delos (fig. 12): [τ]ὸ ἀϝυτô λίθο ἐμὶ ἀνδριὰϲ καὶ τὸ ϲϝέλαϲ, "I am statue and base of the same stone."[17] Since the base and statue are evidently not of one piece, there has been much discussion as to the meaning of the line. We may only note here that it is an iambic trimeter and testifies to the way in which the memorability of verse reinforces the permanence of the written record.

These earliest written expressions that survive by chance rather than by literary merit or historical significance not only show something of the alphabetic impact on an il-

8. Kylix of Korakos
After Jeffery 1961, pl. 67.1

9. Maion's amphora
After Buchner 1978, 135, fig. 4

10. Bubon's boast
After Roehl 1882, no. 370

11. Eumastas' claim
After Roehl 1907, 5, no. 26

literate population but also allow us, as it were, to view the human figure in early Greek art from the inside as well as the outside. And the large part played in these writings by personal assertiveness provides striking confirmation of what readers of Greek literature have long seen as an entirely new spirit in the works of lyric poets like Archilochus, Alcaeus, and Sappho. Gone is the impersonal mouthpiece of the Muses who tells of heroic passions and epic acts in self-effacing fashion; newly arrived, apparently, are poets whose loves and hates, yearnings and disappointments, are cried aloud in an orgy of self-expression. What we cannot know, because there was no alphabet to record them, is whether the nonepic songs that must have accompanied work and worship in the epic age had anything of this intensely personal affect. Or did the opening up of Greece to outside influences (like the alphabet) that brought such a glorious burst of artistic and economic activity also make for personal self-realization and affirmation? All we can know for sure is that early uses of the alphabet do give us informal glimpses into individual lives concerning which there is very little other evidence.

12. Naxian base
After Roehl 1907, 65, no. 4

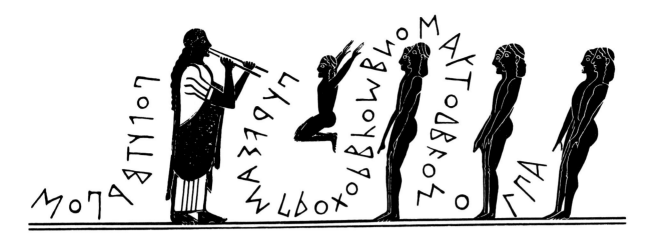

The painted inscription on a Corinthian aryballos of the early sixth century[18] must have been a special order, since painted letters and dancers together refer to a particular event (fig. 13). The single word behind the flute-player ("Polyterpos" or "much delighting") is separate and should apply to him; it may be his name or simply an epithet. The rest of the inscription is a dactylic hexameter, Πυρϝίας προχορευόμενος· αὐτὸ δέ ϝοι ὄλπα, which may be translated, "Purvias is leading the dance; and here to him the olpe." Except, of course, that there are very strong differences of opinion as to the form, syntax, and meaning of the last four words[19]—in part, at least, because of the difference between the pot's name for us (aryballos) and for Purvias (olpe). But surely whether ordered by Purvias or Polyterpos or another, it is a prize of praise and as much a boast of prowess as those lines of Archilochus:

> I am a follower of the Lord of Battles,
> and I understand the lovely gift of the
> Muses.
>
> (frag. 1)

Still more controversial, this time with respect to both date and meaning,[20] is the so-called Nestor's Cup from Pithekoussai off Kyme, Italy (fig. 14). The skyphos itself certainly belongs to the late eighth century and was found in a similar context, although there was some disturbance.[21] What has troubled some scholars is that both the letters and their arrangement are so different from other similarly early texts: the letters are not spindly, and they are arranged in neat horizontal lines, one to a verse, most unusual even for much later texts. And while the joke that it embodies fits what we know of late sixth-century humor, we do not, alas, have any idea about what might have amused the late-eighth-century colonists from Euboea.

Νέστορός : ε[ἰμ]ι : εὔποτ[ον] : ποτέριο[ν:]
hὸς δ' ἄ⟨ν⟩ τόδε π[ίε]ϲι : ποτερί[ο] : αὐτίκα κêνον
hίμερ[ος] : haιρέ]ϲει : καλλιστε[φά]γο Ἀφροδίτες.

The cup of Nestor is good to drink from, but whoever drinks from *this* cup, straightway desire for fair-crowned Aphrodite will seize him.

13. Purvias' prize
After Roebuck and Roebuck 1955, pl. 64

14. "Nestor's Cup"
After Jeffery 1961, pl. 47.1

15. Tataie's lekythos
After Jeffery 1961, pl. 47.3

16. Convivial inscription
After Langdon 1976, fig. 9.49

There is humor both in the suggestion that the precious but unwieldy cup that Nestor has to manhandle in the *Iliad* is good to drink from and in the contrast between it and this poor earthenware skyphos. Humorous too is the mock threat of what will happen to one who drinks, obviously patterned on and a parody of real threats known to us from elsewhere but most relevantly from an early-seventh-century aryballos from neighboring Kyme (fig. 15): Ταταίες ἐμὶ λ|έ υθος· hὸς δ' ἄν μὲ κλέφς|ει θυφλὸς ἔςται, "I am Tataie's lekythos; whoever steals me shall be blind."[22] Not verse, and probably not humorous either, but properly assertive.

skyphos base from Athens[25] was obviously used as "scrap paper" to leave a message (fig. 17): : κάθες : hυπὸ τὸι hοδõι : τὰς θύρας τõ κᾶπο : πρίον⟨α⟩, "Put the saw under the threshold of the garden gate." On the underside of a terracotta sima[26] from the temple of Artemis Laphria in Calydon are incised directions as to its placement (fig. 18): μία ἐπὶ ϝίκατι πὸ ἑσπέρας, "21 toward the west."

More exotic and assertive than these highly practical uses of writing are the famous early-sixth-century inscriptions by Greek mercenaries[27] on the leg of a colossal statue at Abu Simbel in Ethiopia (fig. 19):

βασιλέος ἐλθόντος ἐς Ἐλεφαντίναν
Ψαματίχο | ταῦτα ἔγραψαν τοὶ cὺν
Ψαμματίχοι τõι Θεοκλõς | ἔπλεον· ἦλθον δὲ
Κέρκιος κατύπερθε υἱς ὁ ποταμὸς | ἀνίη·
ἀλογλόςος δ' ἦγε Ποταςιμτό, Α'ίγυπτίος δὲ
Ἄμαςις. | ἔγραφε δ' ἀμὲ Ἄρχον Ἀμοιβίχο
καὶ Πέλεϙος Ούδάμο.

17. Graffito message
After Lang 1976, pl. 2, B1

More encouraging are a couple of very early inscriptions on vessels associated with wine. One cup (fig. 16) is from the Rainy Zeus shrine on Hymettus:[23]]ς προπίγε τενδί, "Pledge this." Another, a long-necked oinochoe of about 700 B.C. found in Ithaca, has an extended but fragmentary text, part of which, at least, has been read as a pledge or toast:[24] ξ]ένϝος τε φίλος κᾳὶ π[ιc]τὸ[ς h]εταῖρος, "dear friend and faithful comrade." Of a much more miscellaneous nature are three other graffiti of the early sixth century. One

18. Builder's note
After Jeffery 1961, pl. 44.4

When the King Psammetichos came to Elephantine, those who sailed with Psammetichos son of Theokles wrote this. They came above Kerkis as far as the river allowed. Potasimto led the foreign speakers, Amasis the Egyptians. Archon son of Amoibichos and Pelekos son of Oudamos [Nobody] wrote me.

19. Abu-Simbel inscription
After Roehl 1882, no. 482

And various individual signatures follow, each in his native city's alphabet (fig. 20):

Ἐλεσίβυς ὁ Τήϊος, Helesibys the Teian
Τήλεφος μ' ἔγραψε ho Ἰαλυσιο, Telephos of Ialysos wrote me
Πύθον Ἀμοιβίχ(), Python son of Amoibichos
Πάβις ὁ ϙολοφώνιος σὺν Ψαμματᾶ, Pabis of Colophon with Psammatas

ΓΓΕΣΙΒVS ΟΤΗΛΟS

ΤΘΓΕΦΟSΜΕΓΡΑΦΕΘΟΙΑΙΛVSΙΟϚϺΕY ΛΕΥ

ΓVΘΟΝ ΑΜΟΙΒΙV

ΓΑΒΙϚ ΟϙΟΛΟΦΟΝΙΟϚ ϚVΝVΑΜΜΑΤ

However ephemeral in intent some of the texts noted above may have been, this at least, like the "Kilroy was here" of World War II, bears witness to a desire both to make one's mark and, as it were, to domesticate a foreign place by using one's own language and script.

More certainly meant as bids for permanence and lasting credit with the gods are the dedications that are found with ever increasing frequency from the beginning of the seventh century. Earliest is the two-hexameter inscription on the thighs of a bronze male figurine from Boeotia (fig. 21):

Μάντικλός μ' ἀνέθεκε ϝεκαβόλοι ἀργυροτόξϲοι
τᾶς {δ}δεκάτας· τὺ δέ, φοῖβε, δίδοι χαρίϝετταν ἀμοιβ[άν].

Manticlos dedicated me from his tithe to the Far-shooter of the silver bow; and may you, Phoebus, grant a pleasing response.[28]

Equally well known is the slightly later Naxian dedication of the Nikandra statue,[29] written on the right thigh:

Νικάνδρη μ' ἀνέθεκεν ηεκηβόλοι ἰοχεαίρηι
 ὄρη Δεινοδίκηο τô Ναηϲίο ἔηϲοχος ἀλήον.
 Δεινομένεος δὲ κασιγνέτη, φηράηϲο δ' ἄλοχος ϝ⟨ῦν⟩

Nikandre dedicated me to the Far-darter who delights in arrows; she, the daughter of Deinodikes, an outstanding woman, sister of Deinomenes and wife of Phraxos now.

Two late-seventh-century dedications raise questions about differences between rich and poor and between verse and prose. An Argive inscription on a bronze aryballos[30] is a single dactylic hexameter (fig. 22): Χαλ οδάμανϲ με ἀνέθεκε θιιοῖν περικαλλὲϲ ἄγαλμα, "Chalkodamans dedicated me, a very beautiful ornament, to the two goddesses." If the dedicator's name (Master of Bronze) suggests a dynasty of bronzeworkers, the aryballos may have been his own work, so that his use of the Homeric tag, "a very beautiful orna-

20. Abu-Simbel signatures
After Roehl 1882, no. 482

22. Chalkodamans' dedication
After Jeffery 1961, pl. 26.3

ment," is not due merely to the exigency of meter. Compare a cheap Middle Corinthian aryballos of clay from the Troad that is inscribed in prose: τενδὶ ϲοὶ Θόδεμος δίδοϲι, "Thoudemos gives this to you."[31] That the humbler gift has the simpler prose inscription might suggest that verse was expensive, but our sample of dedications from this early period is too small to attempt any correlation. It is certainly true that the larger and more formal dedications on stone are most usually in verse. Thus the stone support for the bun-

21. Manticlos' dedication
After Jeffery 1961, pl. 7.1

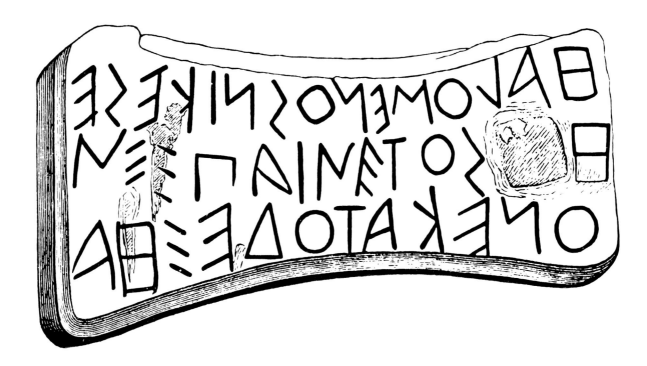

23. Inscribed jumping
weight
After Roehl 1907, 70, no. 6

dle of obols or spits dedicated at Perachora is
in verse: δραχμὰ ἐγώ, ἥερα λευ [όλεν . . . , "I
am a drachma, O white-armed Hera. . . ."[32]
And even a jumping weight of lead found in
Eleusis and presumed, along with its mate, to
be a dedication to Demeter and Kore, is in-
scribed in verse (fig. 23):

hαλόμενος νίκεςεν Ἐπαίνετος hόνεκα τόδε
hα[λτὲρε . . .

Epainetos won in the jump because these
two weights

The rest of the second line, which must have
continued on the second weight, is lost.[33]

 Greek use of the alphabet for dedications
to divinities may have merely been in imi-
tation of Phoenician practice, although as far
as our evidence goes it was not ordinary per-
sons like our Chalkodamans, Epainetos, and
Thoudemos who made dedications in Phoen-
icia, but kings, priests, and governors. It may
be that the alphabet had to come to Greece
in order to be democratized, and that the wide
and rapid spread of literacy was a factor in the
invention of political democracy. At any rate,
even before that invention the different kinds
of public or official use of writing in Phoen-
icia and Greece do reflect the differences be-
tween the eastern monarchies and the Greek
aristocracies and oligarchies.

 Thus the eastern potentates seem to think
only of themselves, as in the ninth-century

24. Mesha stele
After Naveh 1982, fig. 55

Mesha Stele (fig. 24) that begins: "I am
Mesha, son of Chemosh, king of Moab, the
Dibonite—my father had reigned over Moab

thirty years, and I reigned after my father, who made this high place for Chemosh in Qarhoh . . . who caused me to triumph over all my adversaries. . . ."[34] In Greece it is the city that counts, as in this law of the seventh century inscribed (retrograde) on a wall in Dreros, Crete (fig. 25):

(T)άδ' ἔϝαδε | πόλι· | ἐπεί κα κοϲμήϲει | δέκα ϝετίον | τὸν αϝτὸν | μὴ κόϲμεν, αἰ δὲ κοϲμηϲίε, ὄ(π)ε δικακϲίε, αϝτὸν ὀπῆλεν | διπλεῖ | καϝτὸν θιοϲόλοιον ἄκρηϲτον | ἦμεν, ἀϲ δόοι, | κὄτι κοϲμηϲίε μηδὲν ἤμην. . . .

This is pleasing to the city. Whenever a man has been kosmos, this same man shall not be kosmos (again) within ten years. If he becomes kosmos (within ten years), in whatever case he pronounces judgment he shall owe double penalty and himself—god destroy him—be without function as long as he lives and whatever he has done as kosmos shall be null and void.[35]

Once such a powerful tool as the alphabet was firmly in hand, no aspect of life was too private or too trivial to escape control by rules carved on the nearest available wall. A small sample of a seventh-century inscription on Tiryns passage walls illustrates this (fig. 26). Not completely deciphered as yet, it seems to list regulations for meetings where wine and food were consumed, with specified contributions to be provided and fines for noncompliance.[36] Other official inscriptions of the earliest period include lists of magistrates,

one of which, in dactylic hexameter, records the names of certain managers of sacred affairs who first established a contest in honor of the owl-eyed maiden Athena.[37]

Last of all, appropriately enough, we come to the alphabet and the epitaph—"quod semper, quod ubique, quod ab omnibus scriptum est." Surely the Greeks did not have to learn this use from the Phoenicians. Even without writing they had managed in the Mycenaean and Dark Ages to ensure permanent identity to their dead by burying with them durable

25. Law from Dreros
After Jeffery 1961, pl. 59.1a

and very personal objects that might be anything from a gold-inlaid dagger to a tooth-marked blue bead. But now, with letters to spell out name and claims to fame, even the very early epitaphs achieve for the deceased a double memorability—through the use of verse, which might in prealphabetic times have been intoned at the burial, and through the permanent, palpable record of life and death. Earliest, if indeed it is an epitaph at all, is the retrograde inscription on a jar from Crete (fig. 27): Ἐρπετιδάμο Παιδοπίλας ὅδε, "This is of Paidophila daughter of Herpetidamos."[38] Next earliest is the rough Corinthian stone of about 650 B.C. with its single

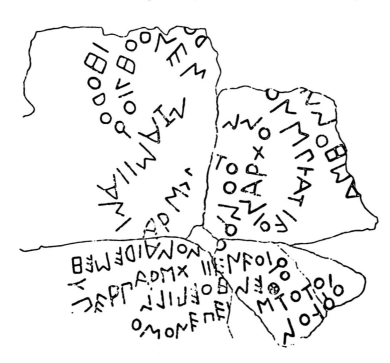

26. Regulations
After Verdelis, Jameson, and Papachristodoulou 1975, 174, fig. 28

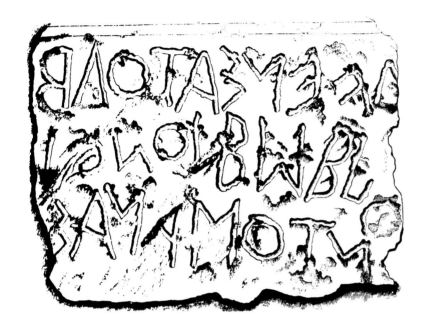

27. Epitaph of
Paidophila (?)
After Jeffery 1982, 829, no. 3

28. Dweinias' epitaph
After Roehl 1882, no. 15

29. Menekrates' epitaph
After Roehl 1882, no. 342

hexameter line written boustrophedon (fig. 28): Δϝεινία τόδε [câμα] τὸν ὄλεσε πόντος ἀναι[δές], "This is the [tomb] of Dweinias whom the ruthless sea destroyed."[39]

Far more elaborate a generation later is the circular monument erected by the Corcyreans honoring Menekrates, a native of Oianthea who served as consul in Oianthea for visiting or trading Corcyreans.[40] The six hexameters are written in a single retrograde line running all around the monument (fig. 29):

ηυιοῦ Τλασιάϝο Μενεκράτεος τόδε câμα
Οἰανθέος γενεάν, τόδε δ' αὐτôι δâμος
ἐποίει.: ἐς γὰρ πρόξενϝος δάμου φίλος· ἀλλ'
ἐνὶ πόντοι ὄλετο, δαμόσιον δὲ καϟὸν
ϟο[].: Πραξιμένες δ' αὐτôι
γ[αία]ς ἀπὸ πατρίδος ἐνθòν σὺν δάμοι τόδε
câμα κασιγνέτοιο πονέθε.:

This is the tomb of Menekrates, son of Tlasias, of Oianthea by birth. The people made it for him, for he was their dear proxenos. But he died in the sea, a great public loss. Praximenes, coming from his fatherland made this, his brother's tomb, along with the people.

Also from Corcyra but more poetic is the three-line hexameter on the tomb of Arniadas, about 600 B.C.: "This is the tomb of Arniadas whom flashing-eyed Ares destroyed as he fought beside the ships in the streams of Arathos. He was bravest by far in the wretchedness of war."[41]

One of the first epitaphs to address the wayfarer belongs to the second quarter of the sixth century and comes from Attica.[42] Its six elegantly carved boustrophedon lines present two couplets, as usual without regard for the verse structure. The lines read (fig. 30):

[εἴτε ἀστό]ς τις ἀνὲρ εἴτε χϟένος | ἄλοθεν ἐλθòν[:]
 Τέτιχον οἰκτίρα|ς ἄνδρ' ἀγαθὸν παρίτο,: ἐν πολέμοι | φθίμενον, νεαρὰν ηέβεν ὀλέσαν|τα.:
 ταῦτ' ἀποδυράμενοι νέσθε ἐπ|ὶ πρâγμ' ἀγαθόν.

Let a man, whether townsman or stranger coming from elsewhere, pass by, having pitied Tetichos, a good man who died in battle, losing youthful vigor. Mourning this, go on to worthy work.

A somewhat later boustrophedon epitaph found in Sigeion is interesting in that it is not only in prose but doubly inscribed, once in the Ionic alphabet and dialect, then again in Attic (fig. 31).[43] The Ionic text reads:

Φανοδίκο|ἐμὶ τὀρμοκ|ράτεος τὸ |
Προκοννη|cίο· κρητῆρ|α δὲ: καὶ ὑποκ |
ρητήριον: κ|αὶ ἠθμὸν: ἐc π|ρυτανήιον |
ἔδωκεν: Συκε|εὐcιν.

I am [the stele] of Phanodikos, son of Hermokrates of Prokonnesos; he gave a krater and a krater stand and a strainer to the prytaneion for the people of Sigeion.

The Attic text is both longer and more confused about the identity of stele and deceased:

Φανοδίκο; εἰμὶ : τὸ h|ερμο κράτος : τὸ
Προκο|νεcίο : κἀγὸ : κρατᾶρα | κἀπίcτατον
καὶ hεθμ|ὸν : ἐc πρυτανείον : ἔδοκα μνᾶμα :
Σιγευ|εὐcι : ἐὰν δέ τι πάcχ|ο, μελεδαίνεν :
με ὁ Σιγειὲc· καὶ μ' ἐπόεισεν : ha'ίcοπος |:
καὶ hἀδελφόι.

I am [the stele] of Phanodikos, son of Hermokrates, the Prokonnesian. And I gave a krater and a krater stand and a strainer to the prytaneion as a memorial for the Sigeians. If I suffer anything, let the Sigeians care for me. Both Haisopos and his brothers made me.

The presumption is that the stele was originally prepared in Prokonnesos, a Milesian colony—hence the Ionic dialect and alphabet. When it was moved to Sigeion, which had recently been occupied by the Athenians, the Attic text was added—thus an alphabetic sample of the Greek city-state chauvinism that made national union so difficult.

The latest text to be considered here, dated to 540 B.C., in addition to its pitiful message, is particularly interesting because the statue

30. Tetichos' epitaph
After Roehl 1907, 70, no. 3

31. Phanodikos' stele
After Roehl 1882, no. 492

76 LANG

32. Phrasikleia's epitaph
After Jeffery 1961, pl. 3.29

it supported has only recently been discovered.[44] The elegiac distich, furthermore, is among the very earliest examples of stoichedon writing and so brings our survey of early Greek writing down to the period in which it became a decorative art as well as a means of instant memorability and communication. The text reads as follows (fig. 32):

σῆμα Φρασικλείας· | κόρε κεκλέσομαι | αἰεί
ἀντὶ γάμο | παρὰ θεὸν τοῦτο | λάχος᾽ ὄνομα.

The tomb of Phrasikleia. I shall always be called maiden, having received this name from the gods instead of marriage.

These few examples of early Greek texts serve not only to illustrate the evolution of Greek mastery of the written word but also to demonstrate the variety of uses, both ephemeral and lasting, both prosaic and poetic, in a variety of local alphabets, and in forms ranging from retrograde spirals through boustrophedon to stoichedon. From our point of view this is valuable historical evidence, but considering what the Greeks had already produced in the *Iliad* and *Odyssey* before the alphabet came (as most of us think), can we say that it came as a great boon to the Greeks? Not if we listen to Plato, who made the mythical pharaoh Thamus chide the inventor of the alphabet in these words:[45]

This discovery of yours will create forgetfulness in the learners' souls, because they will not use their memories; they will trust to the external written characters and not remember of themselves. The specific

which you have discovered is an aid not to memory but to reminiscence, and you give your disciples not truth but only the semblance of truth; they will be hearers of many things and will have learned nothing; they will appear to be omniscient and will generally know nothing; they will be tiresome company, having the show of wisdom without its reality.

Still, we have seen reason to believe that the alphabet was indeed a force for good: on the lowest level as a harmless outlet for assertiveness and insult and as an incentive to self-expression and the setting of new records; more nobly as a stimulus to the composition of new kinds of verse in dedications and epitaphs; and most nobly of all as providing for the writing and publication not only of laws and official records that militate against the arbitrary exercise of authority but also of treatises on subjects where the exactness of prosaic expression is more useful than the memorability of poetic form. So, in the end, it turns out that Bacon, for the Greeks as well as for us, is the better guide: "Reading maketh a full man; conference a ready man; and writing an exact man."

1. *IG* I² 919. See also Lillian H. Jeffery, *The Local Scripts of Archaic Greece* (Oxford, 1961), 68–69, no. 1. For recent bibliography see Peter A. Hansen, *Carmina epigraphica graeca saeculorum viii–v a. Chr. n.* (Berlin, 1983), 239–240, no. 432.

2. The only other truly sidelong alpha found in a possibly Greek context and claimed to be Greek is on a sherd from Pithekoussai with four scratched letters of which only two are complete. In "Appunti di epigrafia greca arcaica," *ArchCl* 16 (1964), 129, and *Epigrafia graeca* (Rome, 1967), vol. 1, 225, Margherita Guarducci read the letters as retrograde Greek *pi alpha*. P. Kyle McCarter, "A Phoenician Graffito from Pithekoussai," *AJA* 79 (1975), 140–141, turned the sherd around and read the letters as retrograde Phoenician *alep lamed*, "an exceedingly common Phoenician combination with a variety of interpretations from which to choose." The "almost sidelong" alphas on Hymettus sherds noted by Jeffery (*CAH*, 3, 1, 828) occur with other tilted letters and appear to result from the style of writing (Merle K. Langdon, *A Sanctuary of Zeus on Mount Hymettus, Hesperia Supplement 16* [Princeton, 1976], 42).

3. The beginning of the second line of verse must be *tou tode* and not *toutou de* since the diphthong of the demonstrative is not written without the upsilon before the end of the fifth century B.C. The ill-written remainder has been variously interpreted: (1) as a vase-name (for example, *toutou de kalmis* by M. Guarducci, "Ancora di epigrafi greche archaiche," *Rendiconti della Reale Accademia dei Lincei* 33 [1978], 390–394, or *tou tode k[alpo]n* by J. Schindler, as quoted in Calvert Watkins, "Syntax and Metrics in the Dipylon Vase Inscription," in *Studies in Greek, Italic, and Indo-European Linguistics Offered to Leonard R. Palmer*, ed. A. Morpurgo-Davies and W. Meid [Innsbruck, 1976], 440–441); (2) as referring to the contents (*to tode karm' in* = "Therefore this first-fruit for him") by Carlo Gallavotti, "Peril centenario dell'iscrizione del Dipylon," *Archaiognosia* 1 (1980), 27–37; (3) as "by another, worse writer" by Jeffery 1961, 68; and (4) as the result of frustration as the writer came near the handle (Hansen 1983, 240).

4. Joseph Naveh, *Early History of the Alphabet* (Jerusalem, 1982), 175–186. See also P. Kyle McCarter, Jr., *The Antiquity of the Greek Alphabet and the Early Phoenician Scripts*, Harvard Semitic Monographs, 9 (Missoula, Mont., 1975). McCarter agrees with Naveh that the Greeks began their acquaintance with the west Semitic alphabet about 1100 B.C. but maintains that they did not complete the development of their own alphabet until 800 B.C. Further comment is added by Frank M. Cross, "Early Alphabetic Scripts," in *Symposia Celebrating the Seventy-fifth Anniversary of the Founding of the American Schools of Oriental Research* (Cambridge, Mass., 1979), 105–111, who counters some of the classicists' arguments for a late borrowing by showing that the Phoenicians were in contact with the West from the eleventh century on, by suggesting that the absence of tenth to ninth century Greek texts is no more remarkable than the extreme paucity of Hebrew texts of that time, and by

urging the necessity of postulating considerable time for the development of the Greek alphabet with its differences and distance from its origins.

5. Martin Bernal, "On the Transmission of the Alphabet to the Aegean Before 1400 B.C.," *BASOR* 267 (1987), 1–20. Because he derives the "new letters" added onto the Greek alphabet from Thamudic and Safaitic letters which disappeared from Phoenicia in the fourteenth century B.C., Bernal postulates transmission in two waves: an earlier mid-second-millennium wave bringing south Semitic letters; and a second wave in the tenth and ninth centuries with Phoenician expansion.

6. Rhys Carpenter, "The Antiquity of the Greek Alphabet," *AJA* 37 (1933), 17.

7. Mabel L. Lang, *Agora*, 21: *Graffiti and Dipinti* (Princeton, 1976), 6–7, A 1.

8. Langdon 1976, 17–18, nos. 21–26.

9. Langdon 1976, 19–20, nos. 30 and 36.

10. G. Buchner, "Recent work at Pithekoussai (Ischia), 1965–1971," *AR* (1970–1971), 67.

11. Trans. Franz Rosenthal in James B. Pritchard, *Ancient Near Eastern Texts*, 3d ed. (Princeton 1969), 653.

12. Trans. Franz Rosenthal in Pritchard 1969, 654–655.

13. Jeffery 1961, 347, 356, no. 1.

14. Giorgio Buchner, "Testimonianze epigrafiche semintiche dell' viii secolo a.c. a Pithekoussai," *PP* 33 (1978), 135–137, fig. 4.

15. The first reading, in Wilhelm Dittenberger, *Sylloge inscriptionum graecarum*, 3d ed. (Leipzig, 1920), vol. 3, 225, no. 1071, is the one most generally accepted. The second reading is that of Herman Roehl, *Inscriptiones graecae antiquissimae* (Berlin, 1882), no. 370.

16. Herman Roehl, *Imagines inscriptionum graecarum antiquissimarum*, 5 (Berlin, 1907), 5, no. 26.

17. Hansen 1983, 219–220, no. 401.

18. Mary C. Roebuck and Carl A. Roebuck, "A Prize Aryballos," *Hesperia* 24 (1955), 158–163.

19. See Hansen 1983, 251, no. 452, for various possibilities.

20. For references see Hansen 1983, 252–253, no. 454.

21. Peter A. Hansen, "Pithecusan Humour: The Interpretation of Nestor's Cup Reconsidered," *Glotta* 54 (1976), 26–28.

22. *IG*, 14, 865.

23. Langdon 1976, 23, no. 49.

24. Martin Robertson, "Excavations in Ithaca, V," *BSA* 43 (1948), 80–82, pl. 34.

25. Lang 1976, 8, A 1.

26. Jeffery 1961, 226–227, no. 4.

27. Jeffery 1961, 354–356, no. 4; 358, no. 48.

28. Hansen 1983, 175–176, no. 326.

29. Hansen 1983, 221–222, no. 403.

30. Hansen 1983, 193–194, no. 363.

31. Jeffery 1961, 373, no. 75.

32. Hansen 1983, 188–189, no. 354.

33. Hansen 1983, 158–159, no. 299.

34. Trans. W. F. Albright in James B. Pritchard, *Ancient Near Eastern Texts*, 2d ed. (Princeton, 1955), 320.

35. Pierre Demargne and Henri Van Effenterre, "Recherches a Dréros," *BCH* 61 (1937), 333–341.

36. Nikolaos Verdelis, Michael Jameson, and Ioannes Papachristodoulou, "Archaic Inscriptions from Tiryns," *ArchEph* (1975), 150–205.

37. Jeffery 1961, 72, 77, no. 18.

38. Jeffery 1982, 829, no. 3.

39. Hansen 1983, 72, no. 132.

40. Hansen 1983, 78–79, no. 143.

41. Hansen 1983, 80, no. 145.

42. Hansen 1983, 11, no. 13.

43. Jeffery 1961, 366–367, nos. 43–44.

44. Hansen 1983, 17–18, no. 24.

45. *Phaedrus* 275ab.

WALTER BURKERT
University of Zurich

Homer's Anthropomorphism: Narrative and Ritual

One of the most perceptive literary critics of antiquity, whose name is not known—he is usually referred to as Pseudo-Longinus—writes with regard to the gods of Homer: "It seems to me that Homer, by relating the wounding of gods, their revolts, punishments, tears, imprisonments, sufferings of all kinds, has turned the men involved in Iliadic affairs as far as possible into gods, but the gods into men" (*De sublimitate* 9,7). In a pointed form he gives expression to a problem that had been felt for a long time, the paradox of Homeric anthropomorphism: the gods of Homer in their unforgettable individuality who had become so important for the whole of the Greek world view were found to be too human or even below human standards.[1] We all know the much older and more radical invective of Xenophanes against Homer and Hesiod who "put upon the gods everything that is shame and reproach among men, stealing and committing adultery and deceiving each other" (Frag. B 11). With Xenophanes there was already developing a system of postulates of what a god should be like: without needs, not only immortal but ungenerated, all-knowing, omnipotent, and hence exempt from any sexual, thievish, or cunning activities.[2] In more modern times we have witnessed the breakdown of idealistic constructs, and as in our world of chance and necessity there is hardly a place left for a being that "knows everything and controls everything," we may more easily sympathize with the restricted yet lively and realistic aspects of Homeric gods. Nevertheless the problem remains of how, at the crossroads of religion and poetry, this special picture of divine beings came to be drawn that was to form both a model and a contrast for developing human consciousness. Why are the gods of Homer so human, and why are the Greeks from an early date both so impressed by and so critical of them?

In the following reflections I shall avoid delving into the problems of Hesiod, whether succession myth, Prometheus myth, or the personifications of abstract entities such as Dike; instead, I shall concentrate on the epic texts that were to become familiar to every educated person in the Greek world, from elementary school to advanced studies—that is, on the *Iliad* and *Odyssey*. I freely use the name of Homer with reference to both, although I think they are the works of two different composers elaborating on the achievements of a long oral tradition. I will present three theses:

1. To present gods in an unheroic, all-too-human vein is a traditional form of narrative, to be understood from its function within heroic tale, developed in Greece under the influence of oriental models.

2. Even in Homer the unquestionable seriousness of religion is not based on such tales, but on traditional ritual, which is essentially nonanthropomorphic; it nevertheless enters narrative as an effective element of epic style.

3. Homeric anthropomorphism is just slightly connected with the spreading use of anthropomorphic images in cult, especially in temples, which we know took place in the eighth century B.C.

"Human" Gods in Traditional Narrative

Credit is due to Walter F. Otto and his book *The Homeric Gods*[3] for showing how a truly religious approach to Homer's gods is still possible. Yet rereading Homer after reading Otto's work, one will still be struck by the amount and degree of those all-too-human elements in the encounters of the gods with one another. The gods are free of heroic constraint, and it is a relief for poet and audience to get off the battlefield now and then; and whatever the postulates of theology, it is right that Zeus should feel violent compassion for Hector, and even have tears for Sarpedon. Yet family affairs in the house of the gods are not only nonheroic and human, they are not seldom beneath the level of civilized conduct. There is in particular a kind of children's perspective that is developed with gusto. Take a scene in the fifteenth book of the *Iliad*.[4] Hera, after violent scoldings and threats by her deceived husband, returns to Olympus. She is greeted by all the other gods with deference; her lips smile, but her eyebrows remain tense and angry, and—handing on anger, as it were—she tells Ares that a son of his has just been slain in battle. Ares starts with a howl to throw himself into battle, although father Zeus has strictly forbidden any intervention of this kind. Athena therefore jumps up in alarm to hold back her brother; she takes off his armor and addresses him as a crazy fellow who has no ears: if he disobeys Zeus, she tells him, father "will come to us in Olympus to wreak havoc, he will catch hold of one after the other, guilty or not" (15, 136–137). This is catastrophe in a children's world, as Hypnos (Sleep) has depicted it before: on an earlier occasion Zeus, deceived by Sleep, had indulged his anger at Olympus, "hurling around the gods in his house, and it was I whom he was seeking foremost of all; . . . I ran away and reached Night; so he finally stopped, though he was quite angry" (14, 256–260). It is here especially that we find the children's perspective of the family tyrant cuffing his children while searching for the real culprit. This scene is experienced with shivers and yet a bit of triumph: "so he finally stopped." Less fortunate is Artemis in the Battle of the Gods when she dares to oppose Hera: "And she—Hera—seized both her hands at the wrist with her left hand, but with her right hand she took the bow from her shoulders, and right with this she thrashed her by the ears, smiling, while Artemis was writhing here and there, and the swift arrows fell from the quiver; with tears in her eyes the goddess ran away" (21, 489–496). This is how wayward children are disciplined by a stepmother; it is left for mother Leto to collect the arrows strewn around.[5] It is clear, I think, that a scene like this is not meant to be sublime but just funny; Hera's smiling is a hint on how the audience should react.

One may be tempted to say that gods are masks of an oppressive superego, as religion is bound up with awe in most civilizations; it seems natural that people should now and then take their revenge by putting to ridicule those superior powers. This is not serious revolt but a form of relief that serves in fact to strengthen the system. It is probably more to the point, however, to note the narrative function of divine burlesque. In a situation of oral storytelling everything depends upon catching and holding the attention of the audience. It is difficult to do so by describing common life; whatever is uncommon, amazing, or thrilling will be more effective. One option is what we call the *heroic*—tales about men above the normal level, which are apt to raise admiration with imaginative identification. The situation is different with gods: for gods, praise and wonder are just normal, routinely developed in hymns that tend to become tedious and dull. What a chance to catch attention by the inverse, portraying glorious gods in banal family situations or even in a childlike position. The remark of Pseudo-Longinus about the inverted roles of men and gods in Homer thus is seen to reflect a basic narrative strategy. The horrible and barbarous punishment of Hera mentioned by Zeus[6] may be seen as an inversion of the second degree, inhumane behavior in the humane sphere, the abnormal versus the mock normality of the divine household, in order to retain the stunning grandeur of the ruling god.

It is remarkable that this kind of narrative is not restricted to Homer's *Iliad*, but has an-

alogies in oriental epic. The most solemn of these texts, the Babylonian New Year's epic *Enuma Elish*, relates the victory of Marduk against Tiamat the Monster of the Sea. It develops all kinds of high style to praise the gods, but amidst the horrible stories of fights for succession we do find those traits from the children's world. When from Apsu and Tiamat several generations of gods have come into being, "they banded together, the brothers, the gods . . . with joyful play in the abode of heaven. Apsu did not control their noise" (I 21, 24–25), so he angrily decides, "Their behavior has become grievous unto me" (I 37), and sets out to kill them all. "Tranquillity shall be restored: well, let us get sleep ourselves!" (I 40).[7] His plans backfire, however, and it is Apsu who is laid to rest in consequence. How this could have been told in another mood is seen in the Hesiodic parallel: Uranos does not allow his children to come to light, so Gaia summons them to rebel, with Kronos taking the lead: "for he—Uranos—was first to plan unseemly deeds" (*Theogony* 172). Here we have an argument about guilt that justifies revenge, while the Babylonian poet chose to introduce the picture of a noisy gang of youngsters driving to despair an old and sullen grandfather. He even repeats the motif in the next generation: when Marduk is born, most wonderful of divine children, his grandfather Anu (Heaven) creates the "Four Winds," a kind of ball, and says, "My son shall play with it" (I 106).[8] The boy of course does this, and he does it so effectively that Tiamat, the Sea, is profoundly disturbed and becomes so angry that she prepares the fearful battle, which is finally to install the kingship of Marduk. Thus we find the traditional concept of the "storm god" artfully transposed into the children's world, in strange but meditated contrast to the huge cosmic struggle that is to ensue.

Another example comes from a well-known scene of *Gilgamesh*:[9] when Gilgamesh has slain Humbaba, and has washed his hair and polished his weapons, "great Ishtar lifted her eyes to the beauty of Gilgamesh: . . . 'grant me your fruit as a gift',' she says (VI 6.8). But Gilgamesh brutally refuses her proposal, giving the catalogue of her lovers all of whom she has loved and destroyed afterwards. "When Ishtar heard this, Ishtar burst into a rage and ascended to heaven. Ishtar went and wept before Anu, her father, before Antu, her mother, her tears were flowing: 'My father, Gilgamesh has grievously insulted me! He has enumerated my insults, my insults and curses!' Anu opened his mouth and said, to great Ishtar he spoke: 'You yourself did incite the king of Uruk, therefore Gilgamesh enumerated your insults, your insults and curses' " (VI 80–91). Compare a scene from the *Iliad*: Aphrodite has been wounded by the spear of Diomedes, her blood is flowing. "Beside herself she went off, she felt terrible pain" (5, 352); Iris and Ares help her to reach Olympus, "and illustrious Aphrodite fell into the lap of Dione, her mother, she took her daughter into her arms and patted her with her hand" (5, 370–372). She asks, "Who has done such things to you, dear child?" (373); Artemis answers that it was Diomedes. Mother begins to console with mythical examples, wiping off the blood, and the pain is fading. Athena and Hera, who are on the other side in battle, begin to make sarcastic remarks. But Zeus smiles, calls Aphrodite to him, and advises her to keep out of battle and rather to pursue the desirable works of marriage. The smile of Zeus is mediating between touching compassion and scornful jokes; it is once more a hint for the audience on how to react. It is clear, I think, that this scene, so very "Homeric" in style, is basically identical with the scene from *Gilgamesh*. In both, there is the same situation and the same mood of the family scene with the crying child, the consoling mother, and the wise and somewhat distanced father. And there are exactly the same characters: the sky god Zeus alias Anu, his wife Dione alias Antu, and their common daughter the goddess of love, Aphrodite alias Ishtar. The most curious fact is that here, and only here, in Greek literature Zeus has a wife at Olympus whose name is just a variant of his own, Dione, just as Antu is the feminine form of Anu. This mother of Aphrodite has brought well-known complications into Greek mythology. I think this is a case of literary borrowing, even if we cannot identify the intermediate texts that must have existed; there were enough places for contacts from Al Mina through Tarsos or Cyprus to Euboea and Ischia in the eighth century. It should be added that the very idea of an assembly of the gods as well as the divine mountain in the north is well established in Hittite and Ugaritic epic, too. This is not the

place, however, to give more details.[10]

The logical conclusion seems to be that the narratives about gods in Homer, including their human or all-too-human characteristics, use traditional strategies of oral tales, while taking certain traits—especially what I have called the children's perspective— from literary models. The models are those of the superior civilizations from which the system of writing, and thus the chance to produce literature in the full sense, was adopted just then. The lack of seriousness of the genre thus was reinforced by its foreign provenience, which meant distance from the closed sphere of domestic religion with its attendant obligations and beliefs.

This is not to deny, but rather to throw into relief, the fact that the composer of the *Iliad* has used this tradition to create a new and highly original structure for his monumental poem. How skillfully the main scenes on Olympus are placed in his composition, how delicately the ease of the gods' life counterbalances the unmitigated cruelty of heroic existence (an ironic mirror, so to speak), and how the intersection of these two planes makes up the totality of the Iliadic world: all of these have been noticed by many interpreters and cannot be pursued here in detail. We are left with a miracle of crystallization out of various traditional elements. The structure of the *Odyssey* is different; this is one of the important arguments for assuming that it had a different composer.[11]

The Autonomy of Ritual

If tales about gods in Homer are meant to provoke smiles rather than to edify, it does not follow that religion is not a serious affair in the world of the epic. The fear of gods is present, as is also seen in the old word θεουδής, 'god-fearing,' which becomes antiquated after Homer. Yet the seriousness, the gravity and solemnity, of religion is bound not to the tales about gods but to the institutions of ritual, which are mainly sacrifice, libation, and prayer. These are well known to the singers and their audience, they appear in typical scenes, and they make effective motifs at important turns of the narrative. But they are not dependent upon the anthropomorphic picture of the gods as drawn in the Olympic family scenes; they would indeed be reduced to the absurd by any consistent application of anthropomorphic ideas. It is only by *not* pursuing these lines or asking pertinent, or rather impertinent, questions about the gods' relation to ritual that Homer can give a picture of serious cult and piety.

Take a scene in the hut of Eumaeus: the swineherd is honoring his guest, Odysseus (incognito), with the kind of feast he can offer, slaughtering a piglet (*Odyssey*, 14, 420–453). "And he did not forget the immortal gods, because he had a good mind," he knew what to do. So he first throws hair from the animal's head into the fire, praying to "all the gods"; when the animal has been butchered, he "places on thick fat raw pieces, taking the beginning from all limbs, and throws them into the fire, sprinkling them with barley" (427–429); when the meat is divided for those present, he puts aside one portion "for the nymphs and Hermes," praying once more; then, before starting to eat, he burns "first offerings for the immortal gods" (446) and pours out a libation of wine; and so they start to eat. This description presents several problems to historians of religion: which divinities are concerned with each act, and why and how?[12] In fact the poet does not tell us what those "raw pieces" are for, or how the nymphs and Hermes are to get their "portion," or why they have to share just one. It is the ritual action per se that in a demonstrative way interrupts the practical proceedings again and again to show that Eumaeus is indeed a very pious man who "does not forget the immortal gods."

Much more grandiose, at the beginning of the *Iliad*, is the image of Apollo approaching with his bow and tingling arrows, moving like night, a god terrible and pitiless. This description is a piece of literature; it may even have an oriental background, as the arrows of pestilence appear in Hittite as well as in Hebrew tradition.[13] Seen from the perspective of real life there would be, first of all, the plague, the burning pyres, and a seer who says that this has been caused by the mistreatment of a priest. One should not be rash about sanctuaries and priests; this is a rule of "caution" (εὐλάβεια), which is so characteristic of Greek religion. The remedy is to comply with the demand of the priest and to give back Chryseis, and the rest is ritual: purification of the army and sacrifice to Apollo right at Troy

(1, 313–317), sacrifice and daylong dancing with singing of *paian* at Chryse (1, 430–487). "And the god rejoiced in his heart, hearing it," "and far-shooting Apollo sent them a prosperous wind" to return from Chryse to Troy (1, 474, 479).[14] That a god should enjoy music is an idea in accordance with the most sublime Christian speculations; but from where exactly is Apollo to hear the song and to release the wind? He should be at the fringe of the earth with the Ethiopians, if we believe the account of Thetis that comes in between the two sacrificial scenes (1, 423–425). So what is he doing with the hecatombs presented "to him" both at Troy and at Chryse? These are exactly the questions that are not to be asked. "The smell of burnt sacrifice [κνίση] reached heaven, whirling around the smoke": this is the end of the first description of sacrifice (1, 317), an image that is as impressive as it is realistic; but what a host of problems it presents for speculative imagination, and what opportunities for a satirist such as Lucian! Three conflicting localities for the gods—the sky, Mount Olympus, and the abode of the Ethiopians by the *Okeanos*—and what is Apollo to do with smell and smoke at Troy or Chryse while he has dinner in the other place? It is the tactful art of the epic singer that glosses over these problems. The experience of the rising smell and smoke concludes the ceremony of sacrifice: this is an experience familiar to singers and audience, turned into a symbol by poetry, a symbol of connection restored between 'below' and 'above'. At Chryse it is the effect that is felt, as the prosperous event, the smooth return, is interpreted as having been caused by the god. This is enough in a practical world, and it will be close to the real attitude and practice of Greeks at that time.

That some people asked questions about the share of the gods in sacrifice, or rather about the fact that only bones were burnt on the altars while nearly all the meat was consumed by men, is seen in Hesiod's Prometheus story.[15] Homer is skillfully vague about these matters. In the *Odyssey* Poseidon seems to be a full member of the feasting community in Ethiopia (1, 25–26); the *Iliad* is less explicit as to this marginal people (1, 423). Athena alias Mentor arrives at Pylos and evidently gets her share in the meal "of Poseidon" (3, 32–66)—who, incidentally, should still be dining with the Ethiopians

right then—when the big sacrifice for her is prepared by Nestor (3, 418–472), she has left Pylos again. Yet here, for once, it is expressly said that "Athena came to meet the sacred ceremony" (ἱρῶν ἀντιόωσα, 435–436); one might even translate this, "to take her share."[16] Gods may be thought to be present at sacrifice—but the audience should not think too much about it.[17]

The paradox of ritual, if it is seen in anthropomorphic terms, is even more apparent in the two oath sacrifices described in the *Iliad*.[18] In the third book the duel of Menelaos and Paris is prepared by solemn oaths. The Trojans are to present two sheep, one white, one black, "for Earth and Sun," the Greeks one "for Zeus" (3, 103–106). For the ceremony wine is distributed; Agamemnon takes the lead, cuts hair from the victims' heads, speaks the solemn oath in the form of a prayer to Zeus, and slices the throats of all the sheep, while the others pour wine from their goblets and join in prayer. Then Priam, who has been present too, withdraws, not forgetting to take the sheep—the two of his, probably—with himself to Troy, evidently to be used in the kitchen (3, 268–312). So what is their relation to "Earth and Sun" for whom they were to be offered? One might say that Earth has received the blood, but Helios? Again, these are questions that should not be asked. Ceremony is ceremony, and things are just done this way—at least in the plain of Troy.

In the nineteenth book Agamemnon takes an oath not to have touched Briseis. The herald brings a boar, Agamemnon cuts hair from the victim's head, speaks his oath to Zeus while turning his eyes to the sky, and cuts the throat of the victim, which is hurled into the sea by the herald (19, 250–268). There is no mention of any deity here "for whom" the animal is slaughtered. It is just the irreversible act of killing that marks the new beginning. The poet is able to turn realistic imagery into symbol even here: the corpse is hurled "into the big gulf of the grey sea, whirling around, a prey for fish" (267–268); as it disappears, the *menis* should be buried likewise in the depths of the sea.

The ritual that is least explicable in anthropomorphic terms is libation.[19] Liquids, and especially wine, are poured right on the ground, "for the gods": *cui bono*? Nonetheless it is one of the most common and widespread rituals in the Near East and in Greece,

and it especially accompanies prayer, as in the first oath ceremony just mentioned. The most memorable use of this ritual is made by the poet of the *Iliad* when Achilles is about to send Patroclus to battle (16, 220–253): Achilles takes a special goblet from a coffer in his tent, cleans it, washes his hands, and draws wine into the goblet. Then he takes his stand in the midst of his court and pours out the wine while looking up to the sky—and Zeus takes notice of him. It is a great prayer to Pelasgian Zeus of Dodona that Achilles speaks, asking for victory and the safe return of Patroclus. Only the first part, however, is granted by Zeus. The poet does not forget to tell us that the goblet is carefully put back into its coffer. The contact evidently is with Zeus high up in the sky, yet it is the circumstantial dealings with the precious cup that make the encounter a ceremony. Wine flowing to the ground, hands lifted to the sky: this is the experience and the image of prayer. Thus ritual enters the narrative as a decisive element to mark the noble and heroic life. This is why sacrifice is included in the "typical scenes of Homer":[20] as the formulas follow each other, ceremonial actions take place in the order and fashion that ought to be, as befits that noble race immortalized by epic song.

In a similar situation the *Odyssey* has a scene of prayer that has proved to be confusing to historians of religion. When Penelope learns about the risky journey undertaken by Telemachus and the suitors' plot to kill him, she first bursts into tears and complaints. Then, calming down, she washes and dresses in clean clothes, and goes to the upper story, together with her maids. She takes barley corn in a basket and prays to Athena for the safe return of Telemachus; she ends with an inarticulate and shrieking cry (ὀλολυγή, 4, 759–767). Both the basket with barley corn and the cry have their proper place in sanguinary sacrifice, but their use in this scene is unparalleled elsewhere. So scholars spoke either of an "abbreviation of sacrifice" or of an otherwise unknown ritual of vegetarian offering, possibly an invention of the poet, if not due to the incompetence of the "redactor."[21] I think there is another, perhaps surprising, explanation for the peculiarities of this scene.

In *Gilgamesh* it is related how, when Gilgamesh together with Enkidu is leaving to fight Humbaba, his mother "Ninsun enters

her chamber, she takes a . . . (special herb), she puts on a garment as befits her body, she puts on an ornament as befits her breast . . . she sprinkles water from a bowl on earth and dust. She went up the stairs, mounted the upper story, she climbed the roof, to Shamash (the Sun God) she offered incense, she brought the offering and raised her hands before Shamash." Thus she prays, full of distress and sorrow, for a safe return of her son (III ii 1–21).[22] The situation of a mother praying for an adventurous son is not a special one. Yet in its details the scene from the *Odyssey* is much closer to the *Gilgamesh* text than to the comparable scene of Achilles' prayer in the *Iliad*; in fact, it comes close to being a translation of *Gilgamesh*. Whereas the ritual is peculiar in the *Odyssey*, none of these peculiarities is found in the passage of *Gilgamesh*. Burning incense on the roof is a well-known Semitic practice,[23] and it is especially appropriate when turning to the sun god. Ceremonial prayer in the women's upper story is otherwise unheard of in Greece. It seems the poet knew that burning incense was out of place in the heroic world, so he took as a substitute the female part in normal sacrifice: *oulochytai* and *ololyge*. Homeric scholars will have difficulties accepting such a perspective. Suffice it to state that even the use of religious ritual as an effective motif within epic narrative has its antecedent in the oriental tradition.

Divine Images in the World of Epic

The problem of anthropomorphism has always been connected with the problem of idols. The Christian invectives especially concentrate both on the immoral conduct of the gods and on the absurdity of venerating manmade objects of wood and metal.[24] The question of Homer's relation to the use of cult images is of special interest since we know that a new situation was emerging in the eighth century with the definite installation of temples and cult images. There was an older and special tradition in Cyprus and Crete, but the findings of archaeology show again and again that many cults and temples began in the eighth century B.C. and persisted.[25] The oldest Greek temple with cult images actually found still seems to be the

temple of Dreros, Crete, dating to the end of the eighth century.[26] At this time the art of fabricating human figures out of metal, wood, or clay was rapidly developing; the problems of which of the surviving figures are to be interpreted as divine and which as human, and of whether they were votives or objects of cult, can just be mentioned here. Let us also note in passing that the existence of permanent temples was to create a new problem for speculative anthropomorphism as to the whereabouts of gods: the gods now had to do a lot of traveling between Mount Olympus, the sky, and their local temples. Curiously enough the *Hymn to Demeter* has Demeter residing in her new temple at Eleusis exactly when she is angry with the other gods, and leaving Eleusis for Olympus when she is reconciled.[27]

There is no doubt that temples are found in Homer. The word νηός seems to be well established in the epic dialect. It is strange, though, that the prayer of Chryses to Apollo in the *Iliad*, "If ever I have roofed a temple for you," seems to imply that he has done so repeatedly, possibly as often as he has burned sacrifice, which he also mentions (1, 39–40);[28] this might refer to a hut constructed again and again for the festival. Besides this case there are two temples at Troy mentioned in the *Iliad*; the temple of Athena, to which I shall return; and a temple of Apollo where Aeneas is cured (5, 446) and where Hector hopes to hang up looted weapons (7, 83). In the *Odyssey* it is especially in the city of the Phaeacians—the idealized colonial town, as has been said—where the founder, together with walls and houses, has established the "temples of the gods" (6, 10). Apollo, though, has his "grove" at Ithaca (20, 277–278).

It is more interesting that twice a goddess is said in the *Odyssey* to return to "her" sanctuary: Aphrodite, after the scandal with Ares, withdraws to Paphos "where she has a temenos and a fragrant altar" (8, 363); Athena, from Scheria, leaves for Athens and "enters the solid house of Erechtheus" (7, 81). It is evident in both cases that realities of cult are in the background. The temple of Paphos is well documented by excavation; it had been in existence since the twelfth century B.C. Some form of common temple for Erechtheus and Athena must have existed on the Acropolis of Athens by the epoch of the *Odyssey*,

and probably the "old image" had been set up by then. Now, as to Paphos, we know that Aphrodite was represented in that temple by a stone, which has survived;[29] so in this case there is absolute incongruity between Homer's imagination and the real image, even if the singer knows about the sanctuary's existence. Things are more complicated with the Athenian Acropolis. In fact the poet of the *Odyssey* seems to know more details about the local cult: the lamp carried by Athena in a famous and controversial scene (19, 34) seems to come right from the Athenian temple, as Rudolf Pfeiffer has recognized.[30] Athena is once described as revealing herself in her "real" form, in epiphany (13, 288–289): "a beautiful and big woman, fit for wondrous (textile) works." This however is hardly what the image at Athens can have been like; it was characterized by a bowl, an owl, and in all probability by a helmet as well.[31] So the imagination of the poet seems to owe nothing to looking at a cult image. Compare the epiphany of Hermes in both *Iliad* (24, 347–348) and *Odyssey* (10, 278–279): a handsome young man, with the first traces of a beard. From all we know, Archaic Hermes statues must have been quite different. Yet Homer gives the picture that was finally to prevail in Greek art from the fifth century on.[32] The conclusion seems to be that there is more influence from Homer's text on Classical Greek art than from early images on the text of Homer.

This calls for some remarks on the notorious problem of the epithets βοῶπις πότνια Ἥρη and γλαυκῶπις Ἀθήνη.[33] I think this problem has become more complicated than ever, since it is no longer possible to refer to some nebulous "origin," now that so many centuries before Homer are archaeologically well documented. The old hypothesis that *cow-faced* and *owl-faced* should refer to some "originally" zoomorphic conception of the respective goddess does not find much support in the iconography of the Bronze Age and Early Iron Age. On the other hand, the formula Ἥρη Ἀργείη seems only to make sense from the middle of the eighth century onward, from what we know about the development of the Argive Heraion. We are left with the dilemma of some very old, even pre-Mycenaean derivation[34] or some relatively recent construct. I do not pretend to solve the age-old puzzle.

Mention must still be made of a most intriguing case of divine images, the gods Aeneas takes with him at his escape from Troy. It is true that the earliest testimonies for this act of *pius Aeneas* are in Hellanicus (4 F 31) and Lycophron (1262–1263); there is also an Etruscan scarab of about 490 B.C.[35] It is still highly probable that the tradition goes back to the oldest stratum of the Aeneas legend, to the epic *kyklos*, even before Stesichorus. It definitely is not a ubiquitous motif; it has not become attached to any of the other Trojan or Greek emigrants who went west. In fact this is a use of *gods* that has hardly a parallel anywhere in the Greek evidence: movable gods, to be carried into exile in a coffer. We know colonists used to take ἀφιδρύματα from their metropolis, but these are tokens of a different kind.[36] There are three directions in which to look for explanation: (1) some Anatolian custom among the descendants of Aeneas;[37] (2) some oriental motif (the *Teraphim* of the Old Testament, family gods that appear in novelistic contexts, to be stolen, or hidden under a skirt, have been compared);[38] or (3) the old situation just before the installation of cult images in temples, when small statues, ancestral or imported, must have existed in Greece and been kept and venerated in chieftains' houses as household or family gods.[39]

The real problem that remains is the temple and statue of Athena at Troy. Three epic texts have to be taken into consideration: the sixth book of the *Iliad*; the abduction of the Palladion by Odysseus and Diomedes as contained in the "Little Iliad" (p. 107,7 Allen); and the rape of Kassandra at the *xoanon* of Athena by Ajax the Locrian according to the *Iliou Persis* (p. 108,2–6 Allen).[40] In addition there is the fact that the Greek city of Ilion did have a central temple of Athena, who was indeed the city goddess. I do not propose to disentangle the complex web of myths and rituals in this case. It is startling to see that the para-Homeric tradition, the tales from the *kyklos*, has become much more important for the Greeks than the text of the *Iliad*; they have both become integrated into the realities of cult. The crime of Ajax, culminating as it does in sexual and religious transgression, looms large in Archaic imagery and literature, and it is connected with that strange ritual of the Locrians who had to offer girls to the temple at Ilion.[41] The Palladion was claimed to

be in the possession of Athens, Argos, and Rome, among others.[42] The two stories evidently deal with different images of Athena, though one may ultimately have evolved from the other. It is more relevant in our context to note that in the story of the Palladion we find the divine image in a role that is uncommon in Greece: it does not represent the deity as being accessible in her temple, but ensures, by its very presence, the existence of the polis through magical effect. Such an image should rather be hidden and not shown to anybody, as later elaborations about Palladia have it. Here again, as in the case of the gods of Aeneas, it is possible to embark on considerations about a non-Greek or else a very early tradition that comes to the surface, earlier than the regular establishment of temples and cult images of the eighth century B.C.

It is different with the famous scene in the sixth book of the *Iliad*. The ritual described there must have looked familiar to the normal hearer or reader even in later centuries. A *peplos* is to be presented to the goddess as an extra gift; there is the queen together with the elderly ladies of the city to form the procession; there is the temple and the priestess appointed by the polis; key and temple door; and of course a statue on whose "knees" the *peplos* is to be laid. One should perhaps not be too realistic—ἐπὶ γούνασι may come in as a formula—and one should be reminded that the offering of clothes has a much more primitive antecedent in hanging textiles from sacred trees. But still this is the most vivid picture of normal Greek cult to be found in Homer, with temple, statue, and priest; the Panathenaeic procession of course comes to mind. Without indulging in Homeric analysis,[43] it may be stated that the function of this scene is in fact to make the transition from the Diomedes book (Book 5) to that most touching piece of Homer's, Hector and Andromache. Both pieces may well have had their own prehistory in oral epic, so that the need to connect them only came in with the monumental composer, who chose to motivate one by the other through the supplication to Athena. This might indicate that this scene belongs only to the final stage of the text as we have it, and is an especially elaborate case of using ritual to create impressive narrative, to bring to life the situation at Troy and the people with their fears and their fate. What is most striking is that the whole of the

cultic effort is discarded as futile in the end: "And Athena said no" (6, 311). The pompous and expensive apparatus of ritual may just be for nothing. This attitude of enlightened skepticism, if we dare to use such a word with regard to so early an epoch, seems well to match the ironic structure of the whole poem, which contrasts the labors of humans with the easy ways of humane yet light-living gods. Let us call it the mark of Homer.

NOTES

1. For Homeric bibliography, see David W. Packard and Tania Meyers, *A Bibliography of Homeric Scholarship, 1930–1970* (Malibu, 1974); Alfred Heubeck, *Die homerische Frage* (Darmstadt, 1974). On Homeric gods, the basic work has been Carl Friedrich von Nägelsbach, *Homerische Theologie*, 3d ed. (Nürnberg, 1884); most inspiring is Walter F. Otto, *Die Götter Griechenlands* (Frankfurt, 1929), trans. Moses Hadas, *The Homeric Gods* (New York, 1954); see also Wolfgang Kullmann, *Das Wirken der Götter in der Ilias* (Berlin, 1956); Emily Townsend Vermeule, *Götterkult, ArchHom*, 3,5 (Göttingen, 1974); Walter Bröcker, *Theologie der Ilias* (Frankfurt, 1975); Hartmut Erbse, *Untersuchungen zur Funktion der Götter im homerischen Epos* (Berlin, 1986).

2. See Oskar Dreyer, *Untersuchungen zum Begriff des Gottgeziemenden in der Antike* (Hildesheim, 1970), 20–24.

3. Otto 1929.

4. See Walter Burkert, "Götterspiel und Götterburleske in altorientalischen und griechischen Mythen," *EranJb* 51 (1982), 335–367, especially 354–355. On peculiarities of Books 14 and 15 (*Berückungsdichter* in the terminology of Willy Theiler, *Untersuchungen zur antiken Literatur* [Berlin, 1970], 24–26), see Albrecht Dihle, *Homer-Probleme* (Opladen, 1970), 83–92; Walter Burkert, "Die orientalisierende Epoche in der griechischen Religion und Literatur," in *SBHeid* (Heidelberg, 1984), 87–92.

5. See Burkert 1982, 355–356.

6. *Iliad*, 15, 17–24; see Katerina Synodinou, "The Threats of Physical Abuse of Hera by Zeus in the *Iliad*," *WS* 100 (1987), 13–22. The "whip of Zeus" (*Iliad*, 12, 37) may be a traditional expression, which was to have a remarkable offspring (Ger. *Gottesgeissel*, Fr. *fléau*).

7. The cuneiform text was published by Wilfred G. Lambert and Simon B. Parker, *Enuma Eliš* (Oxford, 1966); the translation given here is more literal than the most readily available translation by Ephraim A. Speiser in James B. Pritchard (ed.), *Ancient Near Eastern Texts*, 3d ed. (Princeton, 1969), 61.

8. For the reading of the text, based on Lambert and Parker 1967, see Wolfram von Soden, *Akkadisches Handwörterbuch*, 3 vols. (Wiesbaden, 1965–1981), vol. 2, 644; Burkert 1982, 341.

9. See Burkert 1984, 92–95.

10. See Burkert 1984, and on the assembly of the gods, 108; Richard J. Clifford, *The Cosmic Mountain in Canaan and the Old Testament* (Cambridge, Mass., 1972); C. Bonnet, "Typhon et Baal Saphon," in E. Lipiński (ed.), *Phoenicia and the East Mediterranean in the First Millennium B.C.*, Studia Phoenicia, 5 (Leuven, 1987), 101–143.

11. On the "ironic" structure of the *Iliad*, see especially Karl Reinhardt, "Das Parisurteil," in *Tradition und Geist: Gesammelte Essays zur Dichtung* (Munich, 1960), 16–36. On the difference between *Iliad* and *Odyssey*, see Alfred Heubeck, *Der Odyssee-Dichter*

und die Ilias (Erlangen, 1954), 72–87; Walter Burkert, "Das Lied von Ares und Aphrodite," RhM n. 103 (1960), 130–144.

12. See Edward Kadletz, "The Sacrifice of Eumaeus the Pig Herder," GRBS 25 (1984), 99–105; A. Petropoulou, "The Sacrifice of Eumaeus Reconsidered," GRBS 28 (1987), 135–149, with references to earlier literature.

13. For the Luwian god Jarri (Lord of the Bow), with an arrow used in apotropaic ritual, see Gerhard Steiner, Review of M. K. Schretter, Alter Orient und Hellas, Welt des Orients 9 (1978), 341–342. Job 6:4, "the arrows of the Lord are in me," has been understood to mean a kind of plague; hence Saint Sebastian, pierced by arrows, became a helper against plague.

14. See Robert Parker, Miasma: Pollution and Purification in Early Greek Religion (Oxford, 1983), 209–210.

15. See Karl Meuli, "Griechische Opferbräuche," in Gesammelte Schriften (Basel, 1975), 907–1021.

16. Compare Eust. 1475, 60–1476, 5.

17. Compare Odyssey, 19, 42, Odysseus to Telemachus, when Athena is present with a shining lamp: "Be silent, hold down your perception, do not ask."

18. See Walter Burkert, Greek Religion Archaic and Classical (Oxford, 1985), 250–254.

19. See Burkert, Structure and History in Greek Mythology and Ritual (Berkeley, 1979), 41–43; 1985, 70–73.

20. Walter Arend, Die typischen Szenen bei Homer (Berlin, 1933, rpt. 1975), 64–78.

21. A kind of vegetarian offering: Ludwig Deubner, Kleine Schriften zur klassischen Altertumskunde (Königstein, 1982), 625 (cf. Schol. 761 and Eust.). Invented by the poet: Stephanie West, in Alfred Heubeck, Stephanie West, and J. B. Hainsworth, A Commentary on Homer's Odyssey, 1 (Oxford, 1988), 240. "Ohne jede Analogie," according to Meuli 1975, 994, 1, who attributes it to "B" (the redactor) as Kirchhoff had done. Ulrich von Wilamowitz-Moellendorff, Die Heimkehr des Odysseus (Berlin, 1927), 129–130, would leave the passage to the "Dichter der Telemachie." Another prayer of Penelope, with vows, is described in Odyssey, 17, 48–51 = 57–60; here the mention of the "upper story" (49) is clearly an interpolation.

22. The translations of Alexander Heidel, The Gilgamesh Epic and Old Testament Parallels (Chicago, 1946), 41, and Speiser (in Pritchard 1969, 81) are supplemented according to the translation of Wolfram von Soden, Das Gilgamesch-Epos (Stuttgart, 1958, new ed. 1982), 38.

23. Compare Jeremiah 44:17–19, and the Greek Adonia; also the Ugaritic Epic of Keret, ii 73–80, in Pritchard 1969, 143.

24. See Valentin Müller, "Kultbild," in RE Supplement, 5 (Stuttgart, 1931), 472–511; Hermann Funke, "Götterbild," in Reallexikon für Antike und Christentum, 11 (Stuttgart, 1981), 659–828.

25. For a survey see Alexander Mazarakis Ainian, "Contribution à l'étude de l'architecture religieuse grecque des âges obscurs," AntCl 54 (1985), 5–48; and Mazarakis Ainian, "Geometric Eretria," AntK 30 (1987), 3–24.

26. For the date of the sphyrelata see Immo Beyer, Die Tempel von Dreros und Prinias A und die Chronologie der kretischen Kunst des 8. und 7. Jh. v. Chr. (Berlin, 1976); Peter Blome, Die figürliche Bildwelt Kretas in der geometrischen und frül archaischen Periode (Mainz, 1982), 10–15; Michèle Daumas in LIMC, 2 (Zürich, 1984), s.v. Apollon, nr. 658.

27. Hymn. Dem. 302–330, 470–486.

28. See Homers Ilias für den Schulgebrauch erklärt, ed. Carl Friedrich Ameis and Carl Hentze, 7th ed. by Paul Cauer, 1,1 (Leipzig, 1913), 4: "eher eine für den Augenblick hergerichtete Wohnstätte des Gottes. . . ."

29. Sophocles Sophocleous, Atlas des représentations chypro-archaiques des divinités (Göteborg, 1985), 7; pl. 1,1; for the results of the excavations, see Franz Georg Maier, "Alt-Paphos auf Cypern," 6. TrWPr (Mainz, 1985), 12–13.

30. Rudolf Pfeiffer, "Die goldene Lampe der Athena," in Ausgewählte Schriften (Munich, 1960), 1–7.

31. J. H. Kroll, "The Ancient Image of Athena Polias," Hesperia Supplement 20 (1982), 5–76.

32. See Paul Zanker, Wandel der Hermesgestalt in der attischen Vasenmalerei (Bonn, 1965).

33. See Lexikon des frühgriechischen Epos 2, s.v., with references; "ursprünglich kuhköpfig," for example in Authenrieths Schulwörterbuch zu den homerischen Gedichten, 12th ed. by Adolf Kaegi (Leipzig, 1915) after Eduard Meyer, Forschungen zur alten Geschichte, 1 (Halle, 1892), 69 with n. 3. The myth of Io seems to point to zoomorphism; see also Walter Burkert, Homo Necans (Berkeley, 1983), 161–168. "Large, full eyes," LSJ—some find this "poetic."

34. Compare Demeter transformed into a horse, Burkert 1979, 127.

35. For the literary evidence see Ludwig Preller and Carl Robert, Die griechische Heldensage, vol. 2.3 of Griechische Mythologie, 4th rev. ed. (Berlin, 1920–1926), 1516–1517, 1520; the scarab is in LIMC, s.v. Aineias, nr. 95. The testimony of Etruscan vase paintings and the relevance of the "Tabula Iliaca" have been questioned by Nicholas M. Horsfall, "The Iconography of Aeneas' Flight: A Practical Detail," AntK 22 (1979), 104–105; Horsfall, "Stesichorus at Bovillae?" JHS 99 (1979), 26–48; and Horsfall, "The Aeneas Legend from Homer to Virgil," in J. N. Bremmer and N. M. Horsfall, Roman Myth and Mythography (London, 1987), 12–24.

36. Compare Heracleides Ponticus Fr. 46; Max. Tyr. 4,5; Louis Robert, Hellenica 13 (Paris, 1965), 120–125.

37. Compare Nicolaus of Damascus, FGrHist, 90 F 52, about "Tottes and Onnes" arriving at Miletus from Phrygia with "sacred objects for the Kabeiroi, hidden in a chest."

38. Old Testament, *Gen.* 31:30–35; *1 Sam.* 19:13–17.

39. Bronze figurines of the oriental "Smiting God" must have been around in the Dark Ages; see most recently Hubert Gallet de Santerre, "Les Statuettes de bronze mycéniennes au type dit du 'dieu Rechef' dans leur contexte égéen," *BCH* 111 (1987), 7–29. Divine statues in private houses in the later evidence: Zeus of Ithome, Paus. 4,33,2; inscription from Chios, Wilhelm Dittenberger (ed.), *Sylloge inscriptionum Graecarum*, 4 vols., 3d rev. ed. (Leipzig, 1915–1924), no. 987; Franciszek Sokolowski (ed.), *Lois sacrées des cités grecques* (Paris, 1969), no. 118; Fritz Graf, *Nordionische Kulte* (Rome, 1985), 32–33, 428–429.

40. Fernand H. Chavannes, *De Palladii raptu*, diss. Univ. Berlin 1891; Preller and Robert 1923, vol. 2.2, 1266–1274. On Libanios *Ref.* 2, see Wolfgang Rösler, "Der Frevel des Aias in der 'Iliupersis'," *ZPE* 69 (1987), 1–8.

41. Fritz Graf, "Die lokrischen Mädchen," *Studi Storico-Religiosi* 2 (1978), 61–79.

42. Walter Burkert, "Buzyge und Palladion," *Zeitschrift für Religions- und Geistesgeschichte* 22 (1970), 356–368.

43. Erich Bethe, *Homer*, 1 (Leipzig, 1914), 225–254; 2 (1929, 2d ed.), 314–318, argued that the image of Athena establishes 630 B.C. as a *terminus post quem* for the *Iliad*. See also Ulrich von Wilamowitz-Moellendorff, *Die Ilias und Homer* (Berlin, 1920), 302–315; Peter von der Mühll, *Kritisches Hypomnema zur Ilias* (Basel, 1952), 110–112, 126–128.

BERNARD KNOX
Center for Hellenic Studies (emeritus)

The Human Figure in Homer

Matthew Arnold pointed out in a famous passage that Homer nowhere attempts to describe Helen's beauty; rather, we apprehend it through the effect it has on the old men who sit on the Trojan wall. But this reticence about the physical appearance of his characters is characteristic of Homer throughout. What did Achilles look like, for example? We are told that he was *pelorios*, huge, that he had a *kharien*, graceful, forehead and face and *aglaa*, shining, limbs; and he himself proclaims that he is handsome, *kalos*, and big, *megas*. But Agamemnon and Ajax too are *pelorios*, Hector and Priam are *megas*, Nireus and Agamemnon are *kalos*, and Hector's head is *kharien*. As for Achilles' limbs, they are "shining" only once, and that in a passage (*Iliad*, 19, 383) where the overwhelming majority of our manuscripts read not γυῖα, limbs, but δῶρα, gifts. How is Achilles different from other heroes? What color were his eyes, for example? This is a question the emperor Tiberius should have put to his scholars instead of asking them "what songs the sirens sang"—a question any well-read schoolboy could have answered. For about the color of Achilles' eyes we are told nothing, though Homer has epithets for both Athena and Hera that describe (in vague terms, it is true) their eyes. Achilles' hair was *xanthe*—whatever that color was, presumably the same color as his horse Xanthos—but so was that of Menelaus and Odysseus. Did he have a beard? Or was he, like Hermes in Book 24 of the *Iliad* (347–348), an ephebe with the first down on his cheeks?

κούρῳ αἰσυμνητῆρι ἐοικώς
πρῶτον ὑπηνήτῃ, τοῦ περ χαριεστάτη ἥβη.

We might presume that he was bearded from the phrase used to describe his chest in Book 1 (189): στήθεσσιν λασίοισι, "his shaggy breast." But the adjective *lasios* is elsewhere applied to the word κῆρ and though a shaggy breast may be normal on a grown man, a shaggy heart would be cause for alarm. In these cases the word obviously means "manly" or "courageous," but it may mean the same thing in Book 1, for ἐν στήθεσιν elsewhere often refers not to the exterior but to the interior, the seat of the passions and of internal debate. So that this line might be telling us not that Achilles has hair on his chest (and indeed why should he be so singled out? Were Agamemnon and Odysseus smooth-chested?) but that his "heart within his manly breast was divided in counsel." In any case, the vase painters of the sixth and fifth centuries seem to have received mixed signals from the Homeric text, for they portray Achilles sometimes as the bearded warrior (as on the Exekias vase showing Achilles and Ajax) but more often as the handsome ephebe (as on the Sosias Painter's picture of Achilles and Patroclus and on the Achilles Painter's name vase). For Achilles, as for the rest of the heroes, Homer offers us no distinctive overall vision of his physical form and figure.

This might be thought a natural corollary of the idea the late, and much lamented, Bruno Snell developed in his *Entdeckung des Geistes*, that Homer's world had no concept

of the human body as a unity, a form. Pointing out that Homer regularly mentions a part of the body where we would refer to the body as a whole—the spear pierces the skin, χρόα (not the body), and sweat flows from the limbs, γυῖα (not the body)—he comes to the conclusion that "the early Greeks did not . . . grasp the body as a unit." "Homeric man," he goes on, "had a body exactly like the later Greeks but he did not know it *qua* body, but merely as the sum total of the limbs."[1] The Homeric word σῶμα, as Aristarchus first pointed out, was used only of the dead body. Snell dismisses δέμας, Aristarchus' candidate for the living body, on the grounds that it is used only as an accusative of respect: "Its use is restricted to a mere handful of expressions."

Homer, then, has, according to Snell, no word for the living body. "Through Homer," he concludes, "we have come to know early European thought in poems of such length that we need not hesitate to draw our conclusion, if necessary, *ex silentio*. If some things do not occur in Homer though our modern mentality would lead us to expect them, we are entitled to assume that he had no knowledge of them."[2]

This was in its time a stimulating and one might even say creative insight, linked as it was to Snell's much more persuasive and important discussion of the Homeric mentality. But like most generalizations about Homer, Milman Parry's among them, it has lost some of its capacity to dazzle over the years. For one thing, the argument from silence is not really applicable here. It is true that we have a great body of material—"poems of such length"—but the sample consists of archaizing artificial language, limited by its exclusion of forms not compatible with its demanding metrical pattern. For another, Homer's description of physical activity—sweat ran from the limbs, the spear pierced the skin—proves only that Homer's language, like all true poetic language, prefers the concrete telling detail to the abstract general concept. Thirdly, buttressing an argument from silence by ruling out an obvious exception—the existence of the word δέμας—on the basis that it occurs only as an accusative of respect would be a high-handed procedure even if the reason given were true. But it is not. δέμας occurs as the direct object of the verb in two places in the *Odyssey*. It is used once when Odysseus' crew is changed into swine by Circe (they had, Homer tells us, "the heads and voice and hair of swine—and the body"):

> οἱ δὲ συῶν μὲν ἔχον κεφαλὰς φωνήν τε τρίχας τε
> καὶ δέμας . . .
> (10, 240–241)

It occurs again when Athena transforms Odysseus from ageing beggar to handsome mature man (she "increased his body and youth"):

> δέμας δ' ὤφελλε καὶ ἥβην
> (16, 174)

And lastly, Snell has overlooked two other Homeric words that, like δέμας, refer to the human body conceived of not as separate parts but as a unit—the words φυή and εἶδος. This is not the place to present a detailed analysis of Homer's use of these words, but a few examples will suffice to demonstrate that Homer was not the mental primitive Snell took him for.

The word δέμας of course is connected with δέμω—*δόμο; its obvious English equivalent is "build," "frame," "structure." For some of its occurrences in Homer the English word *body* imposes itself as inescapable, as for example when first Telemachus at Pylos and later Odysseus, once again master in his own home, strides naked out of the bath: "from the bath he stepped, in body like the immortals":

> ἐκ ῥ' ἀσαμίνθου βῆ δέμας ἀθανάτοισιν ὁμοῖος
> (3, 468 and 23, 163)

More important than this, however, is the fact that δέμας is very often used to express the physical ensemble that is recognizable as a distinct individual. Poseidon, for example (*Iliad*, 13, 45) "takes on the likeness of Calchas, in bodily form," εἰσάμενος Κάλχαντι δέμας, and so Apollo takes on the bodily likeness of Periphas, δέμας Περίφαντι ἐοικὼς (*Iliad*, 17, 323). And when the gods assume human shapes, δέμας is the word used. Apollo and Athena δέμας δ' ἄνδρεσσιν ἐίκτην (21, 285).

The word εἶδος, of course, is one that later served Plato as one of the names for the ideal forms. In Homer it is always used of the human form and seems to mean something very different from Plato's εἶδος: "appearance," "looks." This meaning, the exact opposite of Plato's εἶδος, is clear to see in Hom-

er's description of the beggar Irus in *Odyssey*, 18, 4:

οὐδέ οἱ ἦν ἲς
οὐδὲ βίη, εἶδος δέ μάλα μέγας
ἦν ὁράασθαι

"He had no strength or force, but, in appearance, he was big to look at." Here εἶδος is appearance as opposed to reality. But it is for the most part a complimentary word. Paris, for example, is blessed with καλὸν εἶδος (*Iliad*, 3, 44), and this meaning, "beauty," "comeliness," can be conveyed even without a qualifying adjective such as καλός; elsewhere Paris is εἶδος ἄριστε, "most excellent in appearance." One of the gifts he has received from Aphrodite is εἶδος. "The gifts of Aphrodite," Hector tells him bitterly, "your hair and beauty [δῶρ᾽ Ἀφροδίτης, ἥ τε κόμη τό τε εἶδος] will do you no good when you lie in the dust" (*Iliad*, 3, 54). But εἶδος can also be used in a different context. Dolon, we are told, was evil in appearance, εἶδος μὲν ἔην κακὸς, but he could run fast, ἀλλὰ ποδώκης (*Iliad*, 11, 316). Priam, on the other hand, is "admirable in build and appearance," δέμας καὶ εἶδος ἀγητός (24, 376), and the dream Zeus sends to Agamemnon in Book 2 (58) resembles Nestor in "appearance and size," εἶδός τε μέγεθός τε.

This dream also resembles Nestor in the last of the three words under discussion: φυήν τ᾽. This is a difficult word for which to find an English approximation; its particular field of meaning is best understood from its contexts. In Book 8, of the *Odyssey*, one Laodamas appraises the physique of (the as yet unidentified) Odysseus. "In φυή, he is not to be despised," he says, and goes on to specify for us what φυή means: "in thighs and calves, his two arms above his stout neck and his great strength."

φυήν γε μὲν οὐ κακός ἐστιν,
μηρούς τε κνήμας τε καὶ ἄμφω χεῖρας ὕπερθεν
αὐχένα τε στιβαρὸν μέγα τε σθένος . . .
(*Odyssey*, 8, 134–136)

Here, in the detailed enumeration of the limbs, is Snell's "physical body of a man . . . comprehended not as a unit but as an aggregate," but it is preceded by a word, φυήν, which *does* comprehend the aggregate as a unity. The term φυή here obviously means something like "physical appearance,"

"shape," or "form," as it does in a similar passage in the *Iliad* (3, 208), where Antenor remembers the visit to Troy of Odysseus and Menelaus: ἀμφοτέρων δὲ φυὴν ἐδάην καὶ μήδεα πυκνά, "I came to know their φυή and their cunning schemes." The φυή is defined in the following lines: "when they stood, Menelaus with his broad shoulders was taller than Odysseus . . . but when they were seated Odysseus was the more majestic." And one remembers that in Sophocles' *Oedipus Tyrannus* when Oedipus asks Jocasta, "What did Laius look like?" and gets the answer, "He was tall, his hair just lately sprinkled with white and as for his shape [μορφή] it was just like yours," the word he uses is φύσις—a later form of φυή.

Homer, then, had the vocabulary and the concepts necessary to give us detailed descriptions of individuals in their physical appearance. But he rarely did so. And it is interesting to see where he did.

He does so when the details of appearance and physique are necessary for the development of the action, as in the passage already quoted, where Laodamas assesses Odysseus' qualifications as an athlete—a prologue to Euryalus' challenge and Odysseus' phenomenal discus throw (the first stage in his recognition at the court of Alcinous). And again in the descriptions of Odysseus' physique transformed by Athena from maturity to old age and back again.

Homer can use a telling physical detail to intensify pathos at a climactic moment, as when Menelaus is wounded by the arrow from the bow of Pandaros: "so, Menelaus, your thighs were fouled with blood, your shapely calves and the fine ankles below."

τοῖοί τοι, Μενέλαε, μιάνθην αἵματι μηροὶ
εὐφυέες, κνῆμαί τε ἰδὲ σφυρὰ κάλ᾽ ὑπένερθε
(*Iliad*, 4, 146–147)

So when Hector's corpse is lashed to Achilles' chariot: "as he was dragged, the dust flew up, and on either side his dark hair was spread, and in the dust lay that head that was once so handsome."

ἀμφὶ δὲ χαῖται
κυάνεαι πίτναντο, κάρη δ᾽ ἅπαν ἐ κονίῃσι
κεῖτο πάρος χαρίεν—
(*Iliad*, 22, 401–403)

This is the first mention of the color of Hec-

tor's hair. And the passage as a whole triggers the memory of an earlier passage—the death of Patroclus. Achilles' helmet, struck from Patroclus' head by Apollo himself, rolls in the dust. It had never done so before "but used to guard the head and handsome brow of a god-like man Achilles," κάρη χαρίεν τε μέτωπον, a line followed immediately by a foreshadowing of Hector's death. Zeus allowed Hector to wear it on his head, yet his day of destruction was near.

> τότε δὲ Ζεὺς Ἕκτορι δῶκεν
> ἧ κεφαλῆι φορέειν, σχέδοθεν δέ οἱ ἦεν
> ὄλεθρος
> (*Iliad*, 16, 799–800)

And Homer does give us, once, a full, unforgettable, detailed picture of a human figure. It is that of Thersites, the ugliest man that came to Troy.

> αἴσχιστος δὲ ἀνὴρ ὑπὸ Ἴλιον
> ἦλθε·
> φολκὸς ἔην χωλὸς δ' ἕτερον πόδα · τὼ δέ
> οἱ ὤμω
> κυρτώ, ἐπὶ στῆθος συνοχωκότε · αὐτὰρ
> ὕπερθε
> φοξὸς ἔην κεφαλήν, ψεδνὴ δ' ἐπενήνοθε
> λάχνη
> (*Iliad*, 2, 216–219)

"He was bandy legged, and lame in one foot; his shoulders were rounded out and sunk over his chest. And above them his head came to a point, and on it the stubble was patchy." He looks, as Cedric Whitman pointed out, for all the world like the Karaghiozes of the modern Greek shadow play.

These three examples are enough to show that Homer could, when he wanted to, create vivid, indeed unforgettable, images of the human form. But he used this power very sparingly, for plot development, for creation of pathos at climactic moments, or for caricature. We are left to form our images of heroes ourselves—not even, as in the case of Helen, through the reactions of others, but through the heroes' own actions and, above all, their speech.

NOTES

1. Bruno Snell, *Die Entdeckung des Geistes*. Trans. Thomas Rosenmeyer, *The Discovery of the Mind* (Cambridge, Mass., 1953), 7–8.

2. Snell 1953, ix.

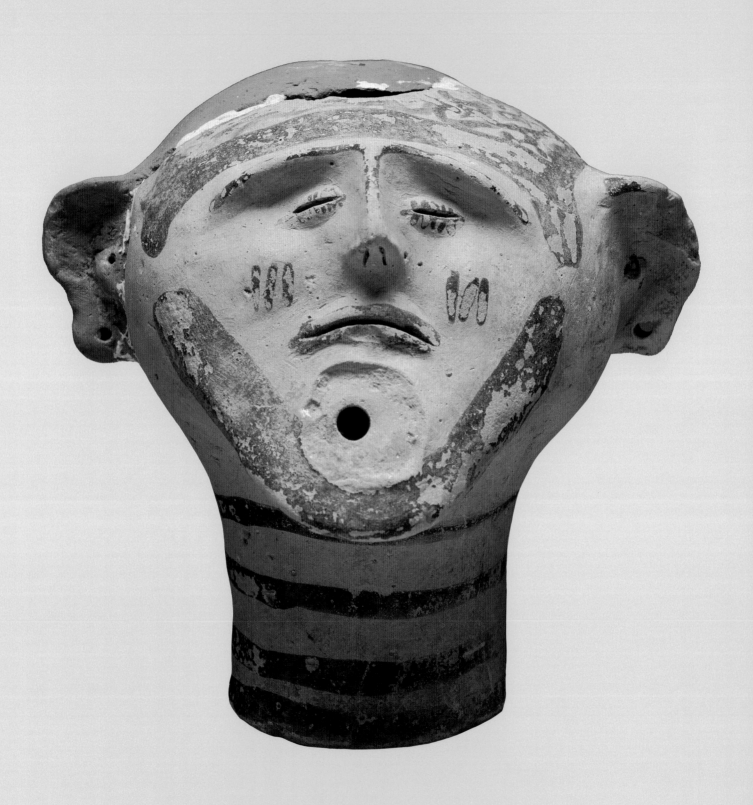

EMILY VERMEULE
Harvard University

Myth and Tradition from Mycenae to Homer

From Mycenae to Homer" seems to imply a voyage. It may be through time, perhaps from the sixteenth century B.C. to the eighth, from the Shaft Graves at Mycenae to the "Monumental Poet" of the final *Iliad*; it may be through space, from the old Argolid to the Ionian coast. This is a standard view of the sequences of history and literature in early Greece, though not one I share fully.

The past two generations of archaeologists have been at extreme pains to discipline themselves from crying aloud, like the nineteenth-century keeper of the British Museum at the Lion Gate at Mycenae, "The very stones of this threshold seem to give back a faint echo of that far-off day when Agamemnon . . ." and so forth.[1] We have tried to keep a strict intellectual distinction between the physical stones of Mycenae and the poetic stones of Homer, and to separate them in date as well as spheres of thought. Yet a more reasonable view may be that, since the body of oral epic we refer to in shorthand as "Homer" was Mycenaean in origin, if not older, and is still Mycenaean in some surviving verses, phrases, names, vocabulary, and interests, Homer *is* the Mycenaean tradition, and the guardian and purveyor of those Mycenaean myths that would be so attractive to the later poets and artists of Greece.

The principal ways in which the Bronze Age could be incorporated into later Greek culture would be through impressive visibility (fortification walls and waterworks, old house and palace remains, tholos tombs, roads and bridges); local survival of families with lore or hereditary religious office in continually maintained sanctuaries; chance or deliberate finds of tombs, especially when they were destined to be involved in hero cult; chance finds of caches of bronze weapons or seals in old habitation contexts; and oral epic preserved both in local series of generational instruction and through traveling singers who knew a poetic version of the histories of several towns or joint expeditions overseas.

To the extent that Archaic and Early Classical Greek culture looked back with curious interest to the heroic, Homeric past and used its towns as stage sets, and its heroes as normative figures for contemporary society, the world we in our innocence call "Mycenaean" was an ever-present backdrop for current religious, political, and historical events. Was it also a backdrop for the new art of the Archaic age? That is a different matter.

Superficially at least, there seems to be no connection between the tradition that informed, say, the best Bronze Age carved ivory figures, and the emergent sculpture of the eighth to sixth centuries. There is comparable discontinuity in architecture and in painting. While the Bronze Age songs survived because the language in which they were expressed survived, and while religious cults and practices survived at least in part because they were attached to places that never lost their inhabitants, the workshop traditions in the arts seem, often, to have died with the econ-

omy that fed them. Under the circumstances it has always seemed remarkable that the old Bronze Age themes and scenes should surface again in the arts of the Geometric world, unless in both periods they were responsive to the themes of poetry. The lion hunt, the warrior between chariot horses (figs. 1, 2), chariot-driving scenes with or without footmen, ships and soldiers, and funeral lamentations are equally popular early and late. Sketches in terracotta of the chariot and team, or the individual rider, male or female (he astride, she often sidesaddle, figs. 3, 4), and the seated, enthroned lady (figs. 5, 6) are also paired across the Dark Age "break."[2]

Even in individual aspects of drawing, like the construction of the profile male figure, there are close analogies between the Bronze Age and the Geometric versions, with long-legged torsos, chests sometimes cut away to render the full outline of the arm against space, the small head and bright reserved eye. The shorthand rendering of profile figures seems to have started in the thirteenth century as an expressive way to stress action and motion without pausing for full detail.[3] Both Bronze Age and Geometric figures seem to have more in common with an ultimately Minoan way of seeing people in motion than with Egyptian, Near Eastern, or Anatolian versions.

It is probably temperamental predisposition as well as individual scholarly interests that divides those who believe in the possi-

bility of continuity from the "heroic" world into the "renaissance" of the Greek eighth and seventh centuries, from those who really prefer the idea of a fresh start for the Greeks after the poverty and restriction of local economies during the Dark Ages. The first group points to the undoubted continuity of language and at least partial continuity of religious ideas and images, as well as some continuity of families, local traditions, and topical memories. The second group points to the distribution of Geometric pottery in Asia Minor, Cyprus, and the east, and undoubted immigration (for the second or third time) in some of those coastal areas, and believes that acquaintance with "oriental" modes of thinking, and of making art, accounts for the new vigor in Greek art as in the Greek economy. They would like the old, barbaric, primitive Bronze Age closed off and done with, to allow a new age of aristocracy-into-democracy to spring into being and progress toward ultimate philosophical and artistic supremacy from uncontaminated roots; while the others believe that if language, Homeric and other epic and lyric poetry, and cult survived, why not the expressive focuses of the artistic image on either side of the gap?

Both "sides" must be right in part. The recent finds from the Idaian Cave in Crete have convinced many that "oriental" (Phoenician, North Syrian) craftsmen were settled in Greece and spreading fashion locally,[4] as well as traders bringing back the alphabet, textiles, and exciting new motifs from Levantine cen-

1. Late Helladic III B:2 bell-krater with warrior between horses, from Pyla-Kokkinokremos in Cyprus, late thirteenth century B.C.
After V. Karageorghis and M. Demas, *Pyla-Kokkinokremos: A Late Thirteenth Century B.C. Fortified Settlement in Cyprus* (Nicosia, 1984), pl. 18.12

2. Late Geometric kantharos with warrior between horses, from the Acropolis of Athens, later eighth century B.C.
First Ephoreia of Prehistoric and Classical Antiquities, Athens; *Human Figure,* 4

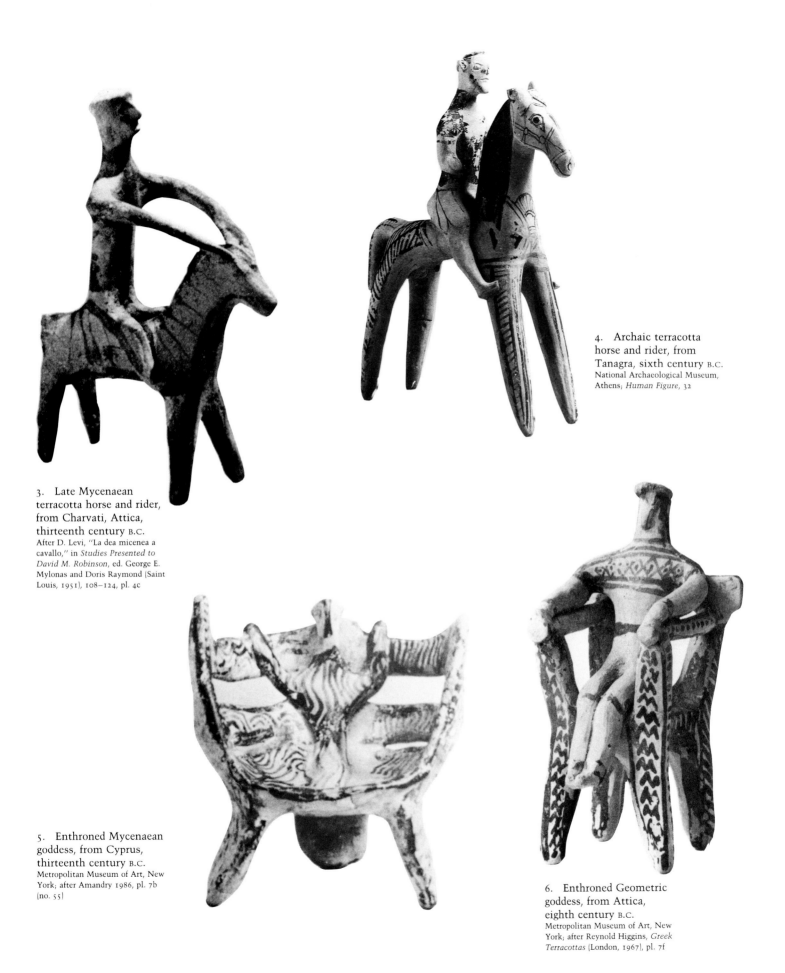

3. Late Mycenaean
terracotta horse and rider,
from Charvati, Attica,
thirteenth century B.C.
After D. Levi, "La dea micenea a
cavallo," in *Studies Presented to
David M. Robinson*, ed. George E.
Mylonas and Doris Raymond (Saint
Louis, 1951), 108–124, pl. 4c

4. Archaic terracotta
horse and rider, from
Tanagra, sixth century B.C.
National Archaeological Museum,
Athens; *Human Figure*, 32

5. Enthroned Mycenaean
goddess, from Cyprus,
thirteenth century B.C.
Metropolitan Museum of Art, New
York; after Amandry 1986, pl. 7b
(no. 55)

6. Enthroned Geometric
goddess, from Attica,
eighth century B.C.
Metropolitan Museum of Art, New
York; after Reynold Higgins, *Greek
Terracottas* (London, 1967), pl. 7f

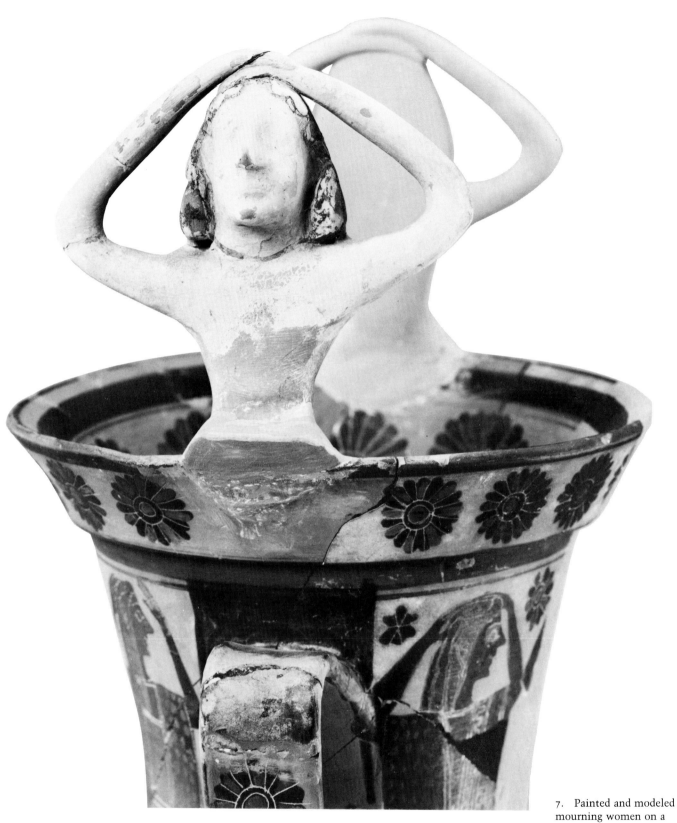

7. Painted and modeled
mourning women on a
loutrophoros by the KX
Painter, early sixth
century B.C.
Kerameikos Museum, Athens;
Human Figure, 33

ters. On the other side, some cultural attitudes evidently restricted the new illustrative powers of the Greeks to subjects that the epic rhapsodes made popular and that their Mycenaean ancestors had illustrated before (perhaps in response to early versions of the same epics); they seldom copied "foreign" compositions for their own sakes.

The sphere in which Bronze Age ideas, translated into art, survive almost without change into the Archaic world, is the sphere of death and mourning. Continuity of gesture and behavior in funerary ritual is familiar and needs little stress. The mourning woman who lifts both hands to the top of her head, or who places one hand there and raises the other in a gesture of farewell, is quite common in the thirteenth and twelfth centuries, and again in the eighth, seventh, and sixth. We can trace it back from the KX Painter's loutrophoros for a girl who died young, the mourning female relative modeled on the rim and painted on the neck (Kerameikos Museum 2865; fig. 7), or a black-robed lady from Boeotia, to a seventh-century bridal-funeral loutrophoros in Boston, the women delicately outlined in formally correct, trained gestures (MFA 24.151; fig. 8),[5] past many Geometric vases where the gesture is ubiquitous, to the common stance on the Tanagra funerary larnakes where the gesture is part of everyday Bronze Age experience (fig. 9),[6] and even to a won-

8. Painted mourning women on a Protoattic loutrophoros-hydria, from Vourva, Attica, late seventh century B.C. Museum of Fine Arts, Boston

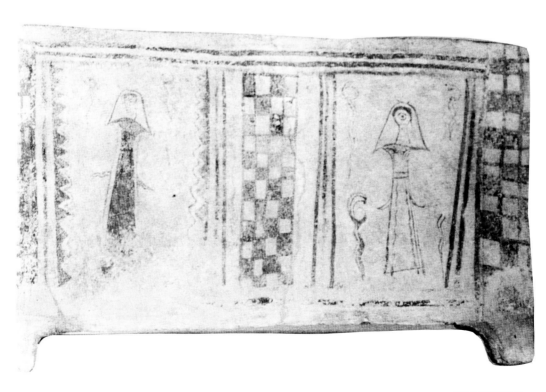

9. Mycenaean painted mourning women on a larnax, from Tanagra
Ludwig Collection; after Berger and Lullies 1979, 17, pl. 2b

derful Minoan coffin with flowery mourning women of the fourteenth century (fig. 10). It may be no accident that this important larnax was found, with other Minoan relics, in an Iron Age tomb whose contents ranged from Protogeometric to early Orientalizing.[7]

The gesture of scratching the cheeks in mourning is even more eloquently made by the mourning woman from Thera, of the late seventh century (Thera Archaeological Museum 392; fig. 11). She has just finished making five bloody scratches on her right cheek (fig. 12), and now pauses, her right hand ready at the top of her left cheek, to start gouging again; the expression is subtle and poignant, as the self-disfiguration halts still incomplete, the mourning unfinished. That gesture also appears on Tanagra larnakes, where drops of blood may flow in rivulets down the cheek (fig. 9), and even before that, perhaps, on the marble faces of Cycladic mourners stippled in red drops or scored with vertical red slashes (National Museum, Copenhagen, 4697; fig. 13).[8] We must respect the stability of ceremonial gesture and ritual behavior at public moments of bereavement and parting, from the Bronze Age to the Age of Solon, and realize that such cultural stability and unbroken tradition in real life may indicate a stable attitude toward ceremonial or funerary art, however many novel experiments were made in the Geometric and Orientalizing periods.

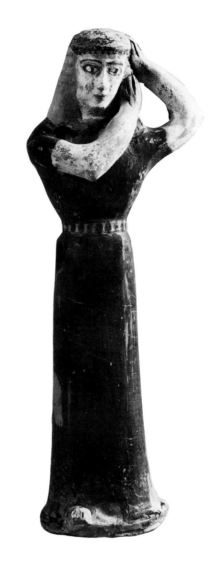

11. Terracotta mourning woman, from Thera, late seventh century B.C.
Thera Archaeological Museum; *Human Figure*, 23

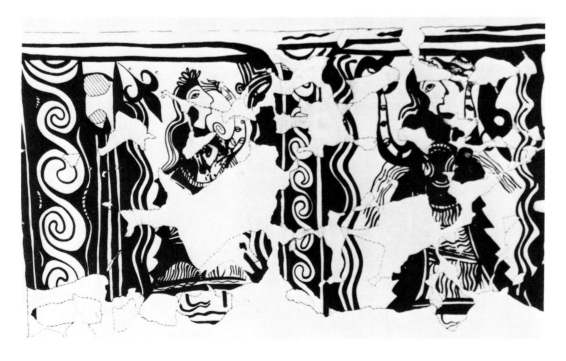

10. Painted mourning women on a Late Minoan III A:1 larnax, from Knossos, in an Iron Age burial
After Morgan 1987, 178, fig. 4, side A

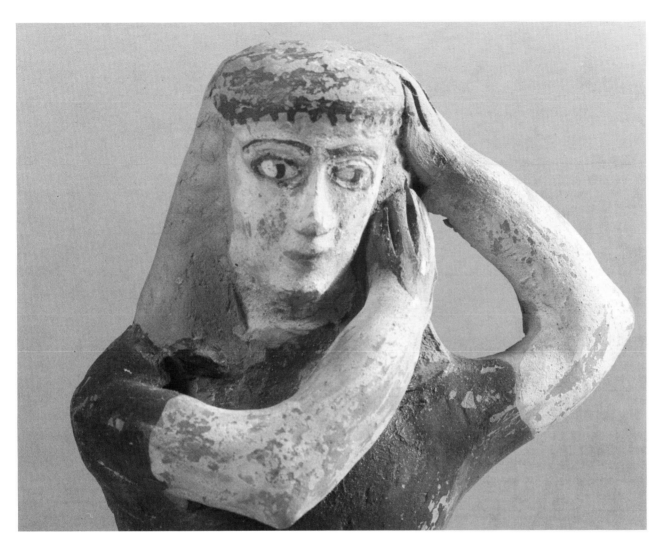

12. Detail of right cheek,
figure 11

13. Head of marble
Cycladic idol with score
marks on cheeks, 2400–
2300 B.C.
National Museum, Copenhagen;
after Thimme 1977, color pl. Va

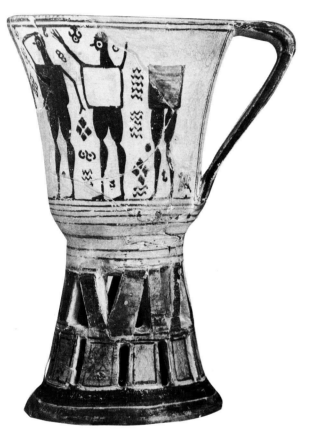

14. Cup on fenestrated base, with painted male mourners and a hero on horseback, seventh century B.C.
Kerameikos Museum, Athens;
Human Figure, 19

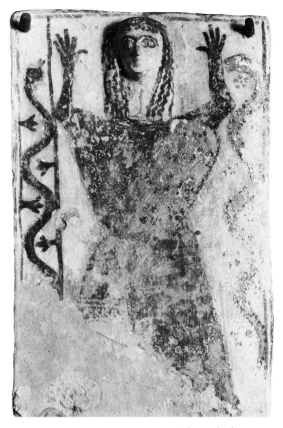

15. Clay polychrome plaque with modeled and painted lady with upraised arms, snakes, and plants, from the Agora at Athens, seventh century B.C.
Burr 1933, figs. 72–73; *Human Figure*, 27

16. Painted Mycenaean rhyton with robed priests and sacred trees, later thirteenth century B.C.
After Vermeule and Karageorghis 1981, IX.15

The gesture of mourning with one or both hands to the top of the head is sometimes combined with a gesture made raising both hands in the air, straight or aslant, like a gesture of blessing or prayer, perhaps combined with farewell (figs. 14–16). A Protoattic cup on a fenestrated foot from the Kerameikos cemetery shows both gestures in a single scene of awed greeting to a hero on horseback (Kerameikos Museum 1153; fig. 14);[9] the mysterious lady with snakes on the plaque from the Agora makes the gesture facing us with authority that may come from special office or ability to interpret the unseen (fig. 15);[10] in the Bronze Age the gesture is more clearly associated with the priests in long robes who stand by sacral trees, seen on a rhyton from Tiryns (fig. 16).[11] These threads of connection appear to run deep in the culture and are not misleading revivals of an oriental nature in the eighth or seventh century.

The same living tradition strikes us in comparing the renowned Early Geometric clay boots, *pedila*, from Athens and from holy Eleusis (fig. 17),[12] where there is such a high proportion of surviving Mycenaean genes, cults, and mental images, with the same idea in Bronze Age Attica, the terracotta boots from graves at Voula and Pikermi (fig. 18).[13] The Geometric boots are imitation leather; the Mycenaean boots imitate twisted, em-

19. Clay model boots, from Kültepe-Kanesh, eighteenth century B.C. After Özgüç 1986, pl. D2

broidered wool. Both express the familiar idea of death as a journey, each person walking his own path, and both endow the wearer with a more than mortal power, as in Alkman's phrase, "Do not try to reach heaven if your strength has no *pedila, apedilos alka.*"[14] How can we tell which is more "Homeric"? For me, it is the well-oiled woolen version of the Bronze Age, the lanolin no doubt being what makes the feet of the wearer glisten shiningly when he puts on his *pedila: possi d'hupo liparoisin edeesato kala pedila* (II.44 +). Bronze Age Attica had been open for a long time to ideas from the east, perhaps particularly Anatolia, where Kültepe offers analogous boot rhyta in its wonderfully inventive rhyton repertory (fig. 19).[15]

Perhaps more amusing—or more serious—than the foot as a container for liquid is the head. In classical times the head-vase, or face-cup, could either be a simple drinking cup or be used in funerary rites. The attractive head from Boeotia (National Archaeological Museum 4073; fig. 20) belongs to the beginning of the fifth century. One supposes that, like most pieces from rich Tanagra, it was found in a tomb, although that in itself does not connect it with the burial rites. The catalogue entry says it was made in imitation of Attic head-vases; the differences are also striking, however, especially the long pointed scarlet bonnet (of a kind worn locally? in imitation of Anatolian pointed caps?) surmounted by a two-handled cup-kantharos, and perhaps the vital, generous expression.[16]

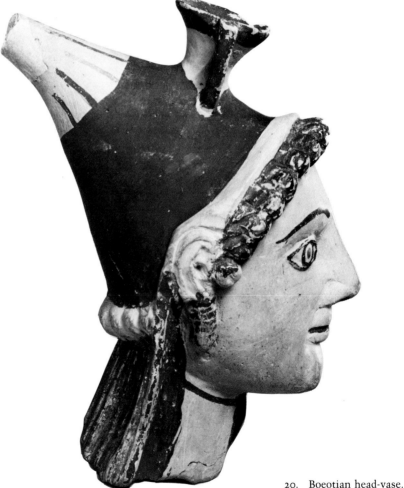

20. Boeotian head-vase, from Tanagra, early fifth century B.C.
National Archaeological Museum, Athens; *Human Figure,* 62

The Attic head-vases, both single and janiform, are used both for drinking, as cups, and for pouring, as oinochoai. Beautiful women are often combined with satyrs or blacks.[17] This may be for color contrast, for indicating two servant social classes, for imagining an incipient story held in perpetual incompletion, or for representing sexual potency and therefore life not death. Many students regard head-vases simply as pleasant conceits and nothing more significant. Perhaps there is on occasion a deeper thought, the idea of the disembodied head as the source of strange and wonderful liquid, miraculous as wine often is, restorative, oracular, transporting the imbiber to another world.[18]

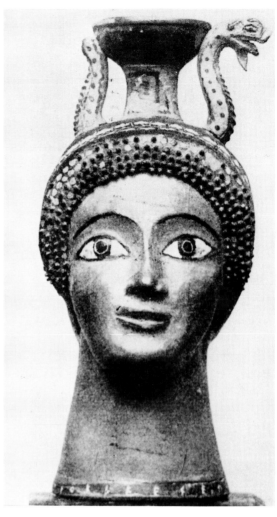

Another Attic head-vase, the vase by Prokles also found at Tanagra, is particularly interesting for the bearded snakes rising up from the crown (Berlin 2203; fig. 21).[19] The serpents are not handles but signposts—a statement, one imagines, about the chthonic and fertility connections of the head, both spheres linked to drink and to death.[20] It is thought-provoking rather than ugly, a fifth-century version of the same association of women, snakes, cult, and liquid that is so marked on seventh-century cult or funerary vessels, such as the Kerameikos jug that has women supporting the rim as though on a *perirrhanterion*, joined by great snakes and a flower (fig. 22).[21] The same linkage is evident

21. Attic head-vase signed by Prokles, from Tanagra, early fifth century B.C.
Staatliche Museen zu Berlin, Antikensammlung; after Pottier 1902, 141, fig. 2

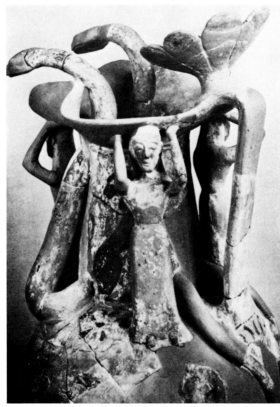

22. Attic mourning ritual vase with modeled and painted women, snakes, flower
After Kubler 1970, pl. 40, no. 149

 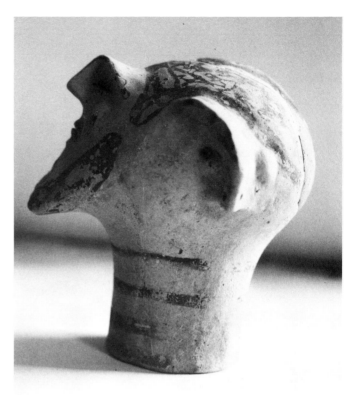

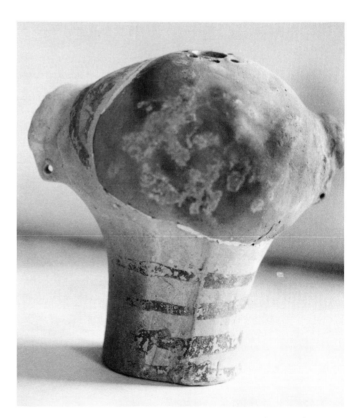

23–27. Aegean rhyton in
the form of a "dead" head,
probably thirteenth
century B.C.
Museum of Fine Arts, Boston

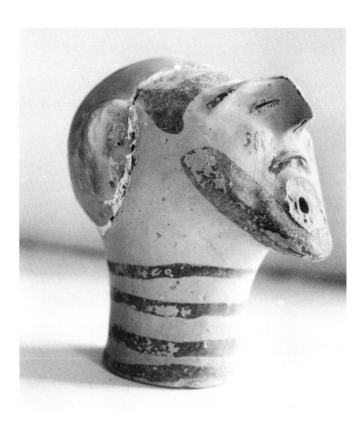

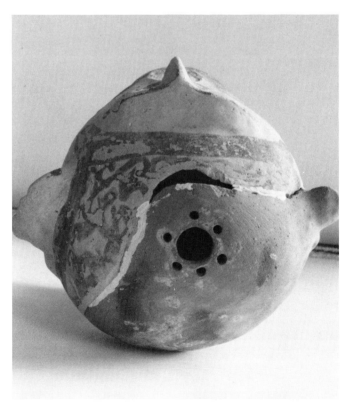

on the famous plaque from the Agora in Athens (fig. 15),[22] where the snakes, the plants, and the lady of authority with raised hands probably have direct links back to the Bronze Age cults of the Acropolis, in which Athena functioned as fertility deity, associated with the holy snake.

In Boston another kind of head, not a cup but a closed rhyton (MFA 1988.153), is male and, apparently, simultaneously dead and mourning (figs. 23–27). It is either Mycenaean or Cypriote, but has no close parallels in either sphere.[23] It is wheelmade, a little bulbous pot on a straight stem, with the features added freehand. The man wore earrings (the holes in the lobes are clear) and has ear-holes, "all the better to hear with," in R. V. Nicholls' words.[24] There is a flatly domed crown; a tremendous, sharp brow ridge jutting almost straight out from the hairline; the eyebrows joined in a continuous arc; a short, straight, thin nose; slashed eyes "closed in death" with straight lashes painted above and below; and downturned lips. There are three vertical gouges on each cheek, recalling the gouges in the cheeks of mourning women. Something broke off the chin, just above the painted beard—perhaps a small cup with a strainer?[25] There is a flat vertical depression down the back of the neck (fig. 26).

The head was broken in antiquity, across the back and the right ear, and a new piece was molded and fired to patch it, in an alien clay (figs. 25–27). The original head is green buff clay with buff slip and matte black paint. The patch is orange clay with black mottling.[26] The patch on the crown of the head has a hole with six smaller holes in a ring around it (fig. 27); if these are necessary to the function of the rhyton, presumably the original head had the same kind of holes.[27] The new right ear was copied from the surviving left ear, and punched for an earring, and there is a swelling behind the ear similar to the original one on the other side.

If the patch is nearly contemporary with the original head, that is, Bronze Age in date, then one might imagine that the head-rhyton traveled in antiquity to a land where the standard clays were different and the Aegean techniques of slip and paint unavailable. That would be analogous to a recorded instance of a "holy object" being sent from an Aegean shrine on the island of Lesbos to the Hittite capital at Boğazköy in the interior of Anato-

lia, to try its efficacy in curing King Mursilis II of an illness.[28] If a miracle-working sacred vase broke abroad, it would be wise to mend it and restore its function. In this case, however, the clay of the patch is not obviously Hittite, although it is not unlike some mottled wares from Tarsus.[29]

If the patch is considerably later than the original head, there is no need for the rhyton to have traveled anywhere. If it was in a shrine, and the shrine was rediscovered in the eighth or seventh century after the Dark Ages, it would have had a history comparable to that of the head of the terracotta female statue in the temple on Kea, rediscovered and set up on a clay ring as Dionysos.[30] The clay is not the kind normally used for fine pottery in the known centers of Greek ceramics, but it could be lamp clay, or pithos clay; perhaps they intended to paint the hair back on?

Almost the first thing one sees is the likeness, in the eyes and brow at least, to the gold and electrum masks from the two Grave Circles at Mycenae (fig. 28).[31] These masks should be part of a funerary tradition already established, concealed from us by a general loss of precious metals earlier than these sixteenth- and fifteenth-century shaft graves, except for the gold and silver eyebands of Crete and the Cyclades. They share with the clay head-rhyton the fine threadlike lashes radiating from the slit compressed lids, the single curved brow, narrow straight nose, and downturned thin mouth. There must be a distance in time between them; the head-rhyton is unlikely to be older than the fourteenth century, and more likely the thirteenth if the four painted rings on the neck connect it to Cypriote heads of that period (although they are very different in structure and are usually complete figures).[32] But it may be possible to trace a stable tradition back at least to the Shaft Graves, and possibly earlier.

The third-millennium Kea pithos fragment with the single arc eyebrows (fig. 29), structurally like the Shaft Graves masks, is not so clearly "dead," since it has round pellet eyeballs.[33] This would be roughly contemporary with the numerous Trojan face-pots; at Troy most are "alive" but there are several that seem to be "dead," with slit eyes, although none have the cheek cicatrices of mourning (fig. 30).[34] Those vertical scorings beneath the closed, slit eyes are perhaps first seen long ago in the fifth millennium, as on a well-known

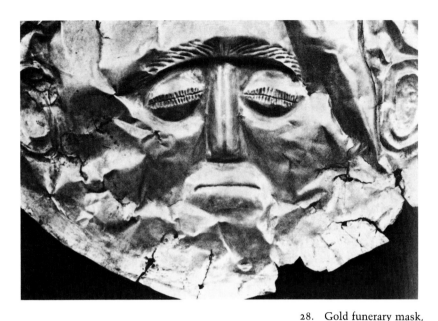

28. Gold funerary mask, detail, from Shaft Grave IV, number 253, Circle A, Mycenae
After G. Karo, *Die Schachtgräber von Mykenai* (Munich, 1930), pl. 47

29. Relief face on pithos, from Kea, Early Bronze Age II or III
After Kopcke 1976, pl. 1.2

Hassuna face-pot from Samarra (fig. 31); one might debate whether they are tear streaks, or even marks of tattooing, rather than mourning scars, but the effect is one of grief, and possibly death.[35] The Anatolian tradition of the "dead" face-pot at Troy may continue to be reflected, in the second millennium, in the male dead-head-rhyton from Kültepe, where the eyes are not shown slit in full closure, but are round, blank, unseeing bulges (fig. 32).[36] That was almost surely a ceremonial rhyton, as the Aegean head must be.

30. "Dead" face-pots from Troy, third millennium B.C.
After Schmidt 1902, nos. 308–309

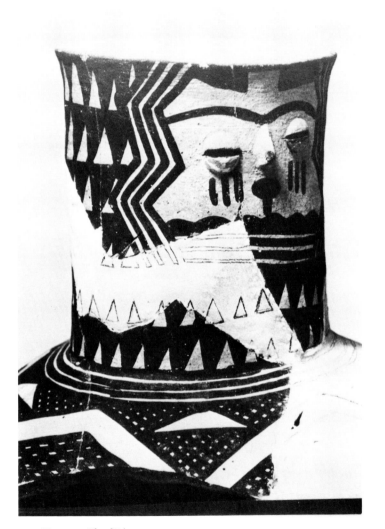

31. Hassuna "dead" (or weeping) face-pot, from Samarra, in Baghdad, fifth millennium B.C.
After Amiet 1977, pl. 21

32. "Dead" face-pot, from Kültepe in central Anatolia, eighteenth century B.C.
After Özgüç 1986, pl. 119

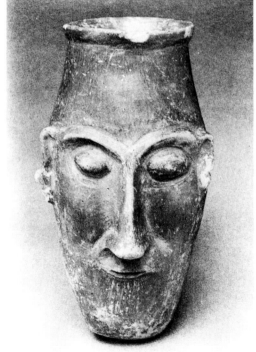

The use of a human dead head in connection with ritual is not entirely unparalleled in the Aegean world. The conical rhyton from Moires in the Mesara Plain of Crete is almost certainly a holy ritual vessel for liquid, and it has a sculpted human face (figs. 33–34); again, the eyes are not shut, but they are not gifted with sight either. It expresses, more than the other rare head-vases, a sense of the solemn sacral use of liquids, and it was probably rescued from a sanctuary context.[37] Other vases have smaller human faces applied to the neck.[38]

Crete has other examples of human head-rhyta, like the famous example from Phaistos, of use unknown, looking slightly comical with its pop eyes and beard protruding like a tongue deep under the chin (fig. 35).[39] The hair on the brow is painted as strong curls, but on the upper cheeks and around the mouth it is painted as quick dashes and drops, and might be drops of blood as easily as whiskers. While it is true that animal-head-rhyta never show emotion or hint at their own function, an exception might have been made for the human head used in a cult context.[40]

There are also true representations of dead heads, as clay death masks; the best comes from Vrokastro, in a Geometric tradition recalling late Bronze Age images (fig. 36),[41] and the idea is similarly expressed in a sanctuary context in the Heraion on Samos in the seventh century (fig. 37).[42] They may not be as functional as the dead faces of the anthropoid coffin lids of the Philistine and Egyptian worlds, with their enigmatic smiles and grimaces (fig. 38, Beth Shean),[43] but they share an ambition to give permanence to the shifting and corruptible face of the departed. These later representations of the physical faces of death stress ceremonial linkage between liquid and death less than the earlier rhyta, but they show us that the theme was one that early Greek coroplasts sometimes urgently wished to express.

The face- or head-vase, which is not a rhyton but is as clearly connected with liquid and memorable style, was also made in Crete both before and after the Dark Ages. The Kannia head is a worn relic of a once beautiful and important construction; the janiform head from Piskokephalo has wide open, star-rayed eyes inside huge eyeballs, eyes that give an impression of vitality and almost masklike power,[44] like some Near Eastern head-vases,

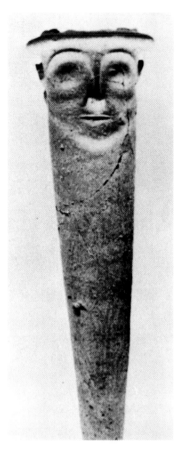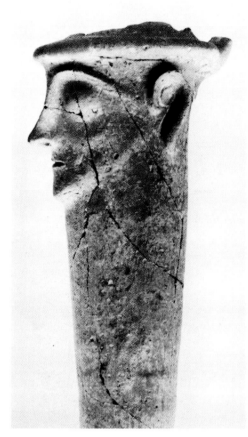

33, 34. Late Minoan III A:1 face-rhyton, from Moires in the Mesara plain
After Lembessi 1977, B, 315, pl. 188

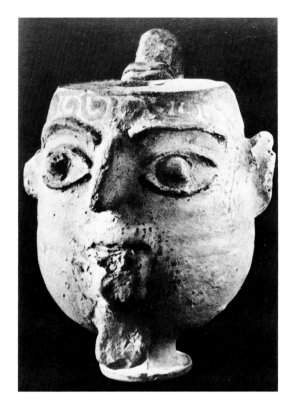

35. Head-rhyton from Phaistos, Crete, Late Minoan III B, thirteenth century B.C.
After Zervos 1956, pl. 750

36. "Dead" face-mask,
from Vrokastro, Crete,
ninth–eighth century B.C.
After Schiering 1964, 13, fig. 15

37. "Dead" face-mask
from the Heraion, Samos
After Schiering 1964, 14, fig. 16

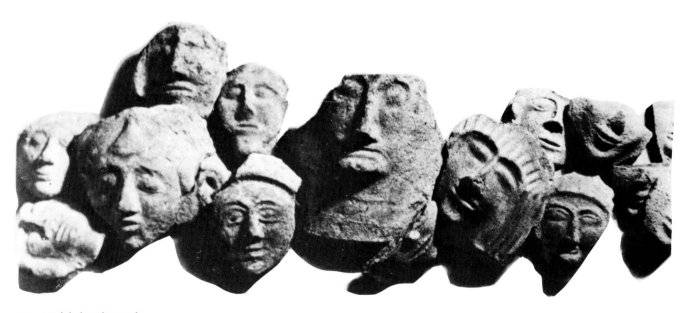

38. Modeled anthropoid
sarcophagus lids with
"dead" faces, from Beth
Shean
After Dothan 1982, 269, pl. 10

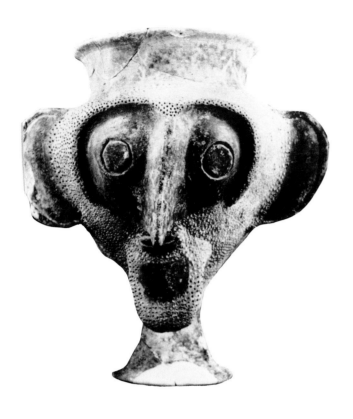

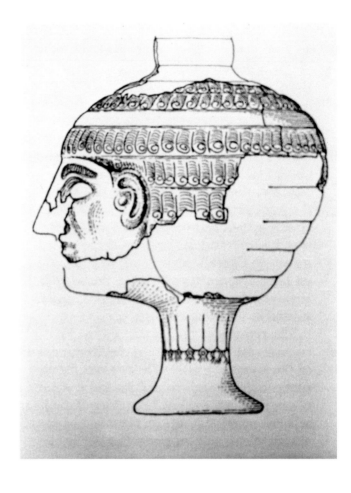

39. Head-vase of the Hyksos period, from Jericho, seventeenth–sixteenth century B.C. After Amiet 1977, pl. 77

40. Bronze head-vase from the Idaian Cave on Crete, ninth century B.C. After Boardman 1961, 81, fig. 35, no. 378

especially the Jericho vase with its "Shaft Grave" eyebrows and "Phaistos" beard (fig. 39).[45] The most impressive of the head-vases in Crete after the Dark Ages is the bronze head from the Idaian Cave (fig. 40),[46] an assurance that the old eastern and Anatolian tradition survived in fine style. Continuity is also evident in the terracotta (mourning?) figure, perhaps from the neck of a vase, apparently splattered about the face with blood droplets (fig. 41).[47] The head as a liquid container, the head as a cup to drink from, the head in grief at death attached to a vase for liquid are part of a tradition that seems unaffected by the cultural break between Minoan and Dorian Crete; with fresh models from the east through Ionia, it comes back strongly into the Classical tradition, often filled with a vitality that may be part of the message, like the East Greek gentleman in Boston colored a rich oriental yellow, smiling enigmatically under his moustache (MFA 98.925; fig. 42).[48]

That the Bronze Age association of the human head and liquid endured into the start

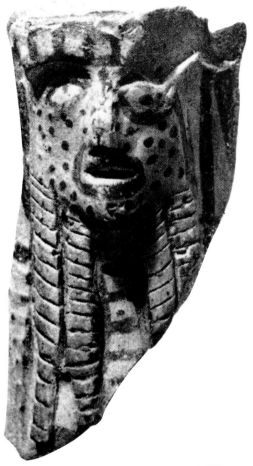

41. Face of a mourning (?) figure from a vase, Crete, seventh century B.C.
After Boardman 1961, pl. 36, no. 475

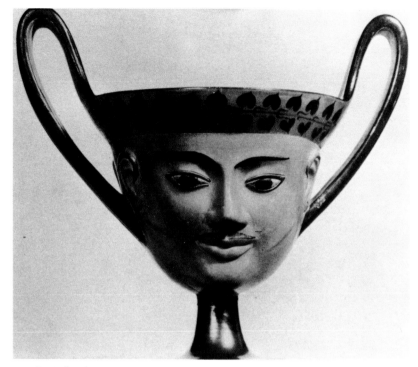

42. Ionic head-vase, about 500 B.C.
Museum of Fine Arts, Boston; after E. Walter-Karydi, *Samos*, vol. 6, pt. 1 (Bonn, 1973), 30, 480b

43. Head-strainer on a Proto White Painted jar from Paphos, Cyprus, eleventh century B.C.
After Maier and Karageorghis 1984, pl. 119

44. Head on a jar from the Granary at Mycenae, late Mycenaean
After Wace 1921–1923, pl. 7c

of the general Dark Ages in a tomb context is again indicated vividly at Paphos in Cyprus, the modeled head functioning as a strainer on the neck of a Proto White Painted jar in an important burial (fig. 43). This links the semblance of the individual head icon with the ceremonial sprinkling at the funeral, probably an act of purification and protection against the miasma of death, as later represented by Greek verbs such as *rhaino, rhantizo*, which refer to blood sprinkled on the earth, or water to cleanse houses and altars after blood has been shed or life taken.[49] This kind of head-strainer does not seem to be known yet on the Greek mainland, but a similar conceit appears on the head-handle of a jug from Mycenae (fig. 44).[50]

The rhyton shares structural features with a number of well-known Mycenaean terracotta figurines as well, like the high brow and nose of the Lady of Phylakopi (rendered in paint),[51] a wheelmade idol from Mycenae,[52] even small and relatively insignificant male heads from Mycenae,[53] the profile of "the Lord of Asine,"[54] or the jutting jaw of the Centaur of Leukandi.[55] For this reason its connections with the Greek mainland artistic tradition, from the Shaft Graves to the thirteenth century B.C., makes it a candidate for connection to the Bronze Age religious tradition, which is slightly better known through shrines and tablets than in Cyprus.

The dead-head-rhyton shows no sign of staining on the inside, as of wine or blood. Its function should have been only purification through the sprinkling of water. One wonders whether sometimes whole idols could be used in the same way—like the idol from the Citadel House sacred area at Mycenae that is punched so full of holes (fig. 45)—to sprinkle and purify holy space or ward off a miasma of disease or threat.[56]

The gouges on the cheek have left no traces of blood, any more than on the Thera figurine, and it is not clear whether other Mycenaean heads that seem to have rivulets of blood on the cheeks are mourning figures; a head from Phylakopi, thought of as female despite its apparent beard, is perhaps the most vivid, with wavy lines (blood?) pouring down on the outer cheeks and beside the nose, as on some Tanagra larnakes (figs. 46, 9).[57] In general, however, the normal Mycenaean figurine is made without reference to emotion or action and is not involved in mourning ritual. A bearded male mourner is at the least unusual, yet it does not seem inherently improbable, given the frequency and intensity of male mourning activity in the poetic tradition at Troy, where heroes weep, cut their hair, and strike themselves, crying aloud the mourning phrases freely.

Some head-vases in Classical times conjoin opposites: the known, like the lovely lady, with the strange or supernatural, like the satyr or the black, those who come from beyond the familiar boundaries. A fourth-century Etruscan example in Boston has a noble bearded warrior's head on one side, and a riddling "oriental" grotesque, almost a nonperson, on the other—a permanent pairing of opposites who can never join, an enduring spir-

45. Clay idol with pierced holes, from the sacred area of the Shrine at Mycenae, thirteenth century B.C.
After Taylour 1969, pl. 13b

46. Terracotta head with painted blood rivulets (?), from Phylakopi on Melos, thirteenth century B.C.
After French 1985, fig. 6.5

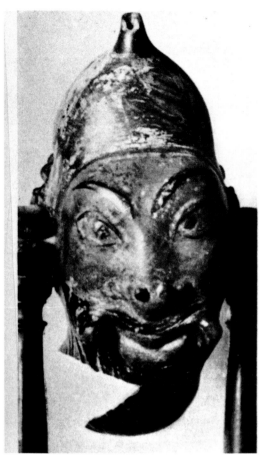

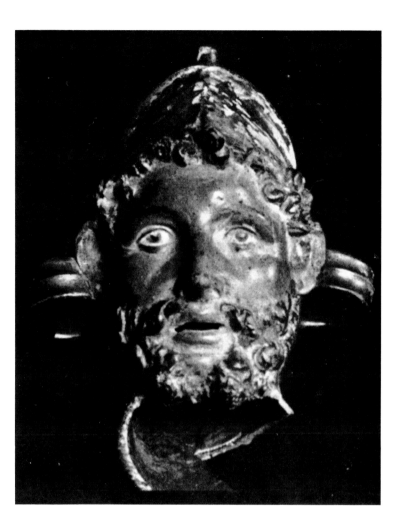

47. Etruscan double head-
vase of an "oriental" and
a helmeted hero, fourth
century B.C.
Museum of Fine Arts, Boston; after
Beazley 1947, pl. 40.7–40.8

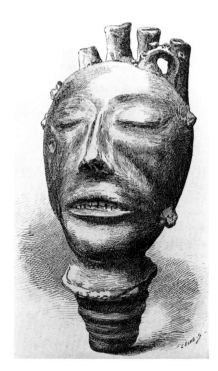

itual puzzle (MFA 03.795; fig. 47).[58] The head
that is at once dead and in a state of ritual
grief for the dead is another expression of the
spiritually impossible, an endless self-perpet-
uating cycle of motion between death and
mourning. Yet the dead head is a head of
power, of communication with the dead and
with the supernatural forces, as in the case of
Orpheus, or even the famous *caput* for which
the Roman Capitolium was thought to be
named.[59] If the dead head could speak, reveal
the future and the past, cleanse through liq-
uid, and mourn, might it not also make
music? That perhaps was the function of the
last dead head discussed here, a strange con-
coction in the Ecole Evangélique at Smyrna,
said to be from Rhodes, perhaps from the
eighth century.[60] With eyes closed in death,
mouth parted in a rictus showing the teeth,
and pipes sprouting from the crown, it seems
like the headpiece for a bagpipe, which should
have made mournful music indeed (fig. 48).

48. "Dead head"
(bagpipes?) from Rhodes,
eighth century B.C. (?)
After Perrot and Chipiez 1894, 808,
fig. 377

NOTES

I wish to thank Jane Carter, Rita Freed, Sarah Morris, Peter Neve, R. V. Nicholls, Wolfgang Schiering, Iannis Tzedakis, and Florence Wolsky for their help with this investigation. A brief account of the Boston rhyton was sent to Dr. Vassos Karageorghis for the *Report of the Department of Antiquities of Cyprus* (1988), 1, 299–300, pl. 39.

1. Charles Newton, *Essays on Art and Archaeology* (London, 1880), 256.

2. Pyla-Kokkinokremos in Cyprus (fig. 1); First Ephoreia of Prehistoric and Classical Antiquities, ERK 630 (fig. 2); National Archaeological Museum 4017 (fig. 4); Cesnola Collection 2018, MMA 74.51.1711 (fig. 5); MMA 31.11.8 (fig. 6). Recent discussions with attention to theories of derivation: Peter Kranz, "Frühe griechische Sitzfiguren: Zum Problem der Typenbildung und des orientalischen Einflusses in der frühen griechischen Rundplastik," *AM* 87 (1972), 1–55; Pierre Amandry, "Sièges mycéniens tripodes et trépied pythique," in *Philia Epee for George E. Mylonas* (Athens, 1986), 167–184.

3. Emily Vermeule, "The Corinth Chariot Krater and Some Relatives," in *Corinthiaca: Studies in Honor of Darrell A. Amyx,* ed. Mario A. del Chiaro (New York, 1986), 81–87.

4. *JHS, AR* (1984–1985); *AR* (1986–1987), 57–58; compare Jane Burr Carter, "The Masks of Ortheia," *AJA* 91 (1987), 380; on Phoenicians in Attica, see Coldstream, *Geometric Greece,* 80.

5. Museum of Fine Arts, Boston, 24.151.

6. Ernst Berger and Reinhard Lullies (eds.), *Antike Kunstwerke aus der Sammlung Ludwig,* 1 (Basel, 1979), 16–19; Vermeule 1986, 201–205.

7. L. Morgan, "A Minoan Larnax from Knossos," *BSA* 82 (1987), 171–189 (KMF Cemetery Tomb 107), fig. 4, side A; Late Minoan III A:1.

8. For example, the head by the Goulandris Master in Copenhagen, National Museum 4697, from Amorgos? Jürgen Thimme, *Art and Culture of the Cyclades* (Karlsruhe, 1977), 203, color pl. V a.

9. National Gallery 19; Kerameikos 1153; K. Kubler, *Kerameikos,* 6, 2 (Berlin, 1970), pl. 7.

10. Agora T 175; National Gallery 27; Dorothy Burr, "A Geometric House and a Proto-attic Votive Deposit," *Hesperia* 2 (1933), figs. 72–73.

11. Emily Vermeule and V. Karageorghis, *Mycenaean Pictorial Vase-Painting* (Cambridge, 1981), IX.15.

12. R. S. Young, "An Early Geometric Grave near the Athenian Agora," *Hesperia* 18 (1949), 275–297, pls. 70–71.

13. As in H.-G. Buchholz and V. Karageorghis, *Prehistoric Greece and Cyprus* (London and New York, 1973), pl. 1248 f, the Voula boot; F. H. Stubbings, "The Mycenaean Pottery of Attica," *BSA* 42 (1947), 55, fig. 24, the Pikermi boot.

14. Alkman's *Partheneion* 1, 15.

15. T. Özgüç, *Kültepe-Kaniş,* 2 (Ankara, 1986), pls. 119.4, D.2, ceremonial without necessarily being funerary; compare F. Fischer, *Die hethitische Keramik von Boğazköy* (Berlin, 1963), pl. 131.1238–1243.

16. Semni Papaspyridi-Karouzou, "Documents du Musée National d'Athènes," *BCH* 61 (1937), 361–362, fig. 8, pls. 27:1, 27:3; *Human Figure,* no. 62.

17. Why blacks? Some traditional explanations are collected in William Biers, "Some Thoughts on the Origins of the Attic Head Vase," in Warren Moon (ed.), *Ancient Greek Art and Iconography* (Madison, 1983), 121. It may simply imitate the traditional Egyptian pairing of Nubian/Ethiopian and Syrian, as representing ethnically the quarters of the world owing tribute to pharaoh.

18. Compare Margot Schmidt, "Ein neues Zeugnis zum Mythos vom Orpheushaupt," *AntK* 15 (1972), 128–137.

19. Berlin 2203; E. Pottier, "Epilykos," *MonPiot,* 9 (1902), 141, figs. 2 a and b; Enrico Paribeni, "Prokles," *EAA,* vol. 6, 484, fig. 550; *ARV*², 1933, "Miserable."

20. Michael Padgett pointed out the likeness of the snakes to the poros bearded snakes of the Athenian Acropolis, as in Theodor Wiegand, *Die Archaische Poros-Architektur der Acropolis zu Athen* (Cassel, 1904), 74, fig. 82 a.

21. Karl Kubler, *Kerameikos,* 6, 2 (Berlin, 1970), pls. 38–42. Some of the funerary bowls and stands have lotus buds on the rim, pls. 46, 54–57, 71; and several have mourning women, pls. 93, 94; as on gaming boards, pl. 102; the connection of mourning and fertility seems assured.

22. Burr 1933, 604–609.

23. Museum of Fine Arts, Boston, 1988.153, Frank B. Bemis Fund. Height, 0.135 m; depth beard to crown, 0.15 m.

24. R. V. Nicholls, "Greek Votive Statuettes and Religious Continuity, c. 1200–700 B.C.," in *Auckland Classical Essays Presented to E. M. Blaiklock,* ed. B. F. Harris (Auckland and Oxford, 1970), 4 and n. 26.

25. About the size of strainers attached to Cycladic ritual strainer jugs with snakes, as in A. Maiuri, *ASAtene* 6–7 (1923–1924), figs. 44, 59.

26. Reminiscent of third-millennium Cretan Vasilike ware, but obviously later.

27. Is it possible that a thin leather thong was laced through these holes before the patch was put in place, with loops long enough to serve as a handle to swing it by? There are no signs of incense having been burned inside.

28. H. G. Güterbock, "The Hittites and the Aegean World: The Ahhiyawa Problem Reconsidered," *AJA* 87 (1983), 134 (=KUB 5.6 ii 57, 60); M. J. Mellink, 140.

29. Hetty Goldman, *Tarsus II* (Princeton, 1956), 197, no. 1051, pl. 308, or 217, no. 1225.

30. Miriam Caskey, "Ayia Irini, Kea: The Terracotta Statues and the Cult in the Temple," in Robin Hägg and Nanno Marinatos (eds.), *Sanctuaries and Cults in the Aegean Bronze Age* (Stockholm, 1981), 127–135, fig. 7.

31. Grave IV, number 253. Compare Emily Vermeule, *The Art of the Shaft Graves at Mycenae* (Cincinnati, 1975), 11, figs. 8–10; G. Kopcke, "Zum Stil der Schachtgräbermasken," *AM* 91 (1976), 1–13, with analogies to the Early Cycladic pithos face from Keos, pl. 1.2 (here, fig. 29).

32. Compare J.-C. Courtois, *Alasia*, 3 (Paris, 1984), fig. 24.

33. Kopcke 1976; J. L. Caskey, "Investigations in Keos, Part II: A Conspectus of the Pottery," *Hesperia* 41 (1972), 375, pl. 81; Early Bronze Age II or III?

34. H. Schmidt, *Heinrich Schliemann's Sammlung Trojanischer Altertümer* (Berlin, 1902), nos. 308, 309, 318, 1037; compare C. Schuchhardt, *Schliemann's Excavations* (London, 1891), 72, fig. 72; Carl W. Blegen, John L. Caskey, and Marion Rawson, *Troy*, 2, 2 (Princeton, 1951), pl. 61, no. 33.214 (Troy III). A face-pot from Boğazköy seems more like the Kea pithos, Winifred Lamb, "Face-Urns and Kindred Types in Anatolia," *BSA* 46 (1951), 78, fig. 3 a; compare F. Fischer, *Die hethitische Keramik von Boğazköy* (Berlin, 1963), pl. 129.1214.

35. P. Amiet, *Art of the Ancient Near East* (New York, 1977), pl. 21, in Baghdad.

36. T. Özgüç, *Kültepe-Kaniş*, 2 (Ankara, 1986), 69, no. 10: "The most important trait of this rhyton is that it represents the face of a dead person"; pl. 119.3, pl. F 4 color.

37. A. Lembessi, *ArchDelt*, 32 (1977) B, 315, pl. 188, Late Minoan III B.

38. The rhyton from Karphi in Herakleion, W. Schiering, "Masken am Hals Kretisch-Mykenischer und frühgriechischer Tongefässe," *JdI* 79 (1964), 4, fig. 5.

39. L. Pernier, L. Banti, *Il Palazzo Minoico di Festós* II (Rome, 1951), 510, color illus.; C. Zervos, *L'Art de la Crète* (Paris, 1956), pl. 750; S. Marinatos and M. Hirmer, *Crete and Mycenae* (New York, 1959), fig. 133; G. Gesell, *Town, Palace and House Cult in Minoan Crete* (Göteborg, 1985), 52.

40. For the issue of sacral or domestic, as determined by context, see R. Koehl, "The Functions of Aegean Bronze Age Rhyta," in Hägg and Marinatos 1981, 179–188.

41. Schiering 1964, 1–16; 13, fig. 15 a, b.

42. Schiering 1964, 14, fig. 16; the fertility notion of a human head-vase (with phallos) also at Samos, E. Buschor, "Spendekanne aus Samos," *BSA* 46 (1951), 33–41, pl. 8.

43. T. Dothan, *The Philistines and Their Material Culture* (Jerusalem, 1982), 269, pl. 10, after F. W. James, "Beth Shan," *Expedition* 3 (1961), 34.

44. Gesell 1985, pls. 173 (Kannia), 55 a, b (Piskokephalo).

45. Head-vase of the Hyksos period from Jericho, Amiet 1977, pl. 77.

46. John Boardman, *The Cretan Collection at Oxford* (Oxford, 1961), 81, fig. 35, no. 378.

47. Boardman 1961, pl. 36, no. 475.

48. Museum of Fine Arts, Boston 98.925; *ARV²*, 1529.1.

49. F. G. Maier and V. Karageorghis, *Paphos: History and Archaeology* (Nicosia, 1984), 140, pl. 119 (Tomb 45/53); compare *Odyssey* 20.150.

50. A. J. B. Wace, *BSA* 25 (1921–1923), pl. 7 c; from the south corridor of the Granary; compare H. Schliemann, *Mycenae and Tiryns* (New York, 1880), 69, no. 81.

51. E. French, "Mycenaean Figures and Figurines," in Hägg and Marinatos 1981, 175, fig. 4; C. Renfrew, *The Archaeology of Cult: The Sanctuary at Phylakopi*, *BSA* suppl. vol. 18 (London, 1985), pl. 32 c, d.

52. French 1981, 176, fig. 7.

53. M. Meyer, "Mykenische Beiträge," *JdI* 7 (1892), 195, figs. 2–3.

54. Otto Frödin and Axel Persson, *Asine* (Stockholm, 1938), 308–310.

55. V. R. Desborough, R. V. Nicholls, and Mervyn Popham, "A Euboean Centaur," *BSA* 65 (1970), 21–30; *Human Figure*, no. 1.

56. W. D. Taylour, "Mycenae, 1968," *Antiquity* 43 (1969), pl. XIII b; 92: "All the larger figures have holes in the crown of the head. . . . Many of the same figures have small holes about the chin, on the neck, under the arms, and even on the back of the arms." (He speculates, for firing, or adornment?)

57. E. French, in Colin Renfrew, *The Archaeology of Cult* (London, 1985), 216, fig. 6.5 (SF 2672), pl. 34 b; "It has now become clear that a heavily modeled or painted chin is not an indication of a beard."

58. Museum of Fine Arts, Boston 03.795; J. D. Beazley, *Etruscan Vase-Painting* (Oxford, 1947), 189, the Bruschi Group, pl. 40.7–8; the Munich Charun must be in the same vein, pl. 40.1–2.

59. Schmidt 1972, pls. 39, 41; S. B. Platner and T. Ashby, *A Topographical Dictionary of Ancient Rome* (London, 1929), 96.

60. G. Perrot and Ch. Chipiez, *L'Histoire de l'art dans l'antiquité*, 6 (Paris, 1894), 808, fig. 377.

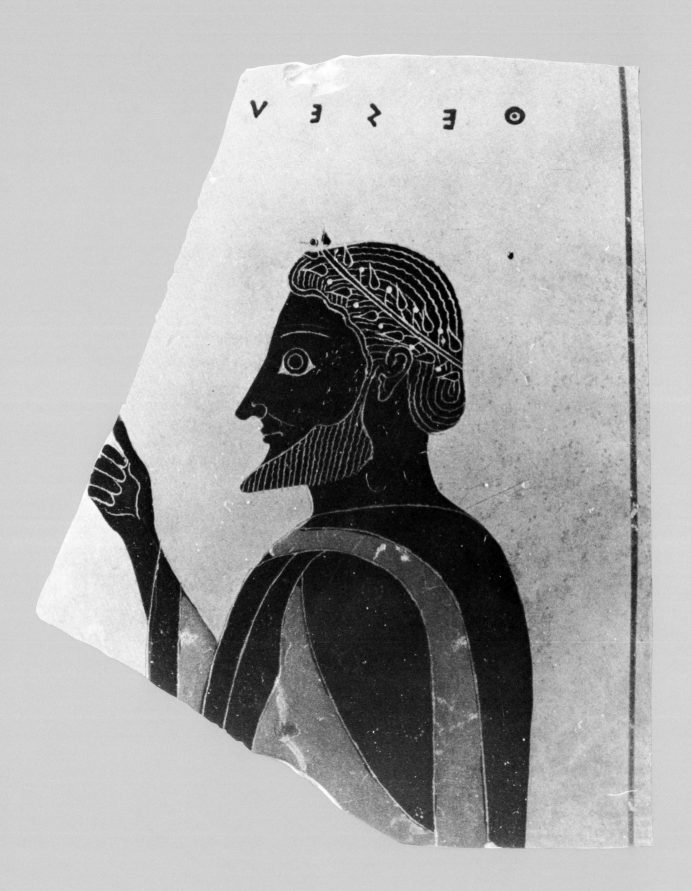

H. A. SHAPIRO
Stevens Institute of Technology

Theseus: Aspects of the Hero in Archaic Greece

Several papers in this volume deal with the heroes of Homeric epic, so I will focus instead on one hero who interested the Ionian Homer little but rather came into his own in Athens of the sixth century: Theseus. My initial inspiration for this paper was the good news that the exhibition around which a symposium and this volume were organized would include the most splendid representation of Theseus in all of Greek art—the one from the west pediment of the Temple of Apollo at Eretria (fig. 11).[1] I shall have more to say about this remarkable monument, but first, a few words on Greek heroes in poetry and art of the Late Archaic period and on what, in my view, makes Theseus special among them.

Most Greek heroes are associated preeminently with a single deed or adventure, or a cycle of adventures: Perseus the gorgonslayer, Jason and his quest for the Golden Fleece, and so on. Of the Homeric heroes, only Odysseus is still interesting after the war ends (and later Aeneas, to the Romans). Even Herakles, the most talked about, most worshiped, most widely traveled, and most painted and sculpted of Greek heroes, is oddly lacking in one key ingredient of human life: change. After a few juvenile incidents— strangling snakes as a baby, murdering his music teacher as a boy—Herakles always seems more or less the same as he moves through his hundreds of deeds, labors, and *parerga*. He is a mature but youthful man in his prime, even at his death on Mount Oita. It is barely possible to sort out the mass of

his adventures into a chronological sequence, but we sense that the Greeks did not much care to do so, since for them Herakles was always the same. Sadly, he often repeats his mistakes and never seems to learn from them, and the melodramatic circumstances of his death, as formulated perhaps first by Sophokles, suggest that he certainly hadn't learned anything about women.

But Theseus is different. The successive stages of his life form a steady progression: from the boy in Troizen, finding the tokens of his paternity and making his perilous way to Athens, to the young prince leading his fellow Athenians to Krete to find adventure and love; from the young man, together with his comrade Perithoös, braving centaurs, Amazons, and other women at home, at the ends of the earth, or beyond (in Hades), to the wise king of Athens, who gave refuge to exiles like Oidipous, Admetos, and Herakles. Theseus' life story is in fact so complete and so varied that it approximates that of a real person in a way that no other hero's life does. It was probably this that encouraged Plutarch to undertake a continuous biography of Theseus, trying, as he says, "to purify fable and make her submit to reason, and take on the appearance of history" (*Theseus* 1).[2]

Among the many aspects of this rich and eventful life I would like to explore only one in the space allotted to me, what I would like to call Theseus as love-hero. I borrow the expression from the literary critic and classicist Charles Beye, who used it in a seminal

1. Cretan oinochoe with Theseus and Ariadne (?), from Arkades
Archaeological Museum, Herakleion; *Human Figure*, 20

article some twenty years ago to describe the character of Jason in Apollonios' *Argonautika*, as the model of the new Hellenistic hero, who conquers with good looks and sexual appeal, rather than by valor or force of arms.[3] Theseus, I shall argue, is a kind of Archaic love-hero, with occasionally striking parallels to the later Jason.

The meager references to Theseus in Archaic poetry suggest that he was perhaps most famous for his inability to resist the temptations of a beautiful girl. The Athenian tyrant Peisistratos was accused of trying to mitigate Theseus' notoriety by excising from the text of Hesiod an unflattering mention of Theseus' mad passion for one Aigle, daughter of Panopeus, for whom he abandoned Ariadne.[4] A century later the Athenians tried an even more daring whitewash, claiming that Athena herself had caused Theseus to desert Ariadne, to return to his royal duties in Athens.[5] Stesichoros knew the story of Theseus' abduction of Helen and apparently told it (and other stories about Helen) so indiscreetly that he then had to write his famous *Palinode*, or retraction.[6] The passing reference to Theseus and Perithoös in the Underworld at *Odyssey*, 11, 631 may allude to the two heroes' abortive attempt to seduce Persephone.[7] Elsewhere in the *nekyia*, Theseus' affair with Ariadne is mentioned briefly in the catalogue of hero-

ines (11, 321–325), with the odd variant that Ariadne was slain by Artemis' arrow not long after leaving Krete, on the island of Dia.

Seventh-century artists may have imagined Theseus in this amorous light as well, if indeed the ardent young suitor on a jug from Arkades represents one of our earliest depictions of him (fig. 1).[8] If the object of his affections here is Ariadne, as the Kretan provenance suggests, then I would like to think of this scene as a forerunner of one some fifty years later that gives us our first certain representation of both Ariadne and Theseus.

The topmost frieze of the François Vase presents a subject unique in Greek art and still not satisfactorily understood (figs. 2–3).[9] The ingredients are clear enough, most identified by inscription: from left to right, an Athenian ship with its crew, the fourteen Athenian youths and maidens sent as tribute to King Minos, with Theseus as their leader, and, lastly, Ariadne with her nurse. Discussion has centered on the locale: whether this is the Geranos, or Crane Dance, on Delos, in honor of Apollo (Plutarch, *Theseus* 21.2), or a victory dance on Krete, just after the slaying of the minotaur. Friis Johansen, in 1945, devoted an entire monograph to the problem, and despite its title, *Thésée et la danse à Délos*, this is in fact the most convincing case for a Kretan setting.[10] Beazley, in his *Development of Attic Black Figure*, accepted Johansen's conclusions despite certain difficulties.[11] The normally sensible Beazley was led into one of his rare acts of desperation, in positing that the ship that carried the young Athenians to Krete had gone off somewhere else for a while, then returned expecting the worst, and instead pulled in just in time to witness the victory celebration on the shore—hence the apparent air of spontaneous jubilation in the gestures of the crew. The case for Delos was revived most vigorously by Erika Simon,[12] but it too has drawbacks—notably, the presence of Ariadne and her nurse, who had been abandoned by this point on Naxos.[13]

I should like to offer a somewhat idiosyncratic reading of the scene, even if space does not permit detailed argumentation. It shows, I believe, the arrival of Theseus and the Athenians on Krete and the first meeting of Theseus and Ariadne.[14] The ship has beached, and the crew, nervous and excited rather than elated, stay behind as the victims of the min-

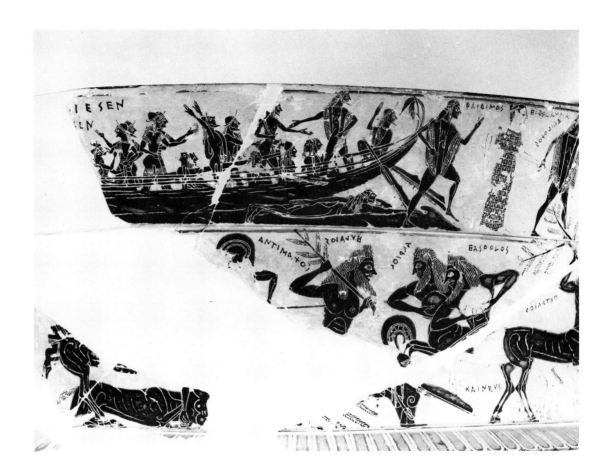

2. Detail of the François
Vase with Athenian ship
Museo Archeologico, Florence;
photograph: Soprintendenza alle
Antichità d'Etruria

3. Detail of the François
Vase with Athenian
youths and maidens and
Theseus and Ariadne
After FR, pl. 13

4. Attic black-figure
fragment with dancing
Nereids by Kleitias
National Archaeological Museum,
Athens; photograph: DAI, Athens

5. Attic black-figure
fragment with Athenian
youth and maiden
National Archaeological Museum,
Athens; photograph: DAI, Athens

otaur disembark (the last, Phaidimos, just hopping out), with Theseus at their head, to be greeted by the Princess Ariadne. The line of alternating maidens and youths resembles neither the winding dance said by some sources to simulate the twists and turns of the labyrinth nor the movement of cranes.[15] They line up to fill the long skinny frieze, but the boys slowly walk while the girls do not appear to be in motion at all. We may compare the same painter's dancing Nereids on a fragmentary vase from the Akropolis (fig. 4),[16] with arms and legs in vigorous, rhythmic movement. Or compare other Akropolis fragments by Kleitias, thought to depict the same subject as the François Vase (fig. 5).[17] The two figures really clutch each other—hardly a dance pose. If these young Athenians, just arrived in a strange land and facing certain death in the labyrinth, hold hands, is that any wonder?

But what of Theseus and his prominently displayed lyre, usually thought to mark him as *choregos*? The instrument, I believe, is simply his attribute, sign of the well-bred, καλὸς κἀγαθός prince. No sensible hero would take a lyre with him to fight a Minotaur, yet in other scenes, inside the labyrinth, we see Theseus' lyre, held for him perhaps by Ariadne, on a hydria in Copenhagen,[18] or by Athena, on the famous Little Master cup in Munich signed by Archikles and Glaukytes (fig. 6).[19] Nikolaos Himmelmann, puzzled by the lyre's presence here, called it proleptic, a reference to the coming victory celebration,[20]

but I don't believe Archaic painters thought this way. Rather, the lyre is simply part of Theseus' iconography, like the distinctive garments or hairstyles he wears in certain periods, and like these it goes everywhere with him.[21]

The lyre has a particular function in this scene, as I shall suggest, but more generally it provides an iconographical link to the god whom Theseus most resembles, Apollo. Bacchylides' Dithyramb 18 begins with these words addressed to Theseus' father Aegeus:

Βασιλεῦ τᾶν ἱερᾶν Ἀθανᾶν,
 τῶν ἁβροβίων ἄναξ|ὠνῶν

King of our holy Athens, lord of luxurious Ionians.[22]

The same words could invoke Apollo, ancestor and patron of the Ionians, who was *patroös* in Athens,[23] or later, Theseus himself as king of Athens. In Apollo's hands the lyre stands for νόμος, in all the meanings of that word.[24] So too for Theseus, whose many achievements, wrote Plutarch, included instituting the first democracy in Athens.

On the François Vase, the real power of the lyre is demonstrated, if my reading is correct. For in this first encounter with Ariadne, the lyre, just like the elaborately embroidered cloak (which I will discuss further, below), enhances the hero's irresistible beauty and charm, his χάρις, to which she falls victim. The motif is standard in Greek myth: foreign princess meets Greek hero, is instantly smitten, and will risk anything for him, even be-

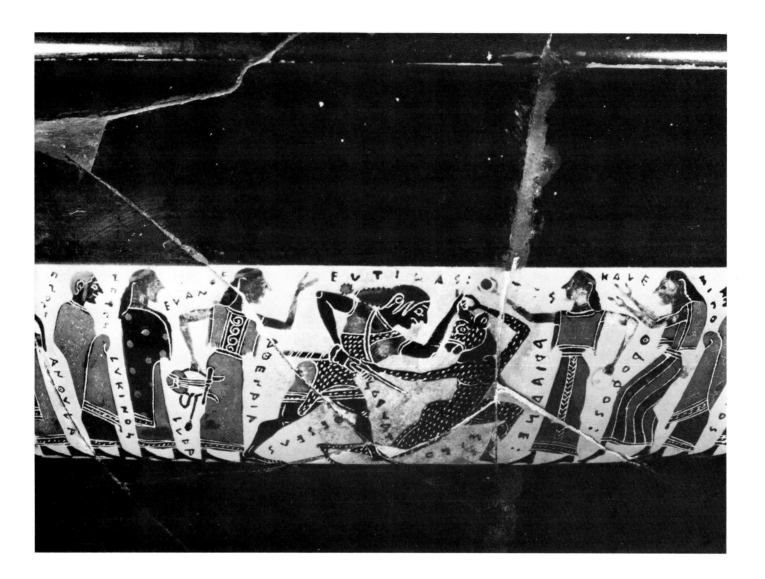

6. Attic black-figure cup
with Theseus and the
minotaur, by Archikles
and Glaukytes
Staatliche Antikensammlungen
und Glyptothek, Munich

traying her father (hence the ball of yarn in
Ariadne's hand).[25] The first parallel that
springs to mind is Jason in Colchis, thanks to
Apollonios' vivid portrait of the love-struck
Medea in Book 3 of the *Argonautika*, a work
of surpassing empathy.

Extant sources do not recount the first
meeting of Theseus and Ariadne, but it must
have been a famous set piece in story and
song, lost to us but known, I believe, to Klei-
tias. The roughly contemporary artist of the
Chest of Kypselos perhaps had it in mind, in
a panel showing Theseus and Ariadne, he
holding a lyre, she a wreath (Pausanias
5.19.1). Plutarch records, very matter-of-
factly, "When he reached Crete in his voyage,
most historians and poets tell us that he got
from Ariadne, who had fallen in love with
him, the famous thread. . . ." (*Theseus* 19.1).

The wonder is that Kleitias chose to ignore
the enormously popular struggle with the
minotaur and instead to present Theseus in
a different guise: the μουσικὸς ἀνήρ, the love-
hero.

If extant Greek poetry does not preserve the
moment of that first encounter, there is one
great poem that at least enables us to imagine
Theseus as he was when he first set foot on
Krete and dazzled the innocent princess. This
is the Ode of Bacchylides, number 17 in most
editions, which recounts an incident on the
journey to Krete, Theseus' miraculous plunge
to the bottom of the sea.[26] In Bacchylides' ver-
sion, written probably in the 470s,[27] King
Minos has evidently gone to Athens himself,
to escort his tribute, the new batch of boys
and girls, back to Krete. This sets the stage
for a dramatic confrontation between the

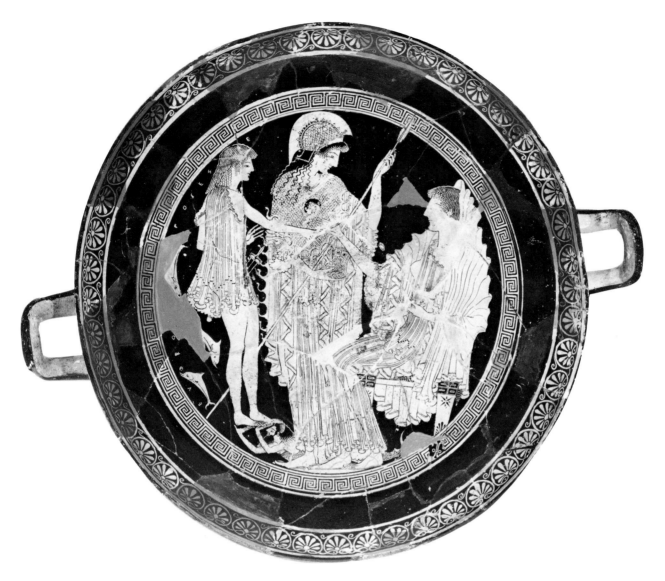

7. Attic red-figure cup with Theseus at the Bottom of the Sea
Musée du Louvre, Paris

hardened tyrant and the self-possessed young prince. Challenged by Minos to prove his divine paternity by retrieving a ring from the depths of the sea, Theseus calmly dives overboard and is carried by dolphins to the palace of Poseidon and his consort Amphitrite.

The ring is conveniently forgotten, and instead the hero receives from Amphitrite two gifts, more impressive—and more useful—tokens of his visit: a purple cloak and a rosebud wreath that had been a wedding present from Aphrodite. When, moments later, he surfaces beside the ship, not even wet, the gifts of Amphitrite shine about him: λάμπε δ'ἀμφὶ γυίοις θεῶν δῶρα. The erotic association of the rose wreath is unmistakable, particularly given its history,[28] and the purple cloak surely has a similar meaning.[29] Jason put on just such a cloak, also a divine gift (from Athena), when he went to meet the Lemnian Queen Hypsipyle, a romantic encounter in Book 1 of the *Argonautika* that foreshadows his later meeting with Medea (1, 722–767).[30] May we not suppose that Theseus was still wearing his cloak when the ship reached Krete? Indeed, might we not imagine that this is the very cloak rendered in meticulous detail by Kleitias, long and adorned with embroidered panels (as was Jason's), in striking contrast to the uniform short *chitoniskoi* of the other Athenian youths?[31]

One question, of course, arises: What elements of the tale are original with Bacchylides, and which drawn from earlier tradition? We can at least be certain that he did not invent the story of Theseus' dive, for a generation earlier a vase-painter close to Euphronios had depicted Theseus at the bottom of the sea, received by Amphitrite (fig. 7).[32] Other details of Ode 17, too, seem to be traditional,

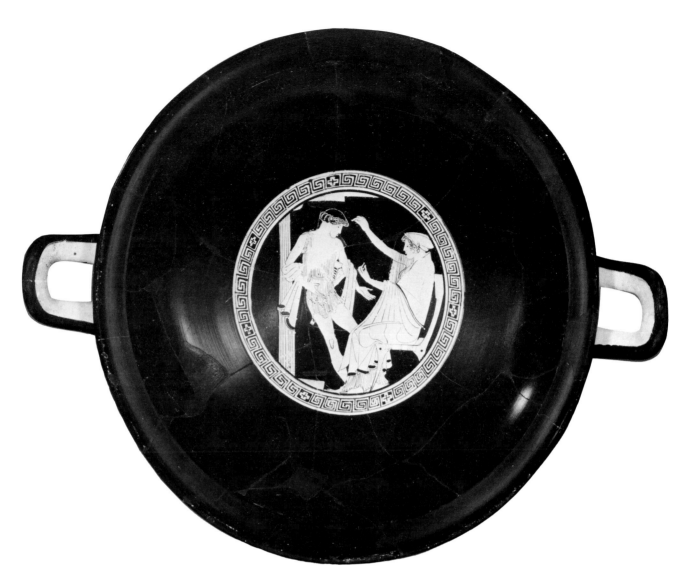

8. Attic red-figure cup
with Theseus and
Amphitrite
Metropolitan Museum of Art,
New York, Joseph Pulitzer Bequest

so it is at least possible that Kleitias knew the story of the cloak. And what of the wreath? I can only say that, of the hundreds of little bits and pieces of the François Vase now missing, the one whose loss I regret most is Theseus' head. The wreath does seem to have been shown on several red-figure vases, the earliest contemporary with or a few years earlier than Bacchylides' poem (fig. 8).[33]

It seems, then, that Amphitrite's gifts of robe and wreath serve a dual purpose. They not only answer Minos' challenge, but also mark the coming of age of the young love-hero, outfitting him for his first erotic conquest. In this regard the Theseus who set sail from Athens was indeed an innocent abroad. Early in Bacchylides' poem, the incident that touched off Theseus' angry words with Minos was the elder king's attempt to take liberties with one of the Athenian girls, Eriboia.[34] In-

cidentally, Kleitias may have known this detail as well, for Eriboia stands first in line of the maidens and youths, closest to Theseus' protection (fig. 3). Theseus chastises Minos' lechery with indignant words: ἴσχε μεγαλοῦχον ἥρως βίαν, "A hero curbs his violence." We who know Theseus' later track record as a seducer and rapist of women may snicker at the self-righteousness of youth. But the fact is, Theseus at this point *is* an innocent, not at all like the conniving Jason, who knows full well how to exploit his attractiveness to women. When Theseus first arrives at the undersea home of his father and sees the fair Nereids, he is afraid (ἔδεισε). The fearless young hero, who could plunge headlong and unafraid into the sea, finally, like Siegfried, learns fear only in the presence of female beauty.

We may stop at this point and ask why

there is such keen interest in Theseus' love life among early Greek poets and artists. Herakles had his share of adventures with women (and boys), but these are mostly incidental to, rather than the focus of, his mythology, and they are seldom seen in the visual arts.[35] In Theseus' case, the primary importance of these stories is not, I think, love or sex per se, but rather the result of love and sex, *generation*. Athenians of the Archaic and Classical periods looked on Theseus as their ancestor. True, there was no one in Athens who claimed direct descent from Theseus, as certain Athenian families claimed descent from other heroes (the Philaids from Ajax, the Peisistratids and Alkmeonids from Neleus),[36] but this may in fact have made it easier for Theseus to be regarded as the ancestor of the Athenian people as a whole. Attic genealogy was certainly on Kleitias' mind when he painted the Theseus frieze, for, as Erika Simon has shown, more than half the names of the Athenian youths and maidens connect them to well-known clans in Athens or neighboring areas such as Salamis, Eleusis, and Megara.[37] Eriboia herself is mentioned by Plutarch among the consorts of Theseus, a neat twist on the story in Bacchylides making her the damsel in distress to Theseus' knight in shining armor. In other versions she is variously a princess from Megara, Athens' traditional enemy, or the mother of Ajax, the "honorary" Attic hero from Salamis who is featured, carrying the dead Achilles, on the handles of the François Vase.[38]

Students of Greek myth will have noticed that the heroines seem to practice something like the reverse of the rhythm method of birth control: whenever they have sexual relations, they invariably become pregnant. Thus even in the brief affair of Theseus and Ariadne, one or more children were conceived, depending on which version we follow. In that of Ion of Chios, quoted by Plutarch (*Theseus* 20.2), their sons were Oinopion and Staphylos. It has usually been assumed, however, that the dominant tradition was the one that made these boys sons of Ariadne by Dionysos, not Theseus, on the basis of Exekias' great London amphora, where Oinopion, identified by inscription and looking filial, accompanies Dionysos (fig. 9).[39] But in fact Plutarch explicitly attributes this version to Naxos, while Ion might rather be expected to reflect the story current in Athens. As for Exekias'

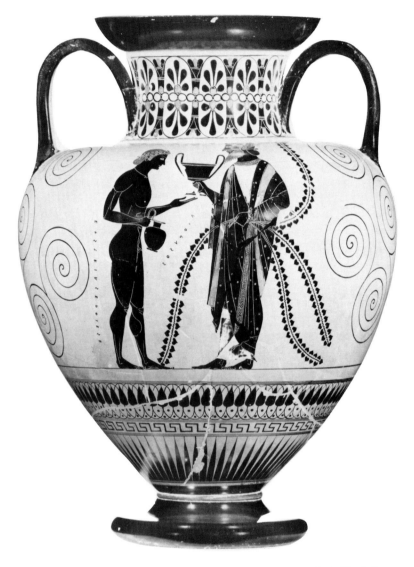

9. Attic black-figure neck-amphora by Exekias with Dionysos and Oinopion
British Museum, London

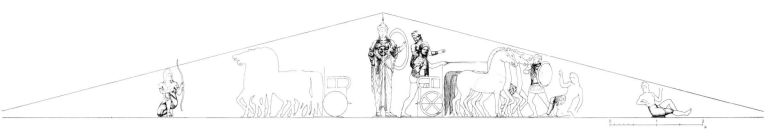

10. Reconstruction
drawing of west pediment,
Temple of Apollo
Daphnephoros at Eretria
Drawing after K. Iliakis from E.
Touloupa, "Die Giebelskulpturen
des Apollon Daphnephoros
Tempels in Eretria," in *Archaische
und klassische griechische Plastik*,
Akten des internationalen
Kolloquiums vom 22.–25. April
1985 in Athen, ed. H. Kyreleis
(Mainz, 1986), vol. 1, Beilage 2

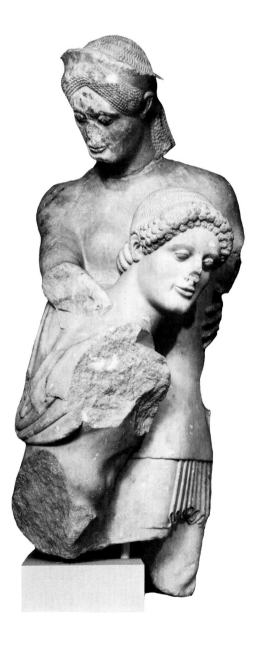

11. West pediment of the
Temple of Apollo
Daphnephoros at Eretria,
Theseus and Antiope
Archaeological Museum, Chalcis;
Human Figure, 66

picture, we miss the twin, Staphylos, and besides, Dionysos has many youthful companions on vases, and the name Oinopion could as well be a play on his function here, the wine-pourer.[40] Nor is there any compelling reason to identify the *kourotrophos* figure beside Dionysos on half a dozen black-figure vases as Ariadne with the twin boys.[41] I follow Carpenter and others in believing she is Aphrodite.[42] Oinopion and Staphylos remain shadowy figures, with no real iconography, and readers may be wondering what difference it makes who their father was. The importance lies in the single verse of Ion preserved in Plutarch: τήν [sc. Chios] ποτε θησείδης ἔκτισεν Οἰνοπίων, "Oinopion, Theseus' son, was the founder of Chios" [Ion's native island, so he should know]. The Athenians of the sixth and fifth centuries claimed to have colonized almost all the major cities and islands of Ionia in the generations after the Trojan War, and several locales were associated with particular oikists, such as Miletos, for example, founded by Neleus, son of King Kodros and ancestor of Peisistratos.[43] The claim was especially useful in the days of the Athenian Empire, but also a century earlier, under Peisistratos, whose activities on Delos reveal his interest in promoting Athens as, in Solon's words, πρεσβυτάτη γαῖα·|αονίας, the "eldest land of Ionia."[44] What more appropriate oikist for an important island like Chios than a son of Theseus? We recall Bacchylides' invocation to the ἄναξ·|ωνῶν (18.1).

All the aspects of Theseus' nature considered here—bravery, martial valor, beauty, sex appeal, and the paternal instinct—are combined in his encounters with the Amazons, the last episode I should like to touch on. In particular, there is the story of Antiope, raped, as Pindar told it in a poem now lost, on an expedition to Themiskyra on the Black Sea, in the company of Perithoös.[45] Other variants, which involve Herakles in this adventure, are evidently later in origin;[46] at any rate they were not known to Attic vase-painters or to the sculptor at Eretria (figs. 10–11), who

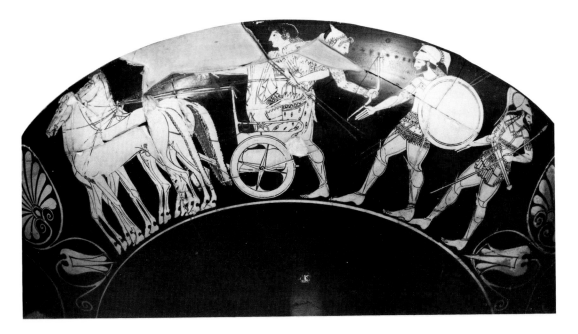

12. Exterior Side A of Attic red-figure cup with the Rape of Antiope
British Museum, London

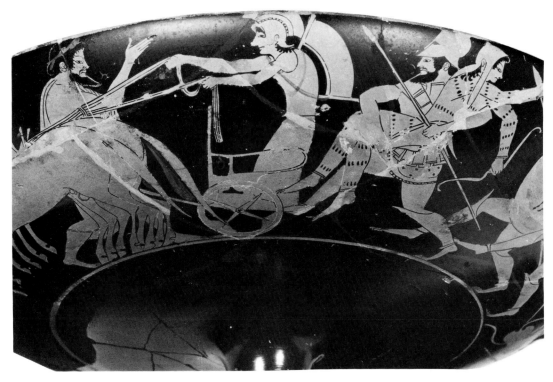

13. Exterior of Attic red-figure cup with the Rape of Antiope
Ashmolean Museum, Oxford

all favored the Antiope episode in the years between 520 and 490. Some seven or eight vases of this period preserve the scene with a considerable degree of iconographical consistency (figs. 12–16; 19).[47] Theseus carries his victim to a waiting getaway car,[48] or has her already in it. His escape is aided by two or three companions—Perithoös and Phorbas when names are inscribed[49]—but the Amazons whom we assume to be in hot pursuit

are left to the viewer's imagination—with one exception. Myson, who painted the scene on the back of his famous amphora in the Louvre that has Kroisos on the pyre on the obverse,[50] repeated the subject on a second vase, essentially unpublished until now, a psykter once in the collection of Mario Astarita in Naples and now in the Vatican (figs. 14–16).[51] The continuous friezelike surface of the vase, uninterrupted by handles, here gave

14–16. Attic red-figure
psykter with the Rape of
Antiope
Vatican Museum

the painter room to depict the story in its un-abridged version, with several Greek hoplites and at least two Amazons in pursuit.

What is, however, most striking in all the scenes of Theseus and Antiope is the empha-sis on rape rather than combat. Perhaps the best indicator that Archaic art saw the An-tiope episode as more erotic than military is a cup in London, perhaps an early work of Euphronios (figs. 12, 17).[52] As recently and in-geniously interpreted by Jenifer Neils, it shows a cycle of Theseus in three amorous encounters: with Ariadne, in the tondo (note his attribute, the lyre); abducting Antiope on Side A; and, on B, taking Helen—or, perhaps better, returning her to her brothers the Dios-kouroi.[53]

As John Boardman has pointed out, most scenes of the Rape of Antiope could scarcely be called Amazonomachies, with no other Amazons present but Antiope herself.[54] Even when other Amazons do appear in pursuit, there is no fighting. Conversely, the full-scale Amazonomachies so popular in red-figure of the Parthenonian period often show Antiope in the fray, when her abduction had long since ceased to be depicted.[55] The locale has moved from Themiskyra to Athens, the patriotic theme now an allusion to Athenian defense against the Persian barbarian. Perhaps the ear-liest pictorial version of this subject, and cer-tainly the most influential, was the painting by Mikon or Polygnotos in the Kimonian Theseion (Pausanias 1.17.2–3). I wonder if the abrupt end to the scenes of the Rape of An-tiope after 490 does not in fact have some-thing to do with the Persian Wars. For once the Amazons became fixed in the Athenian mind as an alter ego of the Persians, then the romance of their national hero with an Am-azon queen might have looked rather un-seemly, almost like treason.

But pre-Persian Athens had no such com-punctions, and neither did the Eretrians, when they paid tribute to the hero of neigh-boring Athens by putting Theseus and An-tiope on the west pediment of the new Tem-ple of Apollo Daphnephoros (fig. 11).[56] The choice of a specifically Athenian myth for a Euboian temple has puzzled some, but I think it need not. Theseus' career associated him with many places in and around Attika: Tro-izen, the Saronic Gulf, and Marathon, in East-ern Attika, just opposite Euboia, among oth-ers. We have noted the interest of the Cean

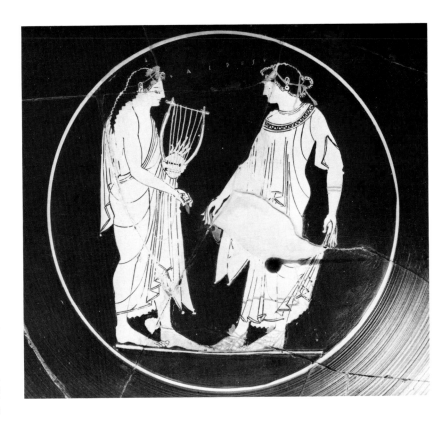

17. Interior of Attic red-figure cup with Theseus and Ariadne
British Museum, London

poet Bacchylides in Theseus, and not long ago were found remains of a temple akroterion group at Karthaia on Ceos, of Theseus and Antiope.[57] At least two stories link Theseus and his family to the island of Euboia. Plu-tarch records that when Theseus had been de-posed in a coûp d'état led by Menestheus, he fled to Skyros, but first sent his children to safety on Euboia (*Theseus* 35.3). The children meant here are doubtless Akamas and De-mophon, Theseus' last-born sons, later known as oikists of far-flung cities in Thrace, Asia Minor, and Phrygia.[58] It is not unlikely that there was a *heroön* or other monument on Euboia commemorating their stay there. The same author reports that, during the Am-azon invasion of Athens, Antiope sent her wounded comrades to Chalkis, on Euboia, where some were buried (*Theseus* 27.5).[59]

The story of Theseus and Antiope was thus surely well known to the Eretrians, but why they chose to give it such prominence at this particular moment is perhaps an unanswer-able question.[60] We might even speculate that there was a historical motivation. In 506, Athens won a decisive battle over Eretria's traditional enemy Chalkis, and Boeotia.[61] If, as I believe, the Eretria pediment belongs in the last decade of the sixth century, the sub-

18. Metope with Theseus
and Athena, from
Athenian Treasury at Delphi
Archaeological Museum, Delphi;
photograph: DAI, Athens

19. Attic black-figure
amphora with the Rape of
Antiope
Staatliche Antikensammlungen
und Glyptothek, Munich

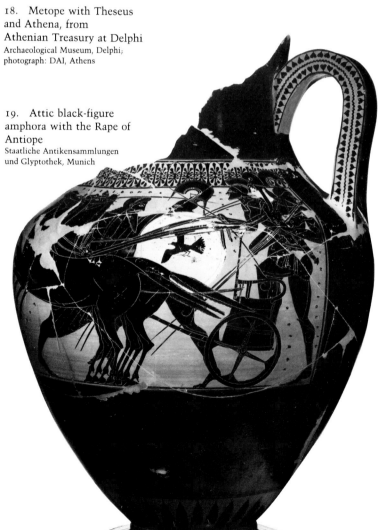

ject was chosen to honor the young Athenian democracy and its hero, the motif of captured and conquered Amazons perhaps suggested by the Amazoneion in Chalkis, burial place of Antiope's followers. The Athenians themselves commemorated the victory with a quadriga dedicated on the Akropolis. The Eretria pediment included a quadriga also, maybe two.[62] Alternatively, Evi Touloupa, who would date the pediment just after 499, when the Eretrians joined the Athenians in supporting the Ionian revolt, sees an allusion to these events in the choice of subject.[63] Either way, a particularly striking element must have been the big, hieratic Athena in the middle of the pediment.[64] No Athenian vase-painters put Athena at the Rape of Antiope, but then, as we have seen, no Athenian vase-painter combined the rape with a proper Amazonomachy, as the designer of the Eretria pediment seems to have done. There is no reason to assume that he was particularly dependent on Athenian models. Certainly Athena, as Theseus' protectress, is not out of place here. We may be reminded of the Louvre cup (fig. 7), whose painter took the liberty of interposing Athena between Theseus and Antiope, even though in the literature Athena surely did not follow Theseus to the bottom of the sea. Or we may recall the metope of the roughly contemporary Athenian Treasury in Delphi, with Theseus standing quietly opposite his patron goddess (fig. 18).[65]

The union of Theseus and Antiope produced a single child, Hippolytos, whose tragic fate we know best from Euripides.[66] Again the hero's dalliance was not without issue. Though Attic art was not interested in Hippolytos, there may be an allusion to him in scenes of the rape of his mother. Twice Poseidon appears, both times striding toward Theseus, as if to urge on his son (figs. 13, 19).[67] But why only here, since the god does not witness any of Theseus' other deeds? Is he perhaps reminded of his own violent courtship of Theseus' mother Aithra, a subject that would enter the vase-painters' repertoire in a decade or so?[68] That episode brings us back to Troizen, Theseus' birthplace, where Hippolytos would later enjoy his principal cult, after a watery death sent him by none other than Poseidon.[69]

The last of Theseus' sons were born to Phaidra, ill-fated stepmother of Hippolytos: the brothers Akamas and Demophon. They

20. Fragment of Attic black-figure amphora with Theseus
University of Lund

fought at Troy, even though the Athenian contingent was led by the usurper Menestheus, and eventually succeeded in winning the kingship in Athens back from him.[70] Their entry into Attic art, with Exekias,[71] coincides with the earliest depiction of Theseus as king of Athens, also by Exekias (fig. 20).[72] Might the recently published fragment in Malibu, with Akamas, belong to the same amphora as the Theseus in Lund?[73] The brothers represent the continuity of Theseus' line after his death, a memory preserved in Kleisthenes' choice of Akamas as one of the ten eponymous heroes.[74] Another subject introduced (perhaps invented) in the time of Exekias links three generations of Theseus' family: Akamas and Demophon at the Sack of Troy, rescuing their grandmother Aithra.[75]

We have been following Theseus' career as lover and father in order to suggest that these activities are central to his principal role in the Archaic period, that of the emerging Athenian national hero. The Greeks themselves surely felt some ambivalence when it came to matters of love and sex, best revealed in the paradox of Aphrodite, who is the protectress of marriage and the promoter of rape and adultery in equal measure. Bacchylides can describe Minos' itching lust for the hapless Eriboia—apparently with a straight face—as "the sacred gift of Aphrodite" (ἄγνα δῶρα).[76]

Yet at the same time the Athenians also recognized the intimate association of love, generation, and the continuity of the polis. This is best demonstrated in the civic cult of the love goddess, Aphrodite Pandemos.[77] Her sanctuary, shared with Peitho, was an ancient one, on the southwest slope of the Akropolis. Its founder was, appropriately, Theseus, who had united all the people of Attika in the so-called *synoikismos* (Plutarch, *Theseus* 24.1). This was not the first time Theseus discharged a debt to Aphrodite. Years before, after his first amorous conquest on Krete, he had dedicated a statue of Aphrodite—a token of Ariadne's love—in Apollo's temple on Delos (Plutarch, *Theseus* 21). By that time, ironically, he had already abandoned the unfortunate Ariadne on Naxos.

In the end, what made Theseus so irresistible, the perfect all-around hero for Athens, may be summed up in the favor that he enjoyed equally of two very different goddesses: Athena and Aphrodite. Duty and pleasure, passion and wisdom, charm and courage, patriotism and conciliation—Theseus embodies all these seemingly paradoxical qualities of the Athenian people themselves. Perikles would one day celebrate this same quirky mixture in them:

φιλοκαλοῦμέν τε γὰρ μετ᾽ εὐτελείας καὶ φιλοσοφοῦμεν ἄνευ μαλακίας.

NOTES

1. The manuscript was submitted in May 1988; more recent literature could not be incorporated.

2. On Plutarch's historical methods in this Life, see now Frank J. Frost, "Plutarch and Theseus," *Classical Bulletin* 60 (1984), 65–73.

3. Charles Beye, "Jason as Love-Hero in Apollonios' *Argonautika*," *GRBS* 10 (1969), 31–55.

4. Plutarch, *Theseus* 20. See W. R. Connor, "Theseus in Classical Athens," in *The Quest for Theseus*, ed. Anne G. Ward (New York and London, 1970), 145.

5. See Erika Simon, "Zur Lekythos des Panmalers in Tarent," *ÖJh* 41 (1954), 77–90, and for a recently published depiction of the story, Vera Slehoferova, "Zwei seltene Vasendarstellungen wohlbekannter Sagen," *AK* 29 (1986), 82–86 and pls. 13–14.

6. See C. M. Bowra, *Greek Lyric Poetry*, 2d ed. (Oxford, 1961), 111–112.

7. See Jenifer Neils, *The Youthful Deeds of Theseus* (Rome, 1987), 7 n. 21.

8. Herakleion Museum 6971; *Human Figure*, no. 20.

9. Florence 4209; *ABV*, 76, 1. Full photographic documentation is now available in M. Cristofani et al., eds., *Materiali per servire alla storia del Vaso François. Bolletino d'Arte* Seria speciale 1 (1981), figs. 62–65 and 160–175.

10. K. Friis Johansen, *Thésée et la danse à Délos* (Copenhagen, 1945).

11. J. D. Beazley, *The Development of Attic Black Figure* (Berkeley, 1951), 33–34.

12. Erika Simon, Max Hirmer, and Albert Hirmer, *Die griechischen Vasen*, 2d ed. (Munich, 1981), 72–73.

13. Recently, Neils 1987, 27, has made the ingenious suggestion that several episodes have been combined on the Theseus frieze in "simultaneous narration," as is certainly the case on the Troilos frieze of the François Vase. But if my interpretation is right, this solution is not necessary either.

14. A similar interpretation was proposed by Charles Dugas, "L'évolution de la légende de Thésée," *REG* 56 (1943), 11–12, then largely ignored. Dugas, however, still accepted the premise that Theseus leads his fellow Athenians in a dance, which I do not accept.

15. The ancient descriptions of these dances are collected and discussed by Friis Johansen 1945, 11–13.

16. Akropolis 594; *ABV*, 77, 8; Botho Graef and Ernst Langlotz, *Die antiken Vasen von der Akropolis zu Athen*, 2 vols. (Berlin, 1925–1933), vol. 1, pl. 24.

17. Akropolis 597d; *ABV*, 77, 3; Graef and Langlotz 1925, pl. 24. The fragment Akropolis 596 also shows the same subject (*ABV*, 77, 9; Graef and Langlotz 1925, pl. 24), but the direction is reversed. On the identification of the subject see Beazley 1951, 34.

18. Copenhagen inv. 13536; *Paralipomena*, 32; *CVA Copenhagen*, 8, pl. 320, 1a. Compare also a neck-amphora by the Affecter, Taranto 117234 (not in *ABV*), illustrated by Heide Mommsen, *Der Affecter* (Mainz, 1975), pl. 59. Here Theseus' fight with the minotaur is the subject of both sides of the vase. On the obverse, his lyre hangs in the background, while on the reverse, the lyre is held by the first youth standing behind Theseus.

19. Munich 2443; *ABV*, 163, 2; Friis Johansen 1945, 41, fig. 22, for the full scene. Friis Johansen 1945, 45, fig. 23, also illustrates a later black-figure neck-amphora on which one of the youths holds Theseus' lyre.

20. Nikolaos Himmelmann-Wildschütz, *Erzählung und Figur in der archaischen Kunst. Abhandlungen der Akademie der Wissenschaften, Mainz* (Wiesbaden, 1967), 77–78.

21. Himmelmann 1967, 87–92, does admit the possibility of attributes as "hieroglyphs" that identify the status of a figure, even when not relevant to the specific context.

22. All translations of Bacchylides in this paper are those of Ann Pippin Burnett, *The Art of Bacchylides* (Cambridge, Mass., 1985), used with permission of the Harvard University Press.

23. On this cult see now Charles W. Hedrick, Jr., "The Temple and Cult of Apollo Patroos in Athens," *AJA* 92 (1988), 185–210.

24. The earliest depictions of Apollo holding a lyre in Attic art are about a decade earlier than the François Vase, for example, on the dinos by Sophilos, London 1971.11.10: Dyfri Williams, "Sophilos in the British Museum," in *Greek Vases in the J. Paul Getty Museum*, 1 (Malibu, 1983), 26, fig. 32.

25. Here the ball of yarn is indeed proleptic (unlike the lyre), but it is not inherently implausible that a proper princess, chaperoned by her nurse, might hold this attribute of the diligent weaver.

26. On the poem, see the detailed discussion by Burnett 1985, 15–37, with full references to earlier literature.

27. For the date see Bruno Snell's edition of Bacchylides (Leipzig, 1970), 48.

28. According to a scholiast on Aristophanes' *Acharnai* 992, the late-fifth-century painter Zeuxis depicted Eros himself wreathed with roses, in the Temple of Aphrodite in Athens.

29. See Charles P. Segal, "The Myth of Bacchylides 17: Heroic Quest and Heroic Identity," *Eranos* 17 (1979), 31.

30. On the cloak see H. A. Shapiro, "Jason's Cloak," *TAPA* 110 (1980), 263–286.

31. On Bacchylides' use of the word ἀίων for the robe, possibly suggesting a linen garment of Egyptian origin, see K. Latte, "Zur griechischen Wortforschung," *Glotta* 34 (1953), 192. See, however, John P. Barron, "Bakchylides, Theseus and a Woolly Cloak," *BICS* 27 (1980), 4, for doubts about the Egyptian association and a different interpretation.

32. Louvre G104; *ARV²*, 318, 1; Paul Jacobsthal, *The-*

seus auf dem Meeresgrunde (Leipzig, 1912), pl. 1, 1. This monograph was the first full treatment of the myth and its representations in Greek art.

33. New York 53.11.4; *ARV*[2], 406, 7; illustrated and discussed most recently in H. A. Shapiro, "Theseus, Athens and Troizen," *AA* (1982), 295–296. For Early Classical vases with Theseus meeting Poseidon at the bottom of the sea (hence a departure from Bacchylides' version) and Amphitrite preparing to crown him with a wreath, see J. J. Pollitt, "Pots, Politics, and Person-ifications in Early Classical Athens," *Yale University Art Gallery Bulletin* (Spring, 1987), 11–12 and figs. 4–5.

34. On this episode see J. Stern, "The Structure of Bacchylides' Ode 17," *RBPhil* 45 (1967), 43. Guntram Beckel, "Götterbeistand in der Bildüberlieferung grie-chischer Sagenbilder" (Waldsassen, 1961), 122 n. 577, suggested a possible allusion to this episode on a black-figure vase of the mid-sixth century.

35. In scenes of the rescue of Deianeira from Nessos, for example, the emphasis is on Herakles' combat with the centaur. His wife is incidental. The meeting of Herakles with Iole, his last lover, the subject of a famous Corinthian krater (Louvre E635; Simon and Hirmer 1981, pl. XI) did not interest Attic artists.

36. On these families and their heroic ancestors, see H. A. Shapiro, "Exekias, Ajax and Salamis: A Further Note," *AJA* 85 (1981), 173–175, and "Painting, Poli-tics and Genealogy: Peisistratos and the Neleids," in *Ancient Greek Art and Iconography*, ed. Warren G. Moon (Madison, Wis., 1983), 87–96.

37. Simon and Hirmer 1981, 73–74.

38. On Eriboia see now *LIMC*, 3, 819–821. Ajax on the François Vase: Cristofani 1981, figs. 106–107. On the genealogical link of Theseus, Eriboia, and Ajax, see now Barron 1980, 3.

39. London B210; *ABV*, 144, 7; Simon and Hirmer 1981, pl. 75.

40. See Thomas H. Carpenter, *Dionysian Imagery in Archaic Greek Art* (Oxford, 1986), 49–50.

41. The representations were first collected by W. von Massow, "Die Kypseloslade," *AM* 41 (1916), 52, and more recently by Carpenter 1986, 24 n. 52. See also Theodora Hadzistelliou-Price, *Kourotrophos* (Leiden, 1978), and Erika Simon, "Ein Anthesterien-Skyphos des Polygnotos," *AntK* 6 (1963), 13 n. 45.

42. Carpenter 1986, 22.

43. Herodotos 9.97; see Shapiro 1983, 94.

44. Solon fr. 28a.

45. Pindar fr. 175 Snell. The same version is also found in other authors: see *LIMC*, 1, 858, s.v. Antiope (Aliki Kaufmann-Samaras).

46. For example, Philochoros, *FGrHist* 328 F 110. See also Frank Brommer, *Theseus* (Darmstadt, 1982), 115.

47. The scenes are collected in *LIMC*, 1, 858–859. See also the fundamental discussion of their iconography by Dietrich von Bothmer, *Amazons in Greek Art* (Ox-ford, 1957), 124–130. Add the unpublished volute-kra-ter New York 59.11.20; *ARV*[2], 224, 1. Only one vase

is clearly later than 490: the fragment in Erlangen, *LIMC*, 1, 859, no. 12. On the iconography of the scene see also Charlotte Hofkes-Brukker, "Die Liebe von Antiope und Theseus," *BABesch* 41 (1966), 14–27.

48. For example, the cup Oxford 1927.4056; *ARV*[2], 62, 77; fig. 13.

49. On the cup London E41; *ARV*[2], 58, 51; fig. 12.

50. Louvre G197; *ARV*[2], 238, 1.

51. Vatican, Astarita Collection 428; *ARV*[2], 242, 77; partially illustrated by Stella Drougou, *Der attische Psykter* (Würzburg, 1975), pl. 16, 1, and by Anna-Bar-bara Follmann, *Der Pan-Maler* (Bonn, 1968), pl. 15, 5. The unpublished krater in New York (see note 47) also has several Amazons in pursuit.

52. See note 47 above. On the reattribution to Eu-phronios see Martin Robertson, "Euphronios at the Getty," *GettyMusJ* 9 (1981), 26, and Neils 1987, 32. The suggestion had earlier been made by Beth Cohen, *Attic Bilingual Vases and Their Painters* (New York, 1978), 379–383.

53. Jenifer Neils, "The Loves of Theseus: An Early Cup by Oltos," *AJA* 85 (1981), 177–179, and pls. 40–41.

54. John Boardman, "Herakles, Theseus and Ama-zons," in *The Eye of Greece*, ed. Donna C. Kurtz and Brian Sparkes (Cambridge, 1982), 5–12.

55. See von Bothmer 1957, chap. 10. The shift is also evident at Eretria itself where, according to an ingen-ious suggestion of Eugenio LaRocca, the Classical re-placement for the Archaic pediment destroyed by the Persians in 490 showed a more generalized Amazon-omachy, and not Antiope: *Amazzonomachia* [exh. cat. Palazzo dei Conservatori] (Rome, 1985), 76–78.

56. See now the definitive publication of the pedi-ment by Evi Touloupa, Τὰ ἐναέια γλυπτὰ τοῦ ναοῦ τοῦ Ἀπόλλωνος Δαφνηφόρου στὴν Ἐρέτρια (Ioannina, 1983).

57. *ArchDelt* 18 (1963), Chronika 282. Only the bases, with parts of the inscriptions, are preserved.

58. See *LIMC*, 1, 436, s.v. Akamas et Demophon (Uta Kron).

59. On this story see Touloupa 1983, 90, and, on its significance, LaRocca 1985, 50–51.

60. Evelyn Harrison, "Sculpture in Stone," in *Human Figure*, 54, has pointed out the appropriateness of "a romantic tale of war and marriage suitable to celebrate a young man's coming of age" to decorate a temple of Apollo. We may also recall the strong iconographical and cultural links between Theseus and Apollo dis-cussed earlier in this chapter.

61. Herodotos 5.77; Russell Meiggs and D. Lewis, *A Selection of Greek Historical Inscriptions* (Oxford, 1969), 28–29. Herodotos adds that 4,000 Athenians were settled in the Lelantine Plain after the defeat of Chalkis.

62. On the problem of one chariot or two see Tou-loupa 1983, 76, who concludes that there must have been two. This is questioned by J. Frel, in his review

of Touloupa, in *AJA* 88 (1984), 417.

63. Touloupa 1983, 119. For another attempt to link the Antiope episode and the Ionian Revolt see Boardman 1982, 12–14.

64. See Adolf Furtwängler, *Aigina; Das Heiligtum der Aphaia* (Munich, 1906), 321–324. Touloupa and others have assumed that the figure of Athena must also belong to the west pediment, though Angelos Delivorrias, *Attische Giebelskulpturen und Akrotere des fünften Jahrhunderts* (Tübingen, 1974), 179–180, suggested that it could belong to the other side.

65. See P. de la Coste-Messelière, *FdD, 4, 4: Sculptures du Trésor des Athéniens* (Paris, 1957), 51–58 and figs. 15–18. On the problem of the date see the recent and good discussion of Werner Gauer, "Das Athenerschatzhaus und die marathonischen Akrothinia in Delphi," in *Forschungen und Funde, Festschrift Bernhard Neutsch*, ed. F. Krinzinger, B. Otto, and E. Walde-Psenner (Innsbruck, 1980), 126–136.

66. Pindar (quoted by Plutarch, *Theseus* 28.2) evidently knew a different version, in which Demophon was the son of Theseus and Antiope.

67. Black-figure amphora, Munich 1414; *ABV*, 367, 87; red-figure cup by Oltos, Oxford 1927.4056 (see note 48).

68. Sophia Kaempf-Dimitriadou, *Die Liebe der Götter in der attischen Kunst des 5. Jahrhunderts v. Chr.*, *AntK*, Beiheft 11 (Basel, 1979), 26.

69. On the cult and sanctuary of Hippolytos in Troizen, see Pausanias 2.32.1–4 and Lewis Richard Farnell, *Greek Hero Cults and Ideas of Immortality* (Oxford, 1921), 64–70.

70. For all the sources on Akamas and Demophon, see *LIMC*, 1, 435–436. The brothers are not mentioned in Homer, but first in the Epic Cycle.

71. Departure of Akamas and Demophon: amphora, Berlin (East) F1720; *ABV*, 143, 1; Werner Technau, *Exekias* (Leipzig, 1936), pl. 2.

72. Fragment, Lund University; *ABV*, 145, 17.

73. Malibu, J. Paul Getty Museum 78.AE.305; E. Anne Mackay, "A New Exekian Fragment," in Malibu 1983, 39–40.

74. See Uta Kron, *Die zehn attischen Phylenheroen*, *AM*, Beiheft 5 (1976), 141–170, on Akamas and, on the choice of the Eponymous Heroes, 29–31.

75. Earliest on the black-figure neck-amphora London B173; *LIMC*, 1, s.v. Aithra, 426, no. 61 (with illustration). For the interpretation see Kron, in *LIMC*, 1.

76. On the interpretation of this phrase see Douglas Gerber, "The Gifts of Aphrodite (Bacchylides 17.10)," *Phoenix* 19 (1965), 212–213.

77. On the cult see Erika Simon, "Aphrodite Pandemos auf attischen Münzen," *SNR* 49 (1970), 5–19.

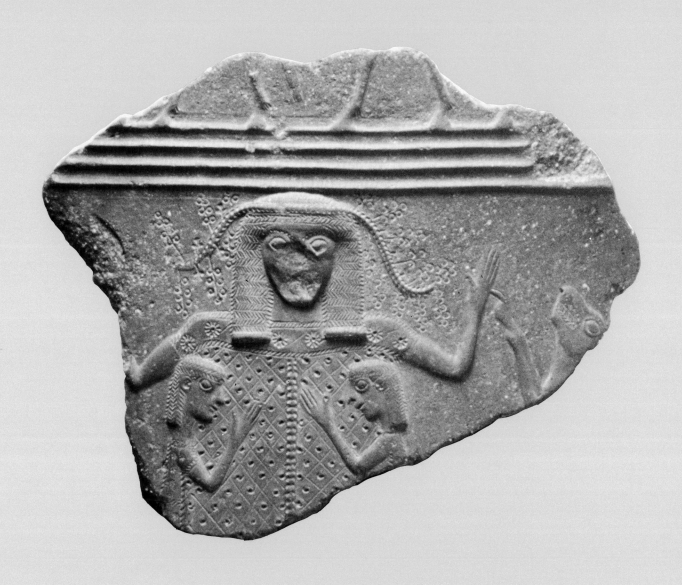

BERNARD C. DIETRICH
University College of Wales

Aegean Sanctuaries: Forms and Function

The Greek temple housing the cult image is a creation of the eighth century B.C. and together with altar and sacred temenos made up the essential elements of the Archaic and Classical Greek sanctuary.[1] This is the orthodox view, which sees few or no antecedents to the characteristic triad of Greek cult. The Archaic sanctuary no less than the rituals celebrated within it had no earlier history: they were un-Minoan and un-Mycenaean, apparently reflecting new traditions that appeared during the so-called Dark Age. However, traditions operate in peculiar ways; they can be hard to detect in a purely archaeological context. The rock of Minoan cave cult, for example, may reappear as an important symbol in the adyton of the Mycenaean temple, like the House of Idols in the cult center on the Mycenaean acropolis, and ultimately in the sacred precinct of Eleusis.[2] The gesture of the upraised arms of the Minoan and Mycenaean goddess, and the contemporary threatening figure of the Smiting God, were also potent religious symbols which survived from the thirteenth to the eighth centuries B.C.[3] At Gortyn the goddess emerged as Athena by 700 B.C.,[4] and the discovery of her image on a Late Geometric *pinax* from the agora suggests a similar history for Athens.[5] She became known as Aphrodite at Kato Syme in Crete, and in Cyprus at Palaipaphos. The name changed, but not the message or function of the symbol. Similar survivals of fundamental religious values can be traced in the case of the even older symbols of butterfly and double axe.[6] Such evidence, in my opinion, is a more valuable indicator of enduring tradition than actual sites, which continued in use but may have changed the nature of their cult.

A few years ago, visiting the remains of Archaic sanctuaries in Cyprus, I was struck by their close observance of Bronze Age forms. One of the best known, the seventh-century sanctuary of Apollo at Kourion, for example, with its open temenos, altars, and peribolos, conformed to a type that Gjerstad classified as common in the Late Bronze Age.[7] Probably there had been an earlier sanctuary nearby at Bamboula, but Kourion itself was an Archaic foundation at some four or five hundred years after the end of the Bronze Age.[8] In the much disturbed grounds of the temenos no clear traces remain of a cella or similar structure during its early existence; nonetheless the reappearance of Bronze Age traditions is evident in comparison with sanctuaries begun much earlier, like Ayios Iakovos,[9] and those that had been in continuous use from the Late Bronze Age until Archaic and Classical times, like Ayia Irini.[10] The tradition was Cypriot in the first instance, beginning in the Early Bronze Age at Vounous in the north of the island,[11] but falling under the dominant influence of eastern models during the last quarter of the second millennium B.C. This applied to both the simple rustic sanctuaries and the more elaborate city temples of Kition and elsewhere, which conformed to the same basic architectural principles of cellae, te-

menos, and altars.[12]

It is well known that western Semitic religious concepts at the time presented a united front, as it were, or koine, that had evolved in Mesopotamian—that is Sumerian and Babylonian—religions[13] and was imposing its architectural and divine iconographical standards on the Aegean.[14] The liwan-type oriental architectural style was also adopted by Mycenaeans in the thirteenth to twelfth centuries B.C., and in monumental form by the settlers in Cyprus for their temple complexes at Palaipaphos, Kition, and Enkomi.[15] Cypriot traditions became submerged in oriental and western forms. The melding of both is graphically illustrated by the splendid cult image of the Horned God, which had been kept in the cella of the Mycenaean temple at Enkomi. Regardless of whether he was worshiped as Apollo Kereates or Reshef, or under yet another name, the figure incorporated both Mycenaean and eastern elements. It was related to the Syrian figure of the Smiting God who was universally revered in the western Semitic religious koine.[16]

The rise of this god in religious iconography[17] was contemporary with that of the western Minoan and Mycenaean Goddess with Upraised Arms. Most recently the pair have been identified as *Potnia* with her *paredros*.[18] They certainly were associated in cult as protecting community deities, but they were worshiped under different titles at their various cult sites. It is of considerable interest that both religious symbols apparently survived the dividing period between the Bronze Age and the Geometric period. The goddess' characteristic attitude continued in the plastic arts until about 700 B.C. and in vase painting to Classical times.[19] The god was a survivor, too, by even the most rigorously critical standards, in Cyprus and in some Aegean sites, of which the most striking example is the Samian Heraion.[20] It is difficult to decide, of course, whether the same meaning survived along with the symbol.[21] What is significant, besides the evidence of survival, is the continuing awareness and receptive attitude to eastern religious ideas. This comes through more clearly in cult content and outward form than is generally admitted. As the characteristic Archaic format of an open temenos with altar and peribolos wall in Cyprus derived from older Bronze Age

models, it is reasonable to expect signs of a similar dependence in the western Aegean as well. Cyprus was the intermediary between east and west. The antecedents of Gjerstad's Type IV sanctuary in Anatolia, Syria, and Palestine have already been discussed elsewhere.[22] Canaanite forms of temple building at the end of the Bronze Age were also reflected in Kition in Late Cypriot II and III, and in the smaller rustic sanctuaries outside the city limits.

In Cyprus these traditions were reinforced by Phoenician settlers and continued well into the Iron Age. But the Mycenaeans eagerly took them over for their own use, with the result that their temples, both in Cyprus and at home in Mycenae, looked back to a common model, or archetype, such as the Philistine temple at Quasile.[23] Modern opinion still seems too rigidly bound to the concept of indigenous "domestic" cult in palace "chapels"[24] to appreciate the extent to which eastern forms were reproduced at important Mycenaean cult centers late in the second millennium B.C.[25] Despite the complicated three levels of the sacred area at Mycenae, Temple Gamma, Tsountas' House, the House of Idols, and the House of Frescoes are directly centered on open courts with altars.[26] In Tiryns, on the western part of the lower acropolis, shrine R117, and later during Late Helladic IIIC, R110 and 110a on the same location, together with the other adjacent buildings, also surrounded an open space with altar.[27] In Phylakopi, on Melos, during Late Helladic IIIA–C, the West and later East Shrines opened onto a court with an altarlike semicircle of stones and baetyl. The destructions of phase 2b did not materially alter this arrangement.[28] So in all three cases the impression of dependence on Cypriot, and ultimately eastern, ways of sanctuary building is unmistakable.[29]

One interesting aspect, which these sanctuaries shared with Cyprus in outward form, is their relation to the city fortifications. Walls and cult were functionally connected in Cyprus, Melos, Mycenae, and Tiryns. In the last case, this aspect of the cult survived the destruction of the fortress: votives continued before the wall, or within a niche in the wall, of the "Unterburg."[30] Evidently the worship focused on a protective community deity, but comparisons with Classical parallels, like Apollo's temple in Corinth, cannot

be pursued here, nor can the relationship of cult center with megaron at Mycenae. A similar division appears in Tiryns, where a form of cult on the upper acropolis about megaron, pillar court, and altar survived the catastrophe at the end of Late Helladic IIIB2.[31] Distinctions between "Staatsreligion" (Kilian) and some form of down-market popular cult in the lower sacred area are not convincing, if one accepts that common origins were responsible for both the larger and the more modest sanctuaries of this kind.

All these temple precincts possessed other physical features that suggest similar types of cult performance. The well-defined central area, with one or more altars, shows that the main ritual occurred in the open at the end of a procession which, in the case of Mycenae, moved along a prescribed sacred route down the west slope of the acropolis. The format closely recalls eastern practice,[32] and it seems in contrast with the typical Minoan palace procession frescoes in which the congregation moves to an interior shrine or cult room like the East Hall at Knossos.[33] The same indoor procedure obtained in the mainland palaces, judging from the Minoan-style frescoes in Nestor's Palace at Pylos. There the participants carry gifts in the direction of the Throne Room.[34] The precise significance of this contrast is not clear, however. There were open-air festivals associated with the palaces, too,[35] so that one would not wish to press the point[36] beyond the obvious architectural differences between the open sanctuaries and interior palace shrines. Perhaps there was a distinction in cult type and deity between the two sacred areas.

In the eastern ritual the purpose of the procession was to convey the sacred image of the deity to and from its dwelling place in the adyton within the temple.[37] In other words, the image was central to the cult: it was dressed and served with food, and it was kept apart in its home, accessible only to the priests but visible through a niche or series of doorways. This is what must have happened in the Mycenaean sanctuaries during the last phases of the Helladic Bronze Age. Colin Renfrew contrasts the open Cypriot and eastern sanctuaries with the roofed Aegean types.[38] However, even assuming that the main part of the West Shrine in Phylakopi was covered with a roof, it is still obvious that Room A to the west served as the adyton of

the temple and communicated with it by means of niches that held votives and revealed them to the worshiper outside. The famous Lady of Phylakopi, the Goddess with Upraised Arms, was found in the same Room A, being kept separate from the offerings and votives on the two platforms in the northwest and northeast.[39] This account simplifies the complex sequence of usage and cult assemblages in the Melian sanctuary, in order to bring out a salient feature which found parallels in other Mycenaean Aegean centers, such as Temple Gamma and the House of Idols in Mycenae. In fact the temple began with a single enclosed room within the sanctuary precinct. This inner room, holding the chief image or images of the cult, became the adyton and nucleus of the later temple. The eastern-type process never developed beyond the single room in Tiryns compared with the more elaborate Temple Gamma of Mycenae.[40] In the Kean temple at Ayia Irini, the evolution from single cella to agglutinative temple complex can be followed in greater detail. It began much earlier there, however, because Rooms I and II, constituting the first elements of the temple, were part of the initial Middle Bronze Age design.[41]

The concept of the temple, that is the inner room, as naos and home of the statue, was common to the Aegean. It can be traced in the west from the Linear B documents[42] and, on the authority of Homer[43] and Herodotus,[44] continued into Archaic and Classical times. Processions with image and altar also endured,[45] but not, or at least to a far lesser extent, the habit of worshiping several seemingly incompatible deities in one sanctuary. The astounding array of images in one and the same cult conveys the impression of a totally un-Christian religious toleration. On the Phylakopi site, for instance, even after excluding all possible votive offerings, the Lady and her companion in Room A, and at least one of the male figures in the West Shrine, still remain unimpeachable as cult images, as do the two figures of the Smiting God whose divine nature is surely also beyond reasonable doubt.[46] The House of Idols in Mycenae presents a similar picture, and one that can no doubt be duplicated at other western sites. I found an extreme example of this catholic taste for several gods from different cultures in the Late Bronze Age II temple at Kamid el-Loz in the Beka valley in Lebanon. Cult im-

ages of male and female Striking Warrior deities, and enthroned gods of Syrian, Egyptian, and Anatolian tradition were placed in adjacent rooms of the temple.[47]

The largest assemblage of Late Bronze Age figures in the Levant has been recovered from the closest point of contact with the Minoan and Mycenaean world, namely, the sacred areas of Ras Shamra and the nearby port of Minet el-Bei da. In the welter of multinational gods and dedications the divine pair of Smiting God and female consort—that is, our Lady with Upraised Arms—emerged as central figures in a tradition that turns out to have begun in the east as early as the Middle Bronze Age.[48] Their nature as war god and fertility goddess was common to Syrian, Lebanese, and Palestinian cults, although their names differed. In the Ugaritic texts, which so clearly reflect the Royal Couple of Canaanite iconography, they are called Baal the divine warrior, storm and fertility god, and Anat, divine virgin, goddess of fertility, the "War goddess par excellence of Canaan."[49] The divine pair of male with female counterpart determined the form of temple and sanctuary until the Iron Age. In Ras Shamra the Royal Couple had twin temples on the acropolis. They had their own temples in the sacred area at Byblos, Hazor, and Lachish. In Beth Shean they shared a temple from the Late Bronze Age to Early Iron (Levels IX, VII, VI), and from Iron I, Level V, each had a separate temple in the sacred area. The same history applied at Megiddo and elsewhere.[50]

The pair migrated westward before the end of the thirteenth century B.C., appearing at Enkomi in Cyprus—and incidentally suggesting to some that Phoenician colonists settled on the island, and indeed further west, as early as the second millennium B.C.[51] Thereafter the iconographic type of the Smiting God became widely distributed throughout the Aegean but curiously disappeared from the Levantine coast.[52] In Cyprus the god and companion impinged on local tradition and on that of the Mycenaean immigrants, resulting in cognate but iconographically different types like the armed Ingot God, which more markedly preserved Syro-Palestinian traditions, and the Horned God of Enkomi with its pronounced Mycenaean, Aegean features.[53] As in the east, sanctuary design was adapted to the cult of the divine pair. The sacred precinct of Kition, for instance, was divided into Temple IV for the Goddess with Upraised Arms and Temple V for the male community god, in a system which was repeated at Enkomi and endured in principle until Archaic and Classical times.[54]

Not surprisingly, the concept of divine pairing surfaces in the Mycenaean documents, in the complementary masculine/feminine forms (Gen) *diwo/diwija* (Zeus and Dia) on both the Knossos and Pylos tablets, and in the forms *posedao* and *posidaeja* on Pylos tablet Tn 316.[55] Altogether a number of un-Greek sacred titles in Linear B, such as "divine slaves," "keybearer," "skinbearer," and the like, invite a reexamination of the documentary evidence with due regard to the profound eastern influence.[56]

In the archaeology of the sanctuaries and dedications, this very same eastern fashion accounts for the division between a male and female divinity at Phylakopi, where votives were placed on separate platforms in the West Shrine.[57] The pairing may be less evident in the architecture of other Minoan and Mycenaean sanctuaries, but it emerges from the juxtaposed cult images of the oriental Smiting God and the Minoan/Mycenaean Goddess with Upraised Arms. It seems, then, that the mixture of foreign and western Aegean styles, which can be observed in the Cyprus figures, recurred in the Minoan and Mycenaean cults as a revealing instance of syncretism in the developing history of Greek religion. What is more, the Royal Couple could be worshiped in the predominantly Mycenaean cult assemblage of Phylakopi and also in the more Minoan-oriented context of Patsos in Crete. In the latter the conservative Minoan worshiper preferred to move the LMIII postpalatial cult of the Smiting God figure with the goddess to the more traditional ambience of a cave.[58]

The cult of the twin deity protectors can be followed until Classical times in Cypriot Kition and Tamassos,[59] and it continued equally tenaciously in Crete, notably at Patsos and Kato Syme.[60] In historical times, the pair emerged as Hephaestus and Aphrodite in Cyprus, and as Hermes and Aphrodite at Kato Syme.[61] The question of how closely we may compare cults in both islands, which are noted for their religious conservatism, with those in Greece cannot be dealt with here, because it involves an analysis of the many variables that contributed to mainland tradition. It is true to say, however, that the ar-

rival of the Smiting God coincided with a growing fashion in the west of dedicating male figures, the best examples of which are the remarkable finds from the West and East Shrines of Phylakopi and from the open Piazzale dei Sacelli at Hagia Triada in Crete.[62]

Stylistically these link up with the later Geometric bronze figures from caves and elsewhere in Crete and on the mainland, and it has been ingeniously suggested that they in fact served as cult images of Zeus, Poseidon, Hermes, and perhaps even Dionysus—in short the identifiable Greek gods on the Linear B tablets.[63] If this suggestion is correct, it will at long last be possible to match up the names with contemporary cult figures, while incidentally reinforcing the impression of eastern influence on the documents.[64] It does certainly seem an attractive thought that the distinctive image of the Smiting God provided the model for the Greek sculptures of the striding Zeus figure and others, including the god Poseidon.[65]

But many questions remain, regarding the date of transition from multiple to single cult images, for instance, and the introduction of large cult statues, which Renfrew, wrongly in my opinion, derives from the life-size Cycladic sculpture of over a millennium earlier.[66] How did they relate in function and significance to the more modest proportions of the Smiting God and the Goddess with Upraised Arms?[67] Before answering these questions, one will need to know more about the divine pair's position in the Minoan and Mycenaean hierarchy, and how far the nature of their cult might have altered during its transmission to historic Greek religion.

Nevertheless, there is a case to be made for linking the divine pair's particular sanctuary type with Archaic forms that evolved from an open space with altar and cella, suggesting a fair measure of continuity. The connection with Minoan and Mycenaean palace cult, on the other hand, is more difficult to judge, because the relationship between the two cult localities remains obscure. Perhaps the problem is not quite as complex as it seems at first, however, since Minoan cult had never been confined to the palace. All types of rural and cave sanctuaries functioned concurrently with the so-called domestic palace shrines, and consequently they must have been part of contemporary religion. Accordingly, the cult of the two had somehow become integrated with Minoan/Mycenaean religion before the end of the Bronze Age and then went on into historical times without interruption. New postpalatial cult sites like Patsos do not therefore affect the overall impression of continuity.[68]

It would then be misleading to interpret the growing popularity of the cult of the divine pair as a break with the past, let alone as an indication of social revolution in a declining Minoan culture after the fall of the palace at Knossos in IIIA. This model has been put forward by those scholars who argue for a total change in the religious tradition at that time, rather than later in the course of the Dark Age.[69] Strictly speaking, neither period marked a completely new beginning, certainly not by the criteria of cult, cult figures, or sanctuary type. It is impossible, for instance, to demonstrate that the characteristic open sanctuary invariably replaced the palace-related cult. In fact they competed, overlapped, and lived, and sometimes died, together, but they did not follow a predictable pattern. At Mycenae the cult center perished with the palace in Late Helladic IIIB, giving rise to the view that there had been no independent cult activity at all in the megaron on the acropolis.[70] Phylakopi, too, was abandoned in IIIC. In Tiryns the lower sanctuary area continued beyond the destruction of the palace, but there was no clearly defined succession from one type of cult to another in the "Unterburg."

The evidence for what happened in mainland cult at the end of the Bronze Age is clearly inadequate. However, it is a workable assumption that Greek religion was the product of progressive evolution without an absolute caesura at any stage of its history. The main effort must therefore be directed at disentangling the complex nature of this development, together with the diverse sources of influence that acted upon it. Changes came from within Greek culture, in response to the kind of external foci of influence that have been discussed. They are hard to detect from the archaeological remains, which can sometimes actually mask new perceptions of inherited religious symbols. Examples of such an internal, organic development are not difficult to find, even among the most fundamental cultic elements whose roles altered in a changing society. Altar and sacrifice, for instance, are well documented in the Bronze

Age, but they served rather different functions then.

There is now general agreement that blood sacrifice was an important feature of Minoan/Mycenaean religion.[71] The remains of sacrificial ashes have been found in most cult areas in palaces, rural shrines, peaks, and caves,[72] but not in connection with cult statues, or even on altars, which either were untouched by fire or show only light traces of burning.[73] Minoan and Mycenaean altars primarily served for the deposition of gifts instead, while the victims were slaughtered on separate platforms or on movable tables both outdoors and indoors, as in Temple Gamma at Mycenae, for example.[74] Hence the act of killing and the consumption of the meat were not central to the prehistoric ritual, which focused on the significance of the victim's blood. This was collected and stored in special rooms during the early palace period and subsequently in the pillar crypts.[75] It was an act of renewal whose central symbols of sacrificial double axe and blood survived, as I have tried to show elsewhere.[76]

The evidence reveals a difference from Greek practice in the Geometric and Early Archaic sanctuaries, where the ritual was associated with a fire or ash altar.[77] The impetus for the latter once more came from the Semitic east, and so did the idea of involving the gods in the shared sacrificial meal.[78] Accordingly, the notion of the gods eating a part of the burnt offerings, which Aristophanes lampooned in *The Birds*, was older than Hesiod's *aition* of Prometheus' deception would suggest.[79] The idea is common coinage in the *Iliad*: men persuade the gods with the aroma of burning meat rising from the fire altar.[80] It is well known in the Old Testament, but ultimately derived from a theme of the ancient Near East. Utnapishtim made sacrifice after the Flood and the hungry "gods smelled the sweet savour, the gods crowded like flies around the sacrifice."[81]

In Cypriot Kourion the Archaic ash altar was in contrast with the old-style sanctuary. Elsewhere both traditions came together remarkably early. Temenos A and Temples 4 and 5 at Kition, for example, seemed to integrate eastern and western ways before the Bronze Age had been rung out.[82] In Greece Apollo Maleatas' sanctuary at Epidaurus shows not conflict but continuity from Mycenaean to historical ash altars. At Mycenae the rectangular stone altar, just west of Temple Gamma, reproduced a thirteenth-century Assyrian type in startling contrast to the Mycenaean fixtures inside the temple itself.[83] The juxtaposition was not accidental; it illustrates the Aegean/Greek willingness to combine inherited traditions with the customs of others. At Kato Syme Minoan/Mycenaean sacrificial procedure was preserved until the seventh century B.C., judging from the scene on a cut-out bronze plaque, in an astonishing case of conservatism.[84] It is almost as if five centuries had passed without a trace, so content were the Aegeans with their old religion.

NOTES

1. Coldstream, *Geometric Greece*, 317; Walter Burkert, *Greek Religion, Archaic and Classical*, trans. John Raffan (Oxford, 1985), 50.

2. On the rock in the Telesterion, see George E. Mylonas, *Eleusis and the Eleusinian Mysteries*, 3d ed. (Princeton, 1974), 83–84; Bernard C. Dietrich, *Tradition in Greek Religion* (Berlin, 1986), 35. On the connection of rock and stone with rebirth in religions, see Mircea Eliade, *The Forge and the Crucible*, 2d ed. (Chicago, 1978), chap. 4, "Petra Genitrix."

3. See references in Bernard C. Dietrich, "The Transmission of Symbolism in Aegean Religion," in *Festschrift L. Press* (forthcoming).

4. G. Rizza and G. S. M. Scrinari trace the development of the Athena figure at Gortyn in *Il Santuario sull' Acropoli di Gortina* (Rome, 1968), pl. 11, no. 59 (seventh century); pl. 14–16.

5. D. Burr, "A Geometric House and Proto-Attic Votive Deposit," *Hesperia* 2 (1933), 542; Emily T. Vermeule, *Götterkult*, ArchHom, 3,5 (Göttingen, 1974), 162, pl. V and Xa. Vermeule believes (164) that it was a local chthonic figure and the gesture of upraised arms a deliberate archaism. For a more convincing case in favor of continuity of tradition, see Stefan Hiller, "Mycenaean Tradition in Early Greek Cult Images," in *Sanctuaries and Cults in the Aegean Bronze Age*, eds. Robin Hägg and Nanno Marinatos (Stockholm, 1981), 92–93, fig. 2.

6. See Bernard C. Dietrich, "The Instrument of Sacrifice," in *Early Greek Cult Practice* (Stockholm, 1988), 35–40; and "A Minoan Symbol of Renewal," *Journal of Prehistoric Religion* 2 (1988), 12–24.

7. Einar Gjerstad, *SwCyprusExp*, 4,2 (Stockholm, 1948), 1–23.

8. Dietrich 1986, 122.

9. Fourteenth century B.C.: Gjerstad, *SwCyprusExp*, 1 (Stockholm, 1934), 356–370; Vassos Karageorghis, *Cyprus: From the Stone Age to the Romans* (London, 1982), 69.

10. E. Sjöquist, "Die Kultgeschichte eines Cyprischen Temenos," *ArchRW* 30 (1933), 308–355; cf. *SwCyprusExp*, 4,2 (1948), 1; Karageorghis 1982, 141–142.

11. See Karageorghis 1982, n. 7.

12. For discussion with references, see Dietrich 1986, chap. 4.

13. See, for example, H. Ringgren, *Religions of the Ancient Near East* (London, 1973), 127.

14. See the vast literature on contemporary metal figurines in P. R. S. Moorey and Stuart Fleming, "Anthropomorphic Metal Statuary," *Levant* 16 (1984), 67–90; H. Gallet de Santerre, "Les Statuettes de bronze mycéniennes au type dit du 'Dieu Reshef' dans la contexte égéen," *BCH* 111 (1987), 7–29. On the liwan-type temple and its parallels, see Gjerstad, *SwCyprusExp*, 4,2 (1948), 2.

15. Dietrich 1986, n. 10.

16. On the full literature, see Dietrich 1986, 135–136, 163–165.

17. His bearing, horns, or sometimes the find context prove the figure's divine status among a massive host of votives. The iconographic type of the Smiting God has been much discussed. Important comprehensive studies are those by V. Müller, *Frühe Plastik in Griechenland und Vorderasien* (Augsburg, 1929); O. Negbi, *Canaanite Gods in Metal* (Tel Aviv, 1976); H. Seeden, *Prähistorische Bronzefunde*, Abt. 1, Bd. 1: *The Standing Armed Figures in the Levant* (Munich, 1980); A. Spykett, *Le Statuaire du Proche-Orient ancien* (Leiden, 1981) (including Iron Age figures); Moorey and Fleming 1984, 67–90; H. Gallet de Santerre 1987, 7–29. The last two studies contain full up-to-date bibliographies.

18. Gallet de Santerre 1987, 16 n. 58, 21.

19. Hiller 1981.

20. Seeden 1980, Group XII; J. D. Muhly, "Bronze Figurines and Near Eastern Metalwork," *IEJ* (1980), 155; Moorey and Fleming 1984, 74. The example from the Artemision on Delos was a Mycenaean dedication (thirteenth century B.C.) but part of a composite deposit, the latest elements of which date to 700 B.C.: Gallet de Santerre 1987, 19.

21. Gallet de Santerre denies that there was a cultural link between the Late Helladic IIIB/C god in the cult deposit at Samos and the figures from the eighth century: 1987, 8. This seems too negative a view in the light of the Samian and related evidence.

22. Dietrich 1986, 136–139, with references.

23. On Qasile see V. Karageorghis, "Kition, Mycenaean and Phoenician," in *Mortimer Wheeler Archaeological Lecture, British Academy 1973*, ProcBritAc (London, 1973), 27; Amihai Mazar, "The Philistine Sanctuary at Tell Qasile," in *Temples and High Places in Biblical Times*, ed. Avraham Biran (Jerusalem, 1981), 105–107.

24. See, for example, Claude Rolley, "Les grands sanctuaires panhelléniques," in Hägg (ed.), *Greek Renaissance*, 113.

25. Perhaps the Minoan temple at Arkhanes is the earliest example of the type in Crete. But its exact form is uncertain. See Dietrich 1986, 140.

26. George E. Mylonas, *Mycenaean Religion: Temples, Altars and Temenea* (Athens, 1977), 92–93; Elizabeth French, "Cult Places at Mycenae," in Hägg and Marinatos (eds.), *Sanctuaries*, 41–48; Bogdan Rutkowski, *The Cult Places of the Aegean* (New Haven, Conn., 1986), 175–178. Clear descriptions and illustrations of both Mycenae and Tiryns in Konstantinos P. Kontorlis, *Mycenaean Civilization: Mycenae, Tiryns, Asine, Midea, Pylos* (Athens, 1985), i–v, 50, 62–63.

27. Klaus Kilian, "Zeugnisse Mykenischer Kultausübung in Tiryns," in Hägg and Marinatos (eds.), *Sanctuaries*, 49–58; Rutkowski 1986, 185–189.

28. Colin Renfrew, *The Archaeology of Cult: The Sanctuary at Phylakopi, BSA* suppl. vol. 18 (1985), chap. 3, "The Sanctuary Sequence."

29. *Pace* Renfrew, who differentiates between the open courtyards of Cypriot sanctuaries and the roofed Aegean shrines: 1985, 413, 435.

30. Kilian 1981, figs. 2, 4, 5.

31. There is some evidence of alterations to the altar in IIIC: Kilian 1981, 53.

32. See, for example, Ringgren 1973, 77.

33. For example, the Grand Staircase Fresco; see M. A. S. Cameron, "New Restorations of Minoan Frescoes from Knossos," *BICS* 17 (1970), 163–166; Robin Hägg, "Pictorial Programmes in Minoan Palaces and Villas" in *L'Iconographie minoenne*, ed. P. Darcque and J. C. Poursat, in *BCH* suppl. 11 (1985), 210–211.

34. *PM*, 2, pls. 119, 125.

35. See, for example, Hägg 1985, 212.

36. Rutkowski 1986, 82, 119, 198, is somewhat vague on processions in Minoan ritual.

37. Ringgren 1973, 77.

38. Renfrew 1985, chap. 3.

39. The latter replaced a similar platform in the southwest of the temple after the destruction in 2b: Renfrew 1985, 71–149. According to Renfrew, Room A was abandoned after the collapse, 112–116.

40. Mylonas 1977, 91–92.

41. Miriam E. Caskey, "Ayia Irini, Kea: the Terracotta Statues and the Cult in the Temple," in Hägg and Marinatos (eds.), *Sanctuaries*, 128.

42. Stefan Hiller, "Mykenische Heiligtümer: Das Zeugniss der Linear-B Texte," in Hägg and Marinatos (eds.), *Sanctuaries*, 95–126.

43. *Iliad*, 1, 39.

44. 1,183; 6,19.

45. For example, Herodotus 2,69.

46. On the terracottas see Elizabeth French, "Figures and Figurines," in Renfrew (ed.), *Phylakopi*, chap. 4, 209–280. The bronze Smiting Gods were not found inside either shrine but on the cult site: Renfrew 1985, 303, 424–425.

47. R. Hachmann and A. Kuschke, *Kamid el-Loz 1968–70* (Bonn, 1980), 37; Moorey and Fleming 1984, 80; Negbi 1976, 142, believes that only male deities were worshiped in the temple.

48. The Middle Bronze Age iconographic types were different, but the couples had the same character of war god and consort: Negbi 1976, 117.

49. F. M. Cross, *Canaanite Myth and Hebrew Epic* (Cambridge, 1973), 30–31; Negbi 1976, 117–119; A. Caquot and M. Sznycer, *Ugaritic Religion, Iconography of Religions*, 15,8 (Leiden, 1980).

50. References in Negbi 1976, 141–142.

51. See, for example, Negbi 1976, 142; compare the interesting discussion in chap. 10 of Martin Bernal, *Black Athena* (London, 1987), including the plausible, but occasionally eccentric, views of Cyrus Gordon and Michael Astour, among others, 416–427.

52. See Negbi 1976, 142.

53. H. W. Catling, *Cypriote Bronzework in the Mycenaean World* (Oxford, 1964), 86; Negbi 1976, 39; Dietrich 1986, 164–165.

54. Vassos Karageorghis, *Kition: Mycenaean and Phoenician Discoveries in Cyprus* (London, 1976), 74–75; compare *CAH*, 3,3 (Cambridge, 1982), 61; Karageorghis 1982, 104–105.

55. Xd 97; Tn 316; An 607.5; Cn 1287.6 (*diwija/diuja*). On PY Tn316 Zeus is already associated with Hera in the Greek tradition, of course, but clashes elsewhere (Tn319) with the odd man out, Drimios. Stefan Hiller-Oswald Panagl, *Die Frühgriechischen Texte aus Mykenischer Zeit* (Darmstadt, 1976), 293, 296, 301. Compare Dietrich 1986, 49, 117.

56. Hiller 1976, 307, 308.

57. Renfrew 1985, 373, 381. The same types were also offered in the later East Shrine in a striking example of duplicate dedications: French 1985, 277 and table 6.2.

58. See P. Faure, *Fonctions des cavernes crétoises* (Paris, 1964), 139; Gallet de Santerre 1987, 18; compare Colette Verlinden, *Les Statuettes anthropomorphes crétoises en bronze et en plomb, du IIIe millénaire au VIIe siècle av. J.C.*, Archeologia Transatlantica, 4 (Providence–Louvain-du-Neuve, 1984), 53.

59. Karageorghis 1976, 75–76.

60. Gallet de Santerre 1987, 26. For the eighth-century B.C. bronze figure on an ingot, see H. W. Catling, "Archaeology in Greece, 1978–79," in *JHS, Ar* (1978–1979), 38, fig. 50.

61. See Bernard C. Dietrich, "Tradition in Greek Religion," in Hägg (ed.), *Greek Renaissance*, 85–90.

62. It has been proposed to date the Cretan bronzes to IIIC rather than later: Renfrew 1985, 437, with the relevant references.

63. Renfrew 1985, 424.

64. S. Hiller, "Mykenische Archäologie," *SMEA* 20 (1979), 193; and compare Dietrich 1986, 117.

65. Walter Burkert, "Resep-Figuren, Apollon von Amyklai und die 'Erfindung' des Opfers auf Cypern," *Grazer Beiträge* 4 (1975), 64; Renfrew 1985, 307.

66. Renfrew 1985, 434–435.

67. There are many discussions of the significance of multiple cult figures, both as reinforcing the concept of divinity and as representing separate aspects of one major deity. See Bernard C. Dietrich, *Origins of Greek Religion* (Berlin, 1974), 283–289; Ringgren 1973, 140.

68. Verlinden 1984, 53.

69. Renfrew 1985, 396, 405, 435, 438.

70. Renfrew argues that the cult center at Mycenae

had always been the sole site of cult, which was not practiced in the megaron: 1985, 401, 403.

71. Doubts were first formally expressed by C. H. Yavis, *Greek Altars, Origins and Typology Including the Minoan-Mycenaean Offering Apparatus: An Archaeological Study in the History of Religion*, St. Louis University Studies, Monograph Series, Humanities, No. 1 (St. Louis, 1949), 41; compare Burkert 1985, 35.

72. Nanno Marinatos, *Minoan Sacrificial Ritual: Cult Practice and Symbolism*, Acta Inst. Ath. Regni Sueciae 8,9 (Stockholm, 1986), 37–39.

73. Marinatos 1986, 15–35; Mylonas 1977, 104; Rutkowski 1986, 106, leaves the possibility open, "fire altars were possibly used."

74. Mylonas 1977, 104–105; Marinatos 1986, 49.

75. Salle Beta at Mallia; Knossos, palace (west wing), Royal Villa, Little Palace: Marinatos 1986, 19–21, 30.

76. See Dietrich, "The Instrument of Sacrifice" and "A Minoan Symbol of Renewal." Marinatos arrives at the same conclusion but by a different route: 1986, 27.

77. For an up-to-date history of Greek altars with all the relevant modern literature, see David W. Rupp, "Reflections on the Development of Altars in the Eighth Century B.C.," in Hägg (ed.), *Greek Renaissance*, 101–107.

78. H. Ringgren, "Symbolism of Mesopotamian Cult Images," in *Religious Symbols and Their Functions*, ed. H. Biezais (Stockholm, 1979), 107; Ringgren 1973, 77.

79. Hesiod, *Theog.*, 535–557, with Martin L. West's commentary in his edition of the *Theogony* (Oxford, 1966), 317–322.

80. *Iliad*, 9, 497–500; 1,66–67, 316.

81. *Gen.* 8:21; *Lev.* 26:31. E. A. Speiser's translation of *Gilgamesh* 11, 160, in James B. Pritchard, *Ancient Near Eastern Texts*, 3d ed. (Princeton, 1969), 95. Compare J. P. Brown, "The Sacrificial Cult and Its Critique in Greek and Hebrew," *Journal of Semitic Studies* 24 (1979), 159–173; 25 (1980), 1–21.

82. Mix of fire altars, offering tables, horns of consecration: Karageorghis 1982, 94–98.

83. Henri Frankfort, *The Art and Architecture of the Ancient Orient* (Harmondsworth, 1970), 132, figs. 149 and 150 a–b; Rupp, 1983, 107.

84. Angeliki Lembesi, To Hiero Tou Herme KAI TES Aphrodites ste Syme Viannou I (Athens, 1985), 230, pl. 43 A15.

RESTORED
CAPITAL ρ

CAPITAL A

EXISTING DRUMS:

a

b

c

TEMPLE III:
RESTORED
COLUMN

RICHARD V. NICHOLLS

Fitzwilliam Museum (emeritus)

Early Monumental Religious Architecture at Old Smyrna

The ancient city of Old Smyrna lies on the west coast of Turkey at the modern village of Bayraklı, a little to the north of Izmir. Near its north edge a sequence of early temples was completely cleared by a team from the British School at Athens under John M. Cook as part of the Anglo-Turkish excavations of 1948–1951.[1] The southern and eastern limits of the precinct in which these temples stood were subsequently excavated by their Turkish colleagues under Ekrem Akurgal from 1966 on, also producing an inscription identifying the goddess worshiped there as Athena. The rich finds of early architectural members so revealed have recently been published by Akurgal, but the associated buildings and their chronology still need much more elucidation.[2] In fact, the material for a detailed account of these temples was fully assembled in 1955, with plans and drawings made by G. U. Spencer Corbett and the author, but it was then ruled that, as a gesture to their Turkish colleagues, the publication of this British part of the joint excavations should be deferred until the latter had caught up with their own schedule. This earlier material has recently been revised by the author—a task that has involved remaking many of the drawings to include the evidence from the subsequent excavations. Some of these drawings illustrate this short interim account. A detailed publication by the British School at Athens is to follow.

The main interest of these buildings lies in the evidence that two of them, Temples II and III, offer for the evolution of monumental religious architecture in northern Ionia over the last third of the seventh century B.C. The process in Archaic East Greece seems to have been somewhat analogous to that gone through much earlier in Egypt: the emergence of highly elaborate forms in more traditional materials, such as mud brick and timber, and then the translation of these on a grander scale into stone.

Apart from these temples, Old Smyrna also offers another piece of evidence highly relevant to the development of monumental stone architecture, indicating that advanced ashlar masonry with both headers and stretchers is not just an Archaic creation but actually a legacy from a much more remote past. In the late ninth century B.C. just such a construction in white tufa ashlar blocks was used for the superstructure of the City Wall 1 tower at Old Smyrna's North-East Gate instead of the more usual mud brick.[3] At this early date such masonry seems as remote from contemporary house and temple building as it is abnormal here, adapted as a tower facing. At this stage was its more regular use perhaps to be found in contemporary palace walls, of which, unfortunately, we as yet know very little?[4]

Inner Defense Platform

The earlier and later phases of the Athena temples can here only be dealt with sum-

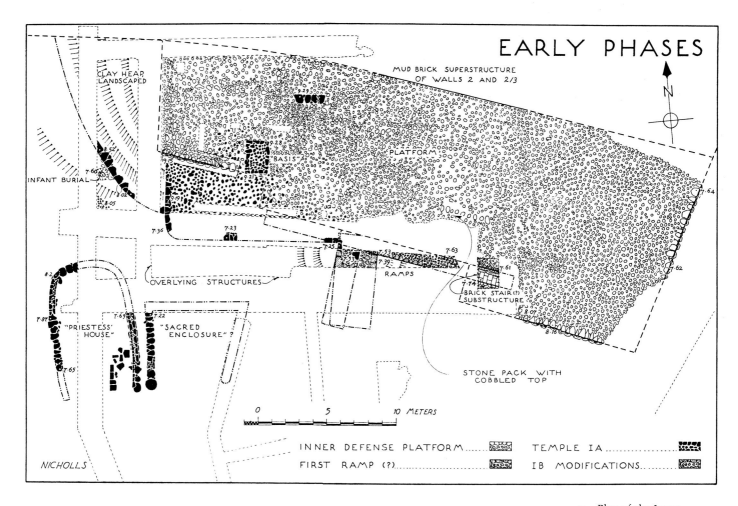

EARLY PHASES

CLAY HEAP LANDSCAPED

MUD BRICK SUPERSTRUCTURE OF WALLS 2 AND 2/3

N

INFANT BURIAL

"BASIS"

PLATFORM

OVERLYING STRUCTURES

RAMPS

BRICK STAIR (?) SUBSTRUCTURE

"PRIESTESS' HOUSE"

"SACRED ENCLOSURE"?

STONE PACK WITH COBBLED TOP

0 5 10 METERS

INNER DEFENSE PLATFORM

FIRST RAMP (?)

TEMPLE IA

IB MODIFICATIONS

NICHOLLS

1. Plan of the Inner Defense Platform inside the North-East Gate at Old Smyrna and of Temple I in the sanctuary of Athena
All drawings by author

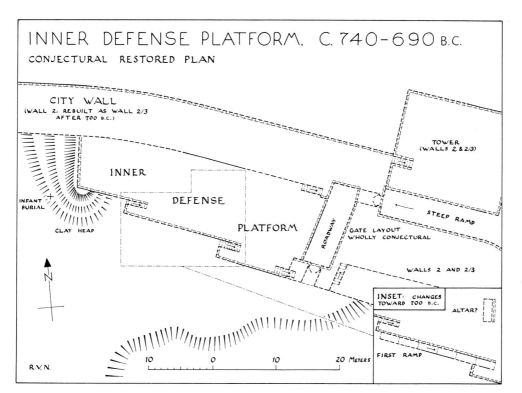

INNER DEFENSE PLATFORM, C. 740–690 B.C.

CONJECTURAL RESTORED PLAN

CITY WALL
(WALL 2, REBUILT AS WALL 2/3 AFTER 700 B.C.)

TOWER
(WALLS 2 & 2/3)

INNER

DEFENSE

PLATFORM

INFANT BURIAL

CLAY HEAP

ROADWAY

STEEP RAMP

GATE LAYOUT WHOLLY CONJECTURAL

WALLS 2 AND 2/3

N

INSET: CHANGES TOWARD 700 B.C.

ALTAR?

FIRST RAMP

R.V.N.

10 0 10 20 METERS

2. Restored plan of the Inner Defense Platform at Old Smyrna, c. 740–690 B.C.

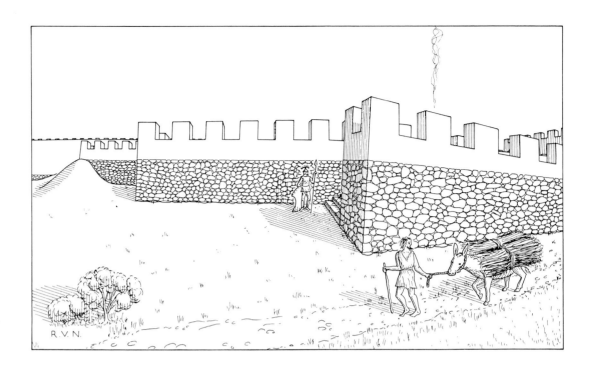

3. Restoration of the Inner Defense Platform as first completed, viewed from the south

marily, the dates used being based on conventional Greek pottery chronology.[5] Initially the site of the temples seems to have been occupied by purely military installations. A large heap of brown clay may possibly have been a facility for making running repairs to the mud brick superstructure of City Wall 1 (the fortification whose tower masonry at the adjoining gate has just been discussed).[6] The raised area between this heap and the gate may at this stage have been occupied by the watchfires and bivouacking of the guards manning the walls and gate, and this may also provide some clue as to the function of the Inner Defense Platform that next covered this site (figs. 1–3). This was erected very early in the Late Geometric period, probably around 740 B.C., as an integral part of the new City Wall 2.[7] It was a massive construction with crudely fitted andesite faces, a solid packed fill of river boulders with a level cobbled top and, possibly, originally a mud brick parapet. The reconstruction (fig. 3) tries to suggest its original appearance, but the role of such an inner fort is puzzling. At the point of transition from the Middle to the Late Geometric period, around 750 B.C., the population of the city seems suddenly to have increased enormously, the new arrivals living in rudimentary curved huts with animal pens, bins, and granaries squeezed between

them in more of a peasant than an urban economy. These extra inhabitants may have provided much of the labor for erecting the vastly more massive City Wall 2. The author is tempted, perhaps rashly, to link this influx with the arrival at Old Smyrna of the Colophonian refugees mentioned by Herodotus and to view this Inner Defense Platform as one of the devices used by the original Aeolian inhabitants of the city to maintain control in the face of this large new body of Ionians.[8]

The appearance of votive offerings may suggest the beginning of a public cult on this platform in the very last years of the eighth century B.C., and the construction of a ramp-way at about that date (fig. 2, inset)[9] may have been to allow access for processions with sacrificial animals, although, unfortunately, the surface of the eastern part of the platform where altars may have stood has been eroded away. If the earlier hypothesis is justified, the new cult, too, may have had political undertones. The adjoining North-East Gate was apparently the main exit to the estuary and to the Smyrna valley and was thus quite probably the very gate that the Ionian refugees eventually closed against the Aeolians while they were celebrating a festival of Dionysos outside the city walls, thus seizing possession of Old Smyrna.[10] Around 700 B.C. a major

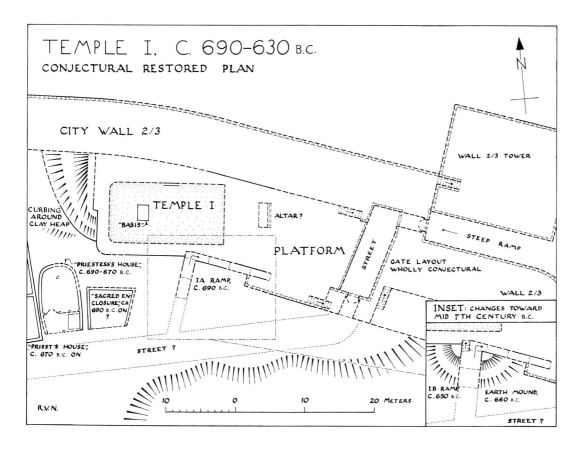

TEMPLE I, C. 690-630 B.C.
CONJECTURAL RESTORED PLAN

CITY WALL 2/3

WALL 2/3 TOWER

CURBING
AROUND
CLAY HEAP

TEMPLE I

"BASIS"

ALTAR?

STEEP RAMP

"PRIESTESS'S HOUSE",
C. 690-670 B.C.

PLATFORM

STREET

GATE LAYOUT
WHOLLY CONJECTURAL

WALL 2/3

IA RAMP,
C. 690 B.C.

INSET: CHANGES TOWARD
MID 7TH CENTURY B.C.

"SACRED EN-
CLOSURE; CA
690 B.C. ON
?

"PRIEST'S HOUSE",
C. 670 B.C. ON

STREET ?

R.V.N.

10 0 10 20 METERS

IB RAMP
C. 650 B.C.

EARTH MOUND,
C. 660 B.C.

STREET ?

4. Restored plan of the
sanctuary of Athena at Old
Smyrna at the time of
Temple I, c. 690–630 B.C.

earthquake seems to have destroyed all the houses inside the city and the brick super-structure of the fortifications. The most vulnerable part of the defenses, that around the north side of the town facing the isthmus, was hastily reinstated as City Wall 2/3,[11] although much of the rest of the circuit was left in ruins. The houses were more gradually rebuilt, mostly as fine rectangular structures with many rooms.

Temple I

The first of the Athena temples, Temple I, was erected around 690 B.C. (figs. 1, 4, 5).[12] Compared with the new houses it may have seemed rather conservative, as if harking back to the earlier curved buildings. These, to be sure, were usually oval, but apsidal forms, as possibly attested here, also occurred more rarely.[13] The platform was extended to the southwest to accommodate the temple, its new faces consisting of fine, large andesite blocks fitted in a Lesbian fashion and without any footing course. Much of the old clay heap was surrounded by curbing and a new lower

end was built for the ramp. Little survives of the temple building itself on top of the platform, but a short length of wall footing and the so-called "Basis" are both oriented to this new platform.[14] The "Basis" is simply a low raised area in the cobbled floor. If its center marks the axis of a building that followed the shape suggested by the new platform and the wall footing mentioned, then it may be possible to infer something of that building's outline. Figure 5 suggests the possible appearance of the sanctuary at the beginning of this phase,[15] which lasted for about sixty years. Problems apparently arose with the stability of the lower part of the ramp, which was shored up with earth mounds and then replaced toward 650 B.C. by the IB ramp (fig. 4, inset).[16]

Temple IIA

Temple IIA seems to have been much more elaborate, although apparently still constructed of traditional materials (figs. 6–8). It was erected after the start of the Protocorinthian Transitional period, probably toward

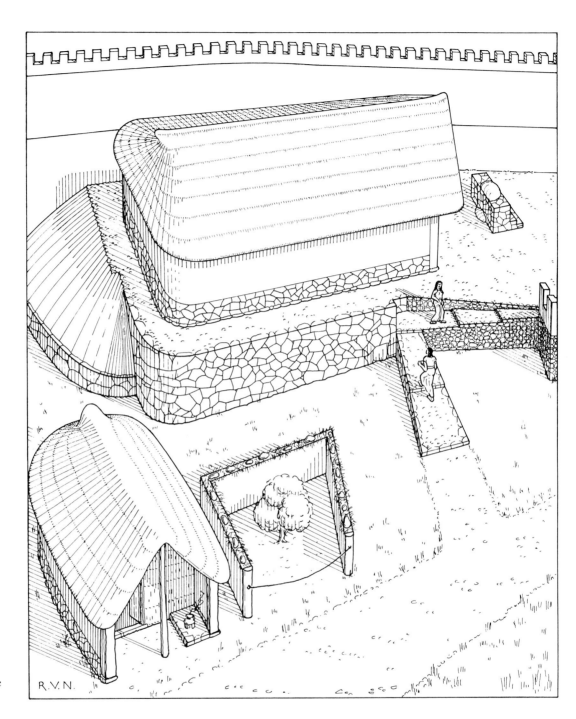

5. Restoration of the Athena sanctuary at the beginning of the period of Temple I, viewed from the southwest

630 B.C.[17] Again a massive extension was added to the southwest of the platform to receive the new temple, in this case with a clearly defined length of 29.94 m, suggesting that from the outset the temple was intended as a hundred-footer, or *hekatompedon*, although the foot used seems slightly longer than the normal Ionic one of 29.6 cm. The south face of the new platform was in andesite polygonal masonry, some of it well dressed and some rather coarser,[18] possibly because the decision that it should be hidden in the next phase (IIB) was actually taken during its construction. For this site was now entering a period of almost constant building activity. Possibly to avoid any risk of collapse, the new ramp seems to have been a curious layered construction with stepped faces.[19] Parts of this temple's south cella wall also survive, thanks to its incorporation in later buildings.[20] Its footings form a sunken *toichobate* with its top flush with the cob-

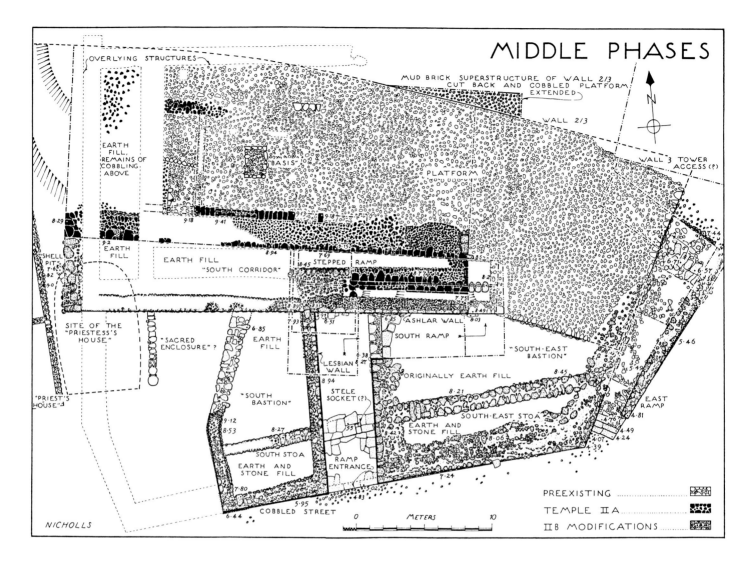

6. Plan of Temple II in the sanctuary of Athena at Old Smyrna

bling; on this rests a low socle of one course of small andesite ashlar orthostates forming a low projecting dado under the slightly narrower mud brick wall that once went above.[21] A cutting in the preserved footing marks the line of the west wall of the cella.[22] Beyond to the west there seems to have been some form of rear shrine, an *adyton* or *opisthodomos*, faintly marked by stone bedding, apparently to take the footings of its north wall. For the floor of this west part of the temple seems to have been at a higher level, although what survives of its cobbling has been heavily mauled by later building. Likewise at the east end of the new temple building the cobbling was lowered about 20 cm and lowered further again over the area beyond the new platform extension. There are no stone column bases from this structure, and there is no evidence that the cobbled surface was disturbed to receive them, yet developments in the suc-

ceeding IIB phase strongly suggest that this temple was, in fact, peripteral. The stone bases attested from seventh-century houses at Old Smyrna (for example, fig. 10, bottom)[23] served to keep the bottoms of the wooden columns a little above the earth floor. On a great stone platform such as this they may have been felt unnecessary, and the bases, if they existed at all, may simply have been discs, possibly of wood, resting on top of the cobbling. Figure 8 offers a possible reconstruction of the initial appearance of this temple on this basis and on the assumption that the form of its wooden columns may be inferred from that of their only slightly later stone successors of Temple III (see fig. 13).[24]

Temple IIB

In the previous IIA stage the lowered area

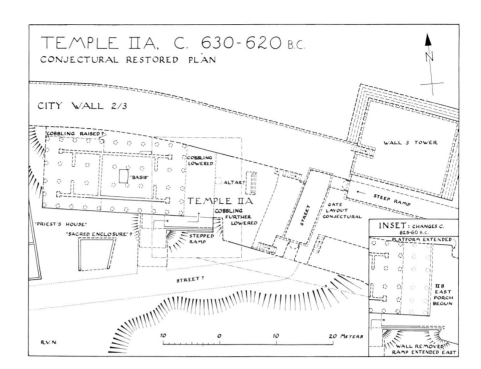

7. Restored plan of the sanctuary of Athena at Old Smyrna at the time of Temple IIA, c. 630–620 B.C.

8. Restoration of Temple IIA as first completed, viewed from the southeast

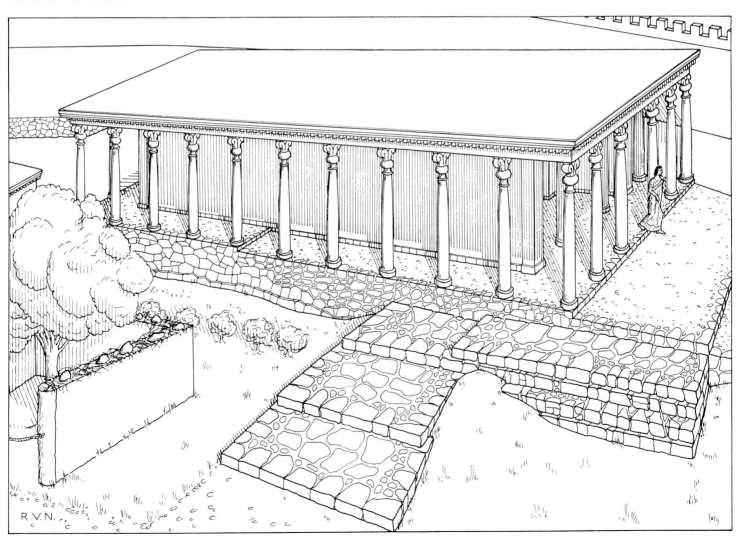

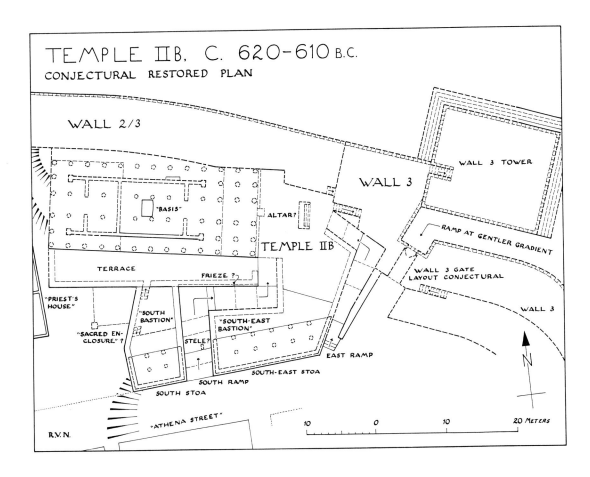

TEMPLE IIB, C. 620-610 B.C.
CONJECTURAL RESTORED PLAN

WALL 2/3

WALL 3

WALL 3 TOWER

"BASIS"

ALTAR?

TEMPLE IIB

RAMP AT GENTLER GRADIENT

TERRACE

FRIEZE ?

WALL 3 GATE
LAYOUT CONJECTURAL

"PRIEST'S
HOUSE"

"SOUTH
BASTION"

"SOUTH-EAST
BASTION"

WALL 3

"SACRED EN-
CLOSURE" ?

STELE?

SOUTH-EAST STOA

EAST RAMP

SOUTH RAMP

SOUTH STOA

"ATHENA STREET"

R.V. N.

10 0 10 20 METERS

N

along the east end of the temple platform was apparently left open as a sort of terrace leading out to the ramp. Very shortly afterward, however, in the initial phase of Temple IIB, the ramp itself was extended eastward to open onto the older platform beyond, and the inner mud brick face of the fortifications to the north was cut back,[25] it would seem to allow an apparent north colonnade to be extended east across this area; the temple could now fill the whole hundred-foot platform (fig. 7, inset).

The new City Wall 3 North-East Gate[26] seems to have been already under construction by the third quarter of the seventh century and to have been set much lower than its predecessors, opening onto the lower ground to the south of the temple. The completion of this gate seems to have led around 620 B.C. to the major remodeling of the southern and eastern parts of the sanctuary constituting the main phase of Temple IIB (figs. 6, 9).[27] A terrace was added to the south of the platform, strangely oriented to the long-vanished Temple I,[28] and the surviving face

of the east leg of the IIA ramp was converted into a relieving wall that was extended westward, reusing the masonry from the rest of that ramp. This was apparently to take the pressure off the fine Ashlar Wall of the South Ramp just to the south. Two large new ramps were in fact built at this stage, the East Ramp[29] and the sunken South Ramp. This latter was a splendid construction. The courses of the Ashlar Wall mentioned curve gently up to the east, following on up the ramp, their line accentuated by a contrasting projecting horizontal.[30] Above, the wall's backing forms a level top, suggesting that the construction continued beyond this in a different material at least up to the full height of the adjoining Lesbian Wall.[31] There are a number of fragments from an animal frieze in relief in white tufa from this area,[32] and it seems possible that it may have been located here, set off by the subtle curved coursing of the Ashlar Wall. To either side of the entrance to the South Ramp great walls[33] enclosed platforms of compacted fill that seem to have carried stoas built of mud brick and timber

9. Restored plan of the sanctuary of Athena at Old Smyrna at the time of Temple IIB, c. 620–610 B.C.

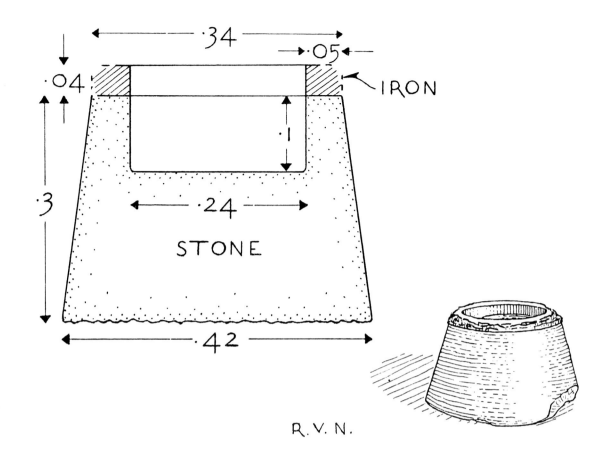

IRON

STONE

R.V.N.

·25

10. *Above*: stone base, from the IIB stoas (?), found in the Weapons Deposit; *below*: andesite column base from a house at Old Smyrna, first half of the seventh century B.C.

and set at the new, higher level now adopted for all save the southwest part of the temenos. A stone base with a socketed top that has an iron ring corroded onto it (fig. 10)[34] has been tentatively linked by the author with inner columns of these stoas resting on the earth fill. Vertical cracking must have been one of the chief hazards with wooden columns, and here the double precaution may have been taken of sweating on an iron ring and of bedding the shaft inside the base. The scale is not much greater than that of domestic building, as shown by the accompanying typical column base from a house.[35]

Main Period of Temple III (Phases IIIA–C and Temple IVA)

Temple III (figs. 11–15) was begun after the start of the Early Corinthian period, probably about 610 B.C.[36] This was to have been a truly monumental building, with andesite substructures and with walls and columns of white tufa. The south wall of the IIB terrace

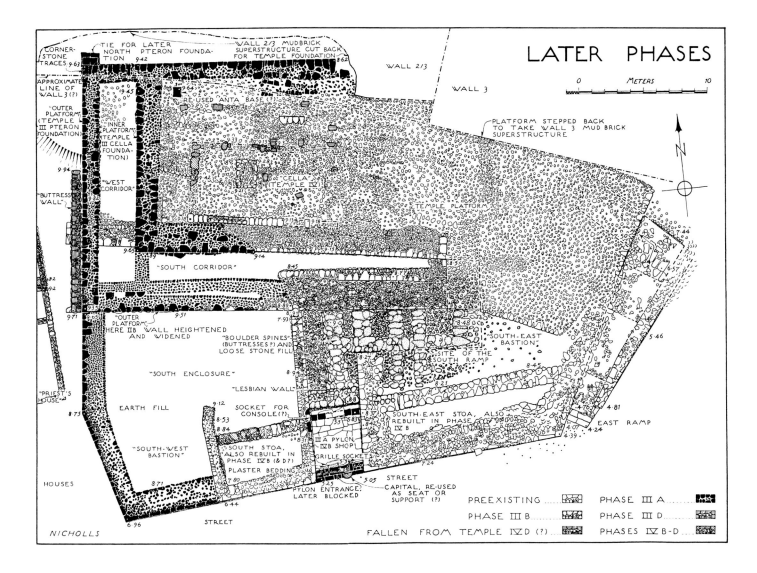

11. Plan of Temples III and IV at the sanctuary of Athena at Old Smyrna

was raised and broadened to form the foundation for the new temple's south colonnade, and new foundations were built for its cella and west colonnade[37] across the western part of Temple II. The mud brick fortifications had to be severely cut into to make room for its north cella wall, and there was no space at all for its north colonnade, whose construction had to be deferred until the whole tell could be enlarged and the city wall and gate moved at least 12 m farther north. That this colonnade was nevertheless eventually intended seems clear from the tie constructed at the northwest corner for its foundations to bond onto.[38] It also appears certain that this building was never completed, even in this partial form, on the evidence of its unfinished masonry and, even more so, of its uncompleted foundations. Thus the north cella wall foundations never extended farther east than they

do now, because this is also the limit of the trench cut into the mud brick of the fortifications to receive them; the south cella wall, likewise, seems never to have got beyond the present bounds of its foundations.

A part of the new construction that appears to have been completed quite early was the Pylon now set at the entrance to the existing South Ramp. Its north edge is marked by a slot cut in the earlier Lesbian Wall to take some form of massive console that has not survived, set directly above the base for the pilaster that once also supported it.[39] Its outer door to the south[40] had a white tufa threshold and jambs and seems originally to have had a frame carrying a hinged (?) grille secured against its inner face; the three white tufa sockets supporting the grille frame were bedded, after fine adjustment, in a weatherproof plaster employed much as we should today

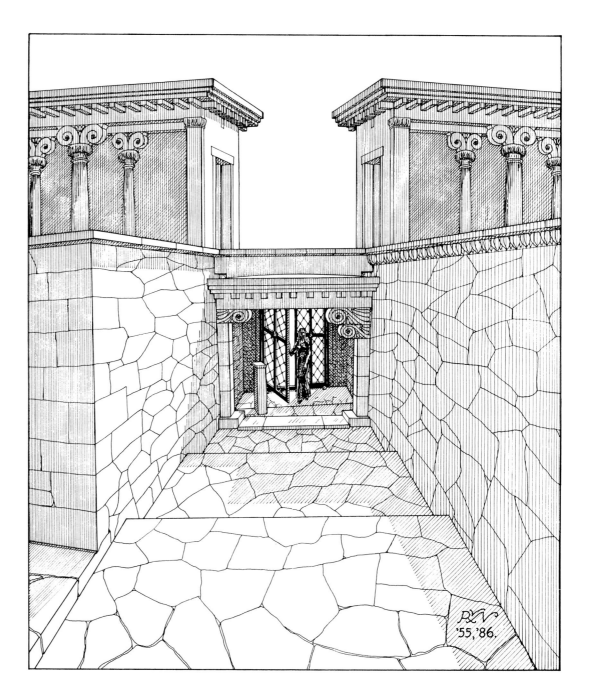

12. Restoration of the South Ramp in the IIIA Phase, viewed from the north and showing the IIIA Pylon and the IIB stoas

use concrete. The curious thing about this building is that it blocked the drainage of the South Ramp and would have flooded when it rained. It is as if its architect was not used to rain! Figure 12 suggests the appearance of the Pylon when first constructed, at this stage still flanked by the earlier IIB stoas, which may now have communicated across its roof. In the next phase work was started on rebuilding these stoas with higher floors, to correspond with the new higher level to which the southwest part of the temenos was now raised,[41] and with white tufa columns,[42] but this never progressed beyond its early stages.

The best preserved of the capitals from the great new temple (fig. 13, Capital A) was

found on the outer step of the Pylon.[43] It has been claimed that the Old Smyrna capitals of this form[44] were actually bases, set either this way round[45] or the other way up,[46] but neither contention seems very plausible. They all have a rounded molding at the bottom, curving through to the underside. When first found, the present example still also retained faint traces of an incised setting-out circle on its underside, giving the diameter of the column drum to which it was doweled below and revealing that this molding projected considerably from the column shaft and may thus also have constituted the upper torus of the latter. On this evidence, this capital can readily be assembled with the three fully surviv-

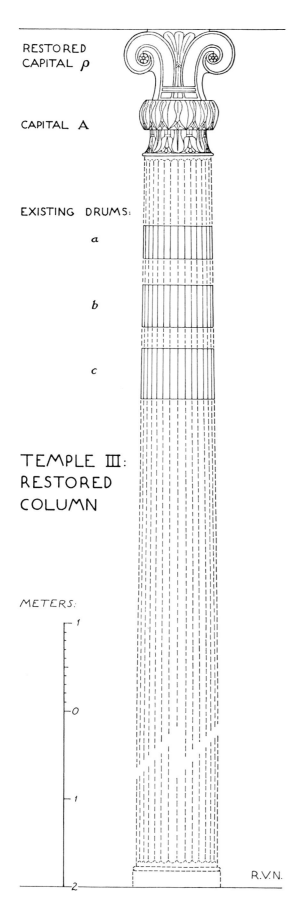

RESTORED
CAPITAL ρ

CAPITAL A

EXISTING DRUMS:

a

b

c

TEMPLE III:
RESTORED
COLUMN

METERS:

1

0

1

2

R.V.N.

ing finished column drums, all with thirty-two flat facets instead of flutings (fig. 13, *a*, *b*, *c*).[47] Because they lack an abacus of their own, it seems likely that these "mushroom-shaped" capitals were used as shown in figure 13 under the volute capitals from this temple,[48] since the bottoms of these last were not circular in plan and thus also required just such an intermediate member between them and the shaft.[49] In Archaic Greece such capitals are conventionally named Aeolic although, at this early stage with faceted columns, "northern Proto-Ionic" or "Proto-Aeolic" might be preferable. It has generally been accepted that traditional early Greek forms had been drastically modified under the influence of Middle Eastern architecture, the idea for both members having possibly reached the Greeks through representations on imported Phoenician and Syrian furniture and ivories.[50] The volute form has completely replaced the rectangular abacus of early Greek capitals. However, although the lower member has in many but not all cases adopted the oriental decoration of hanging leaves,[51] its profile shape may at this stage still also suggest the partial derivation of its form from the Mycenaean palm capital with both torus and cavetto,[52] the cavetto also persisting as a minor vestigial feature under the echinus of some early Doric and Ionic capitals.

The bases may not have survived.[53] The members so interpreted by Ekrem Akurgal seem, in fact, to be unfinished column drums.[54] In figure 13 a flat disc has been restored matching the height of a flat projecting dado that, it seems, may be attested at the bottom of the stone walls[55] above the apparently sunken toichobate, in much the same way as on those of its mud brick predecessor, Temple II, described earlier.

A closer consideration of the plan of the building (figs. 11, 14) yields further information. When construction began, one of the first acts seems to have been to demolish Temple II apart from its cella and to narrow that cella by what was probably most of the width of its north aisle. The resultant building, here designated Temple IVA,[56] seems to have been intended to serve as the interim cult place until part of its successor was sufficiently complete to replace it. The first stage of Temple III, termed Phase IIIA, seems to have aimed at finishing the north aisle of the new cella to do just that, with work con-

13. Restored column of the original Temple III construction in the sanctuary of Athena at Old Smyrna

centrated on the north and west parts of the building, so that at this stage things may have looked somewhat as shown in figure 15,[57] with Temples III and IVA coexisting at different levels.

Some other details of the emerging new temple may plausibly be inferred from its foundations. It is to be presumed that the imperfect right angles of the outer foundation for the stylobate were corrected in the white tufa construction that went above. Anomalies in the distance between this foundation and that for the cella wall suggest that a step about 1 ft wide may also have been accommodated below the south stylobate. The span of the main wooden roof beams was probably 15 ft, and the interaxial distance between the columns seems to have been either 15 ft or 7.5 ft, on the evidence that the deferred north part of the west pteron had itself to constitute a separate unit of the building. Along the west and south colonnades actually constructed it was more probably 7.5 ft or 5 ells, if only because of the sheer number of capitals of which there is surviving evidence from this clearly unfinished building—given by Ekrem Akurgal as seventeen of the "mushroom-shaped" members (apparently increased to twenty-two by lesser unpublished fragments) and twenty-four of the volute ones.[58] Such close spacing may suggest that these outer colonnades were to carry stone architraves.

We now come to the most vexed problem of all, and one which it is to be hoped that the author's Turkish colleagues, who control this material, will elucidate further by providing a much more detailed breakdown of the dimensions involved. This centers on the amazing variations in height and diameter shown by these capitals[59] and also reflected in the unfinished column drums mentioned earlier. These variations seem too numerous to be due simply to the use of broader columns in certain positions, such as flanking the building's central aisle. Ekrem Akurgal has attempted to resolve the dilemma by suggesting that many of the capitals may be from an unprecedented accumulation of strangely similar votive columns,[60] but Gerhard Kuhn has, probably rightly, pointed out that, despite their variability in matters of detail, these members seem all to represent a unified concept, designed for a single large building of great sophistication.[61] The outer colonnades may thus possibly have shown some

form of refinement unmatched in later Greek architecture, such as that suggested in figure 14, but this matter is as yet far from being resolved. The carving is superb and the masonry techniques advanced. One suspects that the East Greek traders and mercenaries in Egypt may have acted as a filter through which the Ionians acquired the necessary new technology without the associated trappings of Egyptian style and that some of the skilled craftsmen themselves might even have been Ionians, Carians, or others from Egypt.[62]

The threat from Lydia may have become real in the last years of the seventh century B.C. when the southern part of the new City Wall 3 seems to have been cursorily and hastily finished to complete the circuit around the tell.[63] It is possible that the still unfinished north wall of the new cella was dismantled again at this time to allow the reinstatement of the fortifications to the north of the temple that had been badly mauled in its erection. At least, in the next stage, Phase IIIB, all thought of demolishing the temporary Temple IVA seems to have been abandoned, so that little more could be built of the south wall of the new cella; instead, the temple's south colonnade seems to have been erected alone on a narrow outer swathe of the stylobate. Problems seem to have arisen above the South Ramp, possibly because of the character of the fill between the Ashlar Wall and the relieving wall behind it, and what appears to have been a system of emergency boulder buttresses blocked up the middle part of the ramp.[64]

Phase IIIC, postulated for about 600 B.C., is of necessity more hypothetical, since its structures no longer survive. It is to be noted, however, that not a single white tufa block of this great temple remains in situ and that virtually all of its surviving members have been found around the outer perimeter of the sanctuary, much of which collapsed at a later date. The same heavy white chip stratum that marks the progress with the temple's building also carries the evidence of its dismantling, in the form of fragments smashed from fine worked surfaces,[65] and the Alabastron Deposit of the end of the seventh century includes two pieces broken from one of the great capitals.[66] The platform apparently began as a fortress, and it seems that the masonry of the unfinished great temple may have been reused to refortify it once more at

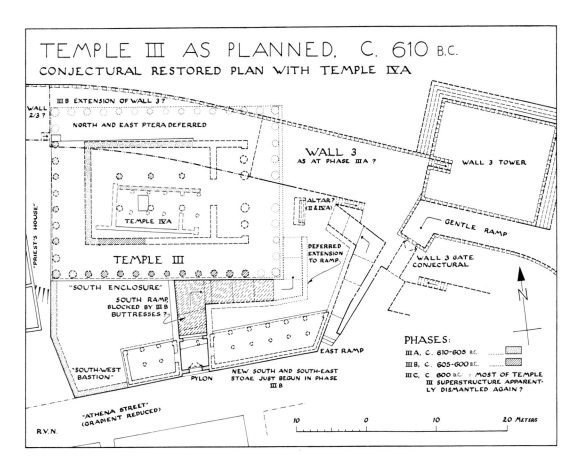

TEMPLE III AS PLANNED, C. 610 B.C.
CONJECTURAL RESTORED PLAN WITH TEMPLE IVA

IIIB EXTENSION OF WALL 3?

WALL 2/3?

NORTH AND EAST PTERA DEFERRED

WALL 3
AS AT PHASE IIIA?

WALL 3 TOWER

GENTLE RAMP

"PRIEST'S HOUSE"

TEMPLE IVA

ALTAR?
(III & IVA)

TEMPLE III

DEFERRED
EXTENSION
TO RAMP

WALL 3 GATE
CONJECTURAL

"SOUTH ENCLOSURE"

SOUTH RAMP
BLOCKED BY IIIB
BUTTRESSES?

N

EAST RAMP

"SOUTH-WEST
BASTION"

PYLON

NEW SOUTH AND SOUTH-EAST
STOAE JUST BEGUN IN PHASE
IIIB

PHASES:
IIIA, C. 610-605 B.C.
IIIB, C. 605-600 B.C.
IIIC, C. 600 B.C. : MOST OF TEMPLE
III SUPERSTRUCTURE APPARENT-
LY DISMANTLED AGAIN?

"ATHENA STREET"
(GRADIENT REDUCED)

R.V.N.

10 0 10 20 METERS

14. Restored plan suggesting the possible final design of Temple III as planned c. 610 B.C. and the parts apparently completed c. 610–600 B.C. and also showing the interim, temporary Temple IVA

the time of the Lydian siege, producing a further massive chip stratum around the perimeter of the temenos.[67] It may thus have been here in the sacred precinct that the Ionians made their last stand after the Lydians had broken into the city, as seems to be strongly suggested by the masses of iron spear and javelin points in the Weapons Deposit of that date.[68] It appears likely, too, that at the time of the Lydian capture of the city the only effective sacred building standing in the Athena sanctuary may have been Temple IVA.

Temple IVB

The Lydians under King Alyattes appear to have sacked Old Smyrna and looted Temple IVA in about 600 B.C.; the greater part of the city seems then to have lain desolate until almost 580 B.C.[69] The Athena sanctuary may have been one of the areas reinstated fairly early, possibly enjoying a measure of patronage in the phase that followed, to judge from its votive sculptures.[70] The former interim

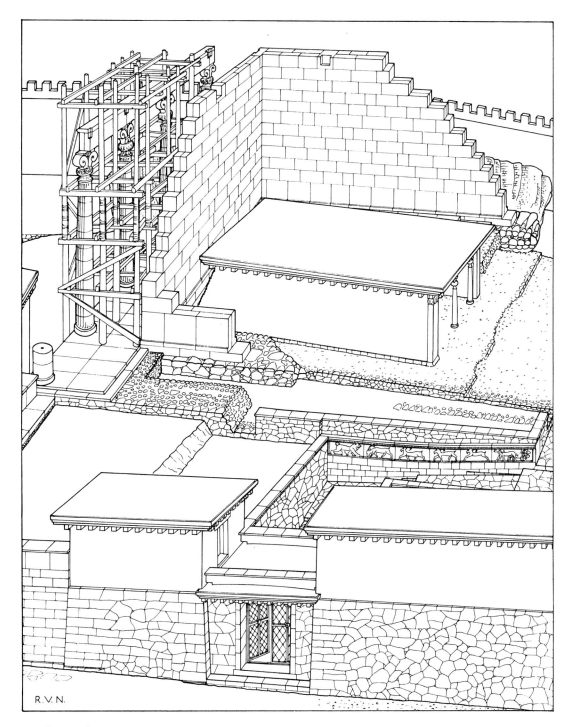

15. Restoration
suggesting the
construction work in
progress on Temple III in
the IIIA Phase and also
showing the temporary
Temple IVA, the IIB South
Ramp, South Stoa, and
South-East Stoa, and the
IIIA Pylon, viewed from
the south

R.V.N.

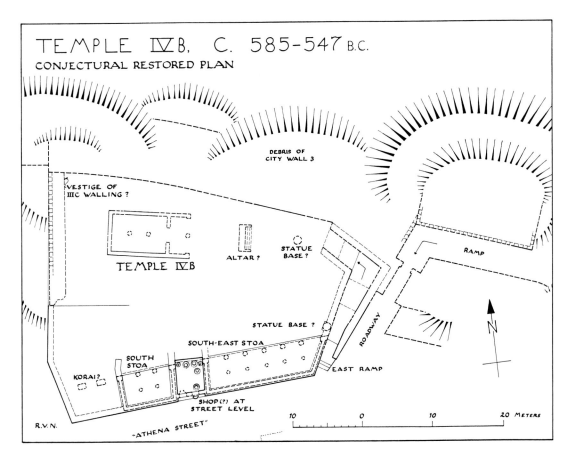

TEMPLE IVB, C. 585–547 B.C.
CONJECTURAL RESTORED PLAN

DEBRIS OF
CITY WALL 3

VESTIGE OF
IIIC WALLING ?

TEMPLE IVB

ALTAR ?

STATUE
BASE ?

RAMP

STATUE BASE ?

ROADWAY

SOUTH-EAST STOA

SOUTH
STOA

KORAI?

EAST RAMP

SHOP(?) AT
STREET LEVEL

R.V.N.

"ATHENA STREET"

N

10 0 10 20 METERS

16. Restored plan of the
sanctuary of Athena at Old
Smyrna at the time of
Temple IVB, c. 585–
c. 547 B.C.

temple, IVA, was rebuilt as Temple IVB,[71] mainly in mud brick, but apparently with a white tufa porch and outer column, and the stoas were reerected, also in mud brick, but with white tufa columns in two diameters (figs. 11, 16); these operations were also marked by further white chip strata. The columns of this phase are all smooth and unfluted; no capitals seem to survive. The site of the old Pylon was now occupied by what appears to have been a lock-up shop,[72] its floor overlying the earlier Weapons Deposit. Both shop and stoas were suddenly destroyed with considerable burning in about the mid-sixth century B.C.[73] Ekrem Akurgal has suggested that the temple may have been looted by Persian armies in the years immediately following the defeat of King Croesus of Lydia in 547 B.C.[74] He may be right, in view of the smashing of the votive statues of the Lydian period, but the houses of the town would seem largely to have escaped.[75] The whole former Pylon area was now filled with debris, largely mud brick, masonry, and ash from the stoas.[76]

Temples IIID and IVC–D

The sanctuary was reinstated but, although still frequented, it was a poor and humble shrine with no fine offerings in the period of Temples IVC–D (figs. 11, 17). There seems, however, to have been one brief, bright interlude, apparently between about 500 and 490 B.C. and thus possibly at the time of the Ionian Revolt, when a new north wall to the precinct was started,[77] later extended to encompass the rest of the area required for the great temple.[78] A substantial chip stratum around the west end of the old foundations of the late seventh century B.C. shows that a new start was made on actually building the great temple, again in white tufa. Where the old west colonnade foundations still protruded above ground they were now broadened westward, presumably to allow space for a full three-stepped stylobate. This whole structure has been named Temple IIID. It never got very far, and nothing seems to be known of its columns,[79] but it appears that some of the decorative features from the lower parts of its cella walls may survive.[80] At about the same time that work on it was halted, the habitation of the town was interrupted for some years.[81] Thereafter, down to the final abandonment of the city—it has been thought in about the middle of the third quarter of the fourth century B.C.—the great temple seems to have remained an unfulfilled dream.[82]

17. Restored plan of the sanctuary of Athena at Old Smyrna over the time of Temples IIID and IVC–D, c. 547–c. 334 B.C. (or possibly later—see note 82)

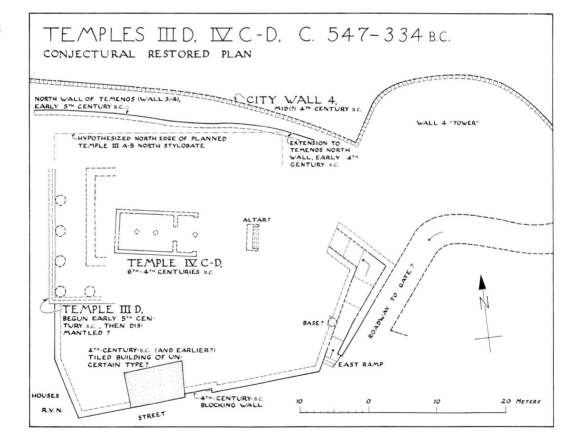

NOTES

1. J. M. Cook, "Archaeology in Greece," *JHS* 70 (1950), 12; 71 (1951), 248–249; 72 (1952), 104–106; J. M. Cook, "Old Smyrna, 1948–1951," *BSA* 53–54 (1958–1959), 15–17, 23, 29; R. V. Nicholls, "Old Smyrna: The Iron Age Fortifications and Associated Remains on the City Perimeter," *BSA* 53–54 (1958–1959), 75–81.

2. Ekrem Akurgal, *Alt-Smyrna, I, Wohnschichten und Athena-Tempel* (Ankara, 1983), 63–128; Athena inscription (by Sencer Şahin): 129–130, pls. N 1–2, 124 a–c; architectural members: 79–99, figs. 53–57, 60–72, pls. I–J, 138–176. His account of the temples is an interim one, inferred from the standing remains of the buildings but without the detailed excavational and stratigraphical evidence and with some of the later structures already removed and some of the earlier ones no longer easily visible. It is hoped that the present article will serve as a useful commentary to this splendidly illustrated volume, to which it makes constant reference.

3. Nicholls 1958–1959, 68–71, 95–98, figs. 18, 19, 30, 32, pl. 17 a–c.

4. Might one cite the construction of the palace of Priam in *Iliad* VI? Certainly it long anticipates the use of such masonry on seventh-century B.C. temples, for example at Isthmia (Oscar Broneer, *Isthmia, I, The Temple of Poseidon* [Princeton, 1971], 3–56) or on Temple III at Old Smyrna.

5. The dates cited rest on John Cook's evaluation of the contexts. The pottery chronology used by Ekrem Akurgal is somewhat more idiosyncratic.

6. Nicholls 1958–1959, 75–77, fig. 21 k; on Wall 1: 122–123; on Inner Defense Platform: 77, figs. 21 g, i, j, 22; on Wall 2: 123–124.

7. The primary construction at this point, it stood to the full height of the Temple I platform and of the main central part of that of Temple II, the temple platforms simply consisting of extensions added on to it (see below); its east part apparently revealed by the Turkish excavations (Akurgal 1983, pls. 91 a, 92 b, 93 a, rear folding plan, grid E7–8, C–D9); but its significance ignored by Akurgal, who wrongly postulates rocky outcrop as shaping site (65); his *spätgeometrischer Bau* (63–64, 119) actually consists of parts of the First Ramp, the Temple I platform and the IB ramp (on all of which see below).

8. Herodotus I.149–150. On the curved buildings: Cook 1958–1959, 14; J. K. Anderson, "Old Smyrna: The Corinthian Pottery," *BSA* 53–54 (1958–1959), 138–142; Akurgal 1983, 27–33 (but note that conventional pottery chronology dates this whole phase in Trench H c. 750–700 B.C.), figs. 14–15, pls. 16–22. Earlier dates have been proposed for the arrival of the Ionians on the evidence of the early preponderance of Ionian-type painted pottery at Old Smyrna: Cook 1958–1959, 13–14; J. M. Cook in *CAH*, 2, 2 (Cambridge, 1982), 779–780, 782, 785, 789; Akurgal 1983, 16–22. Others have been more cautious: V. R. d'A. Desborough, *The Greek Dark Ages* (London, 1972), 183–184; Jeffery, *Archaic Greece*, 224–225. The pot-

tery may simply reflect the way in which the northern Ionian cities dominated the trade of this southern Aeolian outpost.

9. Nicholls 1958–1959, 77, fig. 21 h; Akurgal 1983, pls. 49 b, 50 a–c (see also note 7 above).

10. See note 8 above. Smyrna's application to join the Panionion (Herodotus I.143–144) is apparently to be dated no earlier than the seventh century B.C., on the evidence for the destruction of Melie (G. Kleiner, P. Hommel, and W. Müller-Wiener, *Panionion und Melie, JdI-EH* 23 [1967], 91–93; J. M. Cook in *CAH*, 3, 1 [Cambridge, 1982], 749–750). But the city was already Ionian by 688 B.C., the date of the Olympic victory of Onomastos of Smyrna (Pausanias V.8.7).

11. Cook 1958–1959, 14; Nicholls 1958–1959, 124–126. Part of this wall renewed again in second quarter of seventh century B.C. (because of haste in its original reinstatement?).

12. Cook 1958–1959, 15; Nicholls 1958–1959, 77–79; Akurgal 1983, pls. 49 b, extreme bottom, 53 b, 53 c, bottom, where largely ignored (but see note 7 above), his *subgeometrisches Podium* (64–66, 119) consisting mainly of elements of the Temple IIA platform and the Temple IIIA foundations, on both of which see below.

13. For example, from the end of their currency at Old Smyrna, in Trench B: Nicholls 1958–1959, pl. 74, grid Jxviii.

14. Akurgal 1983, pls. 56 b, c, 57 a; both assigned by Akurgal to his *orientalisierende Cella* (68–69, 119); footing has apparently acquired two extra blocks since time of Anglo-Turkish excavations.

15. Space precludes any discussion here of a number of the subsidiary structures associated with this and subsequent temples.

16. Akurgal 1983, figs. 35–36, pls. 49 b, 50 (see note 7 above).

17. Anderson 1958–1959, 142 nos. 70, 71, pls. 23, 29 (no. 70 from area of possible contamination in Temple III period). The platform largely assigned by Akurgal to his *subgeometrisches Podium* (see note 12 above) and the cella to his *orientalisierende Cella* (see note 14 above).

18. Akurgal 1983, pls. 51, 52 a, bottom, 52 b, 53 c, middle.

19. Akurgal 1983, pls. 59–60.

20. See text on Temples IVA–D.

21. Akurgal 1983, pls. 56–57, 58 a.

22. Same line followed by preserved west wall footings of Temples IVB–D (see note 71 below); distance of just over 32 ft between west face of wall so indicated and west end of platform suggests possible east-west interaxial distance between columns (see fig. 7) of 8 ft. West cobbling: Akurgal 1983, pl. 62.

23. See note 35 below. Other examples: Nicholls 1958–1959, pl. 74, grid Gxvii (*in situ*) and Fxiv (reused in later wall).

24. They also may well have shown similarly variable dimensions (see note 59 below), but this is impossible to evaluate.

25. Nicholls 1958–1959, 79, fig. 22.

26. Nicholls 1958–1959: on Wall 3, 126–128; on its North-East Gate, 72–73, 79 and also evidence of line of east face of East Ramp of temple.

27. This corresponds broadly with the *orientalisierendes Podium* (although, as there defined, this also includes substantial elements of Temple III date) and the *orientalisierende Terrassen* of Akurgal 1983, 66–72, 119–120.

28. Akurgal 1983, pls. 61, middle, 66.

29. Akurgal 1983, pls. 91–94.

30. Akurgal 1983, pls. H 3, 83–86, 87 *a*; the refinements misunderstood and misdrawn in the elevation: fig. 50 *a*; the argument (76–77) that the Ashlar and the Lesbian Walls owe their present appearance to a later refacing seems extremely questionable.

31. Akurgal 1983, pls. H 1–2, 82–83, 85, 87*c*.

32. Akurgal 1983, 101, 152, pls. 134 *e*, 175 *b* and large unpublished fragment; less certainly, pl. 134 *d*.

33. Akurgal 1983, pls. 68–74, 90. The localized substitution of ashlar masonry, especially near the angles (interpreted, 76–77, as marking a later rebuilding), may actually represent a modification introduced midway through the original construction to improve the walls' resistance to the pressure of the compacted fill.

34. From the late-seventh-century B.C. Weapons Deposit (see note 68 below).

35. Nicholls 1958–1959, 55, fig. 9, pl. 13 *c–d*; see also note 23 above.

36. Material from its fills is described by John Cook as slightly but distinctly earlier than that from the Alyattan destruction of Old Smyrna. As already pointed out (see notes 12 and 27 above), much of this construction is assigned by Ekrem Akurgal to his *subgeometrisches Podium* and his *orientalisierendes Podium*; the remainder he ascribes to his *archaischer Tempel*: Akurgal 1983, 76–99, 120–123.

37. Akurgal 1983, pls. 49 *a*, bottom, 52 *a*, top, 53 *a*, 53 *c*, top, 54–55, 61–65.

38. Nicholls 1958–1959, 79; Akurgal 1983, 67, pl. 63; Gerhard Kuhn, "Der äolische Tempel in Alt-Smyrna," *MarbWPr* (1986), 72–73.

39. Akurgal 1983, fig. 50 *e* (but elevation does not distinguish modern restorations), pls. 76 *b*, 77 *b*, 78 *b*.

40. Akurgal 1983, fig. 51 *a–d*, pls. 77 *a*, 78 *a*, 79, 80 *a*.

41. Assigned by Ekrem Akurgal to his *archaischer Tempel*: Akurgal 1983, 76, 120, pls. 61, 69, 97–98, 101 *b, c*.

42. Small unfinished column drums found in the Weapons Deposit (see note 68 below); fill in South Stoa raised before the Alabastron Deposit (see note 66 below) and its north wall probably also raised.

43. Akurgal 1983, figs. 55 *a*, 56, pls. I, 138–140; its positioning on the step possibly connected with the sixth-century shop (see text under Temple IVB).

44. Akurgal 1983, 83–88, 121, figs. 55–57, pls. 138–152.

45. Akurgal 1983, 80, fig. 72 *a*; Kuhn 1986, 39–46, fig. 10.

46. Burkhardt Wesenberg, *Kapitelle und Basen, Beihefte der Bonner Jahrbücher* 32 (Düsseldorf, 1971), 111–114, 146, fig. 230; Akurgal 1983, 80.

47. Akurgal 1983, 81–82, fig. 54 *a, b*, pls. 91, 92 *a*, 93–94 (also fragment, fig. 54 *c, d*, pl. 173 *a*). Found fallen from above the East Ramp where possibly reused (in Temple IVB period?) with unfinished column drum to form base (?).

48. Akurgal 1983, 88–94, figs. 60–69, pls. 153–167.

49. This interpretation considered but rejected: Ekrem Akurgal, "Früharchaische Kapitelle vom Tempel der Athena in Alt-Smyrna," *ASAtene* 59, n. s. 43 (1981), 127–132; Akurgal 1983, 94–96.

50. Yigal Shiloh, "The Proto-Aeolic Capital," *Qedem* 11 (1979), 1–49, 88–91; Philip P. Betancourt, *The Aeolic Style of Architecture* (Princeton, 1977), 17–49, pls. 1–28. The alternative possibility, that such initially wooden capitals were due to direct architectural influence from Palestine and Syria in the tenth to eighth centuries B.C., is also not to be excluded, given that the associated form of Levantine ashlar work seems already attested at Old Smyrna in the ninth century B.C. (see note 3 above).

51. Notable exceptions are Capitals P and Q: Akurgal 1983, figs. 56–57, pl. 152.

52. For example, A. W. Lawrence, rev. R. A. Tomlinson, *Greek Architecture*, 4th ed. (Harmondsworth, Middlesex, 1983), 82, 98, 384, figs. 59, 60, 71; Wesenberg 1971, 3–27, figs. 3–7, 9–25.

53. Unless the fragment of anomalous profile, Capital K, is actually to be viewed the other way up as from a decorated base incorporating the bottom torus of the shaft: Akurgal 1983, fig. 56, pl. 149 *b*. Column bases seem to have had an insignificant role in the later Aeolic Order in East Greece.

54. Nicholls 1958–1959, 81, figs. 21*, 22*, pl. 18 *b*, *c*; Akurgal 1983, 79–80, figs. 53 *a, b*, *c*, *d*, *e*, pls. 91 *a, b*, 93, 172*; examples marked with asterisk not cylindrical but tapered on present author's own measurements; presence of both cylindrical and tapered drums probably means that shafts showed entasis. Complete examples found fallen from above East Ramp (see note 47 above) and reused as footings for the early-fourth-century extension to the temenos north wall (see note 78 below).

55. Akurgal 1983, fig. 80. This fragmentary orthostate apparently unfinished, so that it remains possible that this projection was to carry shallow relief decoration, as possibly also indicated if the fragment, Capital K, is from a base (see note 53 above).

56. This building and its successors of the sixth to fourth centuries B.C. (Temples IVB–D) are not recog-

nized by Ekrem Akurgal, who also disregards the well-attested but humble Late Archaic and Classical pottery from the sanctuary.

57. Figure 15 is based on a much earlier drawing by the author showing some imperfections, including the assumption of a wider distance between the columns.

58. Akurgal 1983, 83, 92, 121–122, 146–151; as some of these examples seem very fragmentary, it may be that the minimal tally might be slightly less; see note 53 above on Capital K. It has been assumed that these capitals were worked in position, but the absence of unfinished examples is curious. If they were carved before installation, they provide less control on progress with the building.

59. Akurgal 1983, figs. 56–57. At this stage the firm evidence is confined to the better preserved of the "mushroom-shaped" lower members, but the much more fragmentary volute members may have shown corresponding variations in scale and height.

60. Akurgal 1983, 84, 96, 121–122. There was probably little space for such votive structures at this date, with the temenos largely serving as a masons' yard and with its fill not yet fully raised to its final intended level. Also, there are no separate foundations for such votive columns.

61. Kuhn 1986, 65–80; he ignores, however, the problem of the variable dimensions.

62. A system of masons' marks was employed on some of the columns, possibly necessitated by their variable dimensions: Akurgal 1983, 98–99, pls. 168–171. The signs seem to be drawn from various Greek alphabets and possibly from some non-Greek Asia Minor ones also.

63. Nicholls 1958–1959, 52–58, 64–65, 126–127.

64. Southernmost part of these: Akurgal 1983, 74, pls. 78 *b*, 80 *a*, 86, 89; remainder removed in excavating South Ramp. At the time of excavation interpreted as the foundations for a building of the Lydian period (Cook 1958–1959, 29) but seem to be buttresses, not foundations, and to be associated with material at the end of the seventh century, while their south face seems clearly earlier than the Weapons Deposit of the time of the Lydian attack: Nicholls 1958–1959, 133. The loose stone fill piled in between them, however, may have been partly added in the sixth century, and the earth fill overlying and completely infiltrating this last is certainly later.

65. Anderson 1958–1959, 144–145; Akurgal 1983, 74. At the time of excavation the Temple IIIA–C white chip stratum does not seem to have been clearly differentiated from those connected with the later white tufa work of Temples IIID and IVB–D, giving rise to the probably largely mistaken view that the dismantling of the great temple extended into the sixth century and even beyond and to Ekrem Akurgal's dating for his *archaischer Tempel*.

66. At the site of the South Stoa; also included a few weapons; on dating: Anderson 1958–1959, 144 nos. 79–85, pls. 23–24; capital fragments: Akurgal 1983, pls. J 2, 148 *a*.

67. Akurgal 1983, pls. 88 *a*, 96.

68. Overlying the floor of the former Pylon. Cook 1952, 107, fig. 12; Cook 1958–1959, 24; Nicholls 1958–1959, 132–133.

69. Herodotus I.16; Cook 1958–1959, 23–29; Anderson 1958–1959, 143–151. The destruction apparently falls before the end of Early Corinthian and the general reoccupation late in Middle Corinthian; for a rare possible exception from the interval, see John Boardman, "Old Smyrna: The Attic Pottery," *BSA* 53–54 (1958–1959), 162 no. 2, pl. 33. Akurgal 1983, 76–99, 120–123, dates his *archaischer Tempel* in the intervening period of relative neglect.

70. Akurgal 1983, 99–101, pls. 125–126, 135 *a*, *b*; possibly also the lion heads (pls. 127–129, 130 *a*, *b*), unless these are earlier functional elements from the great temple; the terracotta statue (104, pl. 130 *d–f*) seems certainly earlier on the basis of its find circumstances.

71. The surviving parts of its west and north walls were later than a white deposit overlying the Alyattan destruction stratum in Temple IVA; their building techniques varied, suggesting that what survived included subsequent restorations. The east porch of the building is today completely plundered, but it (or a later restoration of it) is presumed to be the source of the rejected white tufa blocks and column drum found in its vicinity; its original construction may be marked by white chippings overlying or coinciding with the white deposit mentioned earlier. It is much harder to date the inferred restorations of the building's largely mud brick cella. It has been tentatively assumed that there were two: Temple IVC, presumably following the widespread destruction in the sanctuary at the end of the IVB phase; and Temple IVD, possibly coinciding with the construction work in the temenos around the early fourth century B.C. (see fig. 17).

72. At the time of excavation interpreted, probably wrongly, as a basement and designated the "Pithos Room."

73. Cook 1958–1959, 29; J. M. Cook, "On the Date of Alyattes' Sack of Smyrna," *BSA* 80 (1985), 25–28 (on material from the "Pithos Room").

74. Akurgal 1983, 72–75, 123. However, the proposal to redate to this period events such as the blocking of the South Ramp seems stratigraphically impossible.

75. The destruction of the sixth-century Burnt House (Akurgal 1983, 54, fig. 32 *b*) seems to have occurred some years earlier and was probably accidental: Boardman 1958–1959, 154–162; Cook 1985, 25–26.

76. Akurgal 1983, pl. 76. Both cylindrical and tapered column drums attested from this context, probably indicating presence of entasis in stoas.

77. Originally designated Wall 3/4: Nicholls 1958–1959, 81, fig. 21 *t*, *v*, pl. 18 *a*.

78. Early-fourth-century wall: Nicholls 1958–1959, 81, figs. 21 *n*, *o*, 22, pl. 18 *b*, *c*; Akurgal 1983, pl. 172. Now traced throughout, revealing that both walls form a single line.

79. Possibly very large, if their bases followed the profile of the toichobate (?).

80. Akurgal 1983, figs. 76–78, pls. 173 *b*, 174.

81. Cook 1958–1959, 29–30.

82. To judge from the line followed by the later extension to the north wall of the precinct, these aspirations may have remained alive as late as the early fourth century B.C. The abandonment of Old Smyrna has been linked with the transfer of its population to the new city of Smyrna to the south. The circumstance that the latest pottery from Old Smyrna seemed only slightly later than the latest from Olynthos (destroyed by Philip II in 348 B.C.) appeared to lend support to the ancient tradition that the new city of Smyrna was founded by Alexander the Great, presumably while he was in this area in 334 B.C.: Cook 1958–1959, 34; J. M. Cook, "Old Smyrna: Fourth-Century Black Glaze," *BSA* 60 (1965), 143–153. Unfortunately, however, fourth-century pottery chronology is not yet secure. When the present author studied the terracotta statuettes from Olynthos in 1989, he found that they included a small but significant body of Early Hellenistic figures, suggesting that Olynthos itself was reoccupied and that its latest Greek pottery should also be Early Hellenistic in date. This may, in turn, imply a date nearer 300 B.C. for the abandonment of Old Smyrna. Strabo XIV.646 appears to ascribe the actual construction of the new city of Smyrna to Antigonos and Lysimachos, the latter's involvement presumably dating from 302 B.C. on.

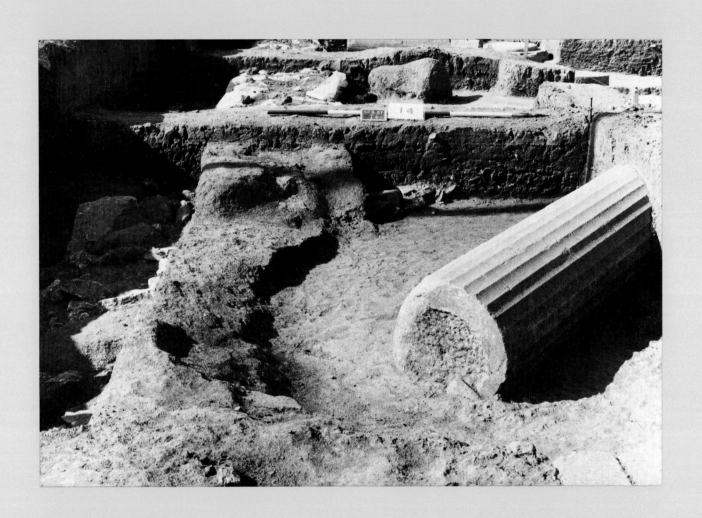

VASSILIS LAMBRINOUDAKIS
University of Athens

The Sanctuary of Iria on Naxos and the Birth of Monumental Greek Architecture

The significance of Naxos, central isle of the Cyclades, in the creation of monumental Greek architecture and sculpture during the Archaic period is well known.[1] Recently, yet another especially interesting monument has been revealed there, by the University of Athens in collaboration with the Technical University of Munich. The remains of a large Ionic temple, built in the early sixth century B.C. and in use until at least the third century A.D., have been discovered in the extensive fertile plain to the south of the modern, and ancient, town of Naxos.[2] G. Welter had sighted remnants of the temple close to the Church of Saint George at Iria in 1930.[3] In 1982 our team located the southwest corner of the temple, in 1986 the building was identified, and in 1987 it was almost completely uncovered.[4] The temple seemingly belongs to an important sanctuary of ancient Naxos.

Much of the evidence suggests, though it by no means proves, the temple's probable dedication to the patron deity of the island, Dionysos. The first indication is its short distance from the city (3 km). Second is its location in the midst of the damp coastal plain, which even today legend associates with Ariadne's arrival on the island.[5] Third is its proximity—as indicated by a series of wells in the plain (fig. 1)—to the most important river on Naxos, known in antiquity as Byblinis, in the bed of which wine, not water, was said to flow.[6]

This evidence has already been indirectly validated by the excavation. A statue of a cui-rass-clad male, found inside the temple and most probably portraying Mark Antony (fig. 2), bears representations whose symbolism especially emphasizes the divine aspect of Antony that was projected in the East—that is Antony as New Dionysos.[7] The original inscription on the statue's base has been erased, and a dedication to Octavian written underneath. The representations include the punishment of Dirke (fig. 2) and Dionysos with kantharos, thyrsos, and panther (fig. 3).

The archaic edifice survived in situ, up to a height of 0.30 m above the ancient ground level (figs. 4–8). Many parts of its upper structure have been brought to light in excavation (figs. 9–10) or located in the surrounding area (fig. 11), so that it is possible to reconstruct accurately its form (figs. 12–13). It was a large temple, comprising a spacious oikos, 13.49 m × 24.23 m at its base,[8] and a porch of four Ionic columns on the south face of the entrance, increasing its total length to 28.33 m.[9]

The oikos, which was divided into three aisles by two rows of four Ionic columns, had a shallow adyton. It was built on three sides of roughly worked blocks of granite, while the side on which the entrance was situated was constructed—at least as far as the orthostats and around its monumental portal—of massive perfectly ashlared blocks of marble. The width of the walls at the base (up to 1.25 m) bears witness to the weight of the stone upper structure (0.85 m wide walls), while the depth of the foundation, 0.95 m, was extremely shallow for such walls. For this reason the

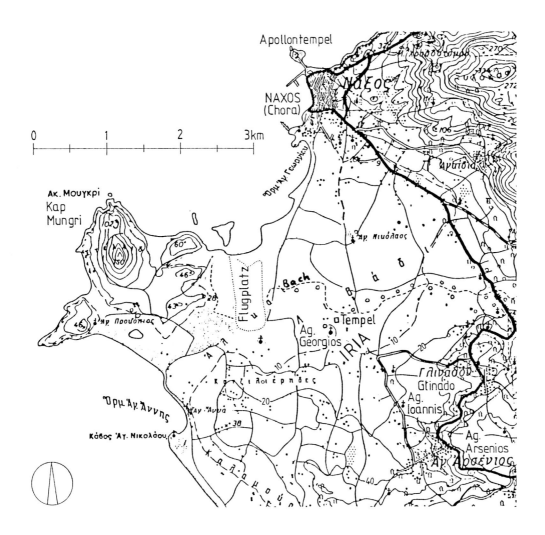

1. Map of the plain south
of the town of Naxos
AA (1987), 570

2. Cuirassed marble
statue (height of torso 1 m)
found in the temple at Iria,
first century B.C.
Naxos Archaeological Museum

3. Dionysos with the
panther, relief on cuirass
of figure 2

foundation was later reinforced, externally and internally, with rows of stones (fig. 14). The doorway on the façade was particularly monumental (fig. 13). It consisted of a monolithic threshold four meters in length, which is preserved in situ (fig. 7), and monolithic jambs, 5.50 m high,[10] a fragment of which has been used as the lintel in the church of Saint George (fig. 11).

Of the marble columns of the interior, four bases have survived (fig. 8), along with several drums (the largest 4.35 m high; fig. 10) and numerous pieces of the Ionic capitals. On the heavy bases we observe the fashioning of the strong, primitive Ionic form on the spot: in some places the initial cylinder from which the articulated form of the base would be cut has remained unworked, uniform (fig. 15). In other instances the distinction of forms is only half complete (fig. 16). Where the work has been finished, above the bottom cylindrical section, the greater part of which was beneath the beaten earth floor, a markedly flattened yet ample torus has been formed, upon which the column stood (fig. 8). On the columns, too, different stages of working have been preserved: from the simple incising (fig. 10) of the flutes to the complete form (fig. 9), which varied from column to column (between twenty-eight and thirty-two flutes) yet nevertheless displayed diverse progressive traits, such as a barely perceptible apophyge at the base. The transverse wall also had a marble base and monumental portal, 2.5 m wide. The roof tiles were Corinthian and also of marble.

The entire porch was of marble. That this was an appendage was emphasized by the fact that in neither its visible part nor its foundations was it joined to the side walls of the oikos. Its shallow (85 cm) granite foundations, preserved in situ, were rearranged in Roman times in the course of major repairs to the temple. However, there is conclusive evidence of its continued existence since the temple was first built.[11] A single layer of marble slabs overlying the foundations simultaneously constituted the euthynteria and stylobate. Upon this stood the four Ionic columns, with high cylindrical members and spira on their base, twenty-four flutes with acute arris angle and diminution on the shaft, and particularly elongated (1.78 m) volute capitals. These columns, from which there are several extant drums and capitals, display

remarkably close affinity in both form and working with the column that was surmounted by the Naxian sphinx at Delphi, dated to c. 570 B.C.[12] Only a few fragments of the entablature have survived, such as a molding of the diazoma and a fragment of the cornice. The temple is dated to c. 570 B.C. not only on the basis of the forms of the capitals, but also from the sherds associated with the undisturbed sections of the floor pavement.

This temple replaced an earlier one that stood on the same site. At present, excavations to investigate the remains of this precursor have made little progress, but even so the data collected furnish valuable information about this building.[13] It was only slightly smaller in size than its successor. The west side wall, uncovered for a length of 15 m (figs. 17, 19), in conjunction with the remnants of two rows of bases of internal supports (figs. 18, 7, and 17), and vague traces of walls beneath the southeast corner of the Archaic edifice, suggests a chamber of not inconsiderable clear width. Because the foundations of the marble façade of the Archaic temple destroyed the southwest corner of this earlier one, it is not yet clear whether the schema of this already three-aisled space was that of an oikos with closed façade, like its successor, or an arrangement with antae. Nevertheless, the wide granite foundations (0.80 m) indicate a stone superstructure, and the presence of fine marble chippings inside the foundation trench of these walls shows that, even in this earlier building, some elements were made of the more refined material, marble. Certainly the bases of the internal supports, worked crudely in the shape of a torus, were of marble—as one of these, discovered in situ below the base of the Archaic building, attests. Preserved on the top of this is the trace of the bedding of a wooden post, which was 29 cm thick. A hearth measuring 2.90 m on the side, containing ashes from burnt sacrifices, has been located inside this temple (fig. 19). From finds associated with the ash, as well as those from below the beaten earth floor of the building, it has been possible to date this earlier temple to the beginning of the seventh century B.C. at the latest.[14]

From this description it is clear that this new discovery is of unique interest in determining more precisely the evolutionary processes involved in the emergence of Greek monumental architecture, especially with re-

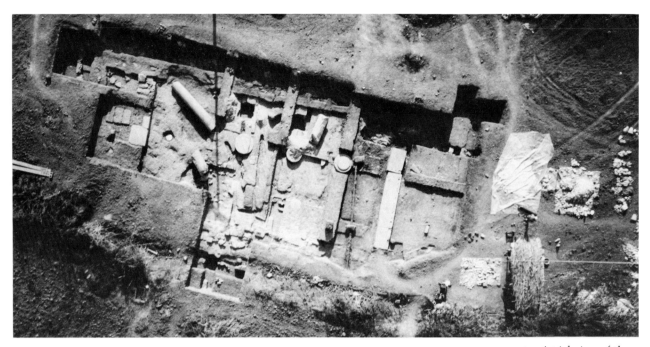

4. Aerial view of the 1987 excavation of the temple at Iria, Naxos
Photograph by G. W. Faisst

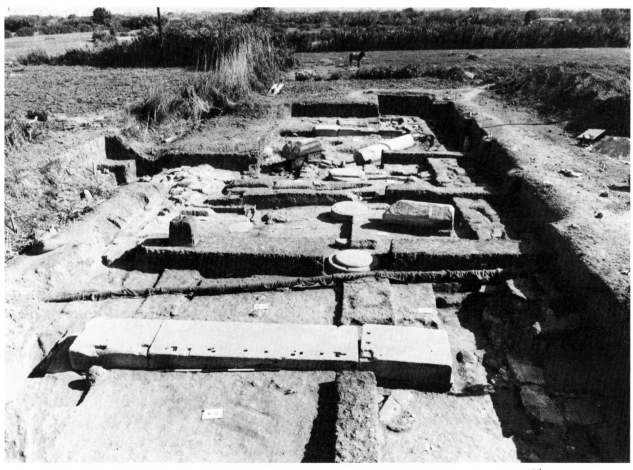

5. The 1987 excavation of the temple at Iria, viewed from the south

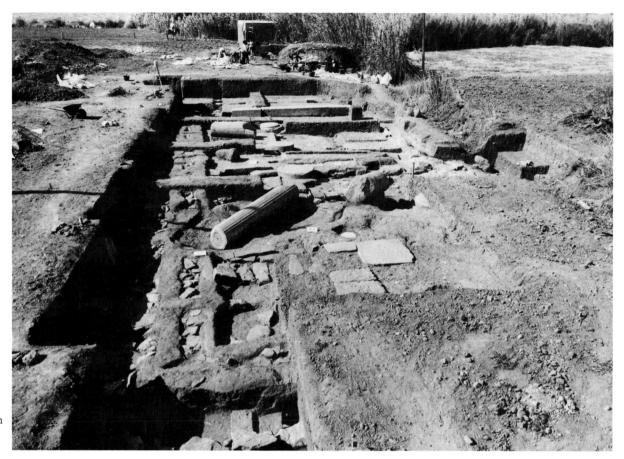

6. The 1987 excavation of the temple at Iria, viewed from the north

7. Marble threshold (length 4 m) of the doorway to the Archaic oikos; top right, marble bases of interior supports belonging to the Archaic and to an earlier temple
Photograph by G. W. Faisst

8. Finished Ionic marble base of an interior column (first from the south on the eastern row), Archaic temple at Iria

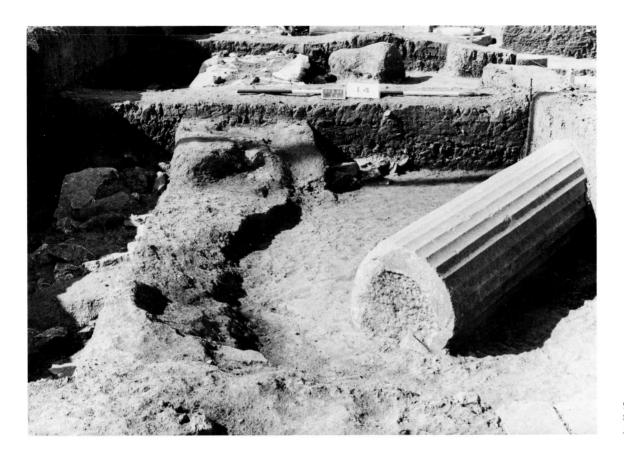

9. Finished drum of a
marble interior column,
Archaic temple at Iria

10. Roughly worked
drum (flutes just traced) of
a marble interior column,
Archaic temple at Iria

11. Church of Saint George at Iria; a large fragment of a doorjamb, belonging to the doorway of the Archaic oikos at Iria, has been used as the lintel of its door

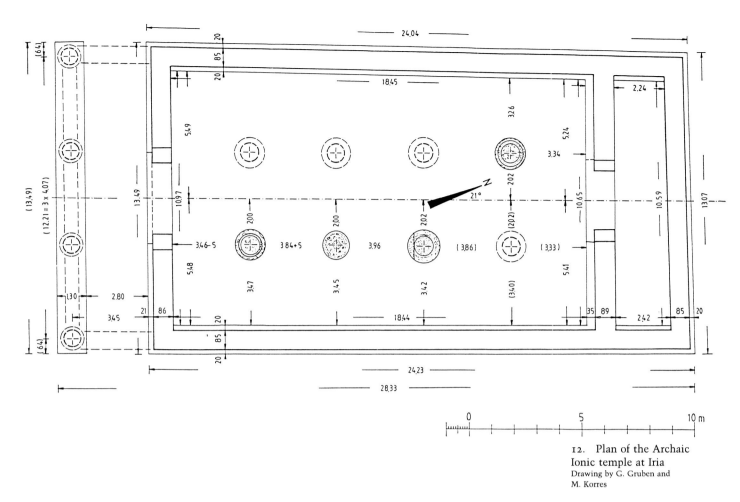

12. Plan of the Archaic
Ionic temple at Iria
Drawing by G. Gruben and
M. Korres

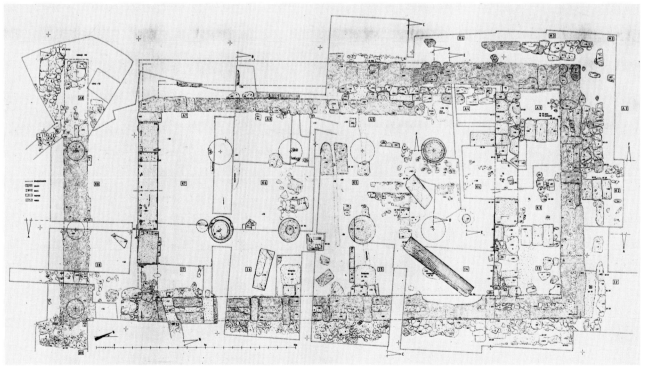

14. Plan of the
excavation at Iria,
1982–1988
Drawing by G. Gruben

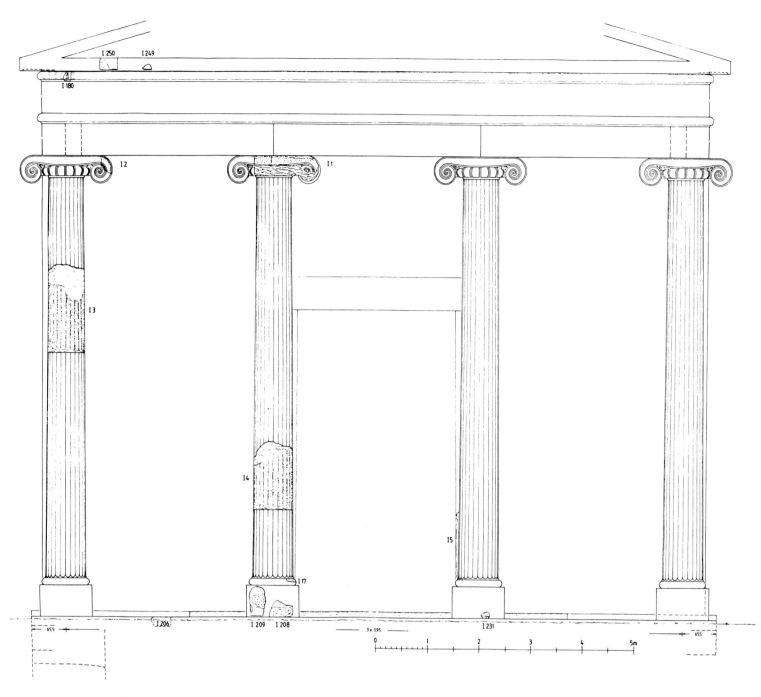

13. Reconstruction of
south façade of the
Archaic temple at Iria
Drawing by G. Gruben and
M. Korres

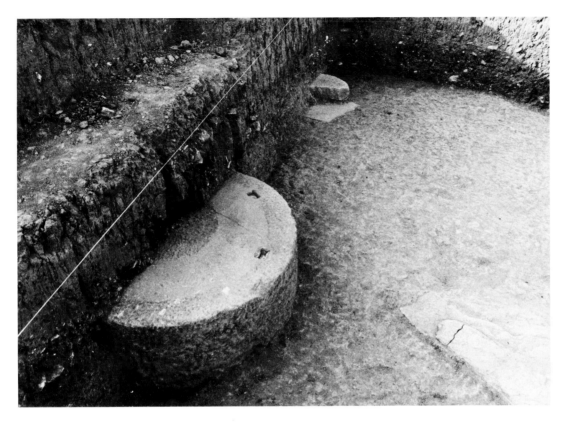

15. Unworked cylinder base of an interior column (second from the south on the eastern row), Archaic temple at Iria; right, half of a smaller marble base belonging to an earlier temple

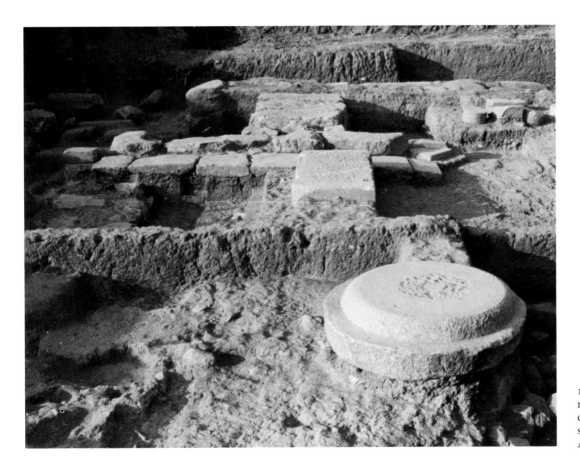

16. Roughly worked Ionic marble base of an interior column (fourth from the south on the western row), Archaic temple at Iria

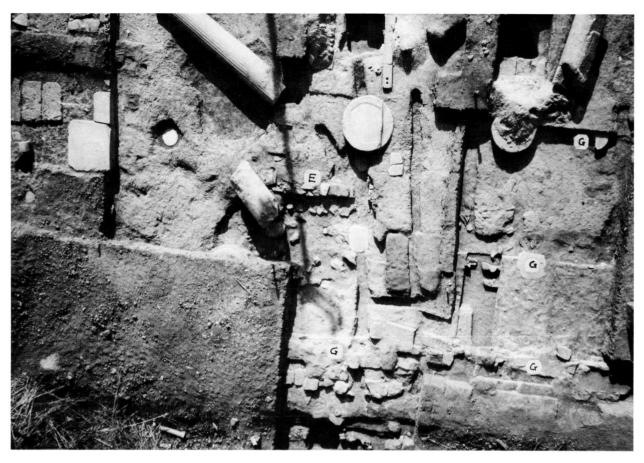

17. Foundations of an
earlier building (G) under
the Archaic temple at Iria
Photograph by G. W. Faisst

18. Marble base of the
southeastern interior
column of the Archaic
temple at Iria (A); on its
left and on a lower level,
a smaller marble base
belonging to an earlier
temple (G)

19. The hearth of the earlier building under the Archaic temple at Iria

gard to the Cycladic current, about which little is known. As we shall see, this current appears to have developed highly significant architectural features, which, together with others, led ultimately to the formation of Classical Greek architecture.

The first feature of interest is the early use of marble. We have seen that the limited use of this refined material is attested in the temple of the seventh century B.C., but the part it played in the temple of 570 B.C. is clearer. Even here we witness a transitional stage with regard to the predominance of this material. However, although the body of the temple is of granite, marble is the medium through which the articulation of the monumental structure is imposed. It is used to emphasize the most critical tectonic forms composing the interior (columns and portal leading into the adyton), as well as the connection with the surrounding space. The use of marble emphasizes the façade and entrance of the building, and consequently determines its impact on a specific spectator.

A second interesting feature of this edifice is its size. It is the largest temple in the Cyclades from that period, and its size is manifest not only in its length, as is the case with most of the large early Greek buildings, but also in its width. The internal clearance of the first temple is estimated as more than 8 m, increasing to 11 m in its successor. For the sake of comparison, we cite the Heraion I on Samos and the temple of Apollo at Thermos, where the corresponding measurements are 5.50 m and 4.70 m, respectively.[15] This wide space in the new temple of Naxos is articulated from the outset into three spacious aisles, with rows of supports. Thus, in conjunction with the absence of a pteron, we have here overt monumentalization of the simple oikos, a structure intermediate between the sacred and secular, which constituted the principal form of cult building (*Kultbau*) in Geometric times.[16]

The third feature of interest is the experimental stage that can be observed on the temple, regarding the formulation of the characteristics of the Ionic order, with a tendency to interpret crucial functional elements through organic forms. An interesting piece of evidence that sheds light on this development is the sculpting of the refinements of the Ionic column on the spot, with considerable license in rendering details, which seems

to have continued for centuries—the sense of form differing, of course, in each period.[17]

Of the features cited, the most important is that this new building verifies that in the Cyclades monumentalization of the simple oikos, particularly its interior space, occurs from the outset, whereas in mainland Greece and Asia Minor, monumentalization is observed rather on the exterior of the more complex early edifices. In addition to the new Naxian monument, we know of a series of early buildings from the Aegean Islands and Crete in which the monumentalization of the square oikos is attested, its principal traits being imposed on the interior and façade. At Dreros in Crete there is a seventh-century B.C. building that displays considerable affinity with the temple on Naxos; it is of the same width, thick-walled, has two rows of internal columns and a hearth.[18] The Pythion at Gortyn is an example of a wide-faced oikos, with much wider internal space.[19] In the Cyclades the temple of Karneios Apollo on Thera and that at Zagora on Andros, though smaller in size, nonetheless show obvious development of the interior of the oikos.[20] In the sixth century B.C., the Letoon on Delos continues this tradition.[21] In the Artemision on Delos the phenomenon observed at Iria is replicated yet again, in the appending of a porch in the sixth century B.C. to the small yet spacious oikos of the seventh century B.C.[22] This phenomenon is repeated even more characteristically in the Oikos of the Naxians on Delos.[23] The dimensions of the seventh-century oikos are very similar to those of the Archaic temple at Iria, there are analogous rows of internal supports, and there is already rudimentary emphasis of the critical architectural elements in marble, as indicated by the remains of the portal on its north side.[24] The building was renovated in c. 580 B.C. by elevation of its faces with monumental marble doorways, comparable with that on the temple at Iria.[25] Some twenty years later a monumental four-columned porch was added to its east side.[26] Two such porches also existed on the large amphiphrostyle temple of Athena on Paros, dating to the sixth century B.C. (15.46 m wide and with a double internal colonnade),[27] while the poros temple of Apollo on Delos was also quite possibly a prostyle oikos, rather than a temple in antis.[28] The persistence of this tradition for the internal space and the front porch in this region is also ap-

parent from a series of buildings with columns in antis on the façade—generally related to the oikoi[29]—in which there are more than two columns between the antae, such as the temple at Sangri on Naxos (five columns),[30] or the temple of Apollo at Karthaia on Kea (six columns).[31]

On the Greek mainland and in Asia Minor there are very few buildings of this type, and in these the characteristic features are not fully developed. The temple at Neandria, for example, is a wide hypostyle oikos;[32] that at Kalapodi, dating to the seventh century B.C.,[33] is tetrastyle prostyle (with internal supports, but narrower aisles); while the sixth-century B.C. temple of Artemis Knakeatis at Tegea is a regular but small prostyle.[34] On the Greek mainland monumentalization is achieved rather in the peripteral edifices.[35] These are entirely absent from the Cyclades in the early years, excepting a few instances promoted by the tyrants, such as the temple of Apollo at Palatia on Naxos.[36] But here too, apart from the characteristic monumental Cycladic doorways, the internal porches are adopted, which develops further the traditional Cycladic schema of the prostyle or amphiprostyle oikos and, like so many other Ionic elements, is later replicated in Classical Attic architecture.[37]

Prevailing scholarly opinion holds that because at any given moment the width of a building was determined by the same technical possibilities, the in antis arrangement was, in comparison to the oikos, the response imposed in the early years, because of both its more decorative façade and its greater length, a consequence of its shape, as the most appropriate expression of monumentality.[38] Similarly, the articulation of the interior into three aisles is considered to have been necessitated by the increase in width, while the lateral supports of the building's timber frame remained in their original position.[39] Furthermore, it is believed that, although monumentalization was initially promoted in Greek buildings principally through the device of the pteron, the tradition of the interior of the square or wide-faced oikos with hestia was mainly retained in buildings associated with mysteries.[40] Only in the fifth century B.C., with the Parthenon and contemporary edifices (temple of Epikoureios Apollo, Propylaia, temple of Nike on the Acropolis and of the Athenians on Delos), was the mon-

umental interior of the buildings developed in general, being organized as an inversion of the exterior, with corresponding elements in the three dimensions.[41]

From the evolution in the Cyclades, however, we see that this is not exactly the case. In the region of the islands, the interior of the building maintained its gravity and was the first part to be arranged in a monumental manner. At the same time, in the course of this monumentalization, special attention was paid to the appearance of the façade, with its impressive walls punctuated by portals and, in a second stage, emphasized by the addition of the porch. Here, the opposite of what occurred in the peripteral temples of the fifth century B.C. was realized, and much earlier: the articulation of the interior was transferred to the façade, in order to organize the neutral external setting. Thus it seems that in the region of the islands a more subjective experience of architecture prevailed from the outset, favoring the development of a determined closed space and the linking of the exterior of the building with a specific human focus: the visitors approaching it and their first impression as they beheld it. This concept developed alongside the more objective, externally balanced, and self-sufficient form of the peripteral temple. It is this same concept which most probably, intruding into Athens in the fifth century B.C., instigates the combination of the two tendencies in Classical architecture.

NOTES

Mrs. Alex Doumas translated my Greek text into English. To her I express my warm thanks.

1. Gottfried Gruben, *Die Tempel der Griechen*, 4th rev. ed. (Munich, 1986), 340–347. Vassilis Lambrinoudakis, "Die Physiognomie der spätarchaischen und frühklassischen naxischen Plastik" in *Archaische und Klassische Griechische Plastik* [Deutsches Archäologisches Institut, Akten des Internationalen Kolloquiums vom 22.–25. April 1985 in Athen], ed. Helmut Kyrieleis, 1 (Mainz, 1986), 107–116 and n. 1 for relevant bibliography.

2. Vassilis Lambrinoudakis and Gottfried Gruben, "Das neuentdeckte Heiligtum von Iria auf Naxos," *AA* (1987), 569–621.

3. Lambrinoudakis and Gruben 1987, 570–571.

4. Lambrinoudakis and Gruben 1987, 569–621. Gottfried Gruben, "Fundamentierungsprobleme der ersten Archaischen Grossbauten," in *Bathron. Beiträge zur Architektur und verwandten Künsten. Festschrift H. Drerup. Saarbrücker Studien zur Archäologie und Alten Geschichte*, 3 (1988), 159–172. Report on the campaign of 1987, *Archaiognosia* 5 (1987–1988), 133–190.

5. Nikos Kephalliniades, *Aghersani Naxou* (Athens, 1987, in Greek), 99–101.

6. Lambrinoudakis and Gruben 1987, 570, 614, n. 87.

7. Lambrinoudakis and Gruben 1987, 608–614; Vassilis Lambrinoudakis, "Neues zur Ikonographie der Dirke" in *Festschrift Nikolaus Himmelmann*, ed. Hans-Ulrich Cain, Hans Gabelmann, Dieter Salzmann (Mainz, 1989), 341–350.

8. South (front) and east side respectively. In the month of August 1988 the excavation of the Archaic temple was completed (report forthcoming in *AA* [1991]). It turned out that the oikos was not precisely rectangular, its north (rear) side measuring 13.07 m and its west side 24.04 m. This irregular plan is not unusual in buildings belonging to the period of transition to monumental form; see for example the oikos of the Naxians in Delos, Paul Courbin, "L'Oikos des Naxiens," *Délos*, 33 (Paris, 1980); "Le temple archaïque de Délos," *BCH* III (1987), 63–78; the temple at Koresia, Keos, below, n. 20; or the early Archaic open sekos in the sanctuary of Apollo at Didyma, Gruben 1986, 360.

9. Measured again at the east side, the west side being 0.19 m shorter (28.14 m).

10. Height restored hypothetically after the proportions of the doorway in the temple at Sangri, Lambrinoudakis and Gruben 1987, 595.

11. For the rearrangement in Roman times see especially the report in *Archaiognosia* 5 (1987–1988). The early existence of the porch is confirmed by blocks of the stylobate, fragments of cylindrical column bases, and column drums, as well as by column capitals, whose very early, elongated volute form dictated the spacing of the columns and, in later times, the arrangement of the free foundation of the repaired

southwest corner column: Lambrinoudakis and Gruben 1987, 586, 595–597.

12. Pierre Amandry, "La colonne des Naxiens et le portique des Athéniens," *FdD*, 2,7 (Paris, 1953); Georgia Kokkorou-Alewras, *Archaische Naxische Plastik* (Munich, 1975), 77, 105.

13. Lambrinoudakis and Gruben 1987, 601–603. Reports on campaigns of 1986–1987, *Archaiognosia* 5 (1987–1988), and 1987–1988, forthcoming in *AA* [1991].

14. In 1988 the excavation brought to light evidence for earlier phases of the cult in the Geometric period.

15. Athanasios E. Kalpaxis, *Früharchaische Baukunst in Griechenland und Kleinasien* (Athen, 1976), 17–26, 47–50.

16. Heinrich Drerup, "Griechische Baukunst in Geometrischer Zeit," *ArchHom*, 3 (Göttingen, 1969), 91.

17. A result of this procedure was, for example, the variety in the thickness and the fluting of the columns: Lambrinoudakis and Gruben 1987, 592, 596, 599.

18. Kalpaxis 1976, 72–73. Most features of the Dreros building are closer to the ones of the 700 B.C. Naxian temple, especially on the hearth and the clear width of the oikos (8.20 m). On the other hand its length (24 m), as well as the thickness of its walls (1.25–1.35 m), relate it to the sixth-century Naxian oikos. As far as we know, the length of the earlier Naxian temple was at least 17 m.

19. Kalpaxis 1976, 79: Late seventh century B.C.; clear dimensions of the room, 16.30 × 14.45 m; number of internal supports unknown.

20. Kalpaxis 1976, 80 (Karneios Apollo temple, seventh century B.C., dimensions of the inside, 7.30 × 12.12 m); 75 (Zagora, seventh or sixth century B.C., dimensions of the inside, prodomos included, 6.26 × 9.12 m). Smaller buildings in the islands as well as on the mainland of dimensions generally inferior to a clear width of 6 m and a clear length of 10 m are left out of this discussion. The same applies to buildings dated to the Late Archaic period or later. It is characteristic that early buildings with columns *in antis* at their front (*Antenbauten*) do not show the same tendency for a larger interior space as the oikoi do. See for examples Kalpaxis 1976, 64–70, especially 66 (temple A of Prinias) and 74 (temple of Koresia, Keos; reexamined recently by Manfred Schuler, "Die dorische Architektur der Kykladen in spätarchaischer Zeit," *JdI* 100 [1985], 361–367; 391, fig. 52).

21. Hubert Gallet de Santerre, "La Terrasse des lions, le Létoon, le Monument de granit," *Délos*, 24 (Paris, 1959). Philippe Bruneau and Jean Ducat, *Guide de Délos*, 3d rev. ed. (Paris, 1983), 169–170; Gruben 1986, 340–341: c. 540 B.C.; dimensions of the interior (vestibule and cella), 7.80 × 9.80 m.

22. Kalpaxis 1976, 76–77. Bruneau and Ducat 1983, 155–156. Dimensions of the interior, 7.5 × 8.60 m.

23. Courbin 1980; Bruneau and Ducat 1983, 119–123; Gruben 1986, 341; Courbin 1987; Lambrinoudakis and Gruben 1987, 603 n. 43, 604 n. 46 and 48.

24. Courbin 1980, pl. 42, 4–5; Courbin 1987, figs. 3 and 6.

25. Courbin 1980, pl. 68–69; Courbin 1987, figs. 7, 8, 10.

26. Courbin 1980, pl. 70–71; Courbin 1987, figs. 11–12.

27. C. 530 B.C. Gottfried Gruben and Wolf Koenigs, "Der 'Hekatompedos' von Naxos und der Burgtempel von Paros," *AA* (1970), 146; Gottfried Gruben, "Naxos und Paros," *AA* (1972), 366–369; "Der Burgtempel A von Paros," *AA* (1982), 197–229, figs. 1, 15, 16. Monumental doorway to the cella similar to the doorway in the temple of Palatia, Naxos (below, note 36).

28. C. 540 or late sixth century B.C. F. Courby, "Les temples d'Apollon," *Délos* 12 (Paris, 1931); Bruneau and Ducat 1983, 128; Gruben 1982, 222–223; Gruben 1986, 340, fig. 283, nr. 4. Dimensions of the interior of the oikos: 8.20 × 10 m. The Naxian and Parian examples cited here show that a predilection for the external porch existed in Archaic times not only in Delos (Bruneau and Ducat 1983, 49), but in the Cyclades in general; compare Gruben 1982, 222–223.

29. Through their accentuated width; compare Drerup 1969, 90–92.

30. Gruben 1986, 342–344. C. 530 B.C. Clear dimensions of the cella: 8.40 × 11.20 m. Within, single transversal row of five columns.

31. Schuller 1985, 368–371, fig. 52, nr. 2. End of the sixth century B.C. Dimensions 16 × 32 m. Single row of six columns in the cella. To these buildings one could add the "Oikos of Karystos" in Delos: Bruneau and Ducat 1983, 134, fig. 21; Schuller 1985, 348–349 (four columns *in antis*, a single row of five columns in the cella; dimensions c. 9.80 × 17.30 m). Also the North and South Buildings at Aliki in the Parian colony of Thasos: Schuller 1985, 358–361, fig. 52, nr. 5; Gruben 1986, 340, fig. 283, nr. 7 (mid-sixth and end of the sixth century B.C.; six and five columns *in antis*; dimensions 16.5 × 15 m and 12.91 × 11.59 m, respectively; cella divided in both buildings into two rooms; in the south room of each building a hearth).

32. But its length is still pronounced (dimensions of the interior, 8 × 19.8 m): Carl Weickert, *Typen der Archaischen Architektur in Griechenland und Kleinasien* (Augsburg, 1929), 54. William Bell Dinsmoor, *The Architecture of Ancient Greece*, 4th rev. ed. (London, 1976), 61–62. One could mention also the early treasuries of Sybaris, Metaponto, and Gela in Olympia, which show a real feeling for wide internal space: Alfred Mallwitz, *Olympia und seine Bauten* (Munich, 1972), 170–176; Gruben 1986, 62. But a treasury is different in character from a temple, and its use is closer to the traditional use of the oikos. On the other hand the rich western cities that founded them were no doubt in contact with the Aegean communities. For the Solonian *telesterion*, which resembles very much the temple at Iria, see below, note 40. Other late Archaic examples of large sacral oikoi exist in Attica, whose links to the islands are well known (Gruben 1986, 344). The Eleusinion on the north slope of the Athenian Acropolis: Nicolaos Papachatzis, *Pausaniou Ellados Periigisis* (Athens, 1974, in Greek), 239

(with adyton; compare the smaller temple at Zoster, Konstantinos Kourouniotes, "To ieron tou Apollonos tou Zostiros," *ArchDelt* [1927–1928], 15–17). The Late Archaic oikos of the Athena temple at Sounion: Gruben 1986, 216–217 (four columns inside). Pronounced width in large oikoi is rare anyway, and in earlier Archaic years is confined to the islands: Kalpaxis 1976, 104.

33. Again, too narrow proportions of the interior (6.5 × at least 20 m; side walls slightly curved): Rainer Felsch, "Kalapodi," *AA* (1987), 14–19, fig. 3.

34. Third quarter of the sixth century; the temple was tetrastyle prostyle, presumably with four internal supports and adyton, not amphiprostyle as Kourouniotes suggested: Ernst-Ludwig Schwandner, "Der ältere Porostempel der Aphaia auf Aigina," *Denkmäler Antiker Architektur* 16 (1985), 102–111. But here again we have to do with a small temple: dimensions of the interior, adyton included, 5.20 × 9.4 m. Even smaller (4 × 8.20 m) is a similar Early Archaic temple at Kombothekra: Ulrich Sinn, "Das Heiligtum der Artemis Limnatis bei Kombothekra," *AM* 96 (1981), 47–56; Schwandner 1985, 111 and n. 135. Two more temples of this type—an earlier one c. 570 B.C. in the sanctuary of Aphaia in Aigina (interior, 5.90 × 10.40 m), Schwandner 1985, 102–111, 128–129, and one c. 500 B.C. in Brauron (interior, 8.50 × 14 m)—are more spacious, but at the same time geographically related to the islands. So, as it seems that the prostyle building evolved out of the oikos, conceived as an enlargement of the latter (Weickert 1929, 116; Schwandner 1985, 102, 111; compare early cases such as the shrines in Aigion, *BCH* 108, 1984, 771; Olympia, Mallwitz 1972, 155; Sounion, Gruben 1986, 216), the prostyle arrangement occurs normally in different regions of Greece already in early times. Nevertheless in the region of the islands it seems to be linked in a more coherent way to a bolder size (compare Gruben 1982, 222–223; see however the large prostyle temple at Foce del Sele c. 540 B.C., 8.9 × 17.22 m). In this kind of study one should of course always keep in mind how difficult it is to interpret badly preserved foundations as prostyle or *in antis* temples; see, for example, the cases of Aigina, Kombothekra, and Brauron above. But the *in antis* building is, as far as we know, rarely monumentalized without being incorporated in a peristyle, as for example the building at Orchomenos: Olga Lappo-Danilewski, *Untersuchungen über den Innenraum der Archaischen Griechischen Bauten* (Würzburg, 1941), 31; Kalpaxis 1976, 69–70. Also the early-sixth-century temple at Selinous: Giorgio Gullini, "Il tempio E 1 e l'architettura protoarcaica di Selinunte" in *Insediamenti coloniali greci in Sicilia nell'VIII e VII secolo A.C.: Atti della 2a riunione scientifica della Scuola di Perfezionamento in archeologia classica dell'Università di Catania, 1977, Cronache di archeologia* 17 (Palermo, 1978), 59, fig. 5. Both have evidently narrow proportions. Also the smaller Archaic temple of Dionysos Eleuthereus in Athens: Lappo-Danilewski 1941, 51. The Early Archaic buildings at Ephesos and Didyma (Kalpaxis 1976, 60: Gruben 1986, 348–349, 360) do not belong to this discussion, as they were not roofed.

35. Kalpaxis 1976, 17–63, 96–102.

36. Gruben and Koenigs 1970, 135–143; Gruben 1972, 319–360, figs. 12–13; Gruben 1982, 160–164, 222–223; Gruben 1986, 344–348.

37. Gruben 1982, 222–223; Gottfried Gruben, "Kykladische Architektur," *MüJb* 23 (1972), 15–16, 28–29.

38. Drerup 1969, 90–91; Kalpaxis 1976, 103.

39. Gruben 1986, 318; Kalpaxis 1976, 104.

40. The first *telesterion* in the Eleusinian sanctuary, which is roughly contemporary (600–560 B.C.) with the Archaic temple at Iria, shows a striking resemblance to it: it is also a spacious oikos c. 14 × 24 m with an adyton—the anaktoron of the mystic cult—and presumably two rows of four interior supports. Its walls were 1 m thick. George E. Mylonas, *Eleusis and the Eleusinian Mysteries* (Princeton, 1961), 67; Gruben 1986, 224–225, fig. 181. This affinity shows that the distinction of types of buildings for use in mystic or regular cult was not very strict in antiquity; Apollo seems to have owned another similar building, the oikos of the Naxians: Courbin 1980 and 1987. So the admittedly impressive group of the typologically coincident five prostyle temples of Artemis with adyton restored by Schwandner 1985, 111, can not be used as an argument for assigning the Iria temple to Artemis.

41. Gruben 1986, 171, 123, 180–181, 191–192, 151.

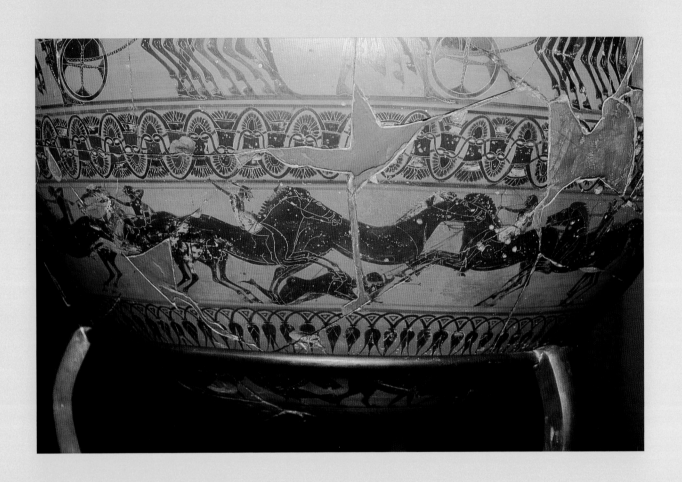

OLGA TZAHOU-ALEXANDRI
National Archaeological Museum, Athens

A Vase-Painter as Dedicator on the Athenian Acropolis:

A New View of the Painter of Acropolis 606

Members of the aristocracy, victorious athletes, victors in musical contests, and others, who mention their profession, made dedications to the goddess Athena on the Athenian Acropolis.[1] The occupations best represented are those of the potters and the painters.[2] Dedications made by potters are usually described as "tithes" or "first fruits."[3]

A marble slab from the Acropolis[4] is representative of a dedication made by an artisan. It bears the portrait of an elderly potter, dressed in a himation and seated on a diphros holding two kylikes. To judge from the letterforms of its dedicatory inscription, it must date from the end of the sixth century B.C.

The goddess Athena Polias, peaceful protector of the city since the Dark Ages, had a temple[5] on the Acropolis. She is already mentioned in Homer, in connection with the arts and crafts (*Iliad*, 5, 733–735; 14, 178–179; *Odyssey*, 8, 493; 20, 72). At the end of the sixth century B.C. she appears on Athenian vase paintings, among the potters and other craftsmen, as their protector. On a red-figure kylix at Munich[6] by the Foundry Painter (about 480 B.C.), the goddess presides over a foundry. Here her presence in the foundry suggests her character as Ergane.

Pausanias (I, 24, 3) on his way to the Acropolis mentions Athena Ergane; obviously he saw there a sanctuary, or a monument of

the goddess. According to Stevens[7] it was a monument, located to the west of the Parthenon. Apparently it had existed since the Classical period.

I believe that Athena in her quality as Ergane[8] had been worshiped on the Acropolis since at least the second quarter of the sixth century B.C. This period coincides with the increasing prosperity of Attic potters and pot-painters, owing in part to the export of the product of their craftsmanship. In fact, some of the best pieces of the leading master painters of the mature black-figure style were found on the Acropolis[9]: the work of Kleitias, the Painter of Acropolis 606, Nearchos, Lydos, the Amasis Painter, and Exekias. The majority of these vases is unsigned, as usual; it is not easy to decide, therefore, whether they were offered by the artists themselves, or by other individuals.

One of the best vases from the Acropolis is a dinos by the Painter of Acropolis 606 (fig. 12).[10] No inscriptions are preserved on the vase to tell us the name of the artist or even the name of the dedicator. Among the seven vases that are ascribed to the painter, three, including this one, have been found on the Acropolis.

J. K. Anderson has suggested that the dinos may have been dedicated in honor of an Athenian nobleman, who lost his life in an Athenian enterprise in the Hellespont.[11] According to him the frieze with Greek mounted javelin throwers riding against barbarian mounted archers may show the con-

To the memory of my father, George A. Alexandris

text of his death, while the main decoration may have been intended to compare it to the fate of a hero of the Trojan war. As far as dedications are concerned, this interpretation seems to remain without parallels.

I would suggest rather that this vase is an offering to the goddess by the painter himself, as his masterpiece. In that case fragments from a black-figure hydria[12] by the Painter of Acropolis 601, also found on the Acropolis, provide an example of a dedication made by a painter contemporary with the Painter of Acropolis 606. Here we have the painter's own statement that he dedicated this vase at the shrine of Athena:

[ΑΝΕΘΕΚΕΙΝ: ΑΠΑΡΧΕΝ: Η]
ΙΕΡΔΕ[ΙΜ]: ΤΕΣ ΑΘΕ[ΝΑΙΑΣ].

The name of the dedicator has perished, but the expression ΑΠΑΡΧΕΝ is the characteristic element, which testifies in this case that the painter has made the offering, described as first fruits.[13]

Among the painters mentioned above, the Painter of Acropolis 606 is of special interest, both because he is insufficiently studied and because we can assign to him an unpublished piece, which will shed new light on his personality. Our acquaintance with the work of the Painter of Acropolis 606 presupposes knowledge of the work of contemporaneous painters in the second quarter of the sixth century B.C. Beazley has described his personality vividly.[14] Here we intend to trace the painter's career, from the earliest phase to the latest, using stylistic criteria, such as the incision of some anatomic and other details, which show the different stages in the evolution of the painter. Useful, too, are any social, political, or religious events that may be connected with some of the painter's works.

The new vase was found in the district of Kynosarges in Attica, and is now in the storerooms of the Third Ephoreia (fig. 1).[15] It is a one-piece amphora type B, with round handles, flaring mouth, and echinus foot.[16] It contains pictures in panels and a floral border above them. The interior of the vase is covered with very thin diluted glaze, forming at intervals successive unequal bands of thicker glaze.[17] Small pieces and the left handle are missing; these have been restored in plaster.

On the principal side of the vase (fig. 2) a four-horse chariot faces left, with a charioteer in it and a hoplite at his side, ready to mount

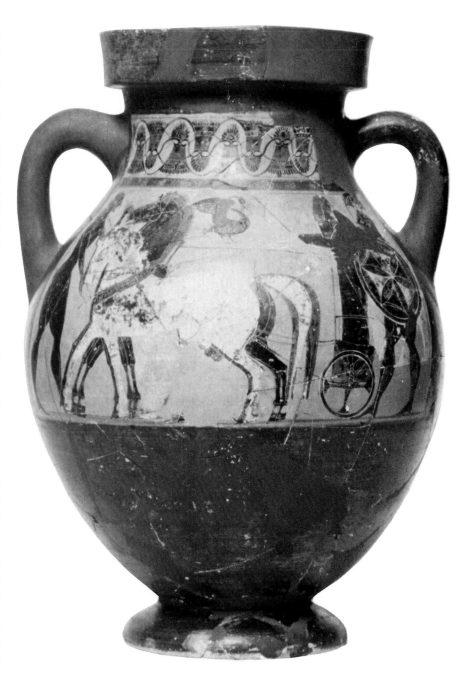

1. Amphora, attributed to the Painter of Acropolis 606, side A, departure of a warrior
Third Ephoreia of Prehistoric and Classical Antiquities, Athens

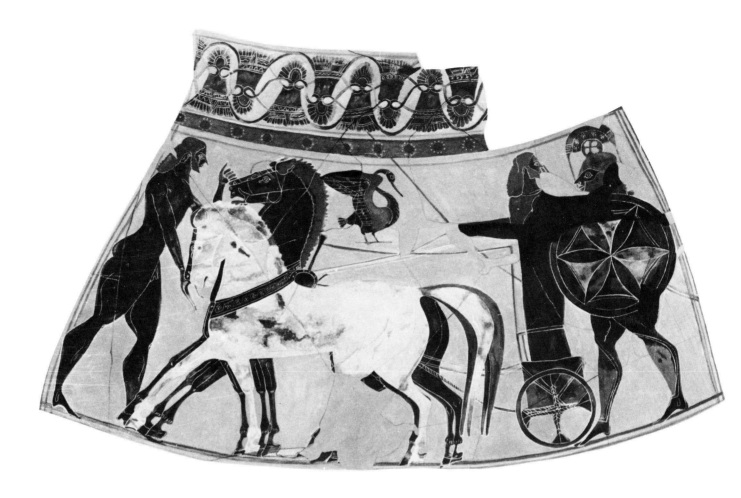

2. Drawing of warrior's departure from figure 1

it, while a groom holds the horses. The charioteer with long hair and beard, in a long robe, looks back to the warrior and holds a whip and the reins. The hoplite wears helmet and greaves and bears a shield and two spears. His long hair ends in a *krobylos*. At the other side, the groom, also with long hair and beard, is nude, calming the horses. The horses are already harnessed. The two inner (pole) horses hold their heads up, while the outer (trace) horses bend theirs. They all wear a bridle with throat lash, noseband, and browband; the cheek strap divides just above the corner of the mouth, one branch going to each end of the cheekpiece of the bit, which has a bow shape. The two pole horses are yoked to the chariot pole (ρυμός) by means of the breastband and the girth. The trace horses are attached by the trace lines to the rail of the chariot; the breastband around the trace horse's neck seems to be purely ornamental, as is the red girth. Finally one end of the yoke band is attached to the yoke peg (ομφαλός) and the other to the top of the chariot (*diphros*) rail. The chariot has as usual a front

and side rail; but the loop of the side rail is not visible because here a piece is missing. Over the horse's back a swan is standing flapping its wings facing in the opposite direction from the chariot. The swan indicates a good omen[18] or perhaps the rural character of the site. The added colors are as usual white and purplish red. White is used for the near trace horse,[19] the mane of the far trace horse, and the triangles of the shield device; red is used for the hair, the helmet, the greaves, the three petals of the star rosette device, the chariot, the manes of the two pole horses, their tails, and part of the swan's wing.

Here we have a monumental scene (fig. 2), which forms a single composition in its own right, made up of a few human figures; it shows an equilibrium of masses, well disposed in the frame of the panel, and gives a strong impression of vigor and vitality.

The style of the Painter of Acropolis 606 is recognizable in the vivid drawing and from the incised details. The figures are serious and severe, with strong and full features. Noticeable is the impressive Corinthian helmet

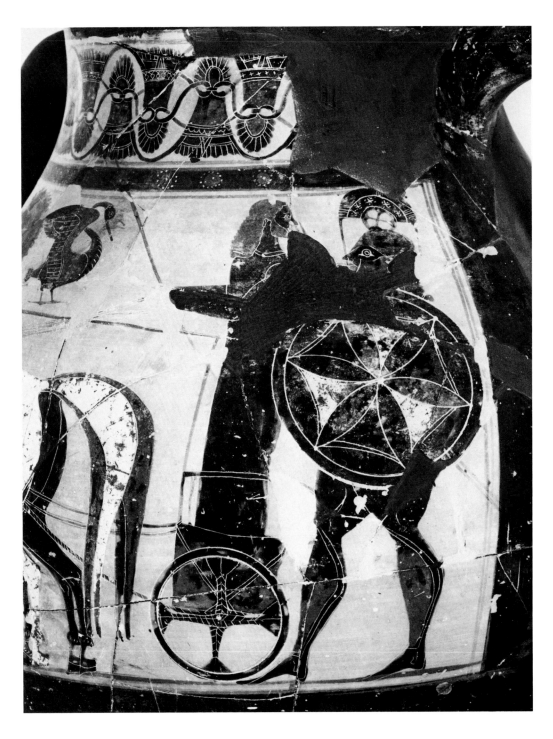

with its high crest resting on a wheel-shaped crest holder (fig. 3). This painter is fond of this kind of crest. On his Acropolis dinos he uses it three times. One of the painters of the Tyrrhenian group, the Timiades Painter, uses this crest on one of his amphorae in the Boston Museum of Fine Arts.[20] Dietrich von Bothmer[21] had already observed that this painter has something in common with the artist of the Acropolis dinos 606. The shield with the star rosette device, compass drawn, is found on other paintings by the same artist.[22] The horses (figs. 3–4) are well proportioned;[23] their bodies are filled out, and their legs are slim. The mane stands upright, solid, and its contour is serrated. The tail is solid.

The painter uses incision mainly for the outline of his design, except for the heads of figures. Incision is used for the facial features and some anatomic details, such as the clav-

3. Detail of hoplite and charioteer from warrior's departure, figure 1

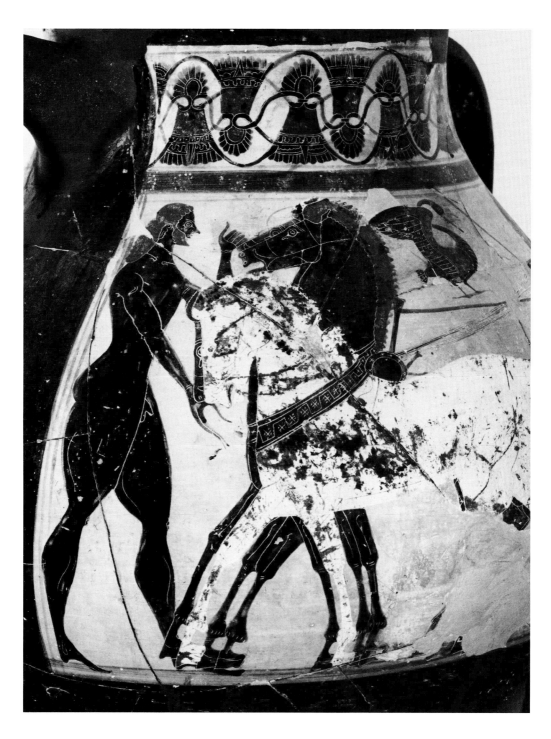

4. Detail of groom
calming horses, from
warrior's departure,
figure 1

icle or the fingers. The muscles of the arms
are indicated by two small lines, which are
among the special features of the painter. The
eyes on the black horses are drawn like the
men's eyes, circular and incised; this is an
Attic invention mainly of the period 580–540
B.C. The tear duct is a short line, ending in a
hook;[24] this is a convention familiar to other
painters. The eye on the white horse is al-
mond-shaped and corresponds to a female

eye. There are short vertical strokes on the
fetlock joint, indicating the short hair there,
and one horizontal line at the coronet; these
are among the special characteristics of the
painter.[25] The incised pattern on the breast-
band is the one used by this painter, as we
can see on one of the horses on the dinos 606
(fig. 17). The details of the bridle[26] are re-
markable. Already on this early piece the
painter shows his love for the incised details

of the harness. But it is obvious that the painter does not yet have enough practice in incision. The same observation could be made about his composition, which is still stiff. The pose of the charioteer with his head turned back is rather unnatural and recalls the charioteer on the dinos by the Gorgon Painter in the Louvre,[27] although this is a considerably earlier piece; our painter's figures are still tame and awkward.

Generally, painters of the black-figure technique do not provide a title for the scenes they are painting; Πατρόκλου ἄθλα by Sophilos[28] is among the rare exceptions. The scene we have described cannot be interpreted as an apobatic exercise,[29] although the roots of the apobatic contest go back to the war habits of the Geometric period, when the nobles, arriving at the battlefield, were obliged to dismount immediately to fight, and then mount again. But as the apobatic contest was introduced later as an athletic contest at the athletic festivals, this explanation has to be excluded. As Scheibler[30] has pointed out, equestrian contests were not among the subjects appropriate for the one-piece amphora; representations with horsemen and chariots have to be connected with the military customs of the class of the *hippeis*; they constitute the expression of the military and political importance of that class.

The scene can be interpreted as the departure of a heroic warrior or a legendary figure,[31] a subject frequently represented in Attic black-figure painting. This scene must be among the earliest. The lack of secondary figures in this representation is noticeable. Here, the pairing of the charioteer and the hoplite emphasizes their social relationship.[32] The figures shown have no specific attributes to make one certain of their identity. The subject, the warrior's departure, should be classed as a mythical paradigm[33] for the contemporary scene of the cavalryman leaving home, and this is how we should interpret our representation. Scheibler[34] observes that all scenes with horsemen and chariots have to be understood as emphasizing the necessity of military readiness, while the subject of the warrior's departure shows the readiness of the hippeis to protect their city. Here we must also take into consideration that in the period when our artist was active, the chariot remained the essential status symbol of nobles—the people who counted in wartime in Archaic societies.

The secondary scene is a komos (figs. 5–8).[35] Five naked men are dancing. The different positions of the arms and legs and the stance of the body represent movements of the komos, as explained by G. Franzius.[36] The leftmost dancer holds his left leg in a position of εκλακτιομός α, his hands are in ξιφισμός α, and the body has the stance of ρικνούσθε α. The second stands in the position of ποδισμός, with his hands in γαστριζεσθε, and he turns backwards. The one with the drinking horn has his left leg in a position of αποπυδαρίζειν; he touches his head with his right hand and holds his body straight. The one playing auloi stands like the second dancer, in the position of ποδισμός, holding his body straight; the pouch for his flute (aulos), the ὀυβήνη, hangs from his left arm. The last dancer holds his body straight, his right leg in the position of ελατισμός α, and his hands in γαστριζεσθε. The hair and beards of the dancers are purplish red, and there are touches of the same color on their chests. The pouch for the flute is painted white.

As for the attributes of the dancers, we must notice the following. The drinking horn[37] appears in Attic black-figure by the

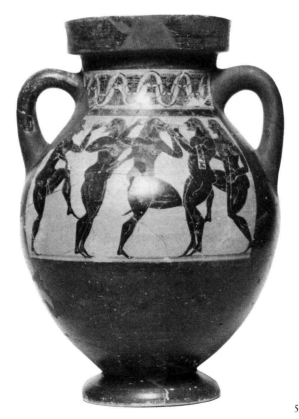

5. Side B: komos

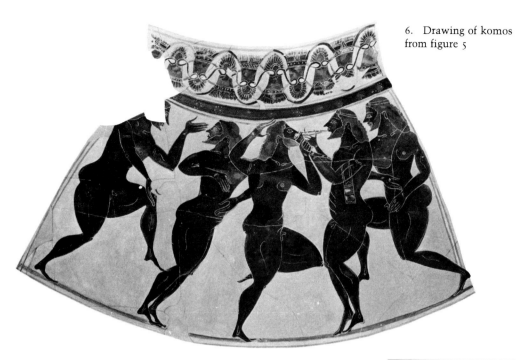

6. Drawing of komos
from figure 5

7. Detail of left part of
komos from figure 5

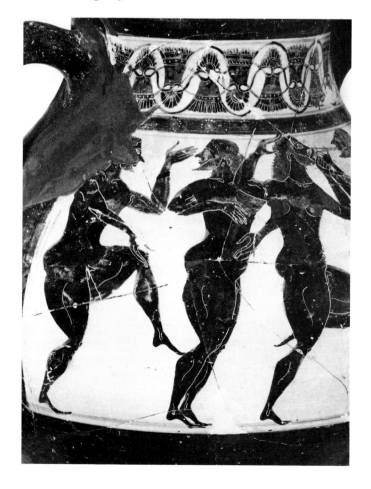

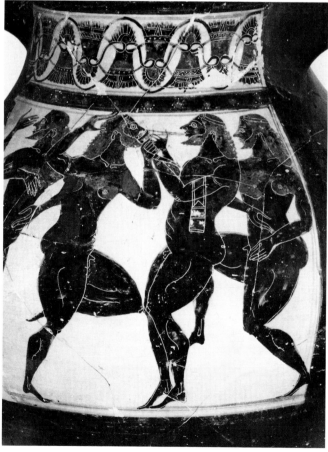

8. Detail of right part of
komos from figure 5

first quarter of the sixth century. It seems likely that the models were those in Corinthian komos scenes, where they appear by the last quarter of the seventh century B.C. The material they were made of may have been bone. The auloi[38] from their first appearance are shown in a religious context or in funeral processions. In black-figure it is the favorite instrument for the komos or the banquet; it is the attribute of Dionysos.

The komos, both in visual arts and in literature, has different meanings[39] because of the evolution of ancient life and of the changing poetical mood. The earliest komast vases reflect the actual performance of the padded dancers. But while the padded dancers may have had some special significance for the Corinthians, as Carpenter suggested,[40] they did not have any special meaning for Athenians. Carpenter argues too that the appearance of the dancers in symposium scenes, where drink and flutes are also important elements, adds to the impression that the Athenians saw these figures simply as revelers naturally associated with drink and love. The Attic skyphos in the Athens National Museum[41] shows the connection between Attic komasts and drink. Indeed, a high proportion of the vases on which these dancers occur were used for wine, or the symposium amphorae[42] and cups.[43] The vases of the KX and C Painters are the earliest,[44] dating from the end of the first quarter of the sixth century B.C. In about 570 B.C., we see a large number of Tyrrhenian amphorae with komos representations. Then in mid-century komasts continue to be popular on amphorae, from Lydos to the Swing Painter.

Returning to our vase, we may say that since the official dances in honor of Dionysos only began early in the third quarter of the sixth century,[45] the interpretation of the scene as a komos in the city Dionysia must be excluded. More likely, the artist is picturing a komos after a symposium.

The one-piece amphora type B is the oldest of the three types.[46] The decorative arrangement, with the figures set in panels, becomes standard from the beginning of the sixth century. The Gorgon Painter is the first Attic black-figure painter to favor this kind of decoration. During the first quarter of the sixth century, the panel becomes wider and often extends below the maximum diameter of the body. Later, this decorative scheme is widely used by Lydos. The upper border of the panel, a lotus palmette, appears in the first quarter of the century and becomes a normal feature in the second quarter.[47] The dotted rosettes on the band below the lotus-palmette pattern recall those on some Corinthian kraters of the first and second quarters of the century.[48] The shape of the panel with the same floral border above is already found on a one-piece amphora by Sophilos, now in the University of Iena, dating from the first quarter of the century.[49]

On black-figure amphorae, the representation of a scene such as a warrior's departure, paired with a komos representation or Dionysiac scene, is rather frequent.[50] Both pictures lead to the conclusion that our amphora was destined for daily life rather than for ritual purposes. The use of our amphora as a wine vase[51] is suggested by its subject; we can also imagine the servants of the amphora's owner going to the market[52] to buy wine to fill the vase. Since the vase was found in an area with graves, we can conclude that it was also used in a burial.

Few amphorae are found in Attica, and most of those come from cemeteries. They were exported, however, in large quantities.[53] Those found in shrines in Attica were used in celebrations or in religious ceremonies.[54] The same type of vase was used for offering the first fruits.[55]

Incision in black-figured technique is a decisive criterion for the chronological classification of a painter's work. Key aspects are improvement in a quality of the line, and in skill and exactness, and an increase in details. In the Kynosarges amphora, these criteria suggest that it is the earliest known piece by the painter. A date of about 575–570 B.C. is appropriate.

Another one-piece amphora of type B by the Painter of Acropolis 606 is in the Collection of Antiquities in the Archaeological Institute, University of Tübingen.[56] The decoration is confined to a large panel on each side. The rest of the vase, except the zone for rays at the base, is painted black. Each panel is decorated with a galloping rider, armed with a shield, a Corinthian helmet, and a spear. On one side a hare accompanies the rider; on the other side there is a hound. An eagle at the right corner of the panel follows the rider, a good omen or an indication of the landscape.

The style of drawing is identical with that

9. Two fragments belonging to a column-krater from the Acropolis, Athens, attributed to the Painter of Acropolis 606
National Archaeological Museum, Athens

of the Kynosarges vase, and the style of incision is similar too, but more developed: the birds' feathers show more detail; the horse's anatomy is clear; and the rendering of the hoplite's features is more natural. An innovation here is the galloping horse in place of the motionless horses of the Kynosarges vase. Here too, as on other contemporary panel amphorae, the vacant space between the horses' legs is filled with a small animal, a dog[57] or a hare.[58] The flying eagle substitutes for the static swan.[59] Whereas the Kynosarges figures are all without a moustache, the hoplite on the Tübingen vase has a curled moustache, a feature that, from now on, appears frequently. A date of about 570 B.C. is appropriate for the style of this vase.

Mounted warriors appear on amphora panels beginning in the second quarter of the sixth century B.C.[60] Although the representations are stereotyped, they have special interest for military history, and especially for that of the mounted warrior.[61] It should be noted that hoplites in the second quarter of the century did not fight on horseback; although hoplites might ride to battle, they dismounted to fight on foot. Webster, in considering vases with horsemen and chariots, suggested that they were made by the painters for the class of the hippeis[62] and that they represented the military activities and achievements of that class. A horseman amphora may be interpreted as indicating the social position of its owner.

To the same painter are assigned a few fragments from an open vase, probably a column-

krater, which were also found on the Acropolis and are now in the Athens National Museum (fig. 9).[63] A boxing scene is partly preserved; only the bearded heads and the hands of three figures are preserved. But this is sufficient for the interpretation of the scene. A boxer is knocking his opponent down with a straight left to the chin, while his right hand is clenched and drawn back in preparation for a final blow. The second boxer acknowledges defeat by holding up his right hand with two open fingers. Both boxers are wearing soft thongs, μείλιχαι; we can see the thin strips of leather around their wrists and their hands. The figure to the right of them must be a judge rather than a trainer; he intervenes with his raised hand and probably proclaims the end of the contest.

The design is skillful and vigorous. The incision is also fine and is executed with more assurance than that on the two earlier vases by the painter. Here too the artist uses incision only where it is necessary: for the outlines of the figures, except for the head, and to accentuate the details of the face and other anatomical details, such as the clavicle, the fingers, or the muscles of the arms. The use of added colors is confined to purple for the hair, the beard, and some of the tongues on the shoulder ornament.

We can observe the following about athletic representations. Early in the sixth century B.C. a number of Greek states organized athletic festivals with their essential feature the institution of organized competitions.[64] The great Panathenaea,[65] instituted in 566,

10. Two fragments belonging to a column-krater from the Acropolis, Athens, attributed to the Painter of Acropolis 606
National Archaeological Museum, Athens

11. Two fragments belonging to a column-krater from the Acropolis, Athens, attributed to the Painter of Acropolis 606
National Archaeological Museum, Athens

included a considerable variety of competitions. It is also likely that there were unofficial contests before 566 B.C.[66]

In fact, athletic representations in Attic Geometric and Protoattic pottery are rare. An increasing interest in athletic contests is evident in Attic vase-painting in the second quarter of the sixth century.[67] In black-figure, boxers appear on some Siana cups from the C Painter's workshop dated not earlier than the traditional date for Peisistratos' reorganizations.[68] Athletes belonged to the richest families,[69] so the winner could buy, or even order,[70] the appropriate offering as a dedication in the shrine of the deity in whose honor the games took place to commemorate his victory. Furthermore, we may assume that this vase was the dedication of a victorious athlete at a boxing contest during the Panathenaic games. Taking into consideration that vases with athletic subjects have been found on the Acropolis,[71] probably as dedications, and that they do not antedate the generally accepted date of Peisistratos' reorganizations of the Panathenaea, we have further evidence for a *terminus post quem* for this subject matter. Combining this hypothesis with the stylistic features, a date between the years 566 and 560 B.C. is appropriate for this vase.

Three fragments from the Acropolis showing parts of female figures (figs. 10–11),[72] together with a fourth, probably belong to a column-krater.[73] The largest piece preserves a nymph (head missing) facing right, and part of a satyr's leg and tail. The dress of the nymph opens on the right side revealing her right leg, in the position of ἐκλακτισμός. Another fragment shows the lower half of a second nymph dancing. A third fragment shows two feet, one of a woman, the other of a man. The fourth preserves a man's head.

It is clear that here we have a representation of a dance, a komos. Nymphs appear with satyrs in pre-Dionysiac scenes. Satyrs originally are not associated with Dionysos; they develop independently before they appear with him.[74] The scene is appropriate for a vase such as a column-krater, used for wine during a symposium.[75]

The design, the manner of incision, and the technique of the added colors are close to the column-krater fragments with the boxers so these two vases must be contemporary with one another.

A large, one-piece amphora of type B in the Antikenmuseen in Berlin is by the same artist.[76] It may have stood as a monument on an Attic tomb. The decoration is confined to a large panel on each side. Here, we see two men riding side by side. The figure in the foreground wears helmet and greaves, and carries a shield and spear; all that is seen of his companion is his face and the front of his brimmed felt hat. An eagle with a serpent in its beak flies beside the riders. A hound accompanies the riders on one side, a hare on the other.

In comparison with the other pieces by the painter, progress is evident in the treatment of the greaves and in the design of the shield device, which is now more elaborate, showing six petals alternating with another six lozenge-shaped ones; the incision is fine and accurate. The manes of the horses have solid topknots, a feature introduced by our painter, and also by the Heidelberg Painter and the Painter of Acropolis 627.[77] The rendering of the eagle is also more natural.[78] The riders are represented close together, almost giving the impression of one man. On an amphora in Naples by Lydos with the same subject, both riders are well distinguished from one another.[79]

Van Berchen and Metzger point out that the kind of warfare in which a heavily armed man dismounted to fight, leaving his horse with his squire, was out of date before this vase was painted.[80] The subject of a pair of warriors derives from the tradition of friendship between men, the brotherhood of war, and the pedagogical connection between older and younger;[81] it accentuates too the social relation between hoplites and their squires. Furthermore, Webster suggests that the squire-knight relationship remained as a method of training after the invention of the cavalry phalanx.[82] Like other such representations, the vase reflects the military readiness of the city.[83] Scheibler believes that this vase, like the other horseman amphorae by the painter, could have been a special commission.[84]

The date of about 565 B.C., or even later, given by Mommsen, is appropriate for the amphora.

The fine dinos (figs. 12–21),[85] now in Athens, in the National Archaeological Museum, is the name-piece of the painter. The shape had already been used by the Gorgon

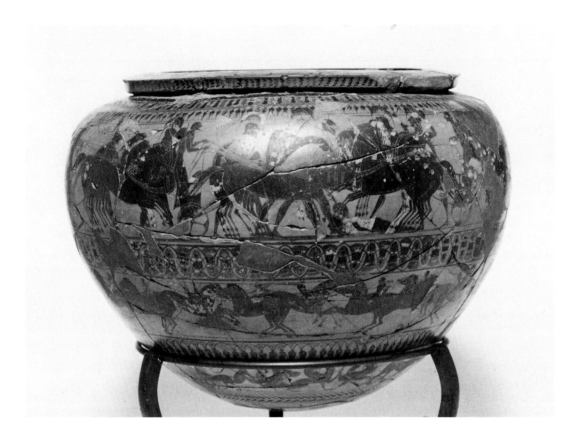

12. Acropolis dinos 606, attributed to the Painter of Acropolis 606

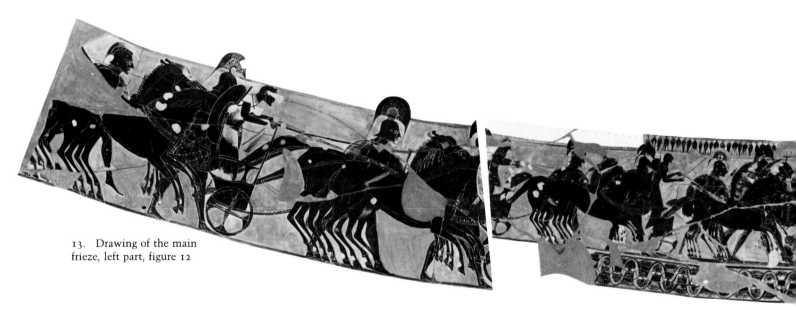

13. Drawing of the main frieze, left part, figure 12

14. Drawing of the main frieze, middle part, figure 12

Painter[86] and by Sophilos.[87] The chief picture is a battle scene extending the length of the main frieze. It is an action scene. There are eight chariots and twenty hoplites, including a dead one. Noteworthy is the group of the two front-line chariots with the dead body lying on the ground between the animals' legs, with five hoplites fighting beyond the horses. The charioteers, holding whip and reins, wear Boeotian shields on their backs for protection. They have short hair, and two of them are beardless and lack moustaches. Their robes feature a vertical wave pattern or dotted rosettes and crosses; two are undecorated. All hoplites have curled moustaches, and beards visible under their helmets. All but two of the helmets are richly decorated with high crests. Three crests rest on wheel-

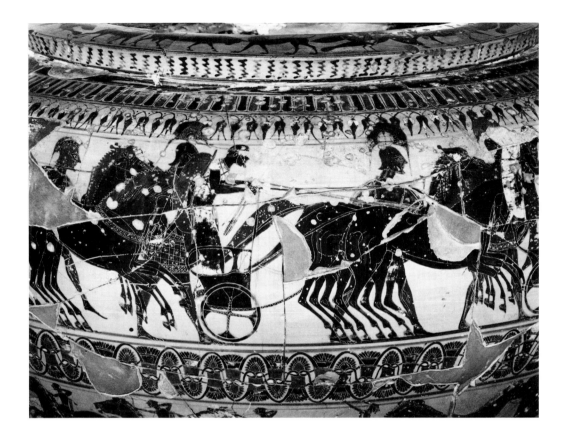

16. Detail of figure 12: two four-horse chariots facing right with their charioteers; behind the horses four warriors; the first wears the helmet with low crest, the second a helmet decorated with a swan's head, the third a helmet decorated with a wheel

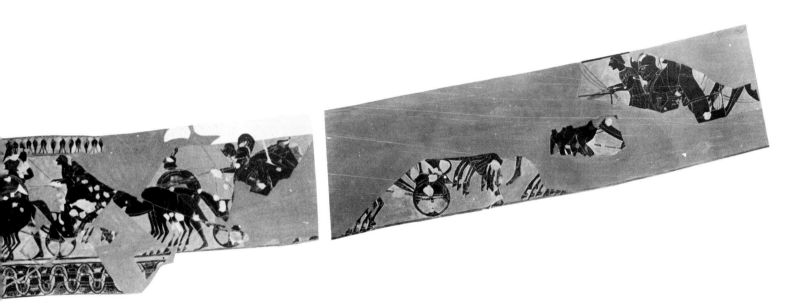

15. Drawing of the main frieze, right part, figure 12

shaped crest holders, four on swans' heads, and another is decorated with two feathers. The cuirasses have rosettes and crosses, except for one, which is plain. Six of their shields are shown from the back. Among these represented from the front, one is decorated with a compass-drawn star rosette, resembling the one on the Kynosarges vase; here the design is more elaborate. Two

shields have lions' heads as a device, one has a cock.

The horses are shown in action; they are wonderfully well drawn, with every detail incised. On some the mane stands upright, its contour serrated; on others it falls on the neck in curls. The manes of all the horses have solid topknots, except for two pole horses. The breastbands are decorated with various

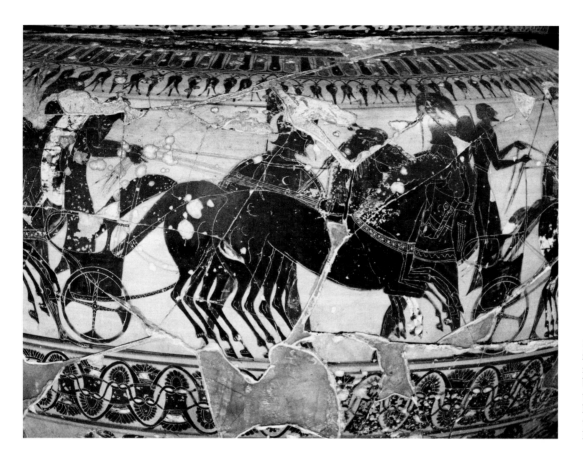

17. Detail of figure 12: four-horse chariot facing right with its charioteer; behind the horses two warriors; the crest of the helmet of the second warrior stands on a swan's head

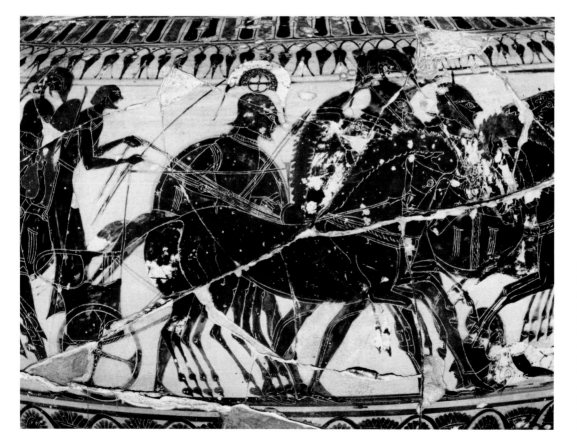

18. Detail of figure 12: four-horse chariot facing right with its charioteer, and three warriors behind the horses; the helmet of the first warrior is decorated with a wheel, and that of the second with a swan's head; part of another four-horse chariot facing left; part of a fallen warrior between the horses' legs

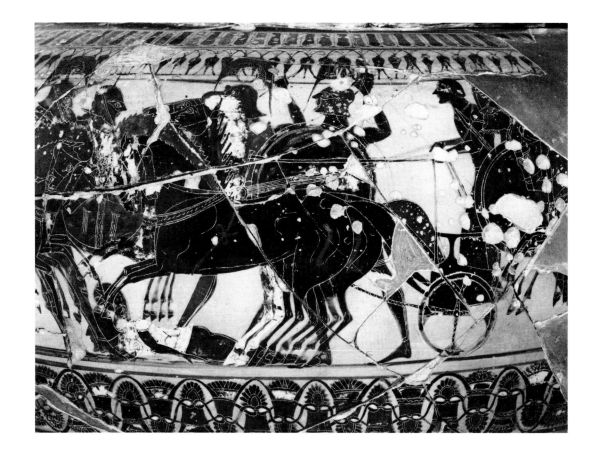

19. Detail of figure 12: four-horse chariot facing left with its charioteer, a fallen warrior, and two warriors behind the horses; the helmet of the first warrior is decorated with a wheel, that of the second with two spear points

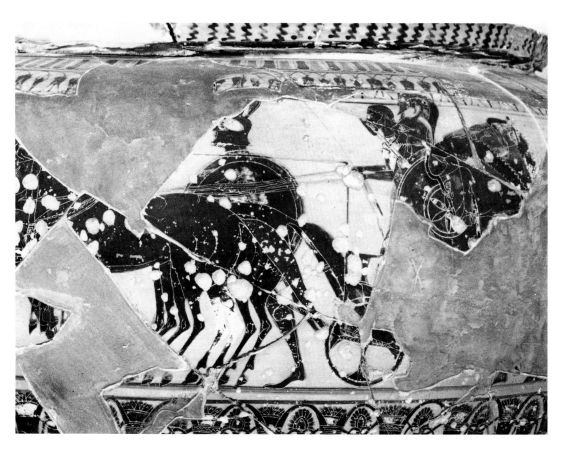

20. Detail of figure 12: four-horse chariot facing left with its charioteer, and two warriors; the second warrior wears a helmet decorated with a swan's head; he holds a shield with a star rosette device; part of the heads of the horses of another chariot

21. Detail of figure 12: rear part of the chariot, part of the four-horse chariot facing left with its charioteer and a warrior; part of another warrior facing right, and part of a charioteer

incised designs: oblique lines, continuous meander, or meander with crosses and dots, as on the vase from Kynosarges. All figures are drawn in clear detail. The design shows affinities with what we consider to be the earliest work of this painter, but now it has become more expressive, and the proportions of the figures are slenderer.

Added white and purple accentuates the figures. Some of the horses in the background are white, while the front trace horses are black to avoid strong contrasts; the manes of some horses are painted purple, others white. Among the painter's chariot horses only the Kynosarges near trace horse is white. Despite partial effacement the elaborate use of added colors still gives the impression of polychromy.

The painter's figures lack the sensitive expressivity found on certain figures of his colleague Nearchos, the other great painter of the period who worked in a monumental style.[88] Nearchos' kantharos in the National Archaeological Museum in Athens exhibits gracefulness and elegance in the figure of Achilles that overshadow early and later artists.[89] It is in composition that the Painter of Acropolis 606 excels. The battle scene of the Acropolis dinos is unique; it shows exceptional mastery of drawing and concise knowledge of composition. The painter created a new effect of density using grouping and overlapping. He was the first to depict a single battle scene as the subject for the whole vase. He was the first to express the new mood.

The scene refers to the heroic past, since in the sixth century chariots were no longer used for war.[90] Very probably such a representation is intended to recall old glories and give the paradigm for imitation.[91]

A secondary frieze displays a cavalry battle (figs. 22, 23). Twelve Greek javelin-throwers ride against ten barbarian archers, also mounted. The Greeks wear brimmed hats and tunics of various colors, red ones, black ones decorated with red crosses, and white ones with incised zigzag decoration. They carry a spare javelin in their left hand and they hold another one with their right. The archers wear red or white belted tunics or black ones with red rosettes, Phrygian hats, and leather boots; they carry quivers on their backs. One Greek has fallen, his head pierced with an arrow.

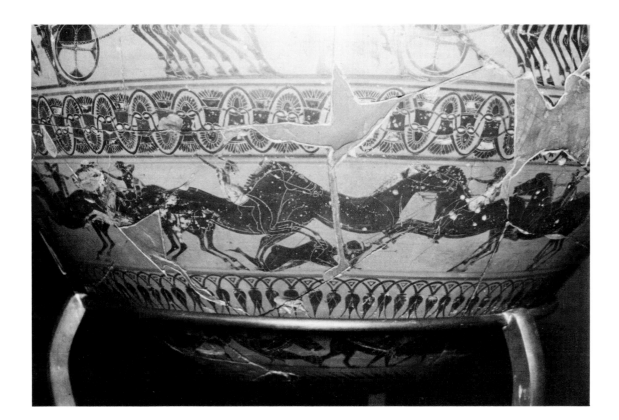

22. Detail of figure 12: part of a secondary frieze with one javelin thrower and four archers, and a fallen warrior

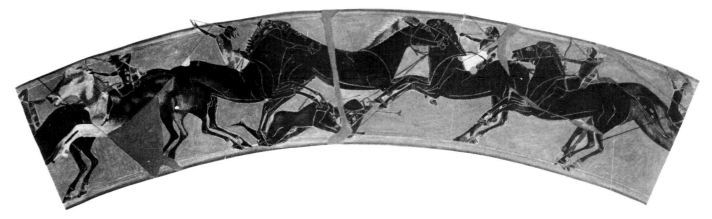

23. Drawing of part of the secondary frieze of figure 12

Five horses are entirely white, the manes of three more are white, while the manes of the rest are red. It is worth recalling that white, mounted horses first appear in Attic pottery in the cavalcade shown on a dinos by Sophilos;[92] the cavalcade of the Acropolis dinos is slightly later.

Here the painter proves himself a good miniaturist, for his drawing is as accurate as on his monumental work. Although the horsemen are small, they are carefully drawn. The horses are big and their anatomy is detailed; most of them have solid topknots. Compared to the horses on the Tübingen amphora, the galloping horses here are more natural. As on

the frieze with the heroic battle the painter overlapped the figures to create the effect of density. Greenhalg has pointed out that this is our earliest illustration of cavalry fighting cavalry.[93] It would seem that the battle is a contemporary one, and in fact J. K. Anderson has interpreted it as taking place in the Hellespont.[94]

The other friezes have grouped animals and florals. The floral between the two narrative scenes described above repeats the lotus palmette border present (figs. 1, 2) on the Kynosarges amphora, but here the design is finer, and there is added white, giving a brighter impression. In the lower zone are animals

placed in groups, and on the underside is an animal whirligig, the foreparts of six animals, alternating lion and horse.[95]

The narrative style, showing events taken from mythology in friezes around a vase, is not new. As early as 590 B.C. the Gorgon Painter had painted a duel scene, flanked by chariots, on his name-piece, a dinos in the Louvre.[96] Sophilos[97] was the first to depict scenes from epic themes, but without many figures; he was the first, too, to initiate in Attica the use of friezes for continuous compositions forming a unified whole.

A new element now was the organization of the composition. In this the Painter of Acropolis 606 differed from his predecessors.

The new generation of painters adopted these elements, as we see on another dinos in the Louvre, by a painter of the Tyrrhenian group, either the Timiades Painter or the Camptar Painter.[98] It shows an Amazonomachy, a horse race, and an animal frieze; the Louvre dinos recalls the Acropolis dinos in the use of three successive friezes, the continuous composition as a unified whole, the grouping, and the overlapping, even the wounded warrior fallen on the ground.

Returning to our painter, I believe that a date of about 560 B.C. is appropriate for the style and the technique of his dinos.

Among the painter's pieces is a fragment in the Odessa museum found at Theodosia in the Crimea.[99] It shows the upper part of a hoplite facing right, holding a shield. The painter of Acropolis 606 is recognizable here by the strong profile of the hoplite and by the motif of the helmet's crest, a swan's head. Very probably this sherd belongs to a vase with a scene similar to that of the main frieze of the Acropolis dinos.

I believe that the latest piece by this painter is his neck amphora with ovoid body, in the Historical Museum of Geneva.[100] On the front and back of the neck there is a bearded male head wearing a red fillet. On the principal side of the body the picture of the rider is set in a panel, bordered above with a band of tongue pattern. The galloping horse is identical with those in the secondary frieze on the Acropolis dinos. The nude rider is slender in comparison to the Kynosarges nude figures. On the other side is a siren with spread wings and head turned back; a flower springs from the ground before her. Added white was used for the face and wing stripes. The incision

shows the exactness and refinement known from the painter's later work. The feathers of the siren can be compared with those of a siren on the Acropolis dinos.

A number of vase-painters put heads on the necks of neck amphorae around 560 B.C. Among them the Painter of Vatican 309 is one of the best known. The closest to our scheme is an amphora in Oxford by a painter near Lydos, dated about 560 B.C.[101] The head on a column-krater in the British Museum, which is among the earliest works by Lydos, shows some similarities.[102]

As for the main scene, we may interpret the rider as an athlete, belonging to the class of the hippeis,[103] but the representation cannot be interpreted as a contest.[104] It is interesting to note that this is the only nude rider so far known by the painter and is among the earliest representations of its kind. It is useful to recall here, too, that equestrian contests were the main part of the cult of the heroized dead.[105]

The three fragments belonging to a four-horse chariot (fig. 24)[106] were believed to be part of the vase with nymphs and satyrs by our painter, discussed above. The yoke peg and the disc by it are drawn quite differently from those we know from all other vases of the painter. The reins and muzzle are also rendered differently. These fragments cannot belong to a vase painted by him.

A neck-amphora with an ovoid body in the Antikensammlung in Munich is a work by a minor painter in the workshop of the Painter of Acropolis 606 and not by the painter himself.[107] The decorative scheme is the same as that of the Geneva amphora, but the details of the painting are different. The feathers of the cock are treated in a different manner from that known on other birds[108] by the painter. The legs of the satyr, represented on the main side of the vase, show clumsiness and cannot be compared with those of the dancers on the Kynosarges amphora. And even the bearded heads on the neck show slight differences in the features.

The Painter of Acropolis 606 flourished in the second quarter of the sixth century B.C., a critical period for Athenian vase painting; it was then that Attic painters found their own way of painting. Those working in miniature developed a new style of refinement. The illustration of legend led other painters to work in monumental style and to create

24. Three fragments from
a vase from the Acropolis,
Athens
National Archaeological Museum,
Athens

excellent compositions. This painter, a contemporary of Kleitias and Nearchos, was one of the more able painters of his time.

He painted the usual shapes, such as the one-piece amphora, the dinos, and the column-krater, and he also tried a new shape, the ovoid neck-amphora. His style is thoroughly Attic. He was rooted in the tradition of the Gorgon Painter,[109] and probably he was his best pupil. As noted above, some of the painter's features recall aspects of the Gorgon Painter—for example, the posture of the charioteer on the Kynosarges amphora,[110] or the use of the panel,[111] or even the similar design of the lotus palmette band,[112] as on his Kynosarges amphora and his dinos.

The artist began by painting compact groups of a few human figures, framed within a panel and with floral borders above, like the Kynosarges amphora. At the same time, however, or even later he painted monumental scenes like those on the amphorae at Tübingen and Berlin, following the general trend. I believe that during his maturity the painter tried a narrative style, using the decorative system of successive bands, as on the Acropolis dinos, a late work; although we lack earlier pieces of that kind, the perfection of his dinos composition presupposes the existence of earlier experiments.

His scenes with horsemen can be divided into a number of subjects, some connected with war, and some with cavalry training, as this kind of vase was made for the class of the hippeis[113] and its representations illustrate the occupations of that class. He painted athletic contests suitable for victorious athletes, such as the column-krater figuring a boxing scene. He depicted battles referring to the heroic past, and others taken from contempo-

rary events, such as his dinos, on which he combined both effectively. He also represented scenes of feasts, such as the komos of the Kynosarges amphora and the dance with satyrs and nymphs—which is the only representation of women we have by this painter—on his krater from the Acropolis. Behind these representations one can see some aspects of the male-dominated society of the period, and the background of its ideals.[114]

His painting is bold and vivid. His figures are well proportioned and powerful. On his early vases the figures are large and amply proportioned; they are rather plain, with a minimum of incision used for limited details only. The art of incision is not developed yet, but it shows already the robust appreciation of anatomy, which is one of the main characteristics of his style. In his mature work the outline of the figures is fine and accurate, as on the amphora in Berlin. The patterns on garments and all incised details are meticulous. But patterns and incision are always incorporated in the design and are not merely ornamental, as in the case of his colleague Nearchos. The added colors, white and red, are elaborately used and well adapted too; on his earliest work they are enlivening touches, added over the black glaze; on his mature pieces the added colors help to balance his masses and to emphasize certain details. In his later work the figures are more slender, and they act with agility, as on dinos 606 and the amphora in Geneva. The subjects he treated gave him the opportunity to move his figures in different ways, not only by themselves but in groups and all together as a whole representation. He had an unsurpassed talent for composition.

At the beginning of his career the painter showed his skill and talent in the representation of the human figure. The brave warrior of the Kynosarges amphora can give the impression of the decisive soldier, who is going off to war ready to face his fate, expressing at the same time the readiness of his city for war. The five dancers on the same amphora successfully convey the festive atmosphere of a celebration. Sometimes the painter used the same model to represent different figures.[115]

For the chronological classification of the painter's works, the fragment with boxers, found on the Acropolis, is of extreme importance. The possible connection of the athletic representation that it bears to the contests of the Panathenaic festivals gives a *terminus post quem* for this vase, which is useful for the dating of the whole of his work. A date of about 575 B.C. for his earliest vase, the Kynosarges amphora, and a date of 560 B.C. for his latest, the amphora in Geneva, are the two limits between which his activity ranges.

His influence on his slightly younger colleague Lydos[116] is evident in the use of the panel amphora, and in subjects such as the komasts, or the pair of warriors. He also influenced some minor artists of the Tyrrhenian group, especially the Timiades Painter.[117]

About half of the painter's preserved vases were found on the Acropolis, where they were dedications, and at least one was exported. Those facts suggest that the painter's vases were esteemed by his contemporaries as pieces of high quality.

The wonderful drawings published here of the Acropolis dinos 606 and of the Kynosarges amphora nr. A.3893 (Third Ephoreia of Athens) are the work of Th. Kakarougas, of the National Archaeological Museum of Athens. The photographs of the vases were taken by G. Fafalis and those of the drawings by D. Yalouris.

1. The large dedications were studied by Antony E. Raubitschek and Lillian H. Jeffery, *Dedications from the Athenian Akropolis* (Cambridge, Mass., 1949).

2. John D. Beazley, *Potter and Painter in Ancient Athens* (London, 1946), 21–25.

3. Thomas B. L. Webster, *Potter and Patron in Classical Athens* (London, 1972), 4.

4. Acropolis no. 1332. Maria S. Brouskari, *The Acropolis Museum: A Descriptive Catalogue* (Athens, 1974), 131–132, fig. 251, with earlier bibliography. Ingeborg Scheibler, *Griechische Töpferkunst* (Munich, 1983), 124, fig. 110.

5. C. J. Herington, *Athena Parthenos and Athena Polias* (Manchester, 1955); John Travlos, *Bildlexikon zur Topographie des Antiken Athen* (Tübingen, 1971), 53–143.

6. Munich 2650, *ARV²*, 401, 2. *Beazley Addenda*, 114. Julius Z. Ziomecki, *Les Représentations d'artisans sur les vases attiques* (Wrocaw, 1975), 82, fig. 33.

7. Gorham Philips Stevens, *The Setting of the Periclean Parthenon, Hesperia*, supp. vol. 3 (Baltimore, 1940), 24, 32, 56–57, fig. 1, 11, 20, 41.

8. On Athena Ergane see Pierre Demargne in *LIMC*, 2, 1, 961, A5, with bibliography.

9. Botho Graef and Ernst Langlotz, *Die antiken Vasen von der Akropolis zu Athen* (Berlin, 1925–1933), vol. 1, pls. 30, 31, 32.

10. Acropolis 606: *ABV*, 81, 1; *Paralipomena*, 30; *Beazley Addenda*, 8. John D. Beazley, *The Development of Attic Black-Figure* (Berkeley, 1951; rev. ed. 1986), 35–36, pl. 30, 5, and 31, 1–2.

11. John Kinloch Anderson, *Ancient Greek Horsemanship* (Berkeley, 1961), 145.

12. Acr 15163: *ARV²*, 80, 1; *Paralipomena*, 30.

13. Beazley 1946; Webster 1972. See also Ingeborg Scheibler, "Künstlervotive der archaischen Zeit," *MüJb* 30 (1979), 7–30.

14. Beazley 1951, 35–36. See also Jean Charbonneaux, Roland Martin, François Villard, *Archaic Greek Art* (New York, 1971), 65, fig. 70; John Boardman, *Athenian Black-Figure Vases* (London, 1974), 35; Robert S. Folsom, *Attic Black-Figured Pottery* (Parkridge, N.J., 1975), 121–122; Martin Robertson, *A History of Greek Art* (Cambridge, 1975), 128–129, pl. 35c; Michalis Tiverios, Ο Λυδός και το έργο του (Athens, 1976), notes 297, 488.

15. The vase (A3893) was found by workmen opening a trench for placing water pipes at the street Kallirroe near house numbers 43–45 in 1965. During earlier ex-

cavations pieces of the street leading to Sounion and a number of tombs, dating from the tenth century to the seventh century B.C., were found. See J. P. Droop, "Dipylon Vases from the Kynosarges Site," *BSA* 12 (1905/6), 80–92. Also two buildings belonging to the Kynosarges Gymnasion were partially excavated at the end of the last century. See Cecil Smith, "Report of the Director for the Session 1895/6," *BSA* 2, (1895/1896), 26. Wilhelm Dörpfeld, "Funde," *AM* 21 (1896), 464.

16. H: 0.533 m; greatest diameter: 0.378 m; diameter of lip: 0.245 m. For the different types of the one-piece amphora see: Mary B. Moore and Mary Zelia Pease-Philippides, *Attic Black-Figured Pottery, Agora*, 23 (Princeton, 1986), 4–7. For type B see also Heide Mommsen, *Der Affecter*, Forschungen zur antiken Keramik 2 (Mainz, 1975), 48–51. During the Archaic period the names αμφορεύς and κάδος were both used for this type of vase. See Ingeborg Scheibler, "Bild und Gefäss," *JdI* 102 (1987), 60. It is the broadest shape: Gisela M. A. Richter and Marjorie J. Milne, *Shapes and Names of Athenian Vases* (New York, 1935), 3. Helga Gericke, *Gefässdarstellungen auf Griechischen Vasen* (Berlin, 1970), 64; Maxwell George Kanowski, *Containers of Classical Greece* (Queensland, 1983), 19.

17. This is not the thin brownish glaze used by the vase painters for drawing; rather, it seems that the potter finishing his work put a sponge or cloth into a dilute glaze and applied it to the interior of the vase.

18. Compare note 59, below.

19. On white chariot horses see Mary B. Moore, *Horses on Black-Figured Greek Vases of the Archaic Period* (Ann Arbor, Mich., 1976), 374.

20. Boston 98.916: *ABV*, 98, 46; *CVA*, 1, pl. 17, 1–2. *LIMC*, 1, 1, 588, 9, pl. 441.

21. Dietrich von Bothmer, "The Painters of 'Tyrrhenian' Vases," *AJA* 48 (1944), 164.

22. On the earliest pieces of the painter, such as his amphora in Tübingen (no. 1298: *ABV*, 81, 5; see text and below, note 56), we find the same device. On the Tyrrhenian amphora at the Boston Museum of Fine Arts by the Camptar Painter (no. 21.21: *ABV*, 84, 3; *Add.* 8) we see the same device on one shield. The same star rosette is found on another amphora by the same painter in Cambridge, Fitzwilliam Museum (no. GR.24.1864: *ABV*, 84, 2; *Beazley Addenda*, 8). Another amphora by the same painter in the Louvre (no. E863: *ABV*, 84, 6; *Beazley Addenda*, 8), shows a shield with a star rosette device like the one we have on the Acropolis dinos 606, see text. On later pieces by the painter the star rosette has become more complicated, as on the dinos Acropolis 606, in the Athens National Museum (no. 15116: *ABV*, 81, 1; *Beazley Addenda*, 8), or the Berlin Amphora (no. V, I, 4823: *ABV*, 81, 4; *Beazley Addenda*, 8). On the shield device see George Henry Chase, "The Shield Devices of the Greeks," *HSCP* 13 (1902), 61–127; M. Greger, *Schildformen und Schildschmuck bei den Griechen* (Erlangen, 1908); Anthony Snodgrass, *Early Greek Armour and*

Weapons (Edinburgh, 1964), 61–67. For the meaning of the shield device, see Léon Lacroix, "Les 'blasons' des villes grecques," *Etudes d'archéologie classique*, I (Paris, 1955–1956), 89–115.

23. Concerning the painter's horses see also Moore 1976, 9, 12, 13.

24. Moore 1976, 234.

25. Moore 1976, 368.

26. For a detailed description of the development of the bridle, see John K. Anderson, *Ancient Greek Horsemanship* (Berkeley, 1961), 73–75.

27. Louvre E 874: *ABV*, 8, 1, 679; *Paralipomena*, 6; *Beazley Addenda*, 1.

28. Athens, NM 15499: *ABV*, 39, 16; *Beazley Addenda*, 4. Güven Bakir, *Sophilos* (Mainz, 1981), 65, A3, pl. 6–7.

29. For possible interpretation as a preparation for a race, concerning black-figure representations, see Webster 1972, 190, 195.

30. Scheibler 1987, 75–98.

31. The subject has been fully treated by Walther Wrede, "Kriegers Ausfahrt in der archaisch-griechischen Kunst," *AM* 14 (1916), 223–374, pl. 15–34. See also Webster 1972, 189–195.

32. Andreas Alföldi, "Die Herrschaft der Reiterei in Griechenland und Rom nach dem Sturz der Könige," in *Gestalt und Geschichte: Festschrift Karl Schefold*, Beiheft zu Antike Kunst, 4 (Bern, 1967), 18–20.

33. Webster 1972, 189. For their meaning in ancient thought see R. Oehler, *Mythologische Exempla in der älteren Griechischen Dichtung* (Basel, 1925); Henri-Irénée Marrou, *Geschichte der Erziehung im Klassischen Altertum* (Freiburg/Munich, 1957), 22–25; Eng. trans., *A History of Education in Antiquity*, trans. George Lamb (New York, 1956); Herbert Hoffmann, "Knotenpunkte, Zur Bedeutungsstruktur griechischer Vasenbilder," *Hephaistos* 2 (1980), 136–138. We have to take in consideration that for the period when our painter was active the mythical repertoire on amphorae was limited: Hans von Steuben, *Frühe Sagendarstellungen in Corinth und Athen* (Berlin, 1968); Karl Schefold, *Götter und Heldensagen der Griechen in der spätarchaischen Kunst* (Munich, 1978); Philip Brize, *Die Geryoneis des Stesichoros und die frühe griechische Kunst* (Würzburg, 1980).

34. Scheibler 1987, 88. For the Homeric battle, which was out of date already in the seventh century B.C., with the appearance of the phalanx, see Henri Metzger and Denis van Berchen, "Hippeis, in Gestalt und Geschichte," in *Festschrift Karl Schefold*, AntK, Beiheft 4 (Bern, 1967), 156.

35. On the representations of the komos in the sixth century B.C., see Adolf Greifenhagen, *Eine attische schwarzfigurige Vasengattung und die Darstellung des Komos im VI. Jahrhundert* (Königsberg, 1929); Herman A. G. Brijder, *Siana Cups I and Komast Cups*, Allard Pierson Series, 4 (Amsterdam, 1983). For Corinthian komasts see Axel Seeberg, "Corinthian Komos Vases," *BICS* 27 (1971), 1–107, pl. 1–15. See

also: Thomas H. Carpenter, *Dionysian Imagery in Archaic Greek Art; Its Development in Black-Figure Vase-Painting* (Oxford, 1986), 86; Angelika Schöne, *Der Thiasos, Eine ikonographische Untersuchung über das Gefolge des Dionysos in der attischen Vasenmalerei des 6. u. 5. Jhs. v. Chr.* (Göteborg, 1987), 116–120.

36. Georgia Franzius, *Tänzer und Tänze in der archaischen Vasenmalerei* (diss., University of Göttingen, 1973).

37. Carpenter 1986, 118; Seeberg 1971, 73, 77 n. 10, 103c.

38. Daniel Paquette, *L'Instrument de musique dans la céramique de la Grèce antique*, Etudes d'Organologie (Paris, 1984), 23; Kathleen Schlesinger, *The Greek Aulos* (London, 1939); Max Wegner, *Griechische Instrumente und Musikbräuche: Musik in Geschichte und Gegenwart*, 5 (Berlin, 1956), cols. 865–881. Giovanni Comotti, *Music in Greek and Roman Culture*, trans. Rosaria V. Munson (Baltimore, 1989), 67–72.

39. Greifenhagen 1929, 35. H. W. Parke, *Festivals of the Athenians* (London, 1977), 128.

40. Carpenter 1986, 86–88.

41. Athens, NM 640, by the KX Painter: *ABV*, 26, 21; *Beazley Addenda*, 3. A procession of naked men and youths carrying various drinking vessels moving to the left.

42. Scheibler 1987, 68–71, 118.

43. Webster 1972, 109.

44. Brijder 1983, 51–52, 121, 126–127, 139–141.

45. They are connected with the increasing importance of the cult of Dionysos, after the introduction of the Great Dionysia and the official cult of Dionysos Eleuthereus by Peisistratos: Carpenter 1986, 88. See also Sir Arthur Pickard-Cambridge, *The Dramatic Festivals of Athens* (Oxford, 1953, 1968), 71; Frank Kolb, "Die Bau-Religions und Kulturpolitik der Peisistratiden," *JdI* 92 (1977), 128.

46. See Moore and Pease-Philippides 1986, 4. Compare Mommsen 1975, 48–51. See also note 16, above.

47. Moore and Pease-Philippides 1986, 6.

48. Compare Tomris Bakir, *Der Kolonnettenkrater in Korinth und Attica zwischen 625 und 550 v. Chr.* (Würzburg, 1974), k.74, a Corinthian krater in the Louvre Museum, no. E622, by the Tydeus Painter, dating from the second quarter of the sixth century B.C.

49. Jena 178: *ABV*, 39, 7. Güven Bakir, "Sophilos, Ein Beitrag zu seinem Stil," *Keramikforschungen*, 4 (Mainz, 1981), A.8, pl. 11–12.

50. Scheibler 1987, 99; see also the pinax (89).

51. Concerning the use of an amphora during a symposium see Karl Schefold, *Griechische Kunst als religiöses Phänomen*, Rowohlts deutsche Enzyklopädie (Hamburg, 1959), 74; Webster 1972, 8. And as wine vase generally, see Scheibler 1987, 68.

52. Scheibler 1987, 65.

53. Scheibler 1987, 58–59.

54. Scheibler 1987, 67.

55. Scheibler 1987, 63. Undecorated one-piece amphorae were used for the harvesting of cereals, at the market, and for storage.

56. Tübingen S.10.1298 (H: 0.50 m): *ABV*, 81, 5; *Add.* 8. Scheibler 1987, 77, fig. 13.

57. For the dog as a battle companion see Robert M. Cook, "Dogs in Battle," in *Festschrift Andreas Rumpf*, ed. Scherbe (Cologne, 1952), 38.

58. For the hare see Konrad Schauenburg, "Zu attischen Kleinmeisterschalen," *AA* (1974), 205 n. 24.

59. For the flying eagle as a symbol of rapidity, or as the symbol of Zeus or of the class of the hippeis, see Metzger and van Berchen 1967, 157–158.

60. Beazley 1951 (1986), 40.

61. Paul A. L. Greenhalgh, *Early Greek Warfare, Horsemen and Chariots in the Homeric and Archaic Ages* (Cambridge 1973), 111.

62. Webster 1972, 179.

63. Athens, NM 633: *ABV*, 81, 2. See also Webster 1972, 204.

64. John A. Davison, "Notes on the Panathenaea," *JHS* 78 (1958), 25.

65. Davison 1958.

66. Davison 1958, 28.

67. Beazley 1951 (1986), 22; Brijder 1983, 129.

68. Webster 1972, 152; Brijder 1983, 40, 127. See also Michael B. Poliakoff, *Combat Sports in the Ancient World* (New Haven, 1987), 68.

69. Brijder 1983, 42 n. 205 with bibliography.

70. Webster 1972, 152.

71. Graef and Langlotz 1925–1933, vol. 1.

72. Athens, NM. 625. Graef and Langlotz 1925–1933, vol. 1, pl. 38; Mary Z. Pease, "The Cave on the East Slope of the Acropolis (The Pottery)," *Hesperia* 5 (1936), 262–263, fig. 10 (9) and fig. 11 (2).

73. See note 106, below. The other three sherds with the quadriga do not belong to the same vase: Pease 1936, 263, fig. 11 (a, d, f).

74. See Carpenter 1986, 125. See also Angelika Schöne, *Der Thiasos, Eine ikonographische Untersuchung über das Gefolge des Dionysos in der attische Vasenmalerei des 6. und 5. Jhs. v. Chr.* (Göteborg, 1987), 116.

75. Webster 1972, 99; Scheibler 1987, 70. See also Richter and Milne 1935, 7; Gericke 1970, 36–42; Kanowski 1983, 67.

76. Berlin 4823 (H: 0.80 m): *ABV*, 81, 4; *Paralipomena*, 30; *Beazley Addenda*, 8; Boardman 1974, fig. 48 A; *CVA*, 5, pl. 1, 2, 3, Bail. A; Greenhalgh 1973, 191, no. A13; Metzger and van Berchen 155, pl. 56, 3; Scheibler 1987, 77–78, fig. 15.

77. Moore 1976, 279.

78. On the meaning of the eagle see note 59. See also Margot Schmidt, Alder, and Schlange, "Ein griechisches Bildzeichen für die Dimension der Zukunft," *Boreas, Münstersche Beiträge zur Archäologie* 6 (1983), 61–71.

79. Naples 2770: *ABV*, 109, 23; *Beazley Addenda*, 12 with bibliography. Erika Simon and Albert Hirmer, *Die Griechischen Vasen* (Munich, 1976), pl. 67.

80. Metzger and van Berchen 1967, 157. As for the relationship between the hoplite and his squire, see Alföldi 1967, 14. Greenhalgh 1973, 59–60, 84, 96–97, 113, 119.

81. Marrou 1956, 72. Gundel Koch-Harnack, *Knabenliebe und Tiergeschenke* (Berlin, 1983), 34.

82. Webster 1972, 181. The author also cites variants of the same subject.

83. Scheibler 1987, 88.

84. On special commissions see Webster 1972, 42; Scheibler 1987, 79.

85. See note 10, above.

86. *ABV*, 8, 1; *Beazley Addenda*, 1.

87. Bakir 1981, Katalogue 64–66.

88. *ABV*, 82–83; *Beazley Addenda*, 8.

89. Athens NM 15166: *ABV*, 82, 1; Boardman 1974, fig. 49; *LIMC*, 1, pl. 75; Joan R. Mertens, *Attic White-Ground: Its Development on Shapes Other than Lekythoi* (New York, 1977), pl. 1 (1); Martin Robertson, *A History of Greek Art* (Cambridge, 1975), pl. 36a; Karl Schefold, *Götter und Heldensagen der Griechen in der spätarchaischen Kunst* (Munich, 1978), fig. 269; Simon and Hirmer 1976, pl. 64.

90. Metzger and van Berchen 1967, 156.

91. See above, note 33.

92. Moore 1976, 376.

93. Greenhalgh 1973, 115.

94. See above, note 11.

95. See Graef and Langlotz, 1925–1933, vol. 1, pl. 32.

96. Louvre E 874; see above, note 86.

97. Sophilos is regarded as a lesser painter than the Gorgon Painter. On Sophilos see Bakir 1981.

98. Louvre E 875: *ABV*, 104, 123; *Beazley Addenda*, 11.

99. *ABV*, 81, 7; Ernst von Stern, *Theodosia und seine Keramik* (Odessa, 1906), pl. 2, 1; Beazley 1951 (1986), 37 and n.5, pl. 31, 3.

100. Geneva MF 153 (H: 0.37 m): *ABV*, 81, 6; *Beazley Addenda*, 8; *CVA*, 2, pl. 1–4.

101. Oxford 1660-1290: compared by J. Boardman, *CVA Oxford*, 3, pl. 1.

102. London BM 1948-10-15-1: *ABV*, 108, 8; *Paralipomena*, 44, 8; Tiverios 1976, 25–27, 33, 36, 37, 41 n. 164, pl. 7.β, and 8, 9.

103. Scheibler 1987, 82. Scheibler pointed out that for

the one-piece amphora this kind of scene has to be connected with the military training of the young hippeis.

104. Webster 1972, 179.

105. Oscar Broneer, "Hero Cults in the Corinthian Agora," *Hesperia* 11 (1942), 134. Von Karl Meuli, "Der Ursprung der Olympischen Spiele," *Die Antike* 17 (1941), 189.

106. Acr. 625, now at the Athens National Museum: *ABV*, 81, 3; Graef and Langlotz 1925–1933, vol. 1, pl. 38; Pease 1936, 263, fig. 11 (a, d, f).

107. Munich 1447: *ABV*, 81, 1; *Beazley Addenda*, 8; *CVA*, 7, pls. 328.1, 2, 329.1, Beil. B4.

108. Compare the Geneva amphora.

109. See text and note 27, above.

110. Compare the charioteer on the dinos in the Louvre, no. E.874; see note 27, above.

111. Tiverios 1976, 79, believes that Lydos was the painter who reestablished this decorative shape in a new form after its first use as a space for horses' heads.

112. Compare the dinos in the Louvre, no. E.874. See note 27.

113. Webster 1972, 179; Scheibler 1987, 79.

114. See above, notes 31–34.

115. Compare on dinos Acr. 606 some of the profiles of the charioteers between them, also some of the hoplites.

116. J. Beazley, *Attic Black-Figure: A Sketch* (London 1928), 16 n. 2, already pointed to the relationship between the painter of Acropolis 606 and Lydos. Tiverios 1976, n. 488, found a similarity in the rendering of the helmeted warriors.

117. See above, note 21, note 98.

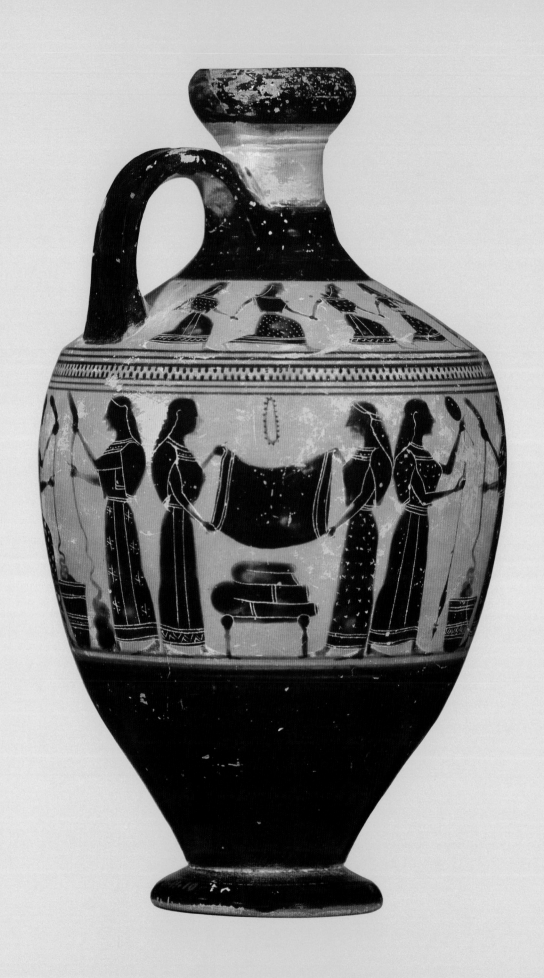

EVELYN B. HARRISON
Institute of Fine Arts, New York University (emerita)

The Dress of the Archaic Greek Korai

Greek dress is pretty meaningless until it is on a human figure, but clothing has a powerful effect on the forms and meanings of human figures in early Greek art. On a lekythos by the Amasis Painter made soon after 550 B.C., we see clothing being made and folded up for storage (figs. 1–2).[1] The two women in the center in figure 1 are folding garments like those they are wearing. If the piece being held up by two women is realistically sized, we could guess that it is intended for a man's tunic, whereas the wider piece on the loom in figure 2 would be for a woman's dress. The folded pieces lying on a stool represent the two sizes. These garments are made of a rectangular piece of woolen cloth woven on a loom like the one in figure 2, with the edges sewn together to form a tube that the wearer puts on over the head and fastens with pins or short seams at the shoulders. The armholes are thus formed by loops of the top edge that hang down on either side. In men's tunics, which are often narrower than women's, the armholes may be reserved at the top of the side seams, but in the Amasis Painter's representations they are certainly sometimes reserved from the top edge, for we see the ornamental edging of the neck continuing along the shoulder and around the upper arm.[2] In women's dresses the armholes are often wide enough so that the arms may be pulled inside for warmth.[3]

If you wear white linen instead of wool, especially outdoors in the cool of the evening, you need an extra garment, most often (in an-cient Greece) a plain rectangle of wool that could either be wrapped around as Dionysos wears it on an amphora by the same painter in Munich,[4] or draped over both shoulders, as it is worn by girls on an early seventh-century hydria neck in the Athenian Agora (fig. 3).[5] Symbolic scenes of women's work at home generally seem to show wool working, as on the vase with which we started (figs. 1–2). Wool was felt to be more basic and indigenous than linen, but not necessarily poorer. Wool takes the rich dyes that can be used to weave complex patterns and even stories, the kind of work that a king's wife may be proud to do. So Helen when she receives Telemachos in the *Odyssey* has a golden distaff loaded with purple wool.[6] A fifth-century vase painter draws Penelope with a figured web.[7]

If we think about archaeological-historical rather than mythic-poetic situations, however, this priority of wool is more a geographical than a chronological matter. Herodotos helps to set us straight on this. He tells how an expedition of the Athenians against Aegina failed so disastrously that only one man came home alive. The wives of the dead men in their grief and rage murdered the survivor with the pins of their dresses. The Athenians were more horrified at his fate than at the loss of their expedition, but rather than punishing the women they simply decreed that henceforth Athenian women should change their costume: they should not wear the pinned Dorian dress but the linen Ionic chiton, which did not need pins. The historian goes

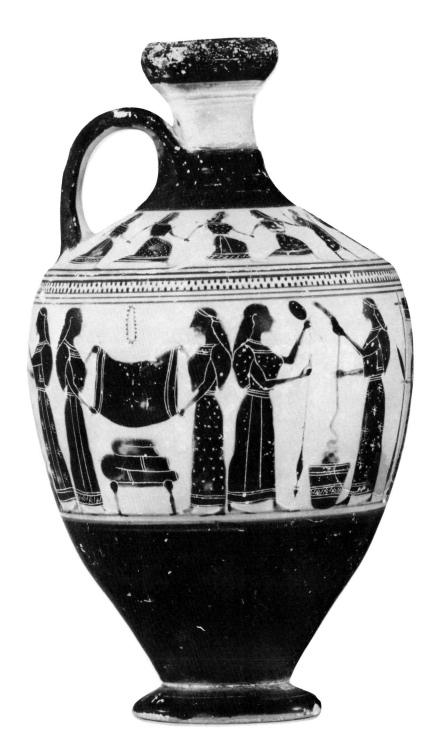

1. Lekythos (right profile)
by the Amasis Painter,
made soon after 550 B.C.
Metropolitan Museum of Art, New
York, Fletcher Fund, 1931

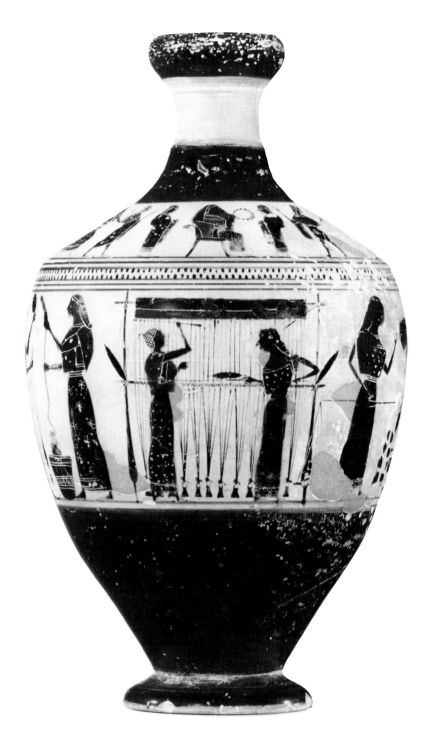

2. Front view of figure 1

on to say that this dress in olden times was not Ionian but Carian, since the original women's dress for all the Hellenes was that now called Dorian.[8]

Herodotos does not date this event. Nicholas Coldstream suggests that it happened in the mid-eighth century,[9] and Sarah Morris favors the beginning of the seventh.[10] Pictures of women on vases are not specific enough to help. Before the middle of the eighth century, as on the Dipylon Painter's amphora in Athens, all that we can see is that the dead woman and her female mourners are wearing long dresses.[11] The hatched and stippled skirts of the dancers shown on a hydria from c. 700 B.C. (fig. 4)[12] have suggested to some that they are still wearing pinned woolen dresses, but these patterns may represent simply texture. The white-skirted dresses on similar dancers from the Agora look structurally the same, and here the hair is hatched instead of the clothes (fig. 5).[13]

The goddess in the seventh-century plaque from the Agora has a diagonal alternation of colors that can best be explained by assuming that she wears a red, presumably woolen, dress with shoulder-seams, giving the effect of a short sleeve, and over it a light-colored cloak draped over her left shoulder, around the back, and caught up under the belt in front. The mark on her right shoulder is not a pin but a scratch where the paint has flaked off.[14]

Looking for archaeological evidence in early times, we find the sewn linen dresses very widespread in the Mediterranean world of the Bronze Age, most plentifully attested in Egypt, where the actual linen survives along with the representations of it.[15] Egyptian art is particularly helpful for understanding how the sculptor of figures in the round

related the garment to the human body. In the Old Kingdom the long dresses of women are shown only as wide as they need to be to accommodate the pose of the figure. Wives standing beside their husbands do not imitate the stride of the men but stand demurely with feet together, as in a Fifth Dynasty statuette group of Ptah-Khenuwy and his wife in Boston (fig. 6).[16] For all the explicit rendering of the female body, the pose tells us that this is a modest, faithful wife. If we took the artist literally, we should have to think that she could never take a step without splitting the dress. In the Middle Kingdom figures of servant girls bearing offerings are allowed to walk, and the artist takes delight in showing the beautiful lines of buttocks, thighs, and calves through the seemingly elastic cloth. One of the finest examples is a wooden offering-bearer in New York, one of a pair from the Eleventh Dynasty tomb of Meket-re (fig. 7).[17] In the New Kingdom men and women alike wear rich linen dresses that are very fine and also voluminous. The sleeveless white undergarment is of more opaque material. So in a portrayal of Nofretari, the wife of Ramses II, in her tomb in the Valley of the Queens, the skirt swings wide beyond the legs, which are outlined as if showing through (fig. 8).[18] The sleevelike fullness over the shoulders projects beyond the arms, which show as if striped through the pleated cloth. The goddess who leads the queen wears the ancient narrow dress.

Unlike figures in painting and relief, those in the round that wear the full dress let the folds cling to the legs so that the body can be modeled through them, as on the protective goddesses from the sarcophagus of Tutankhamen.[19]

3. Procession of women on neck of Early Protoattic hydria
Agora Museum, Athens; photograph from watercolor by Piet de Jong

4. Dancers on neck of
hydria, c. 700 B.C.
National Archaeological Museum,
Athens; *Human Figure*, 15

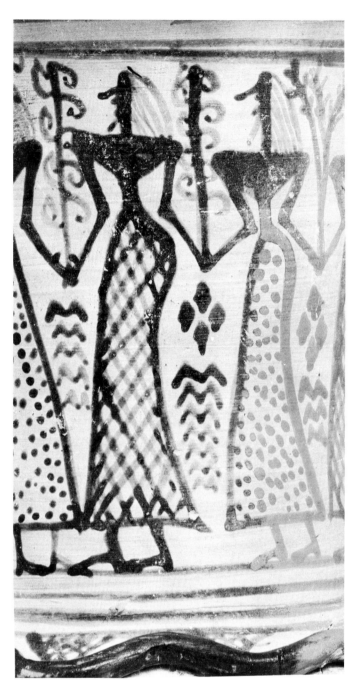

5. Dancers on neck of
Early Protoattic hydria
Agora Museum, Athens;
photograph from watercolor by
Piet de Jong

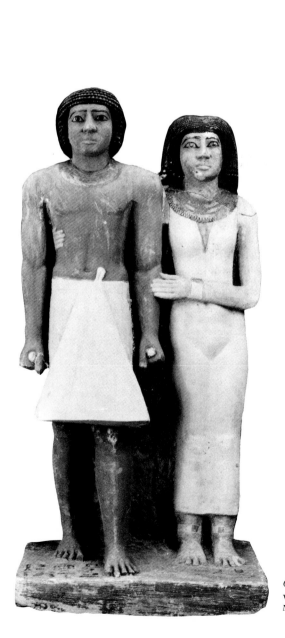

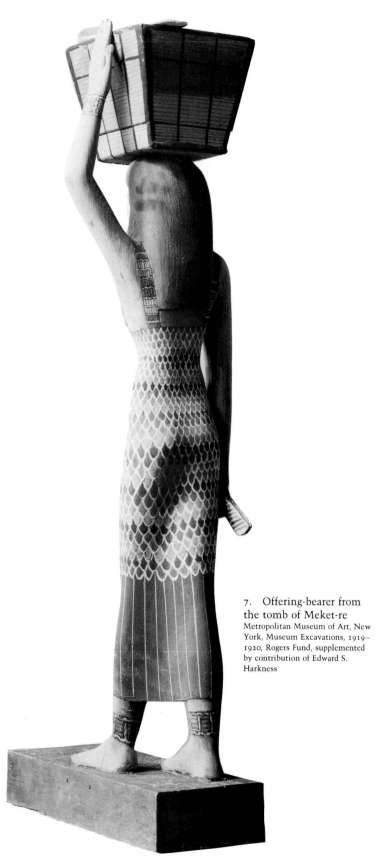

7. Offering-bearer from
the tomb of Meket-re
Metropolitan Museum of Art, New
York, Museum Excavations, 1919–
1920, Rogers Fund, supplemented
by contribution of Edward S.
Harkness

6. Ptah-Khenuwy and his
wife, Fifth Dynasty
Museum of Fine Arts, Boston

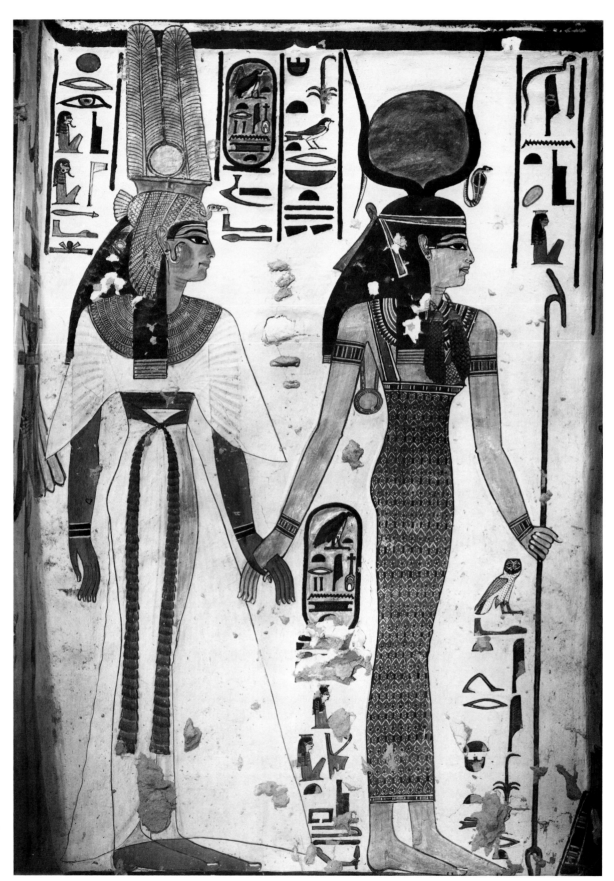

8. Queen Nofretari led by
Isis, Nineteenth Dynasty
Luxor, Valley of the Queens;
photograph: Metropolitan Museum
of Art, New York

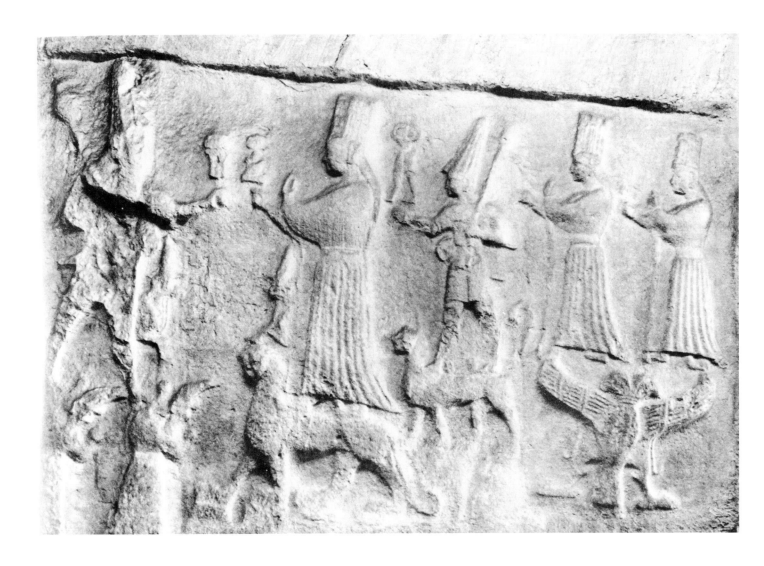

Also in the Late Bronze Age we find women in Hittite reliefs wearing voluminous dresses whose fine-folded skirts and full sleevelike upper parts suggest the Egyptian linen garments, though no attempt is made to show the body through them. The group of goddesses in the rock sanctuary of Yasilikaya offers a particularly good example (fig. 9).[20]

The shape of their full sleeves reminds us of the so-called Psi idols of the Mycenaean period. The upper parts of the Mycenaean idols are commonly painted with a wiggly pattern suggesting soft, shapeless cloth, while their stemlike skirts recall the close-modeled lower parts of Egyptian females in the round. But in the Mycenaean works there is no attempt to model the legs.[21]

The clearest picture of Aegean Bronze Age women's dress comes from the somewhat earlier frescoes in Thera. We can use these to interpret later and more schematized representations, including those in the round. In the so-called House of the Ladies at Akrotiri in Thera women engaged in a sacred rite wear linen chitons which are seamed under the arms and on the shoulders. Like many Archaic Greek chitons they have a colored border along the top, which is sewn along the shoulders and curves down around the armhole, giving the effect of a short sleeve. There is also a colored stripe down the front, which may likewise contain a seam, for in some figures it is left open above the waist to bare the breasts, an act that must have meaning in the ritual (fig. 10). Over this chiton the women wear a flounced kilt fastened by a cord that is wound repeatedly around the waist. It is clear that the upper and lower parts are one

9. Procession of divinities, Yasilikaya
After Ekrem Akurgal, *The Art of the Hittites* (London and New York, 1962), pl. 77 (bottom)

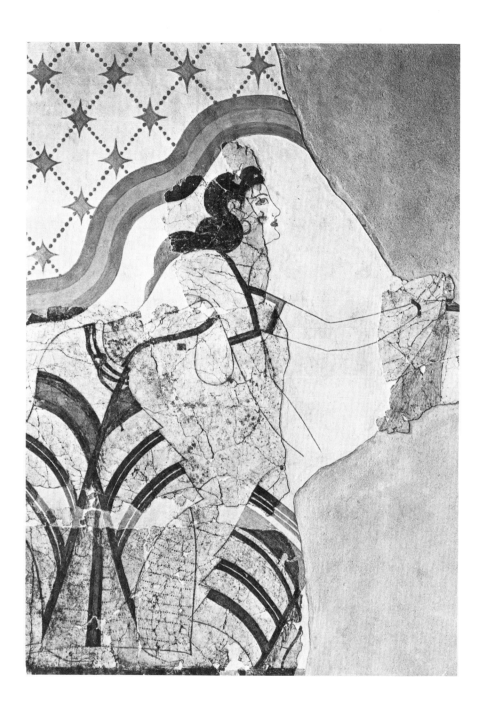

garment, appearing above and below the kilt. Thus the short jacket that we used to think was a part of Minoan and Mycenaean women's dress turns out not to have existed.[22]

As in the Hittite reliefs and the Mycenaean idols, there is no attempt to show any details of the lower body through the dress. When this costume appears in the round, the skirt is a solid, flaring mass, as in the well-known snake goddesses from Knossos.[23]

The large-sized terracotta dancers from Agia Irini on the island of Keos, with similar skirts and bared breasts (fig. 11),[24] have shoulder seams like those of the women in Thera. Some show the colored border as a raised strip (fig. 12).[25] Others have a seam but no border strip marking the edge of the sleeve. The saffron-colored dress is set off from the white arm only by the different color of paint, sometimes demarcated by an incised line, and by the raised seam, which ends where the color ends.[26] All the figures have rolls around the waist, which should represent the tying on of the kilt. Though one figure may preserve a

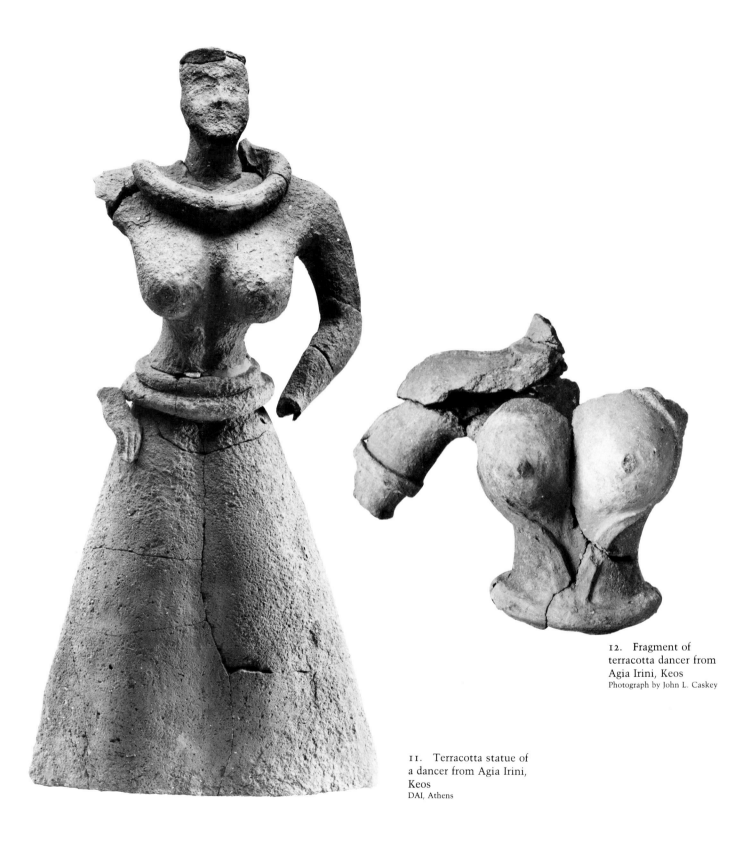

11. Terracotta statue of
a dancer from Agia Irini,
Keos
DAI, Athens

12. Fragment of
terracotta dancer from
Agia Irini, Keos
Photograph by John L. Caskey

plastic indication of flounces,[27] none shows
an offset of the lower edge of the kilt. Such
details must have been indicated only in
paint. As Thucydides says that Carians in-
habited the Cycladic islands in early times,[28]
it is natural to think that the shoulder-
seamed dress of the Bronze Age in this region
was the Herodotean ancestor of what was
later called the Ionian chiton.

Long dress pins are as rare in Mycenaean
Greece as the sewn dresses are common. But
there are early examples in the Shaft Graves
at Mycenae. Like the gold masks and circular
gold ornaments in the Shaft Graves, these
suggest northern connections.[29] How long
these traditions survived on the northern
edge of the Greek world can be seen in the
graves of the sixth and fifth centuries B.C. that
have been excavated recently at Sindos in Ma-
cedonia. Like the Shaft Graves they contain
straight pins, gold masks, and gold roun-
dels.[30]

In Athens pins found in graves of the Pro-
togeometric period indicate that the pinned
Hellenic dress was regular at that time,
which, being the Dark Age, has left us no pic-
tures. A little girl buried in the Athenian
Agora had a long, round-headed dress pin at
each shoulder. The pots that were buried with
her belong to the tenth century B.C. (fig. 13).[31]

Beginning in the late Mycenaean and con-
tinuing through the Protogeometric and Geo-
metric periods we also find clasp pins: fibulae
or brooches. In the Dark Ages they are of
bronze; beginning in the ninth century we
also find them in gold.[32] Common sense sug-
gests that it is these which made up the set
of twelve that accompanied a peplos given to
Penelope in the *Odyssey*.[33]

A way of fastening the woolen dress that
could use a variable number of small clasp
pins is probably illustrated in the so-called
Daedalic sculptures of the seventh century.[34]
The style is most at home in Crete and in
other Dorian lands under Cretan influence.
Here for the first time dresses are shown in
enough detail for us to make out their struc-
ture. The women's garments are tubular and
evidently quite wide, for the sleevelike loops
hang down to the elbows or below. The so-
called Auxerre kore is a good example (figs.
14–16).[35] The upper edge of the back part of
her dress is pulled down over the front part
of the shoulders; this is perhaps what Homer
means when he says a dress is fastened *kata*

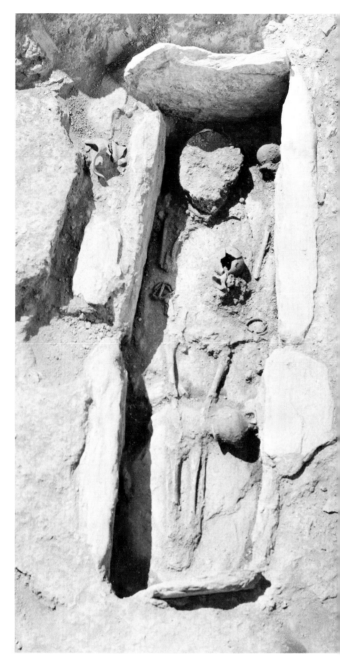

13. Protogeometric burial
of a girl with shoulder pins
and bracelets, tenth
century B.C.
Agora Museum, Athens

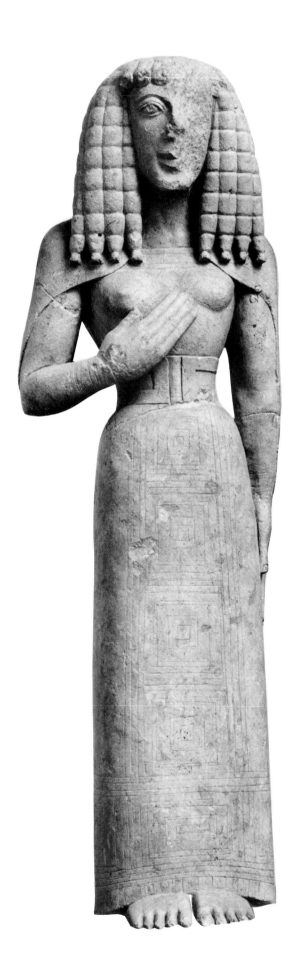

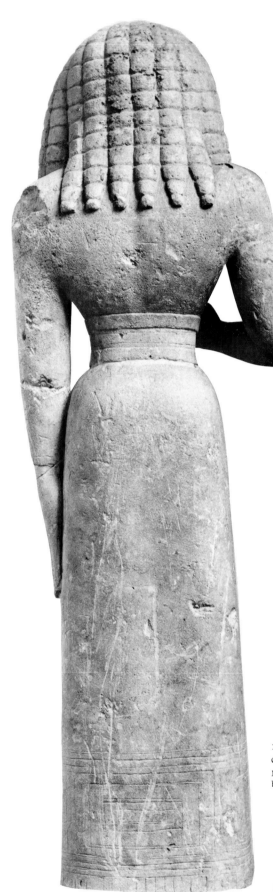

14. Auxerre Kore, third
quarter of seventh century B.C.
Musée du Louvre, Paris; photograph
by Alison Frantz

15. Back view of
figure 14
Photograph by Alison Frantz

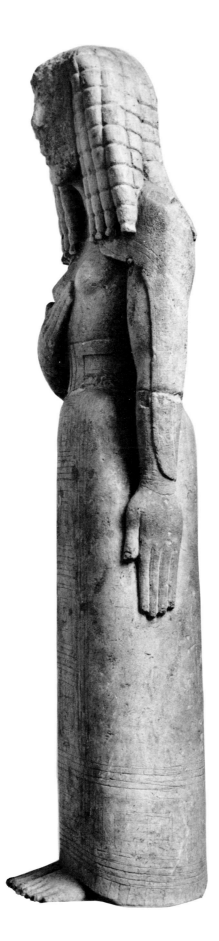

16. Left profile of
figure 14
Photograph by Alison Frantz

17. Ivory relief, the
Daughters of Proitos (?),
third quarter of seventh
century B.C.
Metropolitan Museum of Art, New
York, Gift of J. Pierpont Morgan,
1917

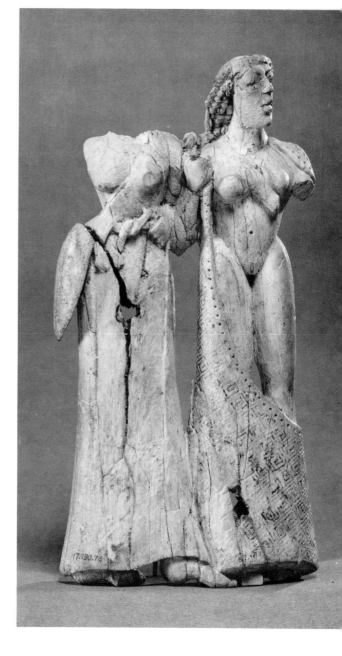

stethos, at the breast.[36] Some of the Daedalic
sculptures show this pulled close together in
front, which would have used more pins to
fasten it across the chest.[37] Most interesting
are some narrative representations (for this is
the time when narrative really gets started in
Greek art) that show females in various stages
of undress. The Morgan ivory in New York
probably represents the daughters of Proitos,
who were driven mad by Aphrodite (fig. 17).[38]
The one at the left has unfastened the pins
over her right shoulder, though the left is still

pinned. The cloth falls down over the belt, which she is beginning to untie. Her sister has undone everything, though part of the upper edge of the dress still rests on her left shoulder and she grasps the garment with her right hand to keep it from falling off altogether. There is no attempt anywhere to show the form of the body through the drapery below the belt. This is like the Aegean representations rather than the Egyptian ones.

A charming wooden relief from Samos shows a young couple, usually identified as Zeus and Hera at their first mating (fig. 18).[39] Rather than unfastening the upper part of her dress completely, she has pinned it at the throat, allowing him to fondle her breasts while she holds the wrists of her lover in a very mild protest. Her belt stays tied.

Still more modest is the girl on a Cretan oinochoe, who holds the wrists of her lover in the same almost tender way. She remains fully clothed, but the boy is no less importunate; we have only to follow the engraved outline of his right hand (fig. 19).[40]

The Cretan pair are sometimes called Theseus and Ariadne,[41] but they could be a mortal couple. We are told that young Cretan aristocrats married at puberty, though the girls did not move to their husbands' homes until they were old enough to manage the household.[42]

Married women wore veils when they went out in public, and the gesture of opening the veil is one with which a wife receives her husband. When Menelaos confronts Helen at the taking of Troy, shown on the seventh-century relief pithos in Mykonos, she does not bare her breast or let him see through her dress, but simply opens her veil.[43] It may be that the veiled lady on a metope from Mycenae represents Helen.[44]

Fully nude and unashamed female figures exist in early Greek sculpture, from the eighth-century Dipylon ivories[45] to the more monumental seventh-century stone reliefs from Gortyn,[46] but these are goddesses, modeled on Near Eastern counterparts. It is interesting to see how these nude goddesses are replaced in the sixth century by clothed figures, while at the same time sculptors gradually explore the opportunities that the thin Ionian dress gives them to model the female body through the drapery below as well as above the belt.

In the first quarter of the sixth century we

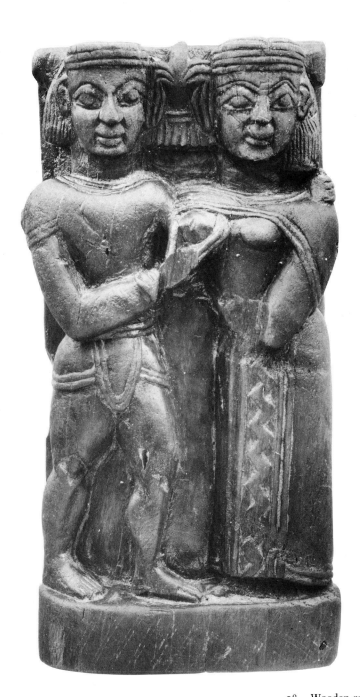

18. Wooden relief, young lovers, found in Samos, late seventh century B.C. DAI, Athens

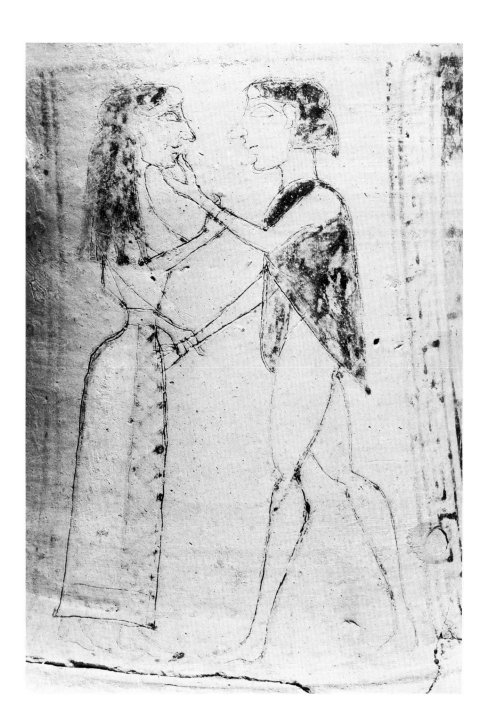

19. Cretan oinochoe,
detail of young lovers,
mid-seventh century B.C.
Archaeological Museum,
Herakleion; *Human Figure,* 20

find the first evidence of buttons used instead of seams to fasten the upper edges of the linen chiton. H. L. Lorimer suggested very plausibly that this was a new invention designed to give the adjustable closing of the pinned Daedalic dress but without the weight of the metal brooches, which might damage the delicate cloth.[47] Fragments of korai in Chios are our earliest examples, dated by Boardman around 580–570 B.C.[48] Little folds spring out

from the buttons and cover the upper torso with a pattern of incised wavy lines. Like the wavy lines on the Mycenaean idols, these suggest something soft and shapeless, but the cloth has no volume of its own. It clings close to the body even at the sides where it dips in pouches over the belt.

The lower parts of these Chian korai are missing, but we can imagine them as being plain squarish or columnar shapes, with no

dance, but the left foot is only tentatively advanced and the legs are not really modeled through the cloth.[53]

By contrast, a big kore from Erythrai whose sculptor may have been influenced by Cycladic works lets the dress cling to the outside of both legs all the way down and even models the knees, though the heavy band of central folds effectively masks the separation of the limbs (fig. 20).[54] A little Milesian bronze kore from Athens wears a veil but no mantle.[55] It would seem that these Ionian veils do not mark their wearers as married women but rather as young women of marriageable age. A votive relief found recently at Miletos, which shows a pair of such figures, is inscribed with a dedication to the Nymphs.[56] The word *nymphe* can be applied to mortal maidens of marriageable age as well as to human brides and the immortal daughters of Zeus.

Around or soon after the middle of the century the sculptors of marble korai began to carve the diagonal mantle in broader, pleat-like folds whose lower edges formed decorative zigzags emphasized by colored borders. A Rhodian plastic vase from Thebes shows the pleats but does not mark the border.[57] The bunch of folds gathered behind the center stripe is pulled all the way to the side but not free of the body.

The skirt is held in the same way by the caryatids from the Knidian Treasury,[58] the earliest of three sets of caryatids in Delphi. I like to think that they may have represented Graces, who had a particular connection with Apollo.[59]

A few years later than the Knidian caryatids, on a kore of which fragments are divided between Lyons and Athens, the legs are very fully revealed but the sculptor is not yet ready to let the ends of the mantle hang free of the body. In his effort to give a freer, more natural position to the bent arm holding the bird, he has cut away the loose chiton between the arm and torso, giving the impression of a long heavy sleeve over an unnaturally thick arm.[60]

A large kore made around 530 B.C. (figs. 21–22),[61] succeeds much more elegantly in freeing the contours of the body from the cloth. It seems likely that she is wearing a chiton with an overfall rather than a short mantle, for there are rows of buttons down both arms, and a mantle would have to be disproportionately wide and short to be

20. Kore from Erythrai, mid-sixth century B.C. Izmir Archaeological Museum; after *Archaische und klassische griechische Plastik*, 1, pl. 1, left

modeling of the legs through the cloth, like a Samian bronze kore from Olympia.[49] She wears a small diagonally draped mantle like those worn by the large twin marble statues of Cheramyes, one in the Louvre, long known,[50] and one recently found at Samos.[51] These also wear a veil over the head, hanging down the back and with a corner tucked in under the belt in front.[52] The diagonal mantle is buttoned along the right upper arm like the chiton underneath. The folds are rounded between the sharply engraved lines that define them. In back the body is modeled smoothly through the veil as far down as the upper part of the buttocks but no farther.

The maidens from the slightly later Geneleos group in Samos wear neither mantles nor veils. Their wonderfully abundant long hair is their chief adornment. They gather the folds of the skirt to one side as if to walk or

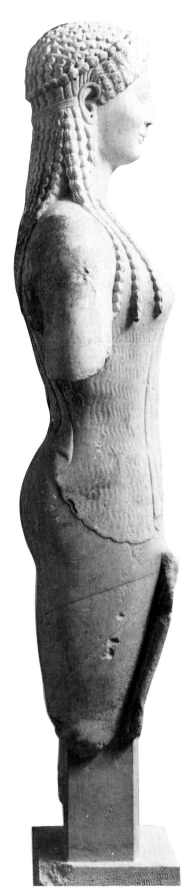

21. Acropolis Kore 678
(right profile), c. 530 B.C.
Human Figure, 55

22. Front view of
figure 21
Human Figure, 55

draped in such a fashion.[62] In either case, a
realistic portrayal would have concealed the
flanks with hanging cloth and we should have
lost the view of her slender waist and some-
thing of her admirable silhouette. Probably
she is meant to be quite young. Both in Ionia
and in Athens, one has the impression that
the girls who wear only the chiton are
younger than those with the diagonal mantle.
In an Acropolis kore made nearer to the end
of the sixth century, the artist has empha-
sized the texture of the cloth and given it
more independence of the body.[63]

The sculptor of the very original Chiton
Kore mentioned above may well have been
the same who made the equally original and
even more admired Peplos Kore.[64] I think the
cataloguers who numbered the Chiton Kore
678 and the Peplos Kore 679 had the sequence
right. The faces have a real family resem-
blance, but that of the Peplos Kore seems a
little more developed.[65] Her dress is unique
among the korai though not among vase
paintings. Brunilde Ridgway has suggested
that she may represent the goddess Artemis,
for her right hand is pierced to hold a thin
shaft that might be an arrow.[66] That is ap-
pealing, since a peculiarity of her dress is also
to be seen on a figure labeled Artemis on a
dinos by Sophilos in London.[67] The overfall
of the kore's woolen dress is open on her left
side but covers the upper part of her right arm.
We could imagine that an opening was left in
the seam just below the fold, through which
her arm would have passed, while the seamed
overfall would have served like a cape to pro-
tect her shoulder. It is very unlikely that it
was really a separate capelike garment, for
drilled holes in both shoulders of the Peplos
Kore indicate that she had two metal
brooches. If the covering of the right arm was
an overfall rather than a cape, these two pins
would be needed to narrow the neck opening
so that the dress would not slip off the shoul-
ders. For a cape a single fastening would have
been enough.

In this figure the artist succeeded in giving
a real sense of a young female body under a
rather heavy layer of cloth, not by letting
everything show through but by subtle mod-
ulations of the deceptively simple surfaces.
This feeling for the complementary rather
than opposing roles of body and drapery is one
of the aspects (or should we say perspectives?)
that leads Greek art beyond what it has

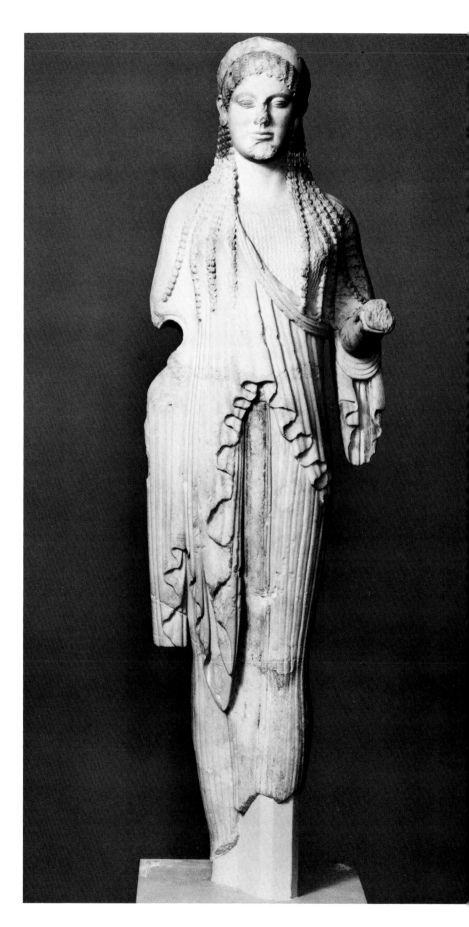

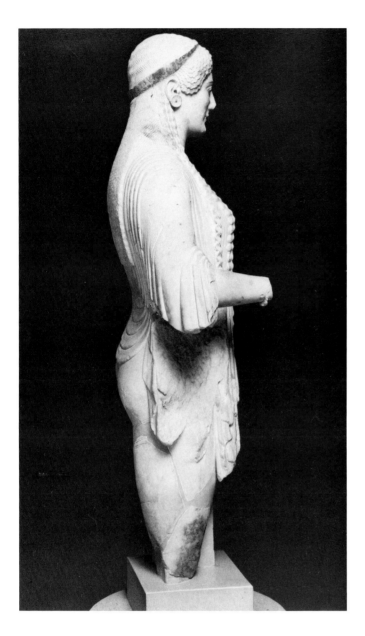

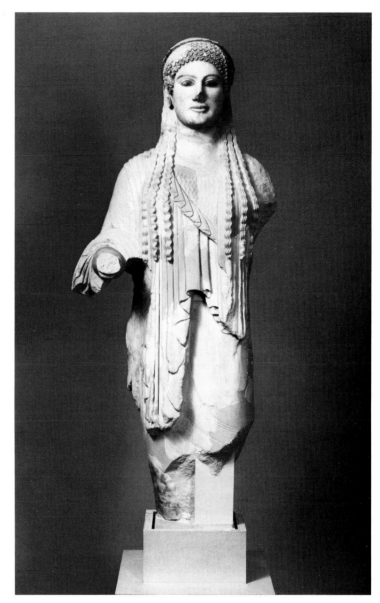

23. Acropolis Kore 685,
c. 500–480 B.C.
Human Figure, 55

24. Acropolis Kore 684
(right profile), c. 490 B.C.
Human Figure, 57

25. Front view of
figure 24
Human Figure, 57

learned from other cultures and into something wholly new that becomes Classical.

At about the same time, around 525 B.C., the pendant cloth of the diagonal himation wins its independence as a separate sculptural form, which can be played off against the asymmetries of the walking stance and the lifted skirt. In the ensuing quarter-century this exuberant, festive style reaches its height in the dazzling series of votives on the Acropolis of Athens and in architectural and votive sculptures in Delphi and Delos.[68]

By the beginning of the fifth century, in another, similar marble kore (fig. 23),[69] the ex-

uberance begins to calm down: folds are finer and less assertive, just as the faces become quieter and the smiles more inward. This slender maiden, though she sets her foot forward, extends both hands with offerings instead of lifting her skirt. We cannot read the meaning of this, since the offerings are no longer there. But the sculptor has made beautiful use of an age-old device, molding the long legs with shallow, pleatlike folds.

A third kore holds her skirt in the usual way, but in the seriousness of her face and the weight of her presence she seems already Classical (figs. 24–25).[70] Like a few other korai

from the Acropolis she has a third garment,[71] a mantle that is draped over her left shoulder and wrapped around her right arm. Probably we should take this to be the equivalent of the veil of the Ionian korai. As the maidens in the procession on the Parthenon frieze wear cloaks draped over their shoulders, so this maiden may wear her mantle as a sign that she is ripe for marriage.[72] Just as the sculptors of nude young males at this time could show the difference between boys and youths and men, so the sculptor of this kore could express her physical ripeness as well as her mature sensibility. Despina Tsolaki has rightly stressed her combination of solemnity and sweetness.[73] Michael Brenson has rightly remarked that she seems both more naked and more secret than the male figures nearby.[74]

NOTES

1. New York, Metropolitan Museum of Art, 31.11.10, Beazley, *ABV*, 154, no. 57. Recent discussion and full bibliography by Dietrich von Bothmer, *The Amasis Painter and His World* [exh. cat., Metropolitan Museum of Art, Toledo Museum of Art, and Los Angeles County Museum] (Malibu and New York/London, 1985), 185–187. Dated to the Middle Period of the painter.

2. Von Bothmer 1985, 92, no. 9, Side A, Herakles, and Side B, young archer, as well as other examples throughout. Such men's garments could be sewn from a single wide piece of cloth, but it is likely that, like those with armholes at the top of the side seams, they were normally made of two narrower pieces, front and back.

3. The Archaic woolen women's dress, whether made from one large piece of cloth with opposite edges folded together and joined by a single seam to form a tube or whether fashioned from two or more smaller pieces sewn together, seems regularly to have been closed on both sides of the body, as it is shown on this vase, not open on one side as in the Classical woolen dress of Athena commonly called *peplos* by modern scholars after the Panathenaic Peplos. For the term, see Evelyn B. Harrison, "Hellenic Identity and Athenian Identity in the Fifth Century B.C.," in *Cultural Differentiation and Cultural Identity in the Visual Arts*, eds. S. J. Barnes and W. S. Melion, Studies in the History of Art 27 (Washington, 1989), 56 n.13. An overfall at the top of the dress, such as the Amasis Painter shows on the vase in figures 1–2, first appears in Attic painting in the works of Kleitias. This overfall may be left unseamed on one or both sides. Painters like Kleitias and the Amasis Painter regularly show an ornamental band at the neck. This suggests that the Archaic overfall was normally fixed in length, being always folded over on the line of the neckband (it might even be that the band we see on the lower portion of the larger folded garment in figure 1 represents such a fold line). In fact, the lower edges of the Archaic overfalls always come just above the belt. The Classical peplos does not have the neck edging, and the lengths of Classical overfalls are very variable. In the seventh century B.C., overfalls do not seem to be customary. For the structure of the seventh-century Greek woolen dress, see E. Harrison, "Notes on Daedalic Dress," *JWalt* 36 (1977), 37–48.

4. Panel-amphora (type B). Munich, Staatliche Antikensammlung und Glyptothek, 1383 (J.75). Beazley, *ABV*, 150, no. 7; Von Bothmer 1985, 102–104, no. 14. Von Bothmer places it late in the painter's Middle Period.

5. Athens, Agora Museum, P 26411. Eva Brann, *Agora*, 8, *Late Geometric and Protoattic Pottery* (Princeton, 1962), 78, no. 417, pl. 25. Early to Middle Protoattic, c. 675 B.C.

6. *Odyssey*, 4, 125–135.

7. Chiusi, C 1831. *CVA*, Chiusi, Museo Archaeologico Nazionale 2 (Italia 60), 16–17, pls. 35–36, with additions to Beazley's bibliography; Beazley, *ARV²*, 1300, no. 2; *Paralipomena*, 475; *Beazley Addenda*, 179.

8. Herodotos 5, 87–88. See Harrison 1977, 47–48.

9. Coldstream, *Geometric Pottery*, 361, n. 10; Coldstream, *Geometric Greece*, 135.

10. Sarah P. Morris, *The Black and White Style*, Yale Classical Monographs 6 (New Haven and London, 1984), 107–115.

11. Athens, National Archaeological Museum, 804. Roland Hampe and Erika Simon, *The Birth of Greek Art* (London, 1981), pl. 235. The amphora 803 by the same painter shows similar female dress, entirely in black silhouette.

12. Athens, National Archaeological Museum, 18, 435. *Human Figure*, 85, no. 15, with bibliography.

13. Athens, Agora Museum, P 10229. Brann 1962, 78, no. 416, pl. 25. Brann interprets the hatched hair as a representation of hairnets, but this seems unlikely, both because of the angular contour of the hair mass and because the cross-hatch pattern is widely used in all media to suggest texture, whether of fur, feathers, cloth, or hair.

14. Athens, Agora Museum, T 175. *Human Figure*, 104–105, no. 27, with bibliography. For a drawing that clarifies the patterns, see Dorothy Burr, "A Geometric House and a Proto-attic Votive Deposit," *Hesperia* 2 (1933), fig. 73 (facing p. 606). Burr, 606, speaks only of a chiton, assuming it to be decorated in patchwork fashion.

15. For actual linen from the Middle Kingdom, see William C. Hayes, *The Scepter of Egypt*, 1 (Cambridge, Mass., 1953), 240.

16. Boston, Museum of Fine Arts, 06.1876. William S. Smith, *Ancient Egypt*, 4th ed. (Boston, 1960), 56 and 58, fig. 32. See also the figures of Mitry and his wife in New York, Metropolitan Museum of Art, Hayes 1953, 110–112, fig. 64.

17. New York, Metropolitan Museum of Art, 20.3.7. See Hayes 1953, 266–267, fig. 174.

18. See William S. Smith, *Art and Architecture of Ancient Egypt*, 2d rev. ed. (New York, 1981), 367, 470 n. 19 (with bibliography).

19. Cyril Aldred, *New Kingdom Art in Ancient Egypt*, 2d ed. (London, 1961), pl. 157. Compare also the figure of Nefertiti in the group in the Louvre, pl. 117, for the clinging of the pleated dress to the legs in three-dimensional renderings and the figure of the queen on a decorated box from the tomb of Tutankhamen, pl. 154, for the flaring form in a flat representation.

20. Ekrem Akurgal, *The Art of the Hittites* (New York, 1962), pls. 76, 77. For a general discussion of Yasilikaya, see Kurt Bittel, *Hattusha* (New York, 1970), 91–112.

21. For typical examples of the so-called Psi idols, female figurines with upraised arms, Phi idols with arms held against the body (sometimes holding a child), and Tau idols with arms folded across the chest, see Carl W. Blegen, *Prosymna* (Cambridge, Mass., 1937), pls. 148–149. For a full discussion of the typology and chronology of these figurines, see Elizabeth B. French, "The Development of Mycenaean Ter-racotta Figurines," *BSA* 66 (1971), 101–187. In general the earliest examples are more realistic than the later ones and give the clue to the positions of the arms, which are often not delineated at all in the later ones. French interprets the garment as "some kind of robe," that is, a long, loose dress (176).

22. Spyridon Marinatos and Max Hirmer, *Kreta, Thera, und das mykenische Hellas* (Munich, 1976), pls. 151, 152 and color plate XXXIX facing pl. 152; Nanno Marinatos, *Art and Religion in Thera* (Athens, 1984), 97–105. See especially fig. 69 (reconstruction of the room), facing p. 96, 100–101, figs. 67 and 68, and 102, fig. 70 (reconstruction of the costume). The description of the dress of these figures (100–101) is clear, succinct, and convincing: "Both women wear a loose fitting robe with a deep *décolletage* which leaves the breast exposed. This robe has decorative border bands edging the sleeves and the hem of the skirt. The band also bisects the front of the robe where presumably the seam was. It is important to note that what appears as a flounced skirt was actually a flounced kilt worn over the robe and tied with cords around the waist. Such cords are clearly visible on figures A and B. When the kilt was put on, the loose robe would cling to the body, giving the impression of a tight jacket (fig. 70)."

23. Marinatos and Hirmer 1976, pl. 70 and facing color pl. XXV.

24. Miriam E. Caskey, *Keos II The Temple at Ayia Irini, Part I: The Statues* (Princeton, 1986), 45–46, no. 1-1, K 3.611, pls. 1:b, 4–7, 66:a, 69, 72, 80, 85. This is the most completely preserved as a figure of all the statues, but, having lost much of its surface, it lacks some details of the dress that are clearer in more fragmentary examples.

25. Caskey 1986, 72–73, no. 5-2, K 3.618, pls. 36, 37: a–h, 73, 82.

26. Compare Caskey 1986, 59: "The sleeve seams were modeled in relief, but the borders of jacket and sleeve were indicated simply by the juxtaposition of the yellow of the garment and the white of the skin." Compare 60–61, no. 3–1; 62–63, no. 3–4. For the incised line on some pieces, compare 65–66, no. 4–1, pl. 28:c; 66, no. 4–2, pl. 26:g right, 28:d.

27. Caskey 1986, 81–82, no. 9-1, pl. 48.

28. Thucydides I, 8, 1. See A. W. Gomme, *A Historical Commentary on Thucydides* 1 (Oxford, 1945), 106–108, for Greek traditions of Carians in early Greece.

29. See Reynold Higgins, *Greek and Roman Jewellery*, 2d ed. (Berkeley and Los Angeles, 1980), 70–71; Wilhelm Kraiker and Karl Kübler, *Kerameikos, 1, Die Nekropolen des 12. bis 10. Jahrhunderts* (Berlin, 1939), 82.

30. *Sindos, Katalogos tis ekthesis* [exh. cat., Archaeological Museum of Thessaloniki] (Athens, 1985), masks: 80–81, no. 115; 148–149, no. 239; 174–175, no. 282; 196–197, no. 322; roundels: 266–267, nos. 430–433; pins: throughout—the most elaborate are from sixth-century graves; for the latest see 310–311, no. 520 (from a grave c. 440 B.C.). Fibulae as well as pins and brooches are found in the Sindos graves. It

is not certain who the people of Sindos were. Stella Miller has suggested to me that they were not Macedonians.

31. H. A. Thompson, "Excavations in the Athenian Agora: 1953," *Hesperia* 23 (1954), 58, pl. 16:a.

32. See Higgins 1980, 100, for gold fibulae. For gold long pins and bronze fibulae from a ninth-century grave in Athens, see Karl Kübler, *Kerameikos*, 5,1, *Die Nekropole des 10. bis 8. Jahrhunderts*, pl. 159.

33. *Odyssey*, 18, 292–294. For discussion of this passage, see H. L. Lorimer, *Homer and the Monuments* (London, 1950), 380–382.

34. This whole subject is more fully discussed in Harrison 1977.

35. Paris, Louvre 3098. Richter, *Korai*, 32, no. 18. For fuller discussion of the dress, see Harrison 1977, 39–40, 46, fig. 7:B.

36. *Iliad*, 14, 178–186.

37. As in the seated figures from Temple A at Prinias: Hampe and Simon 1981, pls. 433–434. See Harrison 1977, 46, fig. 7:A.

38. New York, Metropolitan Museum of Art, 17.190.73. Harrison 1977, 44–45 (with bibliography), fig. 5, and 47, fig. 8.

39. Harrison 1977, 46–47, with bibliography.

40. *Human Figure*, 94–95, no. 20.

41. See H. A. Shapiro, "Theseus: Aspects of the Hero in Archaic Greece," in this volume.

42. Strabo, X, 4, 20 (C482), citing Ephoros. See R. F. Willetts, *Ancient Crete* (London and Toronto, 1965), 113.

43. Miriam Ervin, "A Relief Pithos from Mykonos," *ArchDelt* (1963), A: Meletai, 37–75, pl. 22; Hampe and Simon 1981, pl. 122.

44. *Human Figure*, 108–109, no. 29. Add to the bibliography Friederike Harl-Schaller, "Die archaischen 'Metopen' aus Mykene," *ÖJh* 50 (1972–1975), 94–116.

45. Richter, *Korai*, 21, figs. 16–22; Hampe and Simon 1981, pls. 393–396, 306 with bibliography.

46. Hampe and Simon 1981, pl. 432, 307 with bibliography.

47. Lorimer 1950, 356–357. The fact that these buttons, so often represented in art, have never been found in excavations, suggests that they were made of perishable material, such as cloth or knotted thread.

48. John Boardman, "Two Archaic Korai in Chios," *AntP*, 1 (Berlin, 1962), 43–45, pls. 38–44. Richter, *Korai*, 38–39, nos. 37, 38, figs. 122–128.

49. Athens, National Archaeological Museum 6149. *Human Figure* 125, no. 40.

50. Paris, Louvre 686. Richter, *Korai*, 46, no. 55 (with bibliography), figs. 183–185; John Pedley, *Greek Sculpture of the Archaic Period: The Island Workshops* (Mainz, 1976), 52–53, no. 46, pl. 32 a–c.

51. Helmut Kyrieleis, "Neue archaische Skulpturen aus dem Heraion von Samos," in Deutsches Archäologisches Institut, Abteilung Athen, *Archaische und klassische griechische Plastik*, 1 (Mainz, 1986), 41–43, pls. 20–22.

52. This motif also occurs in the Phrygian Kubaba (Cybele) from Bogazköy, Kurt Bittel, "Phrygisches Kultbild aus Bogazköy," *AntP*, 2 (Berlin, 1963), 7–21, pls. 1–8, as well as on two Phrygian reliefs of Kubaba in Ankara cited in the same article, pls. 10, 11 a. A recently discovered Phrygian ivory statuette of a goddess with two children shows two corners of the veil tucked into the belt (perhaps because both of her hands are occupied with the children): Turkish Republic, Ministry of Culture and Tourism, *Antalya Museum* (Ankara, 1988), 33, 39, 190, no. 42.

53. Richter, *Korai*, 49–50, no. 67, figs. 217–220; 50, no. 68, figs. 221–224. Pedley 1976, 54, no. 49, pl. 34 a, b; 54–55, no. 50, pl. 35 a, b. On the group as a whole, see Elena Walter-Karydi, "Geneleos," *AM* 100 (1985), 91–104, pls. 25–27.

54. Ekrem Akurgal, "Neue archaische Skulpturen aus Anatolien," in *Archaische und klassische griechische Plastik* 1, 1–9, pls. 1–3.

55. Athens, National Archaeological Museum, 6493. *Human Figure* 126, no. 41.

56. Volkmar von Graeve, "Neue archaische Skulpturenfunde aus Milet," in *Archaische und klassische griechische Plastik* 1, 24–25, pl. 6, 2.

57. Athens, National Archaeological Museum, 5669. *Human Figure* 128, no. 43. Richter, *Korai*, 88, no. 146, figs. 462–465. The date 560–550 B.C. given in *Human Figure* and in *Greek Art of the Aegean Islands* [exh. cat., New York, Metropolitan Museum of Art] (New York, 1979), 162, no. 119, seems too early when compared with sculpture in stone; the last quarter of the sixth century proposed by Richter seems too late.

58. Delphi Museum 1526. Richter, *Korai*, 57, nos. 87–88, figs. 282, 283.

59. See *LIMC*, 3, 1 (1986), s.v. Charis, Charites (Harrison), 202.

60. Richter, *Korai*, 57–58, no. 89, figs. 275–281.

61. Athens, Acropolis Museum, 678. *Human Figure*, 154–157, no. 55; Richter, *Korai*, 71–72, no. 112, figs. 345–348.

62. The kore Acropolis 673 (Richter, *Korai*, 75, no. 117, figs. 368–372) has her short himation fastened on both shoulders, but it is buttoned down the right arm only; on the left side it is fastened only at the shoulder, and the chiton sleeve emerges from under it. The slightly sunken border at the neckline of Acropolis 678 has seemed to some scholars to prove that there are two garments here, but Archaic vase painters frequently show an ornamented neck edging even on a dress with an overfall (compare figs. 1–2 and note 3).

63. Athens, Acropolis Museum, 670. Richter, *Korai*, 76–77, no. 119, figs. 377–380. This kore can be contrasted with the early kore from Erythrai (fig. 20), which has essentially the same dress but lets it cling everywhere to the body.

64. Athens, Acropolis Museum, 679. Richter, *Korai*, 72, no. 113, with bibliography, figs. 349–354.

65. Humphry Payne, *Archaic Marble Sculpture from the Acropolis* (London, [1936]), 18–22, has given the most thorough description of the two korai 679 and 678 and the most detailed comparison between the two. His opinion that the two statues are by different sculptors caused him to reverse the apparent dates of the two figures, taking 678 to be an imitation of 679 by a less gifted artist who did not have the feeling for plastic form of the maker of 679. His date of "not later than 530" may stand for 678, but the connections of the Peplos Kore to the goddesses of the east frieze of the Siphnian Treasury should bring her date down to around 525 B.C.

66. Brunilde S. Ridgway, "The Peplos Kore, Acropolis 679," *JWalt* 36 (1977), 49–61. See especially 55, fig. 6, and 58–59. Ridgway suggests that the figure, because its dress is unlike that of contemporary maiden figures, should represent a divinity and that the pierced right hand held either a spear (Athena) or an arrow (Artemis). The latter would seem to fit the hand better. The dress may be considered unusual or exotic but not altogether old-fashioned, since the kore wears a linen chiton under the woolen dress, something not seen in the first half of the sixth century. See further R. M. Cook, "The Peplos Kore and Its Dress," *JWalt* 37 (1978), 85–89.

67. See Dyfri Williams, "Sophilos in the British Museum," *Greek Vases in the J. Paul Getty Museum*, Occasional Papers on Antiquities, 1 (Malibu, 1983), 9–34, especially 20, fig. 19, 27, figs. 33–34, 29: "Artemis, whose finely decorated peplos is fully visible, since, like Hebe, she wears no cloak." Since the left side of Artemis is not visible on the vase, we cannot tell whether the overfall was open or seamed on that side.

68. See especially Richter, *Korai*, chap. 5, nos. 104–107, 110, 116, 118, 122–125.

69. Athens, Acropolis Museum, 685. *Human Figure*, 158–161, no. 56. Richter, *Korai*, 100, no. 181, figs. 573–577.

70. Athens, Acropolis Museum, 684. *Human Figure*, 162–165, no. 57. Richter, *Korai*, 101, no. 182, figs. 578–582.

71. Acropolis 594, Richter, *Korai*, 80–81, no. 124, figs. 398–400; Acropolis 615, Richter, *Korai*, 81, no. 125, figs. 401–404. See also the kore from Delos, Athens, National Archaeological Museum, 22, Richter, *Korai*, 88–89, no. 148, figs. 472–475.

72. On the maidens of the Parthenon frieze, see Harrison 1989, 50–53.

73. *Human Figure*, 163.

74. *The New York Times*, 30 January 1988.

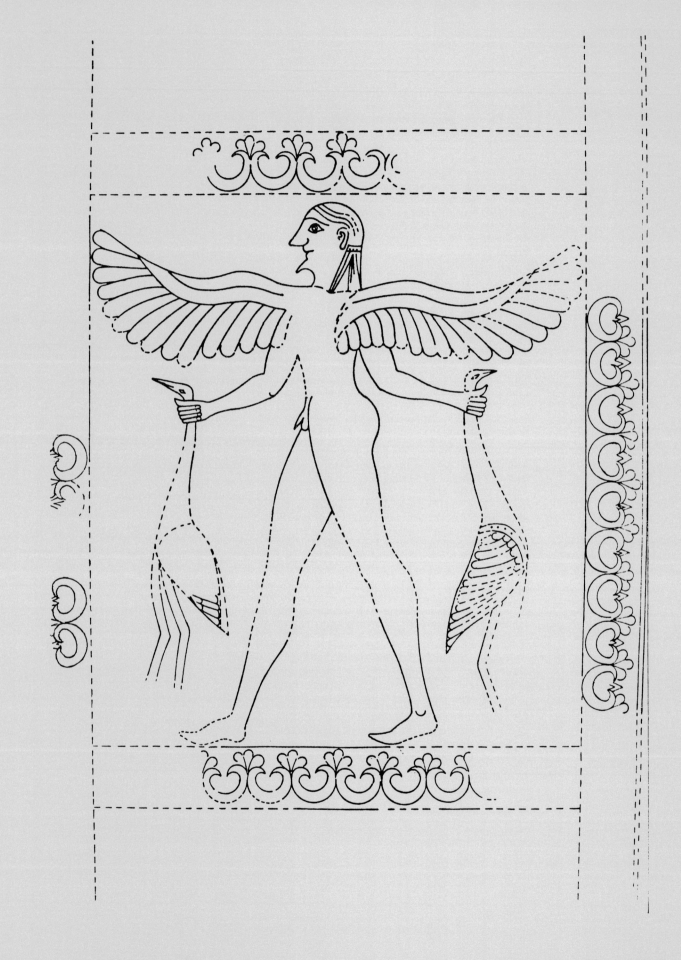

EVI TOULOUPA

Acropolis Museum, Athens (emerita)

Early Bronze Sheets with Figured Scenes from the Acropolis

The bronzes found on the Acropolis during the excavations of 1885–1889 by the Greek archaeologist Panayiottis Kavvadias and the German architect Georg Kawerau[1] are known from the catalogue of De Ridder.[2] Earlier Bather[3] had published some bronze sheets, less impressive to be sure, but still of great importance as they are fragments of dedications that were found in the sanctuary and are datable to Geometric and Archaic times.

We have no exact information about the place and depth at which they were found. What is certain, however, is that they were buried at various places on the Acropolis after 480 B.C. together with all the sculpture, bronzes, and pottery that the Persians destroyed. The excavators had paid little attention to the small bronze objects, dazzled as they were by the brilliant marble and limestone statues. Any of these bronzes that were thought to be significant were placed in what was then known as the "Big Museum" of the Acropolis. The rest were packed into boxes and stored in the "Little Museum." In 1891–1892, Bather, spurred on by Ernest Gardner, then director of the British School of Archaeology at Athens, asked for and received permission from the Greek Archaeological Service to study the bronze sheets. He undertook at the same time to remove the accretions with a stiff brush and a knife. Whatever was determined to need a more thorough cleaning was subjected to chemical treatment. The result of all this was that some of the bronzes were cleaned in such a way that the inscriptions, decorative elements, and scenes were revealed, while others, with corroded surfaces, were destroyed. Bather reports that many of the thinnest bronze sheets had already been destroyed, having been squashed by heavier objects.

The Acropolis Museum very quickly began to be filled with unique finds of full-scale sculpture, so that there was no longer any room for the small finds. The bronzes and pottery were taken to the National Museum, where they have remained to this day. Given the vast number of masterpieces that flowed into that museum from everywhere, it was quite natural that only the finest of the Acropolis bronzes should have been chosen for exhibition. Many fragments of cauldrons, shields, vase handles, bronze sheets, and so on, remained in the storerooms. During World War II, archaeologists and friends of archaeology undertook the care of the art treasures; they packed the antiquities of the National Museum into boxes and stored them according to their value. When, after the war, the unpacking was begun, it became clear that the bronzes had suffered further damage from hasty packing. It is no wonder then that so few sheets were preserved from the Acropolis in comparison to the countless numbers of bronze dedications from the sanctuary at Olympia. The wonder is, rather, that after so many vicissitudes even these few pieces remained.

The Acropolis bronze sheets may be divided into the following categories:

A. Tripod legs and handles of the eighth century B.C.

B. Tripod legs and handles of the seventh century B.C.

C. Sheet bronzes of the seventh and sixth centuries B.C. made for applique and other undetermined uses.

D. Shield fittings of the late sixth and early fifth centuries B.C.

We will discuss each of these groups in turn.

A. Tripod Legs and Handles of the Eighth Century B.C.

Some seventy fragments of tripod legs of this category are preserved. These are hammered sheets with geometric patterns worked on the main surface with hammer and point. They are fragments of the front and side legs, ring, and vertical handles. They are compiled in my article of 1972.[4] Although no human or other figure is shown on these tripod legs, there are some solid cast male figures in the round, about 20 cm high; these were often attached to the rim of the *lebes* on either side of the ring handle, which has a diameter of some 35–40 cm. The figures have compact and well-modeled slender bodies, arms expressing movement, heads turned outward, and eyes wide open with a lively expression. It was this terrifying look that led Semni Karouzou[5] to believe that these are Telchines, the demonic creatures connected with metallurgy. This identification has been challenged by some scholars,[6] particularly because the Telchines are not encountered in Attic tradition. A more likely interpretation is that they are athletes who contended for the tripod. Still other possibilities are that the figures represent Zeus or Theseus, since in a number of cases one of the two figures has the head of a bull, suggesting the minotaur. Whoever they may be, it is striking that these figures, with their extraordinarily lively expressions, appear so early on a vessel that has true Geometric decoration, with a rare variety of combinations to be sure, but nonetheless strictly standardized.

B. Tripod Legs and Handles of the Seventh Century B.C.

Examples of this category found on the Acropolis are fragments of five or six legs, and three handles (see below). The fragment of leg I.1, on which animals are incised in the technique used on the geometric tripod legs, may be considered a link between the Geometric and Orientalizing categories. During the first quarter of the seventh century, a new type of tripod appears with thin hammered legs with embossed representations. Few of these are known, probably because they were so fragile. The relief is formed by hammering the interior, while the main side rests on a soft lead surface; additional point work, still on the back, is used for the contours. It looks as if the demand was not great enough to warrant the making of molds. Just as with the pottery of the period, the scenes are influenced by Near Eastern prototypes. The bronze sheets were probably attached with rivets to wooden boards, which were fastened by dowels to a stone base. Some triangular bases found on the Acropolis have rectangular holes in the vertical channels that run along the edges of the three sides. Kawerau had expressed this idea without having seen the bronze sheets that were found during his excavation.[7] This system of attachment to a wooden backing may explain why only the sides of the metal sheets I.5 (see below) have been preserved, while the middle part that was attached to the wood has been lost by burning or in some other way (fig. 1, and compare figs. 13, 14). These poros bases, with a height of 75 cm, belong to pyramidal constructions of an unknown height. Three such bases, preserved complete, have been found, and fragments of another ten. Some had been built into the north and south walls of the Acropolis. The base at the west of the Parthenon has a concave surface for holding the *lebes* (fig. 2). The diameter of the handles (see below II.1–3) shows clearly that the legs would have been over 2 m tall.

Considering that no molds were used for the scenes that decorated the legs, the tremendous cost of the tripods is evident.[8] For this reason they were soon replaced by another type, with cast polelike legs (*Stabdreifuss*). Yet these last hammered tripods give an impression of affluence rather than of decline, because the artisan using this tech-

1. Reconstruction of an
Archaic tripod composed
of a stone base, wooden
beam, and bronze sheet
Drawing M. K.

2. Triangular stone base
for a bronze tripod,
Acropolis, southwest of
the Parthenon, Athens
Photograph by S. M.

nique was able to give free rein to his imagination in both theme and composition. The only difficulty was that the old aristocratic families could no longer pay the price.

Examples of this category are listed below; dimensions are given in centimeters, unless otherwise indicated. Additional abbreviations used in the descriptions are identified in the list of abbreviations at the end of this chapter; standard abbreviations are given in the list at the beginning of the volume.

I. Legs

1. NM 6957. Figs. 3, 4.
 H 25.5. W 10.4.

Mended from two fragments. Edges broken all around. Very worn. Two fields, one above the other. Narrows toward the top. Running spirals right and left. From top to bottom: two large rosettes, zone of concentric circles connected with tangent lines. Field with leopard[9] moving left, zone with zigzag, boar facing left, zone with tongue pattern.

The slender body of the leopard is decorated with stamped circles. Its head is frontal and has a vertical row of dots between two lines to mark the nose. The tail curves up to the height of the back and turns outward to end in a triangular hook. The legs are long and have big claws. The boar is less carefully de-

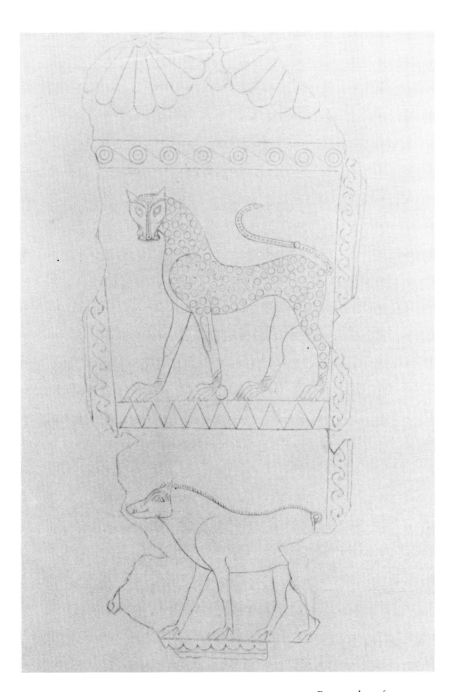

3. Bronze sheet from a tripod leg
National Archaeological Museum, Athens

4. Bronze sheet from an Archaic tripod, with leopard and boar
DAI, Athens

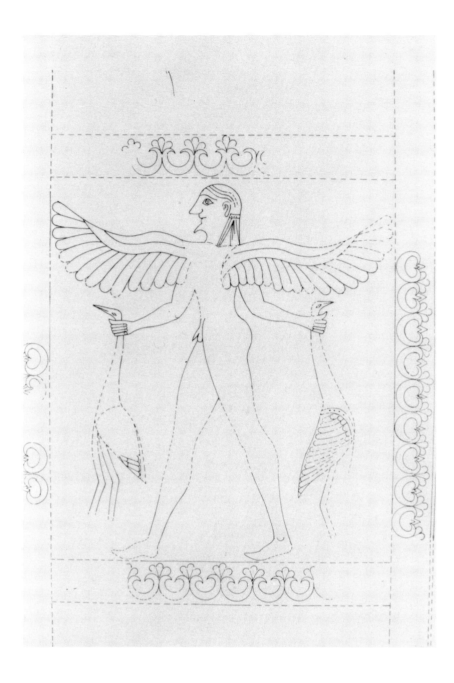

5. Bronze sheet from a
tripod leg
Drawing C. K.

lineated. Along his spine are the usual bristles; his tail is long and forms a ring. The clumsily rendered feet are placed on the horizontal line. All the lines were hammered with a point, and the circles on the leopard were impressed with a small cylinder.

Bather, 244–246, fig. 17; De Ridder, no. 41; Willemsen, 158, pl. 92; Kunze KrBr, 107, 254.

2. NM 6956. Figs. 5, 6.
H 29.4. W 27.4.

Mended from thirteen fragments, much restored. Rectangular sheet narrowing toward the top.

A nude winged man with long legs strides left in sprightly fashion within an empty field. His wings begin probably on his chest and spread almost horizontally toward the sides. In each hand he holds a crane by the neck.[10] He has a tiny beard (unless it is simply a very pointed chin), low forehead, and hair drawn behind his ears to fall in tresses down his back, except for one that hangs in front. The muscles are not shown, either plastically or by incision. Even the toes are omitted; it is possible that he is wearing soft boots with tips turned slightly upward. The scene is framed by crescent-shaped decorative elements from which spring abbreviated palmettes with three fronds. Five tools forming sections of circles of various diameters were used for the curved lines.

The figure has been variously identified as Zeus, Apollo, Dionysos, Hyacinthos, Aristaios, Boreas, a Death Daimon, and a Water Spirit. Male winged figures holding birds are far fewer than their female counterparts. They are known on a relief pithos from Tenos, on Laconian ivory seals, in Crete on a votive plaque from Lato, and on a bronze from Afrati, and they are even known in Italy (Orvieto and Perugia). They are counterparts to the winged Artemis, and there is no need to seek a mythological explanation. Our figure is a daimon, perhaps known from a Cretan mold from an Assyrian prototype. The Acropolis figure is far more elegant than the Artemis holding two swans by the neck on a bronze strip from Perachora.[11] The birds he holds by the neck are still alive.

Bather, 259–262, figs. 26, 28; De Ridder, nos. 45, 46; Lamb, 65, fig. 5. See also OlBer 5, 85; Artemis Orthia, pl. 99, 1–2; Kunze KrBr 11, Beil 2b; ArgHer 2, 49, pl. 49, 1.

2a. NM 16819. Figs. 6, 7.
 H 26.0. W 25.4.

Rosette with ten of the fourteen petals preserved. Part of the hand and forearm of a human figure is visible at the edge of the fragment. In the photograph (fig. 6) the fragment is shown as if it belonged in the same field as the winged figure. During study for the new drawing (fig. 7), however, it was discovered that the field with the winged figure I.2 has no filling ornaments, and the fragment therefore belongs to the field above.

3. NM 16821 and 16822. Figs. 8–10.
 H 13.2. W 7.9.

Figures in two metopes separated by a crescent and five-frond palmette pattern. In the upper field is the foot of a figure in relatively large scale. In the lower one is a scene from the tale of Perseus. The hero appears to move off to the left. The object on his back may be part of his sack (*kibisis*). The hilt and pommel of his sword project above his shoulder. The instrument he holds is a saw-toothed *harpe*.[12] This is the first known representation of beheading the Gorgon with this instrument,

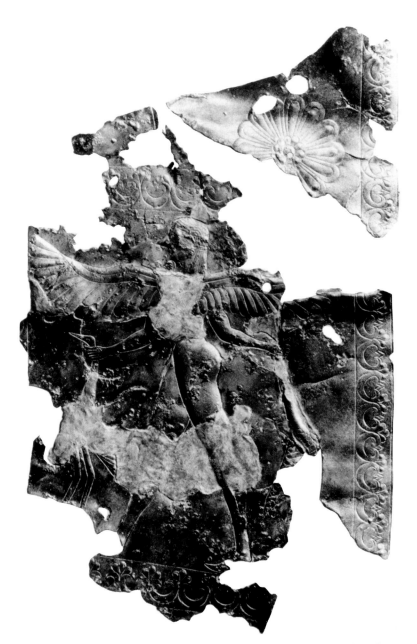

6. Bronze sheet from an Archaic tripod and fragment, with winged god, rosette
DAI, Athens

7. Bronze sheet fragment
Drawing C. K.

rather than with the sword of the earlier scenes. There are, to be sure, some difficulties with the interpretation of this scene in its fragmentary condition. A new examination, however, eliminates any doubt that the two pieces belong together.

Bather, 261–263, 269, figs. 29a, 33; De Ridder, nos. 43, 44; Roland Hampe, "Korfugiebel und frühe Perseusbilder," *AM* 60–61 (1935–1936), pl. 98; Konrad Schauenburg, *Perseus in der Kunst des Altertums* (Bonn, 1960), 21; Fittschen, 153.

8. Bronze sheet from a tripod leg
Drawing Th. K.

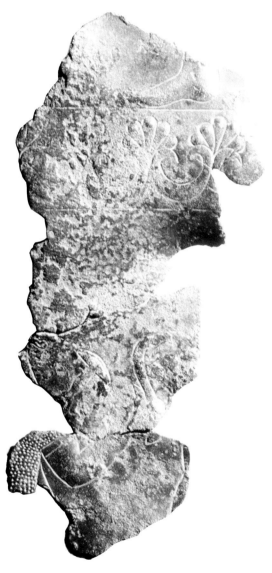

9. Bronze sheet from an Archaic tripod
Photograph by S. M.

10. Detail of figure 9

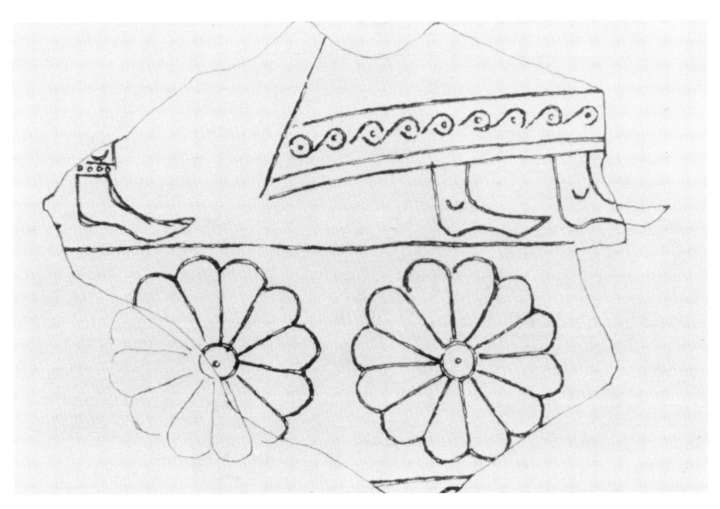

11. Bronze sheet from a
tripod leg
Drawing Th. K.

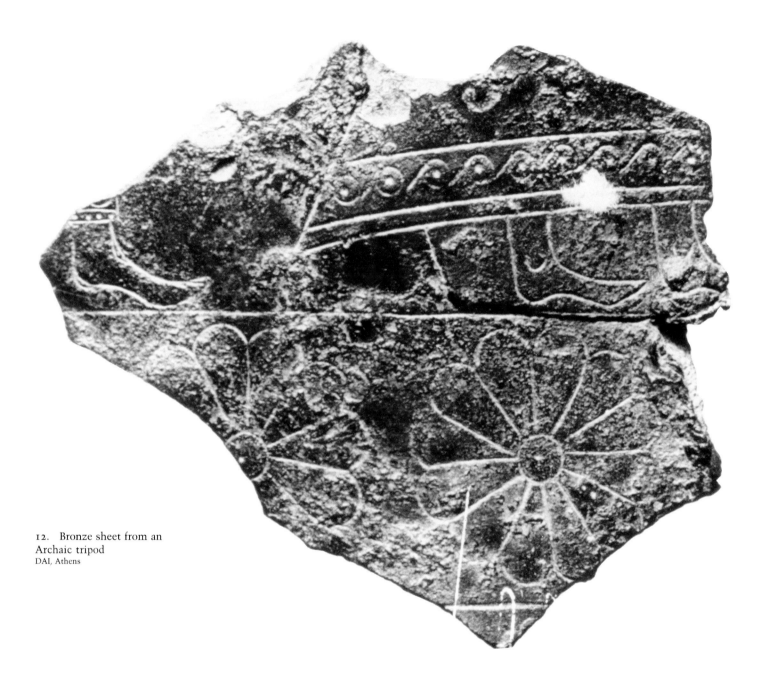

12. Bronze sheet from an
Archaic tripod
DAI, Athens

4. NM 16820. Figs. 11, 12.
 H 5.5. W 6.7.

Fragments of two vertical panels separated by
a band of rosettes between horizontal lines.
Above, the feet of two figures. One wears a
long chiton with a border of running spirals.
The other perhaps wears Scythian trousers.
Here too the toes are not delineated, and the
figures may be thought of as wearing soft
boots. It is probable that the piece belongs to
the leg I.5.

Bather, 246–247, fig. 15; De Ridder, no. 42.

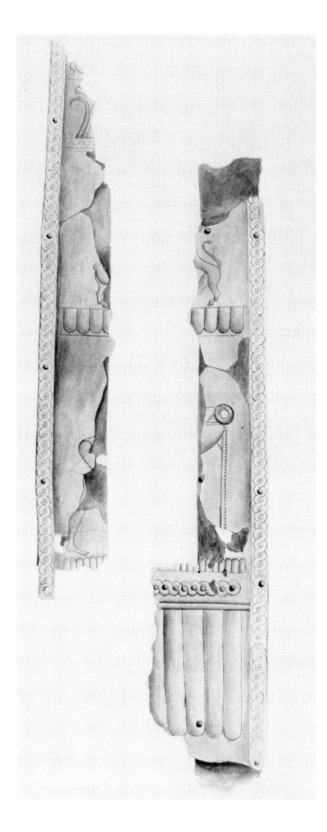

The following pieces are from the sides of one or more tripod legs. The fragments have separately worked borders with a guilloche pattern. The borders are folded over to secure two sheets with rivets, the one with the embossed scene, and the other behind it as a backing. The center of both backing and embossed sheet has been destroyed (see above). Of many fragments without special significance that were preserved, the following two have figures.

5. NM 6955 and 6955a. Figs. 13–16; compare Fig. 1.
 H 43.5. W 6.0.a.
 H 49.4. W 9.0.

In the upper field two lions rampant, facing each other. Their raised forelegs (a small part of the forelegs of one lion is missing, and most of the forelegs of the other) will have touched each other. Below, a male figure. Preserved are the right leg, the hip, and the right elbow or perhaps the shoulder. He strides fiercely toward the center. It was once thought that there was a larger space between the two sheets. In this case, the forelegs of the lions would have rested on some object at the center, and the figure below would have been struggling with another figure in the center for the prize of the tripod. The architect, Manolis Korres, has shown in his drawing (fig. 14) that the lost central piece was not larger than some 3–4 cm, so that there is no room for a second figure. The figure at the left was probably touching the tripod, and two interpretations are possible: the scene could show an athlete dedicating his prize, or, more likely, it could show Herakles making off with the tripod at Delphi. Apollo could have been shown on another of the legs, or he could have been omitted altogether. The trace of a foot on the sheet NM 6955a does not, as previously thought, belong to a hypothetical lost figure on this metope, but to one from another metope on the same or another leg. In any case, the fragment with the long tongue pattern must be placed on the lowest part of the tripod leg. The metopes are separated by horizontal bands with guilloche and small tongue motifs.

Bather, 264, fig. 30; De Ridder, nos. 30–33; Willemsen, 112, 159, 179; Lamb, 64.

13. Bronze sheet from a tripod leg
Drawing Th. K.

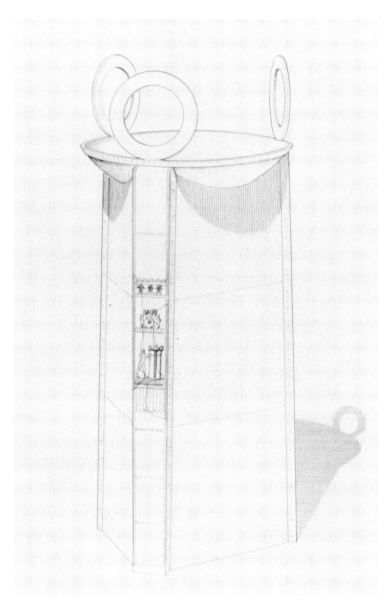

14. Reconstruction of
tripod leg (fig. 13)
Drawing M. K.

15. Bronze sheets from
an Archaic tripod
DAI, Athens

16. Detail of figure 15

6. NM 6955e. NM 16818. Figs. 17, 18.
 NM 6955e: H 51.52. W 6.0.
 NM 16818: H 32.2. W 6.0.

Two pieces of a leg similar to I.5. It is possible that these fragments are the continuation of this leg, or perhaps they were opposite to each other. On 6955e, from bottom to top: rosettes with ten petals, alternating dotted and undecorated; an unidentified form (Bather sees the back of an animal); band with circles and dot in center. On 16818: part of the left shoulder of a bearded figure facing left and apparently in combat. It is not certain whether he is wearing a leather helmet or a crown. Two tresses fall over his shoulder. Above him is an enormous decorative loop decoration with stylized lily (as in the next example), and above this are two rosettes with ten dotted petals.

References same as I.5.

There are many fragments from the same or a similar tripod leg. They have been recorded in the National Museum inventory under the number 6955. Fragments identified and joined during recent years by Petros Kalligas are recorded there.

II. Ring Handles

1. NM 16823. Fig. 19.
 Largest piece: H 8.8. W 14.5. Th 5 mm.

Nine fragments broken along all sides. Some can be joined, others cannot, because the break falls where the metal has been bent. Running loop decoration formed by three lines with stylized lily.

De Ridder, nos. 34–36.

2. NM 16824. Figs. 20, 21.
 The largest: L 12. W 8. Th 2mm.

Four fragments of a handle similar to II.1. The flower pattern rises from a dotted circle. The lower edge of one fragment has been turned outward expressly to form a right angle.

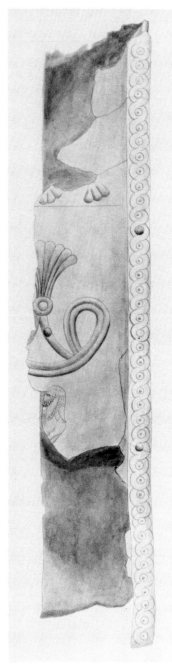

17. Right part of a tripod leg
Drawing Th. K.

18. Bronze sheet from an Archaic tripod
DAI, Athens

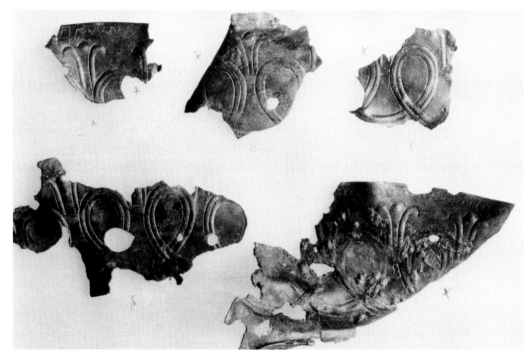

19. Bronze sheets from
handle of an Archaic
tripod
DAI, Athens

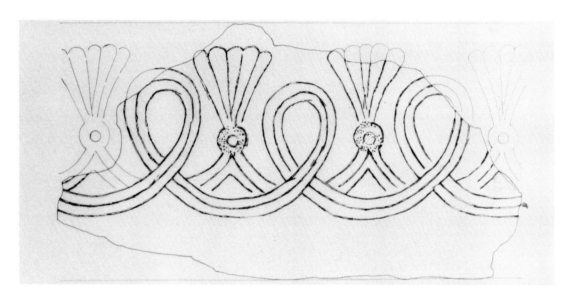

20. Part of a tripod
handle
National Archaeological Museum,
Athens

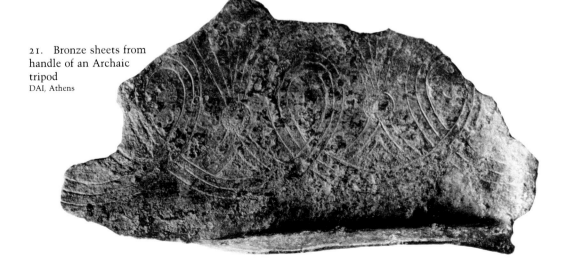

21. Bronze sheets from
handle of an Archaic
tripod
DAI, Athens

3. NM 18119. Fig. 22.
 W 6.7. Diam. est. 40.6.
Four pieces of a handle similar to II.1–2.[13]
They join in pairs. Decoration consists of a
zone of rosettes (seventeen petals) between
narrow zones of concentric circles linked by
tangent lines.

Willemsen, 159, pl. 93.

C. Sheet Bronzes of the Seventh and Sixth Centuries for Applique and Other Indeterminate Uses

A bronze ring, with the cut-out figure of a Gor-
gon (NM 13050) on the vertical axis of the
interior, comes neither from a tripod handle
nor from a shield emblem, for reasons I have
given elsewhere.[14] In my opinion this figure,
which is 41.7 cm in height (exterior diameter
of the ring: 77 cm), was fastened to the center
of a pediment as was sometimes done with a
phiale or shield, or it was attached to the cen-
tral beam so that the beam end was hidden
by the Gorgon's body and the empty part
showed above the roof. Still another possi-
bility is that it formed the central akroterion,
perhaps of the Archaic temple of Athena.

1. NM 6963. Figs. 23–25.
 Dim 16.5 × 10.5. Th 0.5 mm.
Broken on all sides. Fragments of two scenes
from surfaces with planes at right angles to
each other. It evidently decorated two sides
of a chest, or perhaps the cover of a pyxis. The
first scene is of Herakles (?), bearded but with-
out moustache. He wears a short dotted chi-
ton or cuirass, and he draws his bow. His
quiver hangs against his back. His face is full,
his features large, his eye a little bulbous. The
other figure is a warrior with sword drawn
and scabbard hanging from his shoulder. He
wears a Corinthian helmet without nose-
guard, below which three tresses fall over his
right shoulder. He probably holds his victim
by the hair.[15] Band of rosettes (twelve petals)
and palmettes. Roland Hampe believes that
this figure is Menelaos.

Bather, 268–269, fig. 32. De Ridder, no. 40. Lamb,
66, fig. 6. Kunze KrBr, 254. Roland Hampe, *Frühe
Griechische Sagenbilder in Böotien* (Athens,
1936), 81.

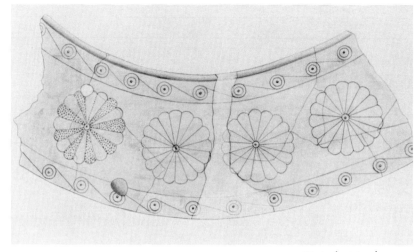

22. Part of a tripod
handle
Drawing Th. K.

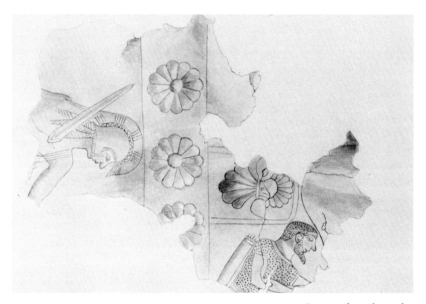

23. Bronze sheet from the
decoration of a chest
Drawing Th. K.

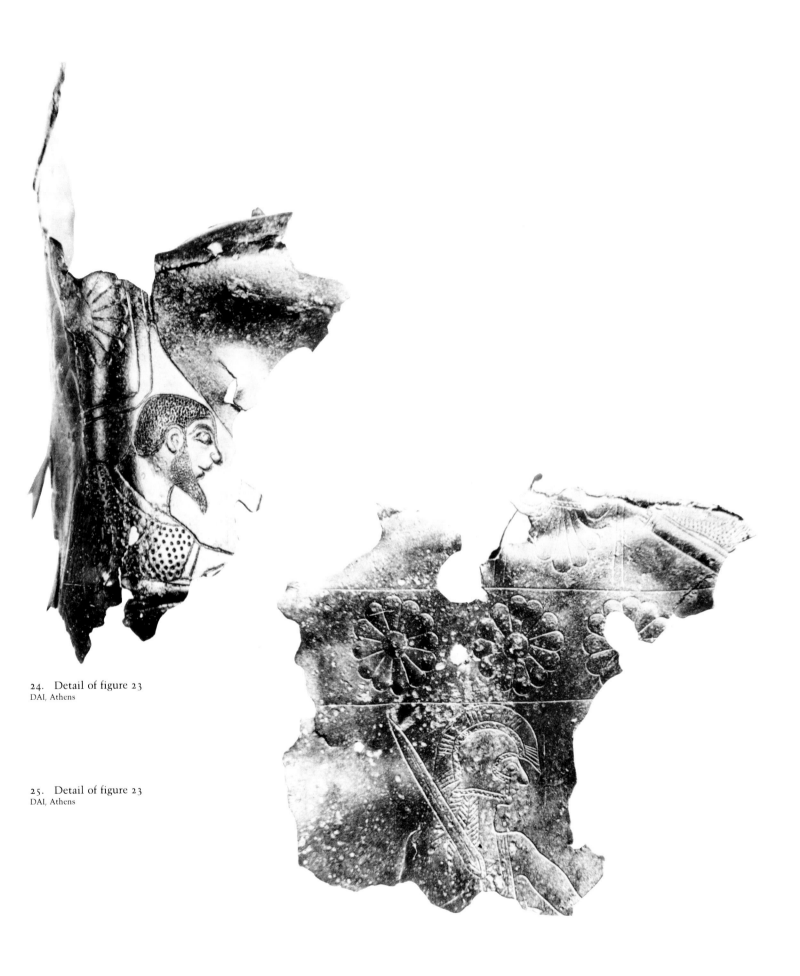

24. Detail of figure 23
DAI, Athens

25. Detail of figure 23
DAI, Athens

26. Bronze sheet from a
cheek piece or greave
DAI, Athens

2. NM 6969. Fig. 26.
Dim 14.2 × 5.2.

Part of a cheek piece or greave. Broken on all
sides, more irregularly below. Preserved is
only part of the right side, with holes for at-
taching it to leather. Head and part of the
body of a snake or dragon. Regular scales are
incised over the body, smaller and more ir-
regular ones on the head. Vertical and hori-
zontal lines indicate the teeth and beard. Be-
hind and below the body is a tendril ending
in a volute. Another over its head likewise
ends in a volute. Fine green patina.

De Ridder, no. 253. Compare *OlBer* 8, pl. 18; *OlBer*
3, pl. 51.

3. NM 16827. Photo DAI, Athens 71/287.
H 9.2. W 8.4.

Fragment of a tripod leg (?) with incised
seven-frond palmette.

4. NM 16828. Photo DAI, Athens 71/288.
H 10.9. W 8.5.

Fragment of a tripod leg (?) with lion head in
relief.

5. NM 7375. Photo DAI, Athens 71/276.
H 8.1. W 5.2.

Bronze sheet with incised boar facing right.
Of the head, only the ear and the eye are pre-
served.

Bather, 261, fig. 27.

6. NM 16830. Photo NM.
H 6.6. W 4.5.

Bronze sheet with part of a male figure car-
rying a fish on his shoulder.

7. NM 16829. Photo NM.
 H 10.0. W 6.9.

Bronze sheet with two clasped hands, incised.

8. NM 16825. Photo DAI, Athens 71/285.
 Dim of largest: 14.0 × 12.0.

Three pieces of a rectangular sheet with embossed overlapping leaves, resembling a lion's mane. The sheet appears to have been cut for a second use.

De Ridder, nos. 37, 38.

9. NM 16826. Photo DAI, Athens 71/286.
 Dim of largest: 14.7 × 9.2.

Two pieces of a rectangular sheet with crescent-shaped ornament and palmettes with five fronds. Minute swellings like pinheads.

10. NM 7021. Photo DAI, Athens 71/275.
 H 25.0. W 15.0.

Rectangular sheet without figure decoration. One surface has attached flat bands with a tongue patterned border. Perhaps from a tripod leg (compare FdD, V, 3, pl. LIII: 512).

De Ridder, no. 375.

D. Shield Fittings of the Late Sixth and Early Fifth Centuries

To the last quarter of the sixth century may be dated a series of bronze strips that belong to the category known as *shield bands* (*Schildbänder*). These are known especially from the relatively large number found at Olympia and published by Emil Kunze in *Olympische Forschungen* (1950). The technique is known from Mycenaean and Geometric times in gold work. The sheet was placed on a bronze mold with a scene in intaglio, and then hammered. Details were engraved on the main side.[16] Shields were dedicated likewise in the Sanctuary of Athena on the Acropolis. Of these only a few are preserved. They consist of: (I) six shield band attachments of trapezoidal shape with scenes adapted to this shape; (II) eight rim attachments ending in palmettes; and (III) seven shield bands (sheathing for leather straps) with scenes arranged vertically in metopes and separated by a decorated band.

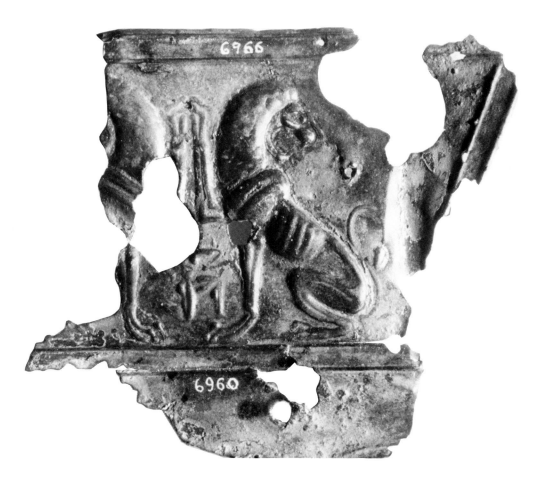

27. Shield band
attachment, with two
lions facing
(no. 6966 written on object
is incorrect)
Photograph by S. M.

28. Detail of figure 27

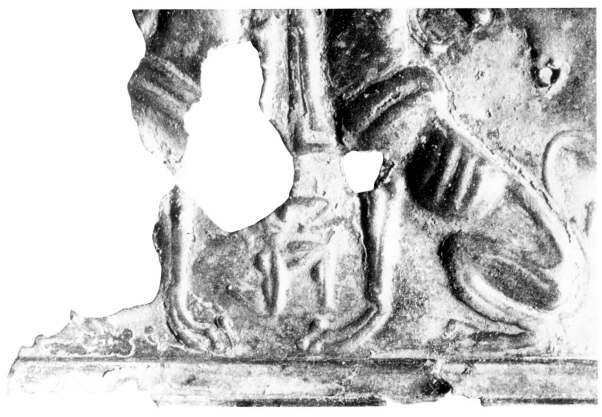

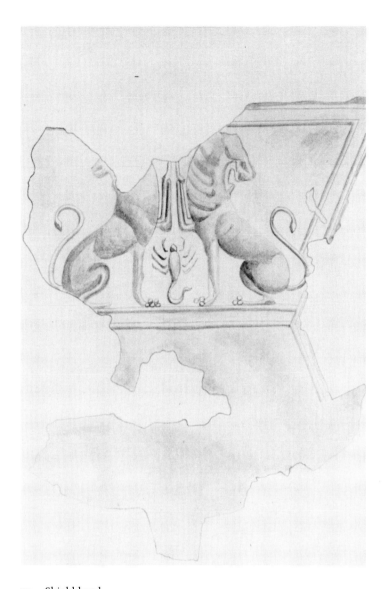

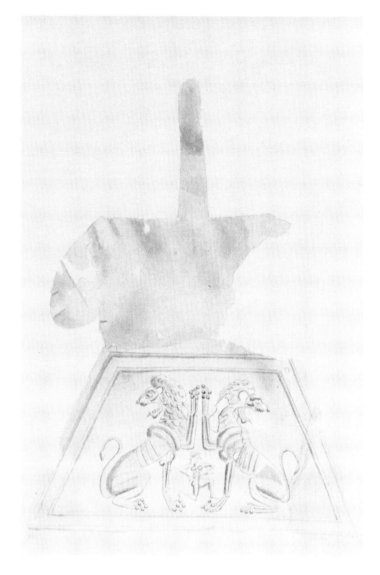

29. Shield band
attachment
Drawing Th. K.

30. Shield band
attachment
Drawing Th. K.

I. Shield Band Attachments

1. NM 6960. Figs. 27, 28; compare fig. 29.
H 9.6. W 8.0.

Mended from two fragments. Fragments from center and sides missing. Two lions facing, heads turned outward with open mouths, seated on their haunches with one foreleg raised. Their tails (one preserved) form a circle and end in a cone. Between them is a small male figure in running pose (*Knielauf*), with a sword in his right hand. He may be a survival of the lion fighter prototype, or perhaps an offshoot of the "master of animals" (*potnios theron*).

Bather, 256, fig. 25. Wolters, 480. De Ridder, no. 369. *OlBer* 3, 103, 2.

2. NM 6961. Fig. 29. Photo DAI, Athens 71/263.
H 16.2. W 12.7.

Similar to I.1 and probably its counterpart, as it comes from the same mold. Fragmentary. Ends in a flat undecorated sheet and flat stem. Framed by a double line in relief.

De Ridder, no. 370. *OlBer* 3, 103,3.

3. NM 6967. Fig. 30.
H 12.6. W 9.5.

Similar to I.1 and I.2 with approximately the same decoration. Fragmentary and corroded. The tails of the lions are raised higher, forming a bow. Between the forelegs a scorpion with tail turned right. Relief not very precise.

De Ridder, no. 372. *OlBer* 3, 103, no. 5.

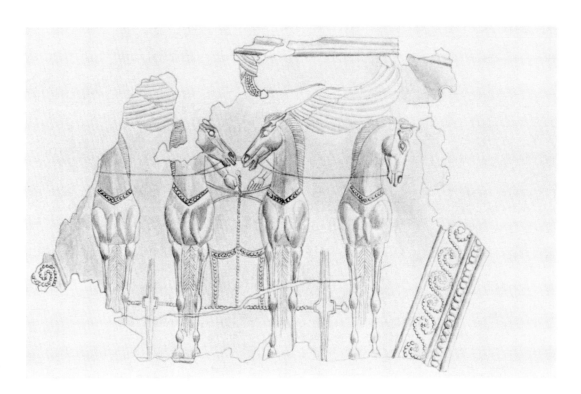

31. Shield band
attachment, with quadriga
Drawing Th. K.

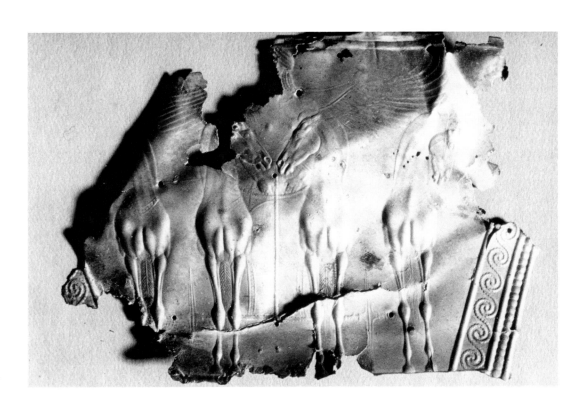

32. Shield band
attachment, with quadriga
Photograph by S. M.

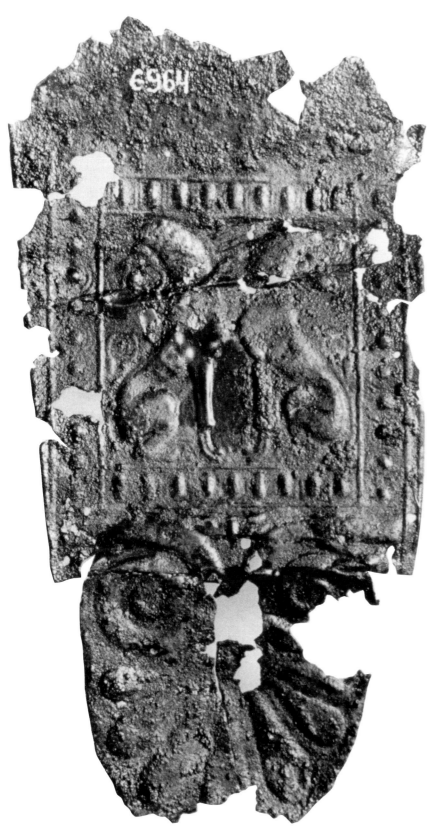

33. Shield rim
attachment, with two
lions facing
DAI, Athens

4. NM 6966. Photo DAI, Athens 71/271.
H 11.2. W 5.0.

Similar to I.3, and perhaps its counterpart. Fragmentary. The scorpion and the lions' manes are poorly hammered.

De Ridder, no. 372. Kunze KrBr, Beil. 5c. *OlBer* 3, 103, no. 4.

5. NM 8601. Photo DAI, Athens 71/277.
H 6.4. W 11.0.

Similar to I.1. Worn and corroded. No filling object between the lions.

De Ridder, *Catalogue des bronzes de la Société Archéologique d'Athènes* (Paris 1894), no. 801. Furtwängler 1, pl. 14, 1. *OlBer* 3, 103, 1.

6. NM 6958. Figs. 31, 32.
H 9.5.

Fragmentary. The fine bronze has no patina. Frontal quadriga with Nike (or Eos). Her face, turned left, is difficult to make out. The wide spread of her wings is striking. Her hands, close together in front, hold the reins. The horses in the middle have their heads turned inward, the outer two outward. A dotted running spiral decorates the frame. The outer edge has a line of heavy dots closely spaced.

Bather, 243, 255–257, pl. 8. De Ridder, no. 374. *OlBer* 3, 106. Lamb, 120, pl. 42 b. See also German Hafner, *Viergespanne in Vorderansicht* (Berlin, 1938), 12.

II. Shield Rim Attachments

1. NM 6964. Fig. 33.
H 18.0. W 6.7.

Two lions seated on their haunches, facing, heads turned outward, tails forming bows. Representation is embossed, in a rectangular frame that has dentils above and below, guilloches left and right. Above is an undecorated plate, below a seven-frond palmette inscribed in an oval sheet.

De Ridder, no. 358. Wolters, 480. *OlBer* 3, 91, fig. 87.

2. NM 6464a. Photo DAI, Athens 71/269.
H 7.2. W 6.2.

Similar to II.1. Damaged, with holes. Only a small part of the decorated plate preserved. Probably from the same mold as II.1.

De Ridder, no. 360.

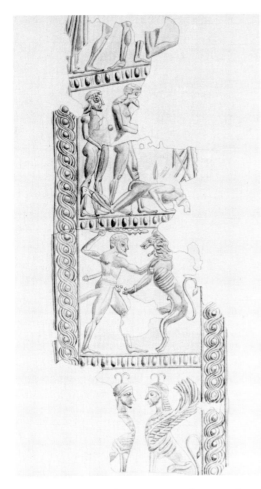

3. NM 16834. Photo DAI, Athens 71/289.
 H 11.4. W 5.2.

Similar to II.1. The nine-frond palmette is cut out, small fragment missing. Relief very precise. It may belong to band III.2 (see below).

Wolters, 479, no. 4, pl. XIV/2 (number incorrectly given as 6960). De Ridder, no. 359. NC, fig. 15b. Lamb, 117, fig. 3/2.

4. NM 16835. Photo NM.
 H 8.0. W 4.3.

Palmette from a sheet similar to II.1. The right half only is preserved with four fronds and the righthand volute. From the same mold as II.3.

De Ridder, no. 362.

5. NM 16836. Photo NM.
 H 4.6. W 5.0.

Nine-leaf anthemion from a sheet similar to II.1. Only a small part of the two outer leaves is preserved.

De Ridder, no. 366.

6. NM 16833. Photo NM.
 H 9.2. W 5.0.

Two volutes of a palmette similar to II.1; from the end of an undecorated metope.

De Ridder, no. 361.

7. NM 16837. Photo NM.
 H 6.3. W 4.6.

Part of a similar palmette, the volutes joining with a band of dentils. The relief is notable for its plasticity.

De Ridder, no. 364. Compare *OlBer* 1, pl. 15.

8. NM 16838. Photo NM.
 H 7.7. W 6.7.

Palmette cut out from a similar sheet. Ends of the fronds broken. Volutes join border as on II.7. Fine sheet with low relief.

De Ridder, no. 368. Compare Kunze, pl. 75, type B 40.

III. Shield Bands

1. NM 6965. Figs. 34–36.
 H 18.5.

Strip with four metopes. From top: (*a*) Traces of legs of two figures joined in fierce struggle. They may be Theseus and the Minotaur, if the size of the thigh is any indication. In this case, the himation to the left will belong to Ariadne. (*b*) Suicide of Aias. Two nude figures at the left side, Diomedes and Odysseus? To the right a draped figure with a staff, Nestor or Phoenix? A dead man, Aias, has fallen on his hands and knees so that the body hangs at some distance from the ground. (*c*) Heracles and the lion. The hero swings his club over his head. Behind him can be seen his sword. The moment of actual battle has not yet come. The beast has leaped to sink his claws into the hero's thigh. (*d*) Two sphinxes sit facing each other so as best to display their lovely womanly profile, their splendid breast, their hair ornament, their fanlike wings. The horizontal bands separating the metopes are decorated with dentils and vertical lines. Along the sides, guilloches. The relief is very precise and shows anatomical features.

Wolters, 474, no. 1, pl. XIV/4. De Ridder, no. 350. Lamb, 117, fig. 3/4. NC 126, 226, pl. 45/8, pl. 137 (2).

34. Shield strip with four metopes
Drawing Th. K.

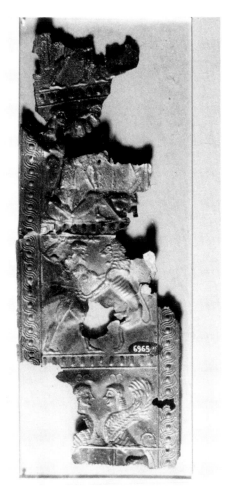

35. Shield strip with four
metopes
DAI, Athens

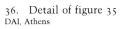

36. Detail of figure 35
DAI, Athens

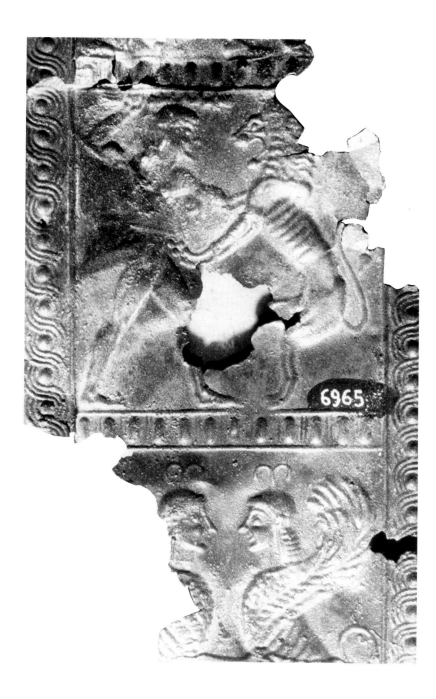

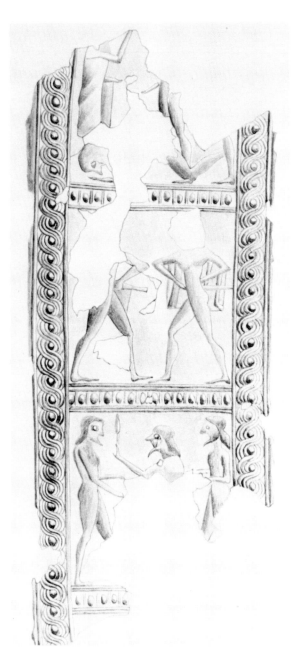

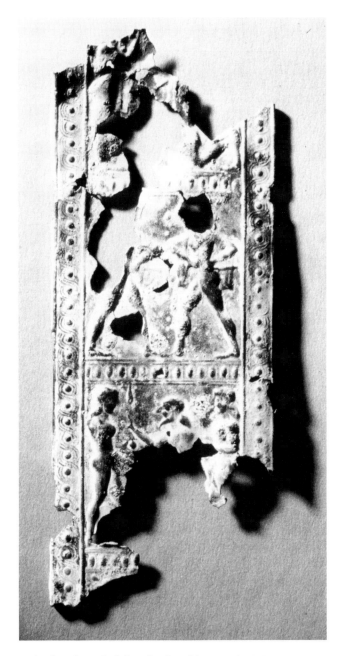

2. NM 6962. Figs. 37–39.
 H 15.7.

Similar to III.1, with three scenes from the Trojan Cycle. From the top: small part of a fourth metope on which a foot can be made out (not visible here). (*a*) The suicide of Aias. The dead man has fallen on his knees and elbows. To the left stands a himation-clad figure, to the right two nude men. (*b*) Fight over the arms of Achilles, if the two opposing figures drawing their swords can be identified as Diomedes and Odysseus. (*c*) Ransom of Hector. Achilles stands alone at the right. His lower left leg is missing. Priam (preserved are only his bearded head, shoulder, and right arm) approaches him with a gesture of supplication. At the right is probably Hermes without his *kerykeion*. His lower legs are missing.

3. NM 6962a. Fig. 40.
 H 2.8. W 3 mm.

Fragment with a figure moving left, probably from the same strip as III.2. The plasticity of the work is striking.

Wolters, 476–478, nos. 2, 3, pl. XIV/1, 3. De Ridder, no. 349. Lamb, 117, fig. 3/1. Kunze, 145–147, Beil 10, 2. NC 136, 226, pl. 45, 4.

37. Shield band with three metopes
Drawing Th. K.

38. Shield band with three metopes
DAI, Athens

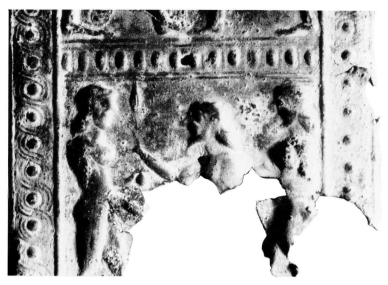

39. Detail of figure 38
Photograph by S. M.

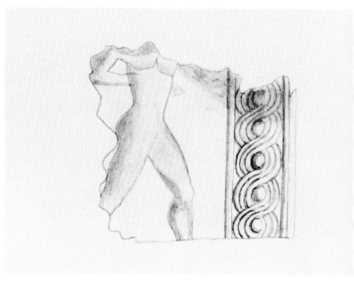

40. Fragment belonging
to shield band pictured in
figure 37
Drawing Th. K.

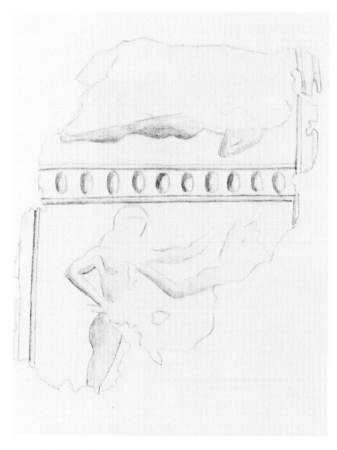

41. Shield band with two
metopes
Drawing Th. K.

42. Shield band with
parts of two metopes
DAI, Athens

4. NM 6961a. Figs. 41, 42.
 H 6.5. W 5.5.

Similar to III.1. Condition very poor. Parts of two metopes; above, a nude male figure lying on the ground with a bird (or perhaps a sphinx) on his shoulder. Below, Theseus and the Minotaur. Frame has an irregular dotted line.

Wolters, 481, pl. 14, 5. De Ridder, no. 351. Lamb, 117, fig. 3/5.

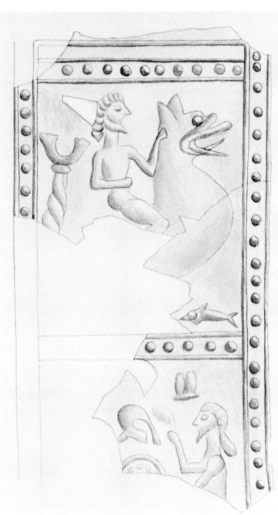

43. Shield band with sea
daimon
Drawing Th. K.

44. Shield band
DAI, Athens

5. NM 6968. Figs. 43, 44.
H 11.0. W 6.3.

Similar to III.1, with two metopes. Large part
missing. (a) Sea god riding a monster of the
deep. This god with his youthful bearing is
not Poseidon, nor is he Heracles, and the sea
monster is neither hippocamp nor Triton, but
a ketos. Perhaps the scene shows Perseus set-
ting out to save Andromeda. The subject is
better known on the terracotta plaques from
Penteskoufia (near Corinth).[17] A fish, lower
right. (b) Thetis giving the arms to Achilles.
The frames are decorated with circles be-
tween two lines.

De Ridder, nos. 355, 357. OlBer 1, 60, fig. 25.[18]
Kunze 74 n. 2, 242. See also Ernst Buschor, "Meer-
männer," Sitzungsbericht der Bayerischen Aka-
demie der Wissenschaften (Munich, 1941), vol. 2,
1, 6.

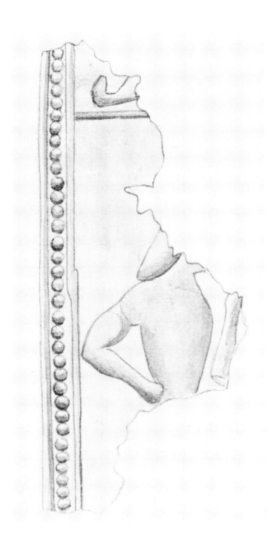

45. Shield band with
nude man
Drawing Th. K.

6. NM 16832. Photo NM.
 H 3.1. W 6.4.

Similar to III.1. Corroded. Small fragments of
two metopes: (a) Feet of two human figures.
(b) Heads of three human figures.

De Ridder, no. 352.

7. NM 16831. Fig. 45. Photo NM.
 H 6.0. W 2.6.

Similar to III.1. Parts of two metopes. Above:
undeterminate. Below: nude youth. Upper
part of body preserved with hair falling over
shoulder, right arm bent with hand on hip.
Frame dotted, simple line between metopes.

De Ridder, no. 354. Compare Kunze, pl. 8, I f.

Chronology

Among the seventh-century tripods with legs
that have incised and relief representations,
the earliest is the leg from Delphi with a Dae-
dalic protome of a winged goddess.[19] It is the
first appearance of the human figure on tripod
legs.

To the middle of the seventh century may
be dated the splendid sheet from the Argive
Heraion on which many figures are shown in
fields with filling ornaments.[20]

The leg B 3600 from Olympia,[21] on which
mythological scenes are depicted in fields one
above the other, has been dated in the last
quarter of the century.

Among the Acropolis legs, B.I.1 still retains
some Geometric elements, and it must be
considered as the link between categories A
and B. Ornaments and animals are incised in
the technique of the Geometric tripods. It is
datable around 700 B.C.[22] The leg with the
winged figure, B.I.2, can be placed a little after
the winged goddess from Delphi, in the sec-
ond quarter of the century.[23] The leg B.I.3, on
the other hand, is later; the leg of the figure
is more carefully worked, and the frame dec-
oration richer than the similar one in B.I.2.
Although Kunze[24] placed it earlier, it belongs
rather in the middle of the century, a little
later than the Louvre pithos.[25] The legs I.5
and I.6 have been dated by Willemsen[26]
among the latest in this category, but still in
the seventh century because of the separately
worked borders. The figure in the same field
with the tripod has good proportions and

lively movement. By itself it could even be placed in the sixth century,[27] were the tripod not firmly Geometric and the rampant lions less Archaic. These lions have more grace and elasticity than those of a Corinthian mirror[28] in the National Museum at Athens. They are closer to the Chimaera on the Thasos plate, datable to the middle of the seventh century.[29] Of the handles, II.3 is the earliest, since it has some Geometric decoration. Of the other two handles, one has incised decoration, the other plastic, but it is difficult to say which is older.

Of the various other sheets of Group C, most are so fragmentary that it is not easy to date them. The fine sheathing for a chest, C.1, can be dated somewhat later than the Mykonos pithos. The helmet, sword, and tresses are very close to the depictions on the pithos.[30] Kunze thought that the sheathing could not be dated before 700,[31] and Blegen thought that despite the style it had something in common with the sheet from the Argive Heraion.[32]

It is not easy to date the embossed sheets from the shields because old and new types are found together on the same band.[33] It is, at least, certain that for the anthemia, which are finials for the bands, different molds have been employed from those used for the metopes. The Acropolis finds have a *terminus ante quem* of 480 B.C., as they were buried after the Persian invasion. Their style proves that they are no earlier than the last quarter of the sixth century. More problematic is the chronology of D.III.4,5,7. The first two have subjcts that are infrequent in Attic iconography, and the decoration of their frames is not the usual guilloche and dentils. They can even be dated to the middle, if not the beginning, of the sixth century.[34] The mythological scenes decorating the metopes of III.1,2 have iconographical elements characteristic of the Late Archaic period: figures locked in struggle, such as Theseus and the Minotaur,[35] or figures that confront each other threateningly, such as Heracles and the lion. Even the figures on the sides of the scenes who seem indifferent to the drama of the dead body in the center (the suicide of Aias), are not rare in the years around 500 B.C. The nude bodies have a developed modeling, and the folds of the drapery are emphasized.

The frontal quadriga, a subject that came to Athens from Corinth at the beginning of the sixth century, recalls, with its excellent design, the first works of the Berlin Painter.[36] It must be dated in the first quarter of the fifth century. The frame decoration is rare, even among the numerous strips of Olympia.[37] It occurs on one strip from Delphi,[38] which has been dated by Kunze around 500,[39] and on two strips from Perachora[40] dated even earlier. The lions sitting on their haunches evidently also originate in Corinth, where they appear in the middle of the seventh century. On the trapezoidal sheets they have an archaistic stylization, but those on sheet II.3 are more Classical. In comparison with the lions of Olympia, they are slenderer, and their legs are reminiscent of the cat family. Compared to the Corinthian lions, they have an elegance that touches on mannerism. Payne dated them at the end of the sixth century.[41]

The wings of the sphinxes still have all the grace and elaboration of the Archaic style. Kunze places strips D.III.1 and 2 very close to his shield band XVII, but dates them even later, at the end of the sixth century.[42] The shield bands had anthemion finials at a very early date.[43] Kunze has distinguished two types, A being the earliest, and B the later. The palmettes from the Acropolis belong to type B; specifically, strip II.7 (16837) is close to type B 40 and strip II.3 is close to type B 80, which are datable in the first quarter of the fifth century.

Workshop

Bather has remarked on the development of a workshop that could be Attic under the influence of Melian and Rhodian pot painting. De Ridder noticed the unity of style and believed that all the bronzes came from the same workshop, which was local. The characteristics of an Attic workshop influenced by Ionian prototypes are observable in the full bodies of the figures of the large bronze sheets discussed at the beginning of this chapter. The field in which the winged god strides, unlike contemporary scenes on Corinthian pottery, has no filling ornament. This is a characteristic also of the great Cycladic pithoi of the seventh century. The faces of Herakles (on the chest sheathing) and Perseus (on the tripod leg) are full, with lively eyes. The scenes on the small strips show that the art-

ists preferred to show the moment before the struggle rather than the fight itself (Herakles-lion, Diomedes-Odysseus). It seems that they also liked to emphasize in the same scene the dramatic moment and a bearing of restraint bordering on indifference on the part of the spectators who frame the scene (the suicide of Aias).[44] The participants in the scene are somehow out of time. The Attic lions, in comparison with those from Corinth, are more imaginary creatures.[45] The sphinxes are more nervously taut than those of the Olympia strips, and their ribs are shown. The frames of III.5, with a scene from the Theban Cycle, and III.6, of Corinthian provenance, are decorated quite differently.

Conclusions cannot be drawn on the basis of the small number of scenes preserved. The entire body of Acropolis bronzes will have to be restudied in order to determine if there was an Attic toreutic workshop. The examples of Geometric tripod legs we have show that the artisans knew quite well how to be inventive within the framework of repeated familiar decorative systems. The tradition goes far back, and it is not possible that Attica, which gave to the world such glorious masterpieces of sculpture and vase-painting, would have remained behind in the art of metal working.

List of Abbreviations *

ArgHer Charles Waldstein. *The Argive Heraeum.* Boston and New York, 1902–1905

Artemis Orthia R. M. Dawkins (ed.). *The Sanctuary of Artemis Orthia at Sparta.* Society for the Promotion of Hellenic Studies, Supplementary Paper No. 5. London 1929

Bather A. G. Bather. "The Bronze Fragments of the Acropolis." *JHS* 13 (1892–1893)

Beil Beilage

De Ridder A. de Ridder. *Catalogue des Bronzes Trouvés sur l'Acropole d'Athènes.* Paris, 1896

Diam Diameter

Dim Dimension

Fittschen Klaus Fittschen. *Untersuchungen zu Beginn der Sagendarstellungen bei den Griechen.* Berlin, 1969

Furtwängler Adolf Furtwängler. *Die Bronzen von Olympia.* Berlin, 1890

H Height

Kunze Emil Kunze. *Archaische Schildbänder.* OlForsch 2. Berlin, 1950

Kunze KrBr Emil Kunze. *Kretische Bronzereliefs.* Stuttgart, 1931

Lamb Winifred Lamb. *Greek and Roman Bronzes.* London, 1929

L Length

NC Humfry Payne. *Necrocorinthia.* Oxford, 1931

NM National Archaeological Museum at Athens

Perachora Humfry Payne. *Perachora.* Oxford, 1940

Th Thickness

W Width

Willemsen Fr. Willemsen. *Dreifusskessel von Olympia.* OlForsch 3. Berlin, 1957

Wolters Paul Wolters. "Bronzereliefs von der Akropolis zu Athen." *AM* 20 (1895), 473–482, pl. XIV

* This list supplements the general list of abbreviations at the end of this volume.

I thank the administration of the National Archaeological Museum who so graciously helped to facilitate my research, and especially Mr. P. Kalligas for all the assistance he provided me. Several of the restorations of bronze sheets were made according to his suggestions; unfortunately, due to limitations of space, I am not able to describe them here in detail. The drawings were executed by the artist Mrs. Th. Kakarougas (Th.K.), except for Drawings 5 and 7, which are the work of the architect Costas Kazamiakis (C.K.), to whom I am also indebted for his many technical observations. Drawings 1 and 14 were done by the architect Manolis Korres (M.K.); the determination of the physical structure and placement of the fragments is also due to him. Drawings 3 and 20 were made available to me from the Archives of the National Museum.

Most of the photographs were generously placed at my disposal by the German Archaeological Institute in Athens (DAI). Those provided by the National Museum are noted (NM) in the text. Special note is made of those taken by the photographer Socrates Mauromatis (S.M.), who also provided all the prints. My sincerest thanks to all of them. Special thanks are due to Miriam Caskey for her valuable assistance in the translation and preparation of this paper.

1. P. Kavvadias and G. Kawerau, *The Excavation of the Acropolis from 1885 to 1890* (Athens, 1906).

2. A. de Ridder, *Catalogue des bronzes trouvés sur l'Acropole d'Athènes* (Paris, 1896).

3. A. G. Bather, "The Bronze Fragments of the Acropolis," *JHS* 13 (1892–1893), 232, 244–271.

4. Evi Touloupa, "Bronzebleche von der Akropolis in Athen: Gehämmerte Geometrische Dreifüsse," *AM* 87 (1972), 57–76, pl. 25–35.

5. Semnis Papaspyride-Karousou, "Ἀρχαϊκὰ μνημεῖα τοῦ Ἐθνικοῦ Μουσείου," *ArchEph* (Athens, 1952), 144.

6. Nicolaus Faraklas, *The Monumental Sculpture of Geometric Times* (Rethymnon, 1987), 40.

7. G. Kawerau, "Dreifussträger von der Akropolis zu Athen," *AM* 33 (1908), 273–278. He proposed two blocks for every base, but the height of the tripod proves that there were three. See also Pierre Amandry, "Trépieds d'Athènes: I. Dionysies," *BCH* 100 (1976), 19, fig. 2, note 8.

8. For the technique see Emil Kunze, *Kretische Bronzereliefs* (Stuttgart, 1931), 70; Kunze, review of W. Reichel, *Griechisches Goldrelief* (Berlin, 1942), *Gnomon* 21 (1949), 4; Dieter Ohly, *Goldbleche des 8. Jahrh. v. Chr.* (Berlin, 1953), 120 n.5; Doro Levi, "Gli Arcadi di Creta e la loro regione," *ASAtene* 10–12 (1928–1929), 31.

9. Leopard or panther, see Angeliki Lembessi, "Δύο μίτρες τῆς Συλλογῆς Μεταξᾶ," *Kretika Chronika* 21 (1969), 102.

10. The birds have been interpreted as geese; they are not, but they could be white storks.

11. Humfry Payne, *Perachora* (Oxford, 1940), pl. 48.5.

12. These teeth have led some scholars to believe that this is not a *harpe*. A. de Ridder 1896, 18, believes that the hand is holding the crest of the helmet; Klaus Fittschen, *Untersuchungen der Sagendarstellung bei den Griechen* (Berlin, 1969), 15, suggests that Perseus is grasping Medusa by one of the snakes of her coiffure; Konrad Schauenburg, *Perseus in der Kunst des Altertums* (Bonn, 1960), 21, asks whether the *harpe* might not be joined with the Gorgon's wing. In my opinion, we have here a *harpe* with "teeth," such as those on saw-toothed scythes and pruning hooks.

13. Franz Willemsen had noticed that the ornaments of both were similar. The handle had been found in an excavation of Kolbe (1938) on the Acropolis. See Stefan Sinos and Arnold Tschira, "Untersuchungen im Süden des Parthenon," *JdI* 87 (1972), 159, 161, 163.

14. Evi Touloupa, "Une Gorgone en bronze de l'Acropole," *BCH* 93 (1969), 862–884, pl. xx.

15. Compare the tresses, sword, and helmet to those on the pithos from Mykonos: *ArchDelt* 18 (1963), pl. 18b, pl. 23b, pl. 27b.

16. Peter Bol, *Antike Bronzetechnik* (Munich, 1985), 56–57, fig. 33.

17. Compare one of those in Antikensammlung, Berlin. *AntDenk* (Berlin, 1886), pl. 7, nr. 26.

18. Roland Hampe, who reproduces a drawing, says that it is the most ancient of this category, from a Corinthian shield of the seventh century B.C.

19. Claude Roley, *FdD* 5, 3 (Paris, 1977), pl. LIII, 512.

20. C. W. Blegen, "Prosymna, Remains of Post-Mycenaean Date," *AJA* 43 (1939), 415, fig. 6. Roland Hampe, *Frühgriechische Sagenbilder in Böotien* (Athens, 1936) pl. 41.

21. Franz Willemsen, "Ein früharchaisches Dreifussbein," *Bericht über die Ausgrabungen in Olympia*, 7 (Berlin, 1961), 181, pl. 79.

22. Franz Willemsen, *Dreifusskessel von Olympia*, *OlForsch*, 2, 1 (Berlin, 1957), 158, pl. 9, dates it before the tripod with the griffins (*Dreifusskesselblech*).

23. Edith Spartz, "Das Wappenbild des Herrn und der Herrin der Tiere in der minoisch-mykenischen und frühgriechischen Kunst" (dissertation, Munich, 1962), and Evangelia Marangou, *Lakonische Elfenbein- und Beinschnitzereien* (Tübingen, 1969), 34, agree that the winged god from the Acropolis is the oldest iconographic representation of this type in the entire series. Emil Kunze, "Anfänge der griechischen Plastik," *AM* 55 (1930), 158, Beilage 47, compares it with the attachment from Boston (99.458), which has moved away from Geometric severity.

24. Emil Kunze, *Archaische Schildbänder*, *OlForsch*, 2 (Berlin, 1950), 138.

25. Roland Hampe, "Korfugiebel und frühe Perseusbilder," *AM* 60–61 (1935–1936), 281.

26. Fr. Willemsen, Dreifusskessel von Olympia, *OlForsch*, 3 (Berlin, 1957), 174.

27. So Sylvia Benton, "The Evolution of the Tripod-Lebes," *BSA* 35 (1934–1935), 91 and n. 1.

28. Humfry Payne, *Necrocorinthia* (Oxford, 1931), 225, fig. 102B.

29. F. Salviat and N. Weill, "Un Plat du VIIe Siècle a Thasos: Bellérophon et la Chimère," *BCH* 84 (1960), 347–380, pl. IV–VI.

30. See note 14 above.

31. Emil Kunze, *Kretische Bronzereliefs* (Stuttgart, 1931), 254.

32. Blegen, 1939, 417, fig. 6: "slightly before 650."

33. Payne 1940, vol. 1, 143–145; Payne 1931, 222–224.

34. Payne 1931, 225, fig. 101, dates the mirror with a similar frame to the beginning of the sixth century. Kunze 1950, 242: "first quarter of 6th century."

35. Kunze 1950, 132, thinks that the representation of D.III.4 is much later than the corresponding example from Aigina (A. Furtwängler, *Aigina: Das Heiligtum der Aphaia* [Munich, 1906], 393, pl. 113, 3, pl. 114, 11), which is dated to the middle of the fifth century B.C. If this is so, then we ought to accept that not all of the bronzes come from the Persian destruction level.

36. Payne 1931, 74.

37. E. Kunze, *Bericht über die Ausgrabungen in Olympia*, 3 (Berlin, 1938–1939), 106.

38. P. Perdrizet, *FdD*, 5, *Monuments figurés: Petits bronzes, terres cuites, antiquités diverses* (Paris, 1908), pl. XXI; see 16.

39. Kunze 1950, 243.

40. Payne 1940, pl. 48, pl. 8, pl. 11.

41. Payne 1931, 226.

42. Kunze 1950, 240, pl. 44, pl. 45; see also 155–156.

43. Kunze 1950, 201–211, pl. 74, pl. 75; see also Ernst Buschor, "Altsamische Grabstelen," *AM* 58 (1933), 38.

44. Compare Kunze 1950, 146.

45. Hans Gabelmann, *Studien zum frühgriechischen Löwenbild* (Berlin, 1965), 51.

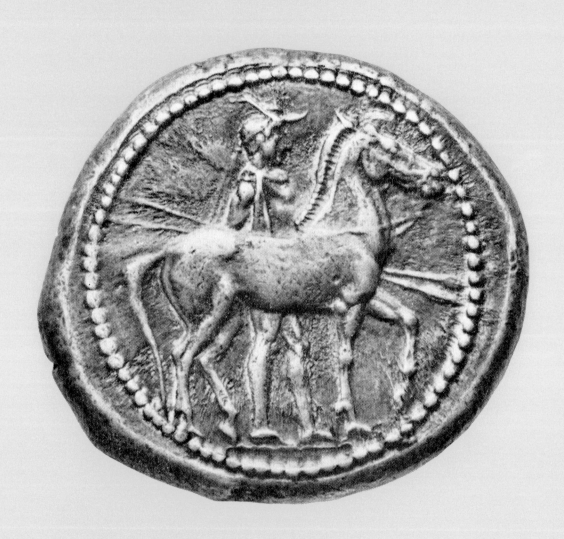

MANDO OECONOMIDES
Numismatic Museum, Athens

The Human Figure in Archaic Greek Coinage

In the seventh and sixth centuries B.C. Greek life changed, evolved, and became more complex. The characteristic and individual feature of Greek political life was the polis, the city-state. Nikolaos Kontoleon wrote in his *Aspects de la Grèce préclassique*:[1]

> En réalité le rôle créateur fut joué par les villes-cités dont la naissance, aprés la décadence du monde mycénien, caractérise l'époque nouvelle commençant avec le VIIIe siècle. C'est depuis lors que l'art grec se développe "κατά πόλει ς" à l'intérieur des cités.

Urban development is surely the most important feature of the Archaic period, providing the stimulus for far-reaching developments.

Social and military patterns were changing, states were entering into formal relations with other states, often over long distances, and a new wealth was producing major architectural monuments. The striking of coins was a new invention, the first coins appearing in the late seventh century B.C. in the area between Lydia and the Greek cities of the coast. It became first a convenience and then a necessity for transactions.

We shall never know if this idea was Lydian or Greek, because the first coins are uninscribed and the designs with which they were stamped do not reveal their origin. The first coins have a distinctly religious character,

and it is not impossible that, as tradition tells us, they were struck under the supervision of priests in sanctuaries. In time each town had its own emblem engraved on its coins, often the symbol of the guardian deity of the city. For example, the owl on Attic coinage is the emblem of Athena, the lyre of Apollo appears on the coins of Delos, and the cantharus of Dionysos figures on Naxian issues.[2] At the very beginning a remarkable variety of animals was engraved on the issues of the various mints of Asia Minor. The accuracy and sophistication of the engraving of these animals are not surprising if one recalls the skillful workmanship of Minoan and Mycenaean seals, the technique of which is not far removed from that of die engravings.[3]

Two very important Mycenaean settlements, Miletus and Smyrna, struck coins at the beginning of the sixth century B.C.[4] Animals are the most typical subject matter of early coinage, whereas the human figure is rarely depicted. Die cutters had the idea of engraving the human figure on the obverse of coins probably in the middle of the sixth century. The artists now began to depict not only the emblems of the guardian deities but also the divinities themselves:[5] gods, goddesses, heroes, nymphs, satyrs, all of whom are modeled after human prototypes, certainly anonymous.

The tradition of depicting animals as emblems of the gods clearly influenced the early representations of the human figure. For instance the head of Athena on Archaic Ath-

To the memory of Nikolaos Kontoleon

273

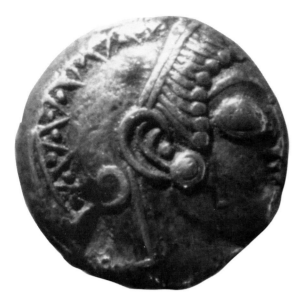
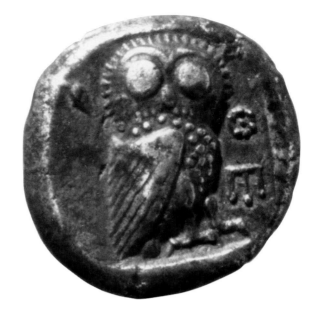

1. Tetradrachm, Athens
Numismatic Museum, Athens

enian tetradrachms (the "first owls") is shown with large bulging eyes—the "owl-eyed" Athena of Homer (fig. 1). The style of the head is paralleled in contemporary vase painting.

A helmeted head appears on a stater dated c. 520 B.C., attributed to Calymna on the basis of similar types of heads on the signed coinage of that island from the third century B.C. An *A* appears on the helmet of some specimens; it is more likely to designate the wearer, Ares (?) or Achilles (?), than the mint of Aeneia.[6] The head of a bearded warrior is represented in a primitive manner. The eye is shown as a pellet, the nose is unnaturally large under the helmet, the beard is engraved fairly sharply. Here is an art both simple and skillful.

The head of Herakles on the obverse of the one-sixth stater from Erythrae in Ionia, struck at about the same period, is in some respects similar to the head on the Calymna stater, especially in the form of the nose and the primitive manner of rendering the face (fig. 2).[7]

The figure of a horseman on the black-figure Siana cup (Rhodes) found in Corinth, attributed to the Taras Painter (fig. 3),[8] resembles the Calymna stater and the one-sixth stater of Erythrae both in the generally primitive rendering of the face and in the bulging eye.

The early drachms of Naxos in Sicily, with the head of a bearded Dionysos wearing an ivy wreath on the obverse,[9] seems to be more artistically advanced, although contemporary with the Calymna stater. The engraving displays some sensibility and assurance. The eye

is not represented as a pellet but is closer to the natural shape. In the series of representations of female heads—which are more frequent than male heads in early coinage—early staters and drachms of Cnidus dating c. 520–495 B.C. show the head of Aphrodite with almond-shaped eyes,[10] a development paralleled in vase painting.

Another interesting issue from Asia Minor, dating to about the same period as the specimens from Cnidus, is an electrum one-sixth stater of Phocaea with the head of a goddess on the obverse.[11] Here the engraver has emphasized the luxuriant hair around a delicately modeled face, a masterpiece of the art of engraving in Ionia. This work is comparable, especially in the rendering of the hair, to some of the korai found on the Acropolis of Athens.

Early Syracusan tetradrachms of the last decade of the sixth century B.C. exemplify the fineness of Archaic style in the depiction of female figures: on the reverse of these coins the head of the nymph Arethusa is rendered like a small medallion.[12] The head of Arethusa is stylistically related to those of the sandstone metope with two running female figures from Foce del Sele.[13]

There are two particularly important examples of representations of male heads, which are rare at the beginning of coinage. One is the head of Herakles wearing the lion skin on the obverse of a distater of Dicaea in Thrace,[14] dating to c. 520 B.C. (fig. 4). This is a fine sculptural creation, which has been compared with a masterpiece of the Archaic period, the head of the Rampin Rider (fig. 5).[15]

2. One-sixth stater,
Erythrae
Jenkins 1972, 44, no. 52

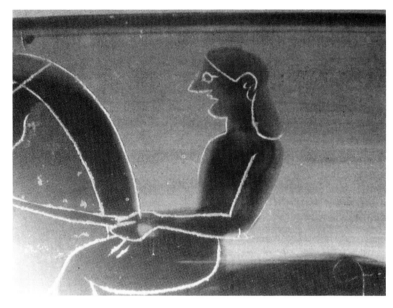

3. Black-figure Siana cup
Human Figure, 36

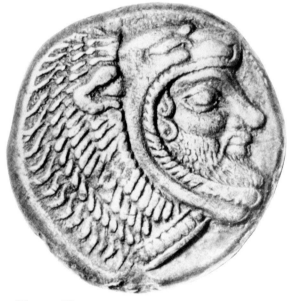

4. Distater, Dicaea,
Thrace
Kraay and Hirmer 1966, pl. 127,
no. 391

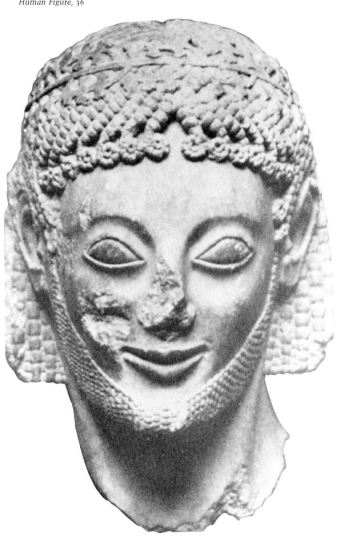

5. Head of the Rampin
Rider
Robertson 1975, pl. 25c

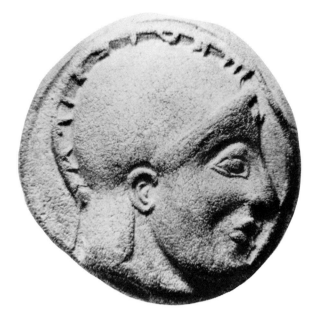

6. Tetradrachm, Skione,
Macedonia
Kraay 1976, pl. 26, no. 470

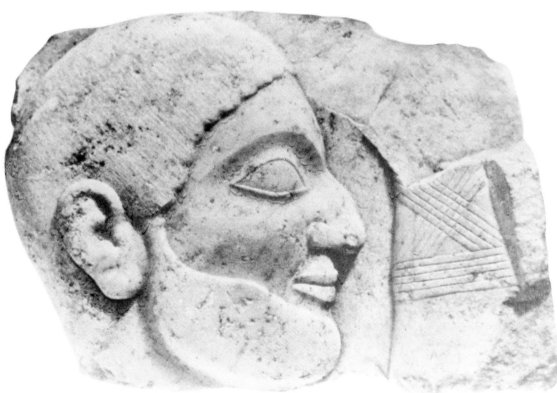

7. Grave relief, fragment
Kerameikos Museum, Athens;
Robertson 1975, pl. 30b

The second is the head of Protesilaos on the obverse of a tetradrachm of Skione in Macedonia,[16] c. 500–480 B.C. (fig. 6), which bears a close resemblance to a grave relief fragment (fig. 7) of the mid-sixth century B.C. in the Kerameikos Museum, Athens.[17] Both types provide evidence that Attic art influenced the Archaic coinage in northern Greece.

The distortion and exaggeration of the human figure in order to create a dramatic impression is a noteworthy stylistic feature of early Greek coins. Representations of Gorgons are an example, as on the silver staters of Neapolis in Macedonia dating to the last decade of the sixth century (fig. 8), which are comparable to contemporary bronze reliefs and works of sculpture, such as the Gorgon from the west pediment of the temple of Artemis at Kerkyra (fig. 9).

Representation of the whole body rather

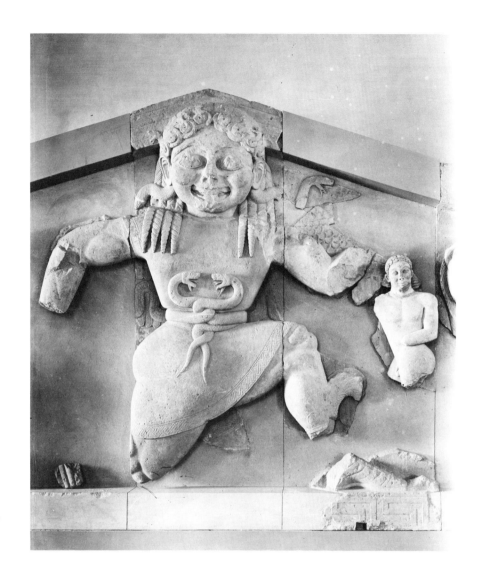

9. Gorgon from the west
pediment of the Temple of
Artemis at Kerkyra (Corfu)
DAI, Athens

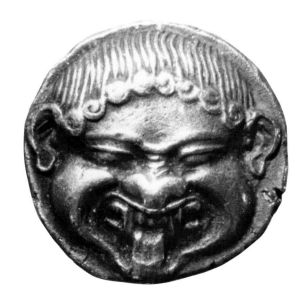

8. Stater, Neapolis,
Macedonia
Numismatic Museum, Athens

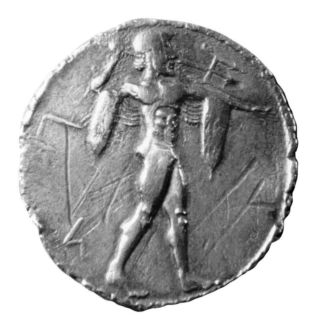

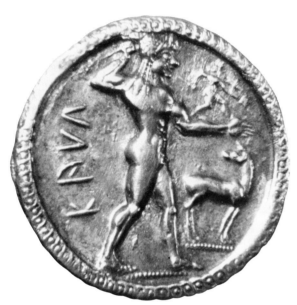

than just the head was the next step taken in putting more complex compositions on coinage. These include some remarkable creations, among which we may point out two issues struck in southern Italy in the last decade of the sixth century B.C.: a stater of Poseidonia with Poseidon brandishing the trident (fig. 10), and a stater of Caulonia with Apollo holding a branch in the right hand, supporting a small running figure on the left hand (fig. 11). According to Léon Lacroix's widely accepted theory, Apollo is bringing laurel branches to Delphi from the Vale of Tempe whither he had gone to purify himself after slaying the serpent Python.[18] Both of the figures, Poseidon and Apollo, are rendered with the greatest skill and attention to detail.

Some very interesting coin types make their appearance in the second half of the sixth century B.C., with figures shown in action rather than standing still. One of the most characteristic examples of the period is the type of kneeling Herakles holding his bow and brandishing his club[19] on the obverse of an electrum stater of Cyzicus, c. 520–500 B.C. The typical manner of depicting a running figure in Archaic art, the so-called *Knielauf*, is also represented in Archaic Greek coinage. A running winged figure is shown on the obverse of a stater dated to c. 530 B.C. from an uncertain mint in Chalcidice in Macedonia.[20] There is an extremely abrupt transition between the chest seen frontally and the legs in profile. In the late sixth century B.C. this type appears with all the elements for further development as, for example, the running Nike with head turned back on the obverse of an electrum stater of Cyzicus (fig. 12).[21] This is a very fine representation full of life and movement; the engraver has opened up new vistas.

All of these representations on Archaic Greek coinage are close to the marble statue from Delos, probably by Achermos of Chios, of the mid-sixth century B.C. (fig. 13).[22] Parallels are also to be found in vase painting—for example, the figure of running Hermes in the tondo of the black-figure Siana cup of 560 B.C.[23] In the beginning of the fifth century B.C. the type evolves further. The running motion is more naturalistically shown, and the engraving is more developed. The tetradrachms of Peparethus with a young winged god[24] and staters of Elis with Nike carrying a wreath[25] are well-known examples in this category.

10. Stater, Poseidonia
Numismatic Museum, Athens

11. Stater, Caulonia
Numismatic Museum, Athens

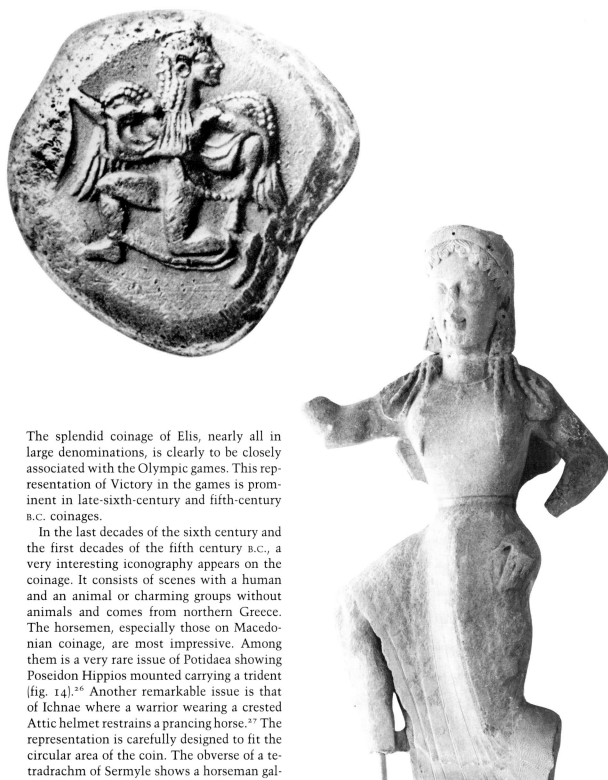

12. Stater, Cyzicus
Kraay and Hirmer 1966, pl. 198,
no. 705

13. Nike from Delos
National Archaeological Museum,
Athens

The splendid coinage of Elis, nearly all in
large denominations, is clearly to be closely
associated with the Olympic games. This rep-
resentation of Victory in the games is prom-
inent in late-sixth-century and fifth-century
B.C. coinages.

In the last decades of the sixth century and
the first decades of the fifth century B.C., a
very interesting iconography appears on the
coinage. It consists of scenes with a human
and an animal or charming groups without
animals and comes from northern Greece.
The horsemen, especially those on Macedo-
nian coinage, are most impressive. Among
them is a very rare issue of Potidaea showing
Poseidon Hippios mounted carrying a trident
(fig. 14).[26] Another remarkable issue is that
of Ichnae where a warrior wearing a crested
Attic helmet restrains a prancing horse.[27] The
representation is carefully designed to fit the
circular area of the coin. The obverse of a te-
tradrachm of Sermyle shows a horseman gal-
loping to the right with the hound under the
horse running in the same direction.[28]

The series of Alexander I, king of Mace-
donia, should also be mentioned. Some of the
obverses of this series show a huntsman wear-
ing chlamys, kausia, and diadem, holding two

spears, and standing by a horse (fig. 15).[29] The typology of this coinage originates in that of the Macedonian tribes, in particular the Bisaltae,[30] whose territory with its silver mines was annexed by Macedonia (fig. 16).

All of these man-and-animal groups attributed to the different Macedonian tribes[31] are distinguished by unusual and surprisingly powerful engraving. The representations allude to the prosperity of this region, through the cultivation of the fertile earth of Macedonia.

All of these strong figures (we cannot be sure if they are mortals or gods) also have their own charm, derived from the powerful rendering together with expressive composition. We mention among them the dodecadrachms of the Derrones showing a bearded male seated in a kind of two-wheeled carriage drawn by a pair of oxen or a herdsman and two oxen, where the herdsman is identified as Hermes by the caduceus he holds (fig. 17).[32] We may also note the octadrachms of the Orrescii and the Edoni—the former with a naked bearded warrior, wearing kausia and carrying two spears, standing between and guiding a pair of oxen;[33] the latter with a herdsman (Hermes) carrying two goads and standing by a pair of oxen.[34]

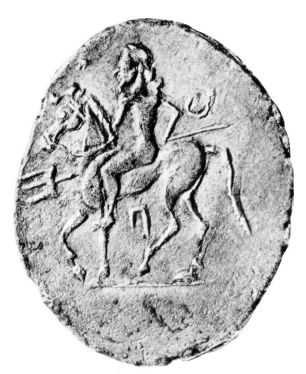

14. Tetradrachm, Potidaea
Kraay and Hirmer 1966, pl. 128, no. 395

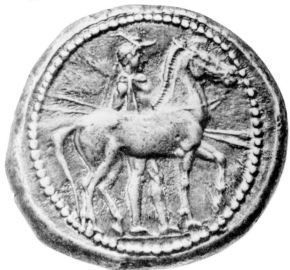

15. Octadrachm of Alexander I
Kraay and Hirmer 1966, pl. 169, no. 557

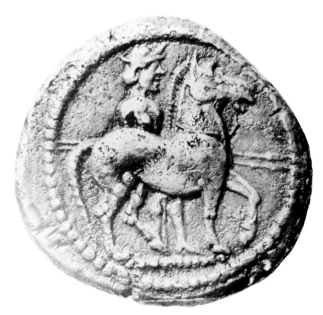

16. Octadrachm, Bisaltae
Kraay and Hirmer 1966, pl. 125, no. 384

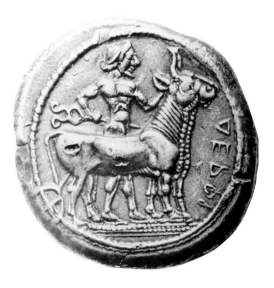

17. Dodecadrachm of the
Derrones
Kraay and Hirmer 1966, pl. 126,
no. 387

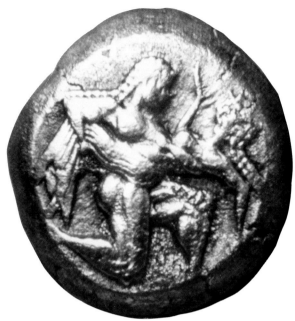

18. Stater, Thasos
Pontolivado Hoard 1971; Mando
Oeconomides, "Μνήμη Δ.
Λαζαριδη," *Acts of Archaeological
Congress, Kavalla (9–11 May 1986)*
(Thessalonike, 1990), 533–537

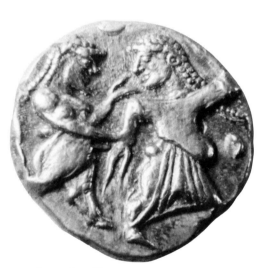

19. Stater, Lete (?),
Macedonia
Numismatic Museum, Athens

There are also some other very picturesque coin types from northern Greece—for example, a tetradrachm with two nymphs facing each other, wearing chitons, diadems, and earrings, and lifting an amphora (from an uncertain mint in Macedonia).[35] This symmetrical composition with the amphora in the center is a merry country scene related to the vine and Dionysos. Such scenes are very common in northern Greece, where this god was particularly worshiped.

Another scene linked to the worship of Dionysos is the abduction of a nymph. The obverse of a stater of Orrescii, struck in the last quarter of the sixth century B.C., has a bearded centaur with animal ears carrying off a nymph.[36] A similar scene also appears on the obverse of Archaic staters of Thasos, which controlled mines of precious metal both on the island and on the mainland opposite. Here a satyr carries off a nymph who raises her hand in protest (fig. 18).[37] A third example is provided by a stater, probably from Lete in Macedonia, where a nymph is seducing a satyr[38] (fig. 19).

Finally comes the exceptional technical triumph of representing a four-horse chariot group on coins, exemplified by an issue of Chalkis, c. 540 B.C. according to Kraay's chronology,[39] where the facing view of a quadriga is shown on the obverse of a stater (fig. 20). It is interesting to note that later in the century Syracuse, though not a Chalcidian colony, adopted the same range of types for the major denominations, except that they were shown in profile rather than frontally. We may compare the chariot relief from the Acropolis, c. 570 B.C. (fig. 21)[40] and the limestone metope from Selinus, mid-sixth century B.C.[41] The Archaic engravers were influenced by contemporary styles, but without following them blindly. They never show contemporary works of art, they do not copy, and they are sometimes very conservative in respect to style.

These Archaic issues are the forerunners of the magnificent Classical coinage, the beauty of which will remain eternal.

20. Stater, Chalcis
Jenkins 1972, 55, no. 77

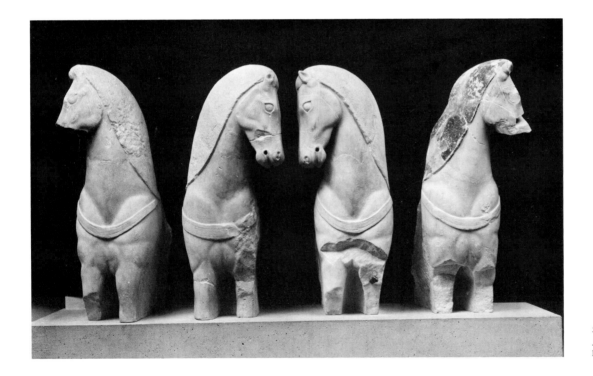

21. Chariot relief,
Acropolis Museum
DAI, Athens

NOTES

I wish to express my deep gratitude to Judith Binder and John MacIsaac for their work on the English version of my text. Thanks are due to the director of the Deutsches Archäologisches Institut for photographs used in figs. 9 and 21, and to the director of the National Archaeological Museum, Athens, for the photographs used in fig. 13.

1. Nikolaos Kontoleon, *Aspects de la Grèce préclassique* (Paris, 1970), 83.

2. Colin M. Kraay, *Archaic and Classical Greek Coins* (London, 1976), 3.

3. Martin Robertson, *A History of Greek Art* (Cambridge, 1975), 148.

4. Liselotte Weidauer, *Probleme der frühen Elektroprägung* (Fribourg, 1975), 29, XX nos. 126–127, pl. 14 and 71 (Miletus); Colin Kraay and Max Hirmer, *Greek Coins* (London, 1966), pl. 178, no. 592 (Smyrna ?); Weidauer 1975, 37, XLIII nos. 180–182, pl. 20.

5. Kraay 1976, 3: "The most obvious theme is the patron deity, whether shown as a head or full-length figure."

6. Kraay and Hirmer 1966, 329 no. 390, pl. 127; G. K. Jenkins, *Monnaies grecques* (Fribourg, 1972), 36 nos. 30–31 and 45; Kraay 1976, 38, 353 no. 103, pl. 5.

7. Jenkins 1972, 41 and 45 no. 52.

8. Athens National Museum 530; *ABV*, 54 no. 57.

9. Kraay and Hirmer 1966, 281–282, pl. 1 nos. 1–3.

10. Herbert A. Cahn, *Knidos, Die Münzen des sechsten und des fünften Jahrhunderts v. Chr.* (Berlin, 1970), 26 and 28, pl. 13, nos. 24, 33.

11. Jenkins 1972, 39, 44–45, no. 51.

12. Erich Boehringer, *Die Münzen von Syrakus* (Berlin, 1929), 110–113, nos. 2–17a (row I).

13. Richter, *Korai*, 95–96, 173, fig. 548.

14. Jenkins 1972, 66 no. 97.

15. Robertson 1975, 96–97, pl. 25c.

16. The name of the founder is given in full along the crest support of the helmet. It would be impossible to identify the founder without the inscription. Note that the coin of Skione is one of the earliest examples of a representation on coins that accounts for the name of a mythical hero.

17. Robertson 1975, 98–99, pl. 30b.

18. Léon Lacroix, "L'Apollon de Caulonia," *RBN* 1959, 5–24.

19. Jenkins 1972, 40, 42 no. 47.

20. Kraay 1976, 133, pl. 26, no. 468.

21. Kraay and Hirmer 1966, pl. 198, no. 705.

22. Athens National Museum 21; Robertson 1975, 68–69, pl. 14c.

23. See note 7.

24. Kraay 1976, 119, 360, pl. 22 no. 402 (described as Boreas).

25. Charles T. Seltman, *The Temple Coins of Olympia* (Cambridge, 1921), pl. I, 8 no. 13, 9 no. 19, 10 no. 30; Kraay 1976, 104, pl. 18 no. 324.

26. Kraay 1976, 85, 134, 362 no. 471.

27. Kraay 1976, 140 no. 491.

28. Kurt Regling, *Die Antike Münze als Kunstwerk* (Berlin, 1924), 14, pl. VIII no. 209: "wegen der zahlreichen Analogien auf Vasen und Reliefe sei auch des Tieres (meist Hundes) unter dem Pferdekörper gedacht."

29. Kraay 1976, 140, 142, 143, pl. 27 nos. 493, 495; M. Jessop Price, *The Coinages of the Northern Aegean*, BAR, 343 (1987), 44–45, pl. VIII no. 3.

30. Kraay 1976, 140, pl. 26 no. 484.

31. Kraay 1976, 138–141; Jenkins 1972, 67–68; Price 1987, 43–47, pls. VIII–IX.

32. Kraay 1976, 140, pl. 27 nos. 486 and 488.

33. Kraay 1976, 139 no. 481; Kraay and Hirmer 1966, 123 no. 376.

34. The inscription on the reverse is of King Getas. Kraay 1976, 139 with n. 4, pl. 26 nos. 482 and 483.

35. Jenkins 1972, 63, 65–66 no. 100.

36. Regling 1924, pl. VIII no. 198; Kraay and Hirmer 1966, pl. 123 no. 375.

37. Kraay 1976, 149, pl. 29 nos. 518–519; O. Picard, "Problèmes de numismatique thasienne," *RA* (1982), 10.

38. Kraay 1976, 148–149, pl. 29 nos. 514–517.

39. Kraay 1976, 89 with note 2, 357, pl. 15 no. 262.

40. Maria S. Brouskari, *The Acropolis Museum: A Descriptive Catalogue* (Athens, 1974), 45 no. 577 with bibliography.

41. Robertson 1975, 97, 119, pl. 33d (Palermo Museum).

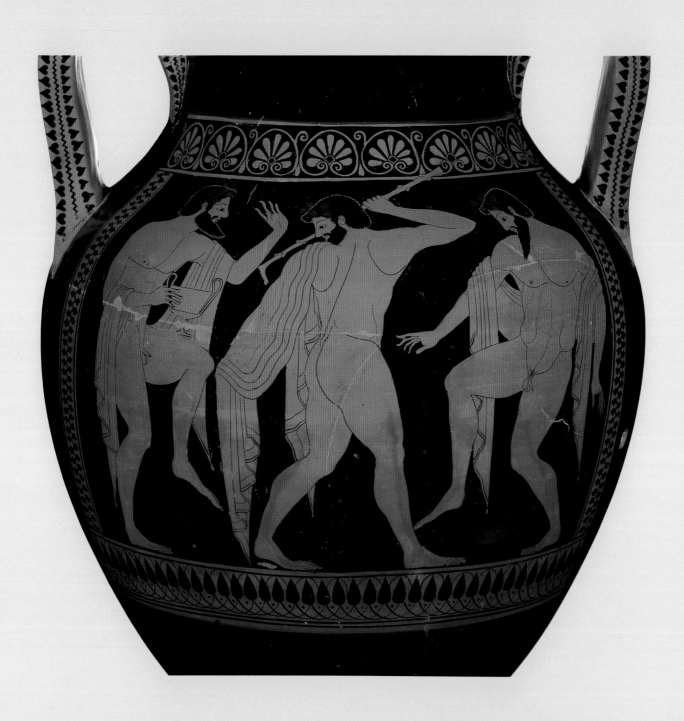

DYFRI WILLIAMS
British Museum

The Drawing of the Human Figure on Early Red-Figure Vases

It is hardly necessary to repeat how important the human figure was to the Greek artist and how central it is to our understanding of Greek art. I should explain, however, why I shall confine myself in this paper to the male nude and not include the female. My reason is artistic, although for the Greeks there may have been sociological factors at play as well. Even though we find some fine studies of the female nude, as on Onesimos' cup in Brussels or Douris' cup in New York,[1] the decorators of vases did not, in those studies, make experiments of the kind we shall be observing with the male nude during the Late Archaic period, the period on which I shall concentrate.[2]

I use the word *drawing* quite deliberately, for I believe that what is usually called vase-painting might better be called vase-drawing, despite the use of the brush, for if sculpture presents inflected surfaces to match those that surround forms in nature, and painting creates areas of pigment to correspond to areas of color, the designs on Greek vases can only really be called drawing, an art that employs lines that are in fact nowhere to be found in nature.[3]

Once the extended influx of oriental influences had effectively put pay to the severely conceptual approach to the decoration of vases at the end of the eighth century B.C., the way stood open for many new developments, including new approaches to the drawing of the human figure. It was at Corinth that the black-figure technique seems to have been developed early in the seventh century, and the apparent supremacy of this pottery in the marketplace ensured that technique's dominance over a variety of outline, silhouette, and mixed techniques, as well as its adoption at Athens by the century's end. It was at Athens, of course, that the technique was perfected and great strides made in the understanding and representation of the human figure. As is well known, in the black-figure technique the figures are basically solid black silhouettes; interior details have been added with incised strokes that cut through the glossy black slip to reveal the pale orange clay beneath. It is clear that, however excellent the artist and however inspired his work, this technique tends to restrict the artist's ability to represent the human figure. First, the incised lines are slow, controlled lines of even depth, and some of the responsiveness to the hand that drew them is lost as a result of friction against the leather-hard clay body of the unfired vessel. Second, since the silhouettes are black and the interior markings a paler orange than the background, it is impossible for the artists to break their contours in any way that will allow the two areas, figure and background, to communicate and so achieve a real sense of the third dimension. The resultant figures appear totally subdued to the picture surface. And when we look at a work by Exekias or the Amasis Painter, we see that the limits of the technique have indeed been reached, although not of course its end.

The birth of the red-figure technique, how-

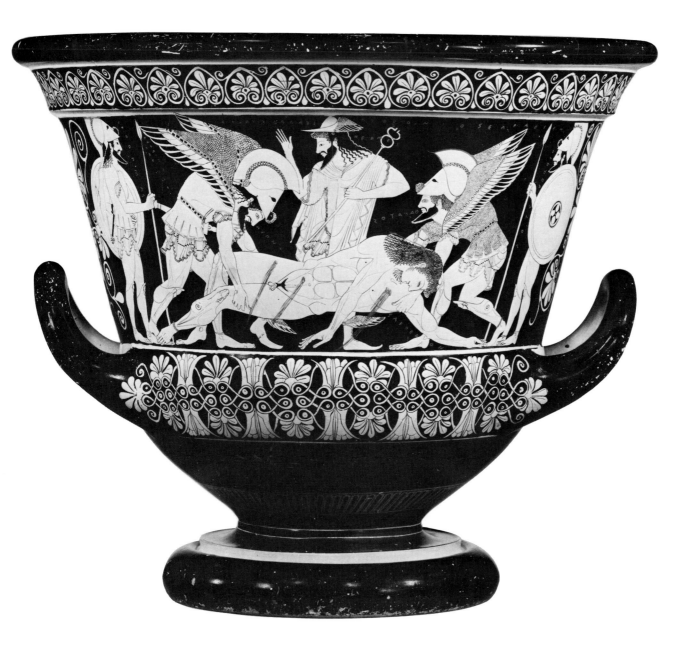

ever, was to open up new possibilities. Not all of these were seen at first, as its initial naivete reveals: one should note the dearth of interior markings and the absence of relief lines, especially for the contour, as on the very early red-figure lip-cup fragment from Naukratis.[4] As a result, one may perhaps assume that art-historical considerations were not in themselves the driving force behind the creation of the new technique. Many ingenious solutions have been proffered to explain why some artists around 530–520 B.C. did suddenly begin to employ the red-figure technique: my own personal feeling is that it was a period when there were many technical experiments in the air, including the invention

of white ground and the so-called Six technique, some perhaps prompted by the commercial acumen of a potter like Nikosthenes, others by the artistic instincts and searchings of painters such as Psiax, and that the red-figure technique was the experiment that in the end proved most successful.[5] Indeed, after nearly half a century of competition and the spectacular developments in the drawing of the human figure, outlined below, that made full use of the new technique but were beyond the reach of the old, the black-figure technique finally died out at Athens, apart, of course, from its continued use in the manner of "a pious archaism" on vases like Panathenaic prize amphorae.[6]

1. Calyx-krater, by Euphronios, side A
Metropolitan Museum of Art, New York, Bequest of J. H. Durkee, Gifts of D. O. Mills and C. R. Love, by Exchange

The early history of red-figure is well known, from its earliest exponents to a group of artists that Beazley was to call the "Pioneers," a group who had "a deepened interest in the human frame and in human movement,"[7] namely Euphronios, Euthymides, and their companions. With this group of artists, which may be represented by Euphronios' Sarpedon krater in New York, many remarkable breakthroughs took place (fig. 1).[8] In the realm of anatomy great lessons were learned, just as they were at the same time in sculpture. For example, the musculature of the stomach, which had only been cursorily and irregularly marked in black-figure, and in the works of Psiax and his apprentice Euphronios had been given an unnatural number of segments,[9] now suddenly achieved a completely natural form—indeed it was perhaps Psiax who set the Pioneers on the road with his interest in unusual poses, already visible on the Cleveland cup.[10]

On Euphronios' Sarpedon every muscle, sinew, and fold of skin seems to have been noted and included; and the way that Sarpedon's left leg is shown in frontal view is particularly adventurous.[11] On a contemporary krater once in a Dallas private collection we also see a rather bold occlusion: the lower left leg of the falling Kyknos is completely hidden by his thigh.[12] And on Psiax's fragmentary cup in Munich the archer on one side of the exterior has been given a fine back view, which includes a hesitantly foreshortened lower right leg (fig. 2).

In addition, we now see these artists begin to continue the contours of their figures into the reserved area to mark other features, thereby giving them a much greater sense of form and volume. This technique is made possible by the use of the same line to mark the contour of the figure and its interior details, so that, for example, on the hips of Sarpedon, the relief contour line swings in to

2. Cup, by Psiax, side A
Staatliche Antikensammlungen
und Glyptothek, Munich

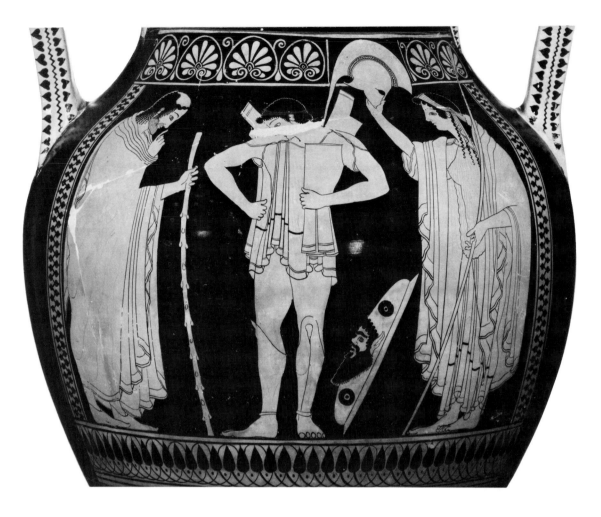

3. Amphora, by
Euthymides, side A
Staatliche Antikensammlungen
und Glyptothek, Munich

model the bulge of muscle over the hip bone. The result is that one imagines that the muscle projects beyond the contour of the figure, thereby creating the illusion of three dimensions. The same is true of the shoulder blades of the archer on Psiax's Munich cup.

At this time artists also began to realize the potential of drapery to enhance the illusion of three dimensions. For example, the idea of stacking folds of drapery is perfected, as on the upper arm of Hermes on Euphronios' krater, a device already found in the works of the Andokides Painter,[13] and one that helps to create the illusion of the thickness of the material and to some extent the shape of the limb that it surrounds. Also the treatment of selvedges, especially those of the short chitons on Euphronios' krater, has matured from a flat zigzag to what is in fact a horizontal cut or section-in-plan through the three-dimensional volume of the folds of the drapery, rather than a true lower edge of the pendant material. This important device, which developed slowly from the middle of the sixth century B.C., came to final fruition in the hands of the Pioneers and their pupils.

If we turn now to Euthymides' famous amphora in Munich with its friendly jibe—*hos oudepote Euphronios*—we see how, in contrast to Euphronios, Euthymides concentrates on simple, large, powerful forms moving in space, and not on anatomical minutiae.[14] Two new ideas are of particular importance. First, on the front, where we see Hector arming, the key figure has been given a strongly and convincingly foreshortened left foot (fig. 3). This has been foreshortened in a plane at right angles to the vertical axis of the figure; no other sort of foreshortening is attempted until the end of the fifth century.[15] Second, on the reverse, the central figure, Eledemos, shows us his back, and Euthymides has, with a masterly touch, used the spine to indicate how the figure turns, leading the eye from the full view of the back to the profile view of the legs (fig. 4).

It is perhaps interesting to pause here and consider the ways that Late Archaic artists

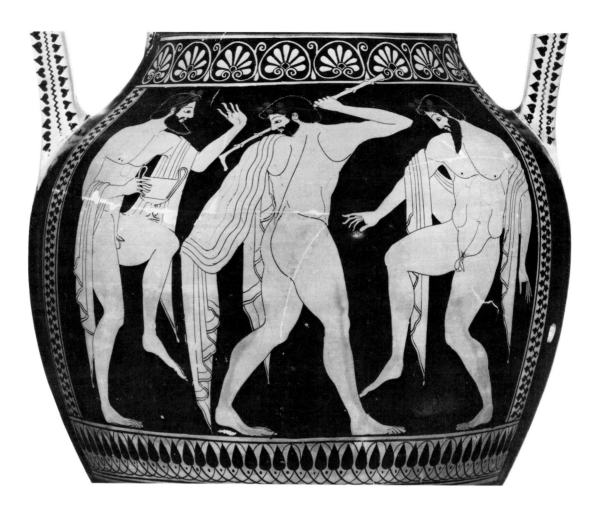

4. Amphora, by
Euthymides, side B
Staatliche Antikensammlungen
und Glyptothek, Munich

working in the red-figure technique normally employed their lines. The lines are divided into two varieties, the relief and the dilute, both, I am sure, produced by the brush. Relief lines are used to mark contours and major internal forms; dilute glaze lines mark other muscular planes and patterns. There is little significant deviation between any two artists as to which internal forms to mark with relief and which with dilute. Collar bones, pectorals and shoulder blades, spine and hips, and the imaginary line from navel to groin are all usually done with relief lines. The now regular quadruple division of the stomach muscles and the muscles of the legs and arms are regularly done with dilute glaze lines.

What does this systematic division—one that was not, of course, possible in the black-figure technique—signify? To answer this we can only examine its effect. The relief line is stronger and more emphatic, the dilute glaze line less so. This means that we first see the areas marked off by the relief lines, and later our eyes pick up those in dilute glaze, as no

doubt the artist intended. But why should we see the chest before the stomach? The only suggestion that I can make is that in nature the well-developed male chest stands out higher than the stomach and is seen to do so by reason of the degrees of shadow which show up the variation in the depth of modeling. This means that when we see an interior relief line we are to imagine an area of strong shadow next to a projecting form, be it an ankle bone or chest, nostril or hip. Where we see dilute glaze markings we expect softer shadow and a slighter projection. This in fact amounts to a system of tonal gradation and is yet another step on the road to showing the three-dimensionality of the human form.

Now the Pioneers *were* pioneers, and not all their inventions were built on or even taken up by other artists for many years. Into this class falls the use of a dilute wash in the hollows of Sarpedon's stomach muscles. This early representation of a pool of shadow, which must be distinguished from the use of a wash to indicate a different surface texture,

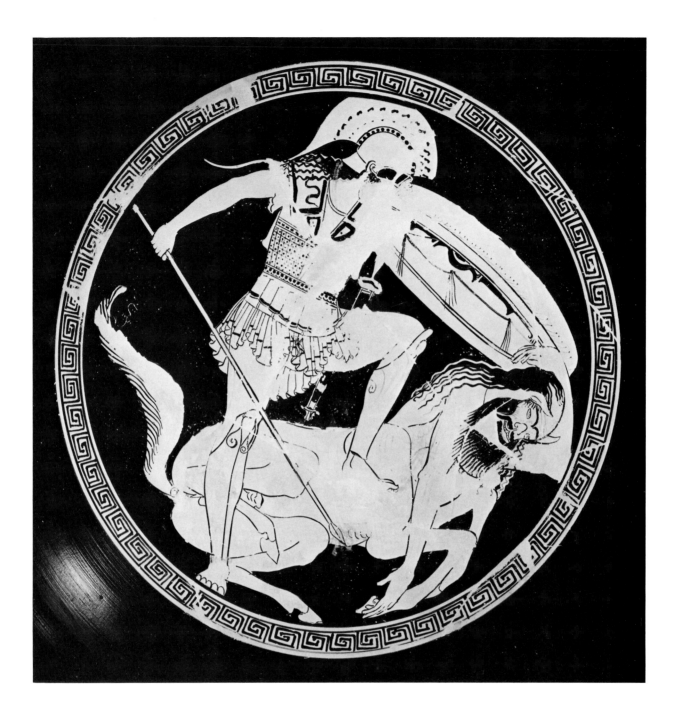

such as an animal skin, is also to be seen on Euphronios' other grand works like the Antaios krater in the Louvre.[16] It is the natural extension of the tonal gradation, noted above, but Euphronios' pupils restricted its use to inanimate objects.[17] It was not developed further until the 450s, when some painters like the Niobid Painter in his later years, the Lykaon Painter from the Polygnotan Group, and the Achilles Painter used on their grander pieces dilute glaze not only for the deep shadow inside hats and in drapery folds, but

also alongside relief lines for the chest and the stomach muscles.[18]

To the same class belong the remarkable profile eyes of Achilles and Patroklos on the tondo of the Berlin Sosias cup, a piece contemporary with Euphronios' major kraters. These eyes are completely without parallel and proved to be thirty or more years ahead of their time.[19]

The next generation of artists, the pupils of the Pioneers, developed further some of the ideas of their teachers. For example, they con-

5. Cup, by Foundry Painter, interior
Staatliche Antikensammlungen und Glyptothek, Munich

tinued to add to the store of unusual poses and views of the human figure. In particular they concentrated on the head, widening the use of the tried and trusted frontal head, but now also attempting three-quarter heads (fig. 5).[20] A number of Late Archaic artists have left us three-quarter heads, including Douris, Onesimos, the Brygos Painter, the Foundry Painter, the Triptolemos Painter, the Kleophrades Painter, and the Berlin Painter.[21] It might be noted that this view of the head appeared in the related realm of relief sculpture at about the same time, as can be seen from a number of figures in the pediment of the Megarian Treasury at Olympia.[22]

The back view of the head was also tried, now not just as a flat form, as Psiax had tried it on his New York cup,[23] but with part of the face beginning to show, as on the fragment of an alabastron in Würzburg, an early work of Onesimos (fig. 6).[24] On a cup in the Louvre, a more mature work by the same artist, we see what is, so far, the earliest occurrence of *profil perdu* (fig. 7), an idea that never gains much popularity, but makes occasional appearances, as on the Achilles Painter's pointed amphora in the Cabinet des Médailles and toward the end of the century in gigantomachy scenes.[25]

6. Alabastron, by Onesimos
Martin von Wagner-Museum, Würzburg

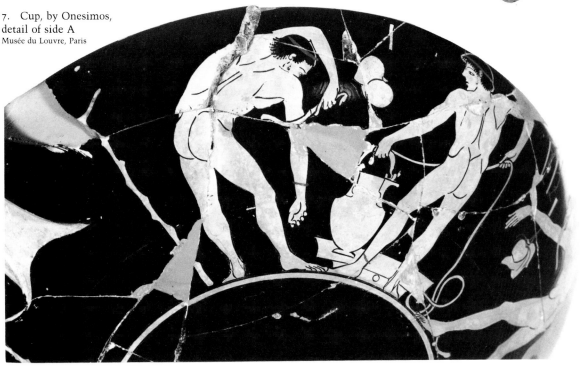

7. Cup, by Onesimos, detail of side A
Musée du Louvre, Paris

Elsewhere we find fancy foreshortenings of whole animals and human figures. There are a number of examples of horses, cattle, and centaurs in extravagantly foreshortened views, but my brief is the human figure.[26] First, therefore, a word is required on the back view of a reclining symposiast to be found on Epiktetos' London cup, potted by Python.[27] Some years ago Martin Robertson used the close similarity between the back view of the symposiast on Epiktetos' cup and one on the Douris symposium cup in London as part of his argument to suggest that Epiktetos borrowed from Douris in his middle period, in other words that Epiktetos was active after 490 B.C.[28] Robertson admitted that this pose was "the *kind* of thing that came in with the Pioneers," but went on to say that there was no precise parallel in their work. Now, although this is strictly true, there are fragments from an elaborate cup of the last decade of the sixth century in Dr. Herbert Cahn's collection with a particularly detailed back view of a couch and symposiast, which is closer to Epiktetos' version than to Douris' (fig. 8).[29] It seems, therefore, most likely that this idea did in fact originate in the ambit of the Pioneers and not among their successors.[30]

There are, however, three particularly noteworthy examples of the sort of advanced foreshortenings attempted by the artists of the first decades of the fifth century that go beyond the experiments of their predecessors. The first is on a remarkable fragment by Douris in Bryn Mawr (fig. 9) on which a fallen warrior presents little more than the top of his head, his ears, probably his nose (now missing), his chin, the outline of his chest, and one raised knee, as he lies on his back, his right arm outflung in death.[31] The second example is on a particularly lively komos cup by the Brygos Painter in the British Museum where we get a most unsavory view—not break dancing, but perhaps break-wind dancing (fig. 10).[32] Finally, on a damaged piece in Florence, probably by the Antiphon Painter, we see another komast, dancing with head thrown back so that his face becomes heavily foreshortened (fig. 11).[33] It is a piece that reminds me of one of the Apostles in Melozzo da Forli's frescoes from the apse of the Basilica dei Santi Apostoli in Rome, fragments of which are preserved in the Pinacotheca in the Vatican.[34] By coincidence, this fresco also in-

8. Cup, side A
Dr. H. A. Cahn, Basel; author photograph

9. Cup, by Douris, exterior
Ella Riegel Memorial Museum, Bryn Mawr College

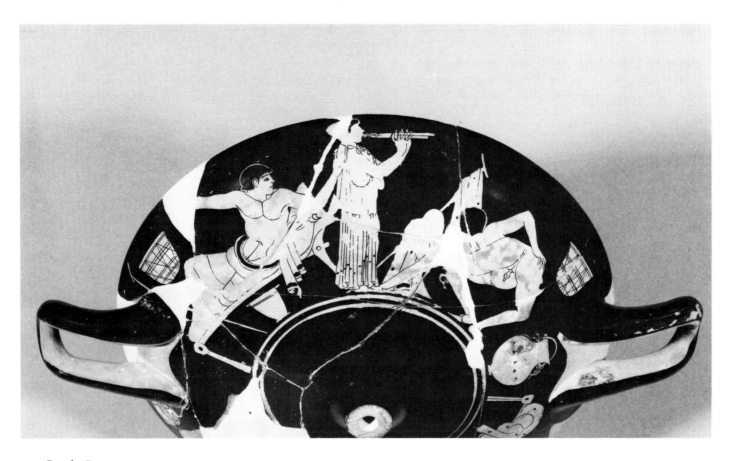

10. Cup, by Brygos
Painter, side A
British Museum, London

11. Cup, by Antiphon
Painter, interior
Soprintendenza alle antichità
d'Etruria, Florence

cludes a putto lying on a cloud on his back,
only the top of his head showing, as on
Douris' fragment in Bryn Mawr.[35]

Melozzo da Forli was a pupil of Piero della
Francesca, and an interest in the human fig-
ure and in the foreshortening of its parts was
very much a thing of the second half of the
quattrocento in Italy. Indeed in the Milan
manuscript of della Francesca's *De prospet-
tiva pingendi*[36] we find a carefully numbered
study of a head thrown back, which also re-
calls the figure on the Antiphon Painter's cup.
It is tempting to compare the way that the
generation following the Italian pioneers—
Brunelleschi, Masaccio, and Donatello—ap-
plied and experimented further with the dis-
coveries of their predecessors to the situation
I have been sketching in the Kerameikos of
Athens. I do not mean to set Onesimos and
Douris, the Brygos Painter and the Antiphon
Painter, alongside Uccello and Pollaiuolo,
Mantegna and Piero della Francesca, but there
is perhaps something of the same bravado of
pose and movement, brought about by a com-
plete confidence of technique and a deep in-
terest in the human body.

12. Cup, by Antiphon
Painter, interior
Hermitage Museum, Leningrad

A new idea that was introduced in these early decades of the fifth century is the limited use of hatched shading in dilute glaze. We find it on metal objects, such as shields (figs. 5 and 13) and cauldrons, where their curvature becomes extreme.[37] This hesitant use of hatching is, in fact, the beginnings of proper shading, the drawing technique that was slowly to revolutionize two-dimensional art. It seems to have been applied only once to the human or animal body on vases in these years, on the bellies of the centaurs on a remarkable psykter in the Villa Giulia.[38]

Many of these remarkable images are well known, but I should now like to look in greater detail at some more subtle and less well-known developments. On either side of the outside of an early work of the Antiphon Painter, now in Houston, a youth is seated on a rock.[39] One of these youths has normal pectorals but the median line that divides them has been extended right down to the navel; on the other the right pectoral does not meet the median line, the left is not drawn at all and the median is again extended down to the navel. Several other early cups display the Antiphon Painter's hesitant development of a new form for the male chest. On a cup from his early mature period in Leningrad, however, we see in the figure of a boxer on the tondo what will be the painter's final solution to his quest (fig. 12).[40]

To understand the Antiphon Painter's momentous changes in the drawing of the male chest we should bear in mind the form handed down to him from previous generations of artists. During the first three-quarters of the sixth century the frontal chest is com-

monly indicated by a flat, rounded U, only very occasionally with the hint of the beginning of a dividing line between the pectorals in the middle to make it a W. Such a lack of a firm dividing line between the pectorals continues in early red-figure. In fact it is only really with the Pioneers that this line, which is quickly to become a standard feature of the male chest, makes its debut.

Fully outlined pectorals together with a central dividing line is, therefore, the form the Antiphon Painter received from Onesimos, his teacher. It seems that the Antiphon Painter began by seeking to break the closed pectoral pattern. He must have realized that however sinuous or expressive the drawing, no real feeling of a third dimension could ever be attained with the traditional form, for unbroken contour lines can do little more than separate one area from another, and indeed they tend to bind such areas closely into the plane of the picture surface. But the Antiphon Painter went further than this and decided to lengthen the median line. Since we see him first trying this extension on twisting figures, it is possible that he was partly concerned with the problem of showing the transition of a near frontal chest to profile hips, much as Euthymides sought to use the line of the spine on his figure of Eledemos. It is clear, however, that the Antiphon Painter was immediately aware of the potential of this line to indicate volume, for he skillfully inflects it, once to show the fullness of the chest and then a second time for the protrusion of the stomach, thereby creating two sectional lines of the type referred to above when discussing drapery.

The main aim of the Antiphon Painter's innovations in the drawing of the male chest thus seems to have been a desire to increase the illusion of three dimensions. If we look at the boxer on the Leningrad cup more closely, we see how the artist has combined several other features to achieve this end. The figure is set obliquely, somewhere between frontal and profile—a pose whose limits are naturally set by the legs. Such a pose inevitably leads the eye from the foreground back into the distance, thus forcing us to imagine the figure in three dimensions. In addition, the Antiphon Painter has encouraged this illusion by means of a number of foreshortenings and accents. The new chest form has enabled him to foreshorten the pectorals con-

vincingly, by drawing one pectoral line long and slowly curving and the other shorter and much more strongly curved. To this he has not only added the natural displacement of his extended median line, but also used its second swelling to bring the direction of the median into harmony with that of the line from navel to groin. The hips are given the impression of an oblique pose by omitting the vertical line between the lower abdomen and the area of the iliac crest on one side. This last idea is not new, for it seems to appear first on the works of Euthymides and is a regular feature in the drawing of Late Archaic artists; what is unexpected is the retention of the change of direction in the line bounding the lower edge of the abdomen caused by the iliac crest.

The shoulders are also accented differently: the right and nearer shoulder is boldly marked both below and above, whereas the left is unstressed. The lower contour of the right shoulder is in itself nothing new—Onesimos has it often—but it has rarely been drawn so heavily or so purposefully. The upper contour, however, has a feature that does not seem to have been attempted by Onesimos, that is the continuation of the contour line into the reserved area of the arm. This sort of interruption of the contouring extends that noted on Euphronios' Sarpedon, for the line does not continue on to follow a feature, but is quickly stopped. This is usually only allowed at obvious folds, like the joint of chin and neck, in the crook of the arm or the bend of the knee, but the Antiphon Painter has deliberately used it here to add to the plastic quality of the figure. Similar primitive phrasing, which is what it may be called, is to be found occasionally on the works of other artists of the time.

There is one further effect of the extended median line and the broken pectorals, one that was surely an aim of the Antiphon Painter. For suddenly the torso has become a complete and unified entity. No longer are the pectorals one isolated area, the stomach with its less heavily accented parts a second, and the hips and groin a third. All three areas are now bound together by the painter's new open framework. The dilute glaze markings of the stomach are now tethered to the strongly accented median and to the navel, thereby uniting the two. This integration of all the parts marks a considerable advance in

the linear representation of the male nude.

On a particularly fine early-middle-period cup by the Antiphon Painter, a large fragment in Leipzig, we find something else that is new (fig. 13).[41] Here a *hoplitodromos* rushes to the left. Speed, grace, and power seem combined in this splendid figure. The head is bent like a sprinter dipping for the line, the right hand flashes up to the head, and the toes are pointed as every muscle is strained in a glorious burst of speed.

We might note again the Antiphon Painter's slight phrasing of lines, including the extended median, and his breaking of the contour of the figure at the inside and outside of the elbow, under the outside of the deltoid, under the youth's right pectoral, and at the knee. In addition, however, the good preservation of the dilute glaze lines enables us to examine their relation to the relief lines, thereby revealing a further remarkable innovation in the system of tonal gradation. Starting from the median, the contour of the

youth's left pectoral is at first done in dilute glaze, but as we come over the *serratus magnus*, where the pectoral stands up higher from the rib cage, thereby casting more shadow, the painter adopts the relief line. This relief line is in turn allowed to thicken from a narrow stroke into a wide sweep as the contour enters the area of deep shadow under the armpit.

We ought to mention perhaps the other contemporary vase-painters who adopted the extended median line in one form or another. These are the Brygos Painter, the Dokimasia Painter, the Briseis Painter, the Triptolemos Painter, and the Kleophrades Painter. In the case of the Brygan form of the chest (which includes the Triptoleman) with extended median and only one pectoral, suffice it to say that it has no infancy and no development and is not used consistently or to any real effect; in other words, it probably appeared in response to the Antiphon Painter's innovations.[42] Indeed it does seem, as far as one can

13. Cup, by Antiphon Painter, interior
Antikenmuseum der Karl-Marx-Universität, Leipzig

judge, to appear slightly later than the Antiphon Painter's form. As for the Kleophrades Painter, his first experiments with an extended median were on his two pointed amphorae, and they seem to be connected both in function and in date with the earliest Brygan occurrences. His later use, as on the London stamnos, does not realize the innovation's full potential for indicating volume, suggesting that he, like the Brygans, may have been the borrower rather than the initiator.[43]

The later history of the open-plan torso, with broken pectorals and strong median line, is not simple and would take us well beyond this volume's chronological limits: it is sufficient to say that it continues even in south Italy in the fourth century.

Although we may be able to conclude that the Antiphon Painter's innovations were independent of other decorators of vases, there is perhaps one other medium to which we might, with caution, turn: sculpture. The quantity of sculpture from the first two decades of the fifth century is not great, but fortunately the pediments of the temple of Aphaia on Aigina provide us with an ideal series. The figures from the west pediment are still Archaic in style and in date cannot be much after 500 B.C. With the east pediment, which should belong in about 495–490 B.C., much has changed.[44] The tendency to cover the marble with unrelated areas of superficial pattern, so typical of Archaic art, has given way to a desire to integrate all the parts into a unified whole, with the result that the figures seem to have come alive beneath the surface of the marble. This has been achieved, of course, by means of a greater understanding of the various parts of the body and their interrelation, but it has also come about because of the sculptor's willingness to break up the old areas of pattern and to interlink them all. It is interesting to see that one of the devices used is the accentuation of the median line, the very resource used by the Antiphon Painter. We see it well on the two warriors on the right of Athena in the east pediment; a glance back at the "Ajax" of the west pediment demonstrates the development. The extended median line is of course later to play an important and more obvious role as a modeling line in low relief friezes, such as that of the Parthenon.

It seems, therefore, that some sculptors around 490 B.C. were trying to break the old

areas of pattern, just as the Antiphon Painter sought at the same moment to break the closed chest form and unite the various parts of the torso in order to achieve a greater three-dimensional presence. It is likely that the Antiphon Painter's innovations were not completely isolated from these developments in sculpture and similar ones that one might postulate in the realm of free painting, but the very slow and occasionally hesitant journey toward his final solution would suggest that his was a purely personal search.

I should like to conclude with a few brief remarks on the human figure in free painting, for this is an area not touched on in the other papers of this volume. For free painting in Athens in the Archaic period we have, of course, little more than the scheme set out by the Elder Pliny with all its limitations.[45] We can perhaps discount his theory of three stages, although his suggestion of an Egyptian-inspired origin set in Corinth may not be so far from the truth. His names, too, may record actual figures of the seventh and sixth centuries. Gisela Richter and Martin Robertson have even suggested that Eumaros—who, according to Pliny, was the first to mark the difference between the sexes in painting, presumably by differentiating the color of their skins—might in fact be the Eumares who is named as the father of the sculptor Antenor, who was active in the last decade of the sixth century.[46]

Kimon of Kleonai is the next figure to be mentioned by Pliny. He is credited with the invention of *katagrapha*, or *obliquae imagines*.[47] These are usually interpreted as foreshortened figures, which is usually taken to support the idea that Kimon was a contemporary of the Pioneers. This does not, however, seem to be borne out either by Pliny's use of the phrase elsewhere or Greek usage of the word *katagrapha*, both of which suggest that it refers to nothing more than profiles. One might, for example, quote Plato: "If we are disorderly towards Heaven we may once more be cloven asunder and may go about in the shape of outline (*katagraphen*) carvings on stelai, our noses sawn down the middle."[48]

Kimon's next innovation is listed as the representation of faces, or rather heads, in different postures, looking backward or upward or downward. Now this could refer to the ambitious poses of heads attempted by some Late Archaic vase-painters (see figs. 5–7 and

9–11),[49] but one could equally take Pliny's words quite literally and assume that what is meant is profile heads looking up and down or turning backward, and these, of course, occurred on vases from the beginning of the sixth century.

Pliny continues by noting that Kimon also marked the attachment of the limbs and gave prominence to veins: this corresponds so closely to innovations attributed to Pythagoras of Rhegion in bronze sculpture that one must ask oneself whether this statement should really be taken at face value.[50]

In addition, Kimon is said to have invented the wrinkles and folds in drapery. The inclusion of wrinkles in this statement suggests that Kimon is being credited with something more than the invention of hanging folds of drapery, which can be found on vases from the middle of the sixth century B.C. It would seem, therefore, that Pliny had in mind the sort of naturalistic developments normally associated with the late fourth century B.C. or even the Hellenistic period. It has now been noticed that there are "press folds" on the frieze of the Parthenon, as well as on one of the pedimental figures, and one could quite well imagine that they were first tried on this great monument.[51]

As a result, it might be argued that this list is little more than a hotchpotch of developments, which are at any rate susceptible to various interpretations and may well be of different dates. It seems, therefore, rash to use it to support the idea that Kimon was a contemporary either of the Pioneers, or of Onesimos and the Brygos Painter, or even of Pheidias.[52] Similar caution is probably advisable in the use in turn of vase-drawings themselves, especially in the Archaic period, as a means of discovering what free painting looked like in any detail or what free painters contributed by way of new ideas.[53] The example of the Antiphon Painter's personal quest for a new chest form suggests that some decorators of vases in the first decades of the fifth century were independent, thinking artists. We, therefore, assign to them a purely imitative role at our peril, whether we are thinking of free painting or trying to divine what elaborate metal vessels might have looked like.[54]

NOTES

I am very grateful to all those who helped me to acquire photographs of the vases illustrated here: they are Guntram Beckel, Dietrich von Bothmer, Herbert Cahn, Alain Pasquier, Eberhard Paul, Gloria Pinney, the late Xenia Gorbunova, and Klaus Vierneisel.

1. Brussels A 889: *ARV*[2], 329, 130; Martin Robertson, *Greek Painting* (Geneva, 1959), 105. New York 23.160.54: *ARV*[2], 441, 186; Gisela M. A. Richter and Lindsay F. Hall, *Red-Figured Athenian Vases in the Metropolitan Museum of Art* (New Haven, 1936), pl. 61.

2. Frontal female faces appear early: the Sophilos dinos, London GR 1971.11-1.1: Dyfri Williams, "Sophilos in the British Museum," *Greek Vases in the J. Paul Getty Museum*, 1 (Malibu, 1983), 26 fig. 31. Sappho is given a three-quarter face on the Brygos Painter's kalathos, Munich 2416: *ARV*[2], 385, 228; Reinhard Lullies and Max Hirmer, *Griechische Vasen der reifarchaischen Zeit* (Munich, 1953), pls. 94–96. Other ambitious poses are extremely rare and seem to be confined to the erotic: Louvre G 13: *ARV*[2], 86, a; *CVA Louvre* 19, pl. 69, 2; Berlin 3251: *ARV*[2], 113, 7; *CVA Berlin*, pls. 57–59.

3. For this definition of the arts see Philip Rawson, *Drawing* (London, 1969), 1. Compare also the opinion expressed by C. M. Robertson, *Between Archaeology and Art History*, Oxford Inaugural Lecture (Oxford, 1963), 16.

4. London GR 1888.6-1.609 (E 134,2): Dyfri Williams, *Greek Vases* (London, 1985), 36 fig. 42.

5. Compare Williams 1985, 35–37; Dyfri Williams, "An Oinochoe in the British Museum and the Brygos Painter's Work on a White Ground," *JBerlMus* 24 (1982), 26; and Dyfri Williams, "The invention of the Red-Figure Technique and the Race between Vase-painting and Free Painting," in N. Spivey and T. Rasmussen (eds.), *Looking at Greek Vases* (Cambridge, 1991), 103–108.

6. P. E. Corbett, "Preliminary Sketch in Greek Vase-Painting," *JHS* 85 (1965), 20.

7. J. D. Beazley, *Attic Red-Figured Vases in American Museums* (Cambridge, Mass., 1918), 27; *ARV*[2], 13.

8. New York 1972.11.10: Dietrich von Bothmer, *Greek Vase Painting* (New York, 1987), cover, no. 19; Bothmer, "Der Euphronioskrater in New York," *AA* (1976), 485–512. Compare also Bothmer, "The Death of Sarpedon" in *The Greek Vase*, ed. S. L. Hyatt (Latham, N.Y., 1981), 63–80; Bothmer, "Euphronios and Memnon? Observations on a Red-Figured Fragment," *MMAJ* 22 (1987), 5.

9. Psiax: Cleveland 76.89: *ARV*[2], 7, 7; John Boardman, *Athenian Red Figure Vases: The Archaic Period* (London, 1975), fig. 15. Euphronios: Dallas, private: Martin Robertson, "Euphronios at the Getty," *GettyMusJ* 9 (1981), 24–26; Jiri Frel, "Euphronios and His Fellows," in *Ancient Greek Art and Iconography*, ed. Warren G. Moon (Madison, Wis., 1983), 152–153, fig. 10; Bothmer 1987, 10, fig. 6. Compare also the works of the Golouchow Painter: Warsaw 142463: *ARV*[2], 10, 1; J.

D. Beazley, *Greek Vases in Poland* (Oxford, 1928), pl. 3, 1.

10. Psiax's later works show a greater understanding of human anatomy: Munich inv. 8323 (2587) (*ARV²*, 7, 8) and New York 14.146 (*ARV²*, 8, 9; Richter and Hall 1936, pls. 1 and 2, 1). The chronology adopted by Joan Mertens, "Some New Vases by Psiax," *AntK* 22 (1979), 22–37, especially 32–37, runs counter to this development.

11. Note that a frontal leg also appears on the Golouchow Painter's oinochoe mentioned in note 9.

12. Once Dallas, private: Robertson 1981, 31; *Wealth of the Ancient World: The Nelson Bunker Hunt and William Herbert Hunt Collections* (Fort Worth, 1983), no. 6.

13. Munich 2301: *ARV²*, 4, 9; *ABV*, 255, 4; Lullies and Hirmer 1953, pls. 1–7.

14. Munich N. I. 8730 (2307): *ARV²*, 26, 1; Lullies and Hirmer 1953, pls. 24–31.

15. Compare Williams 1985, 52–53 and 57–58. Compare also now Elfriede R. Knauer, *A Red-Figure Kylix by the Foundry Painter: Observations on a Greek Realist*, Indiana University Art Museum Occasional Papers (Bloomington, Ind., 1987), 11–12. I do not believe her suggestion that more varied axes were employed in free-painting—see below.

16. Louvre G 103: *ARV²*, 14, 2; Erika Simon, Max Hirmer, and Albert Hirmer, *Die Griechischen Vasen* (Munich 1981), pl. 105. Compare also the Kachrylion cup, London E 13 (*ARV²*, 109, middle; *LIMC*, I, pl. 242, no. 78)—an imitation of a Euphronios vase?

17. Dilute glaze inside the mouths of oinochoai: London E 768: *ARV²*, 446, 262; Williams 1985, 45 fig. 49. Compare the black glaze inside the mouth of the oinochoe on Munich 2648: *ARV²*, 441, 185; Lullies and Hirmer 1953, pls. 88–89. Solid black glaze under the feet of cups hung up on the wall: London E 54: *ARV²*, 432, 52; Martin Robertson, *A History of Greek Art* (Cambridge, 1975), pl. 78 c.

18. Niobid Painter: Louvre G 341 (*ARV²*, 601, 22; Simon and Hirmer 1981, pls. 191–193); Berlin 2403 frr. (*ARV²*, 599, 9; T.B.L. Webster, *Der Niobidenmaler* [Leipzig, 1935], pl. 24, b–c). Lykaon Painter: New York 06.1021.116 (*ARV²*, 1044, 1; Richter and Hall 1936, pl. 128). Achilles Painter: Vatican 16571 (*ARV²*, 987, 1; Simon and Hirmer 1981, pls. 198 and XLIII) and Centre Island (New York), private frr. (calyx krater, attributed by D. von Bothmer). Compare works by later artists, such as Aison (Madrid 11.265: *ARV²*, 1174, 1; Simon and Hirmer 1981, pls. 221–223).

19. Berlin 2278: *ARV²*, 21, 1; Simon and Hirmer 1981, pl. 117. Occasionally Late Archaic artists approach the same idea, as in Onesimos' cup, Rome, Conservatori 26.M.A.I.: *ARV²*, 329, 129; Eugen von Mercklin, "Antiken des R. Museo Industriale in Rom," *RM* 38/39 (1923/1924), pl. 2, 1, where the pale pupil is right in the corner of the eye and a bunch of eyelashes has been added above.

20. On frontal faces see now Y. Korshak, *Frontal Faces in Attic Vase Painting of the Archaic Period* (Chicago, 1987). On three-quarter faces see A. Conrad, "The Development of the Frontal Face and the Three-Quarter View in Attic Red-Figure Vase-Painting to the End of the Fifth Century" (M.A. thesis, New York University, 1972). Compare Knauer 1987, 10–12; also J. D. Beazley, "Kleophrades," *JHS* 30 (1910), 58 n. 69.

21. Douris: Cab. Méd. 537 and 598 frr.: *ARV²*, 429, 19; *LIMC*, I, pl. 143, no. 889. Onesimos: Munich 2637: *ARV²*, 322, 28. Brygos Painter: Munich 2416: *ARV²*, 385, 228; Lullies and Hirmer 1953, pls. 94–96 (Sappho). Foundry Painter: Munich 2640: *ARV²*, 402, 22; Simon and Hirmer 1981, pl. 157. Triptolemos Painter: London market (fragmentary cup with the capture of Dolon). Kleophrades Painter: London E 441: *ARV²*, 187, 57; Boardman 1975, fig. 137. Berlin Painter: Getty Mus. 77.AE.5.1–4, etc.: M. Robertson, "The Berlin Painter at the Getty and Some Others," in *Greek Vases in the J. Paul Getty Museum*, Occasional Papers, 1 (Malibu, 1983), 55–61 (more fragments have now been acquired by the Getty Museum: these are to be published by M. Moore, who gave a preview in her lecture at the Beazley Centenary Colloquium, London).

22. On the Megarian Treasury see P. C. Bol and K. Hermann, "Die Giebelskulpturen des Schatzhauses von Megara," *AM* 89 (1974), 65–83.

23. Psiax: New York, see note 10. Note also the Epeleian cup in Florence: *ARV²*, 149, 14; *CVA Florence* 3, pl. 82; and a neck-amphora related to the Nikon Painter: *ARV²*, 653, 1; *CVA Providence Rhode Island*, pls. 15, 2 and 16, 2.

24. Würzburg HA 469: *CVA Würzburg* 2, pl. 17, 5.

25. Louvre G 291 (plus four frr.): *ARV²*, 322, 36. For the Achilles Painter's piece: Paris, Cab. Méd. 357: *ARV²*, 987, 2; Robertson 1975, pl. 106 b, and see his comments (258, 324), some of which should now be modified. See also J. D. Beazley, "The Master of the Achilles Amphora in the Vatican," *JHS* 34 (1914), 209 n. 30.

26. The earliest complex view of a horse is the amphora by Exekias: *ABV*, 147, 5; M. Moore, "The Death of Pedasos," *AJA* 86 (1982), 578–581, pl. 76. 1. For a rear view of a horse, Boston 95.29: *ARV²*, 324, 65; L. D. Caskey and J. D. Beazley, *Attic Vase Paintings in the Museum of Fine Arts, Boston*, 2 (Oxford, 1954), pl. 43, 81. For rear views of centaurs, Getty S.80.AE.313 (ex Bareiss 408); Basel 173,6: *ARV²*, 454, top; Konrad Schauenburg, "Herakles bei Pholos," *AM* 86 (1971), pls. 34–36. For a rear view of cattle, once Geneva, R. Boehringer: Bernard Andreae, "Herakles und Alkyoneus," *JdI* 78 (1962), 140–141, figs. 11–13. For an under view of a horse, Palermo V 659: *ARV²*, 480, 2; *CVA Palermo*, pl. 10; centaurs, Munich 2640: *ARV²*, 402, 22; Simon and Hirmer 1981, pl. 157; Hamburg 1937.3; Eugen von Mercklin, "Kentaur auf Freierfüssen," *AA* 52 (1937), 65 fig. 3. Compare now Knauer 1987, 24 n. 79a.

27. London E 38: *ARV²*, 72, 16; Martin Robertson, "Beazley and After," *MüJb* 27 (1976), 37 fig. 10.

28. Robertson 1976, 40–41. London E 49: *ARV²*, 432, 52; Robertson 1976, 37 fig. 11.

29. Basel, H. A. Cahn 680 frr.: I, within a line border, draped figure and aryballos, sponge and strigil hung up; A, symposium; B, youths at a cockfight; border below, line and band. I am extremely grateful to Dr. Cahn for allowing me to mention and illustrate his fragments. They have been attributed by Dietrich von Bothmer to the Hegisoboulos Painter (*ARV*[2], 175, bottom). See now the handlist to the exhibition "Attische Meisterzeichnungen: Vasenfragmente der Sammlung Herbert A. Cahn, Basel," Freiburg, October 1988–March 1989, 8 no. 25.

30. It would not surprise me if, one day, a companion piece to the Munich calyx-krater by Euphronios (see most recently, Klaus Vierneisel, "Kelchkrater des Euphronios," *MüJb* 38 [1987], 231–233) were to appear that included such a back view of a symposiast on a couch. I also find it unlikely that there was anything like the sort of overlap that Robertson postulates between the careers of Epiktetos and Douris. The two-figure tondo of the London komast cup by Douris recalls the tondo of the Epiktetos cup, as Robertson notes, but there is a world of difference, and a number of pieces could be set between the two in chronological terms (for example, Louvre G 287: *ARV*[2], 321, 14; Beazley 1918, 84).

31. Bryn Mawr P 936: *ARV*[2], 438, 131; *CVA Bryn Mawr*, pl. 15, 8–9. Compare also perhaps the fallen jockey on the neck of the early Apulian krater, Munich 3268: Trendall, *RVAp* 16, 51; Hilde Rühfel, *Kinderleben im klassischen Athen* (Mainz, 1984), 59 fig. 33 (detail).

32. London E 71: *ARV*[2], 372, 29.

33. Florence 10.B.180: *ARV*[2], 335, 9; *CVA Florence* 1, pl. 10. Compare also a fragmentary kalpis by the Kleophrades Painter where a satyr throws his head back in a similar fashion as he masturbates: Getty 85 AE 188, 202, and 339.

34. Vatican, Pinacotheca no. 269: Corrado Ricci, *Melozzo da Forlì* (Rome, 1911), pl. 13b.

35. Ricci 1911, pl. 15, bottom (putto).

36. Milan, Biblioteca Ambrosiana, Cod. Ambr. C. 307 inf., folio 103 verso: Kenneth Clark, *Piero della Francesca* (London, 1951), pl. 146, upper.

37. Hatching on shields is particularly common in the Brygan school, for example, Munich 2640: see fn. 21. Hatching on a cauldron: Berlin 2294: *ARV*[2], 400, 1; *CVA Berlin* 2, pl. 73, 1.

38. Rome, Villa Giulia 3577: A. Furtwängler and Karl Reichhold, *Griechische Vasenmalerei* (Munich, 1904), pl. 15; J. D. Beazley, *Attische Vasenmaler des Rotfigurigen Stils* (Tübingen, 1925), 471, connected it with the Harrow Painter. The markings down the median lines of male figures and along their pectorals on some pieces by the Brygos Painter and the Foundry Painter (compare also Makron and the Triptolemos Painter) do not seem to be shading, but rather hair.

39. Houston, de Menil Museum: *ARV*[2], 1646 add as 85 *bis*; *Münzen und Medaillen Auktion*, 40, pl. 36, no. 90; Herbert Hoffmann, *Ten Centuries That Shaped the West* (Mainz, 1970), 388–391, no. 177.

40. Leningrad 655 (1536): *ARV*[2], 340, 64; Anna A. Peredolskaya, *Krasnofigurnye Atticheski Vazy* (Leningrad, 1967), pl. 44, 9 and pl. 47.

41. Leipzig T.516 frr.: *ARV*[2], 336, 15; Paul Hartwig, *Die griechischen Meisterschalen* (Stuttgart, 1893), pl. 62, 1.

42. For an example by the Brygos Painter, Boston 10.176: *ARV*[2], 381, 173; Lacey D. Caskey and John D. Beazley, *Attic Vase Paintings in the Museum of Fine Arts, Boston*, 1 (Oxford, 1931), pl. 7. It occurs on a few mature pieces such as this, and on many late works, but not on any early ones.

43. Munich 2344: *ARV*[2], 182, 6; *CVA Munich*, pls. 199–204. Berlin 1970.5: Adolf Greifenhagen, *Neue Fragmente des Kleophradesmalers* (Heidelberg, 1972), pl. 5. London E 441: *ARV*[2], 187, 57; Williams 1985, 42, fig. 47. It is also interesting to note the Kleophrades Painter's unfortunate use of the extended median on two hetairai on London E 201: *ARV*[2], 189, 77; Beazley 1910, 30, pl. 3.

44. For the east pediment see Dieter Ohly, *Die Aegineten*, 1 (Munich, 1976). For the dating of both pediments see most recently Dyfri Williams, "Aegina, Aphaia-Tempel XI: The Pottery from the Second Limestone Temple and the Later History of the Sanctuary," *AA* (1987), 669–674.

45. Pliny, *NH*, xxxv, 34–41.

46. Gisela M. A. Richter, *Attic Red-Figured Vases: A Survey* (New Haven, 1946), 42; Robertson 1975, 227.

47. Pliny, *NH*, xxxv, 34 (56). This is most recently discussed by Knauer 1987, 11–12, which appeared after I had written this paper.

48. Plato, *Symposium* 193 A.

49. Compare Knauer 1987, 12.

50. Pliny, *NH*, xxxiv, 19 (59 end). Veins, of course, are not usually shown on vases.

51. See most recently Hero Granger-Taylor, "The Emperor's Clothes: The Fold Lines," *BClevMus* (1987), 114–123. Compare Rhys Carpenter, *Greek Sculpture: A Critical Review* (Chicago, 1960), 210–211; and Brunilde Sismondo Ridgway, *Fifth Century Styles in Greek Sculpture* (Princeton, 1981), 52.

52. J. J. Pollitt, *The Ancient View of Greek Art: Criticism, History and Terminology* (New Haven, 1974), 76 and 108 n. 8, adduces an epigram of Simonides (*Anth. Pal.* 9, 578) to suggest a date for Kimon in the first decade of the fifth century.

53. Recent contributions on this theme include John P. Barron, "New Light on Old Walls, the Murals of the Theseion," *JHS* 92 (1972), 20–45; Susan Woodford, "More Light on Old Walls: The Theseus of the Centauromachy in the Theseion," *JHS* 94 (1974), 158–165; Beth Cohen, "Paragone: Sculpture Versus Painting, Kaineus and the Kleophrades Painter," in Moon 1983, 171–192. See further Dyfri Williams, "The Invention of the Red-Figure Technique and the Race between Vase-Painting and Free Painting," in N. Spivey and T. Rasmussen (eds.), *Looking at Greek Vases* (Cambridge, 1991), 103–118.

54. On this supposed imitative role see Michael J. Vickers, "Artful Crafts: The Influence of Metalwork on Athenian Painted Pottery," *JHS* 105 (1985), 108–128; and most recently H. Hoffmann, "Why Did the Greeks Need Imagery? An Anthropological Approach to the Study of Greek Vase Painting," *Hephaistos* 9 (1988), 143–162, who sensibly seems to shy away from Michael Vickers' extreme position (150). For a brief answer to Vickers, see R. M. Cook, "'Artful Crafts': A Commentary," *JHS* 107 (1987), 169–171.

Abbreviations

AA	Archäologischer Anzeiger
ABV	J. D. Beazley, *Attic Black-figure Vase-painters* (Oxford, 1956)
Agora	The Athenian Agora: Results of Excavations Conducted by the American School of Classical Studies at Athens
AION	Annali dell'Istituto Universitario Orientale di Napoli: Archeologia e Storia Antica
AJA	American Journal of Archaeology
AJAH	American Journal of Ancient History
AJP	American Journal of Philology
AM	Mitteilungen des Deutschen Archäologischen Instituts, Athenische Abteilung
AntCl	L'Antiquité classique
AntDenk	Antike Denkmäler
AntK	Antike Kunst
AntP	Antike Plastik
AR	Archaeological Reports
ArchCl	Archeologia classica
ArchDelt	Archaiologikon Deltion
ArchEph	Archaiologike Ephemeris
ArchHom	F. Matz and H.-G. Buchholz, *Archaeologia Homerica* (1967–)
ArchRW	Archiv für Religionswissenschaft
ARV²	J. D. Beazley, *Attic Red-figure Vase-painters*, 2d ed. (Oxford, 1963)

ASAtene	Annuario della Scuola Archeologica di Atene e delle Missioni Italiane in Oriente
BABesch	Bulletin Antieke Beschaving: Annual Papers on Classical Archaeology
BAR	British Archaeological Reports
BASOR	Bulletin of the American Schools of Oriental Research
BCH	Bulletin de correspondance hellénique
BClevMus	Bulletin of the Cleveland Museum of Art
Beazley Addenda	L. Burn and R. Glynn, *Beazley Addenda: Additional References to ABV, ARV,*² *and Paralipomena* (Oxford, 1982)
BICS	Bulletin of the Institute of Classical Studies of the University of London
BonnJbb	Bonner Jahrbücher des Rheinischen Landesmuseums in Bonn und des Vereins von Altertumsfreunden im Rheinlande
BSA	Annual of the British School at Athens
CAH	*Cambridge Ancient History* (Cambridge, 1928–1940)
CJ	Classical Journal
Coldstream, Geometric Greece	J. N. Coldstream, *Geometric Greece* (London, 1979)
Coldstream, Geometric Pottery	J. N. Coldstream, *Greek Geometric Pottery* (London, 1968)
CQ	Classical Quarterly
CSCA	California Studies in Classical Antiquity
CVA	Corpus Vasorum Antiquorum
Délos	Exploration archéologique de Délos faite par l'Ecole Française d'Athènes
EAA	*Enciclopedia dell'arte antica, classica e orientale*
EranJb	Eranos Jahrbuch
FdD	Fouilles de Delphes, Ecole Française d'Athènes
FGrHist	F. Jacoby, *Fragmente der griechischen Historiker* (Berlin, 1926–1958)
FR	A. Furtwängler and K. Reichhold, *Griechische Vasenmalerei* (Munich, 1900–1925)
GettyMusJ	J. Paul Getty Museum Journal
GRBS	Greek, Roman, and Byzantine Studies
Hägg (ed.), Greek Renaissance	Robin Hägg (ed.), *The Greek Renaissance of the Eighth Century B.C.: Tradition and Innovation* (Stockholm, 1983)

Hesperia	Hesperia: Journal of the American School of Classical Studies at Athens
HSCP	Harvard Studies in Classical Philology
Human Figure	*The Human Figure in Early Greek Art* [exh. cat., National Gallery of Art, Nelson-Atkins Museum of Art, Kansas City; Los Angeles County Museum of Art; Art Institute of Chicago; and Museum of Fine Arts, Boston] (Washington and Athens, 1988)
IEJ	Israel Exploration Journal
IG	Inscriptiones Graecae
JBerlMus	Jahrbuch der Berliner Museen
JdI	Jahrbuch des Deutschen Archäologischen Instituts
JdI-EH	Jahrbuch des Deutschen Archäologischen Instituts. Ergänzungsheft
Jeffery, Archaic Greece	L. H. Jeffery, *Archaic Greece: The City-States c. 700–500 B.C.* (Oxford, 1976)
JHS	Journal of Hellenic Studies
JWalt	Journal of the Walters Art Gallery
Kerameikos	Kerameikos. Ergebnisse der Ausgrabungen
LIMC	*Lexicon Iconographicum Mythologiae Classicae* (Zurich and Munich, 1974–)
LSJ	H. G. Liddell, R. Scott, J. Stuart Jones, *Greek-English Lexicon*, 9th ed. (Oxford, 1940)
MarbWPr	Marburger Winckelmann-Programm
MMAJ	Metropolitan Museum of Art Journal
MonPiot	Monuments et mémoires. Fondation E. Piot
MüJb	Münchener Jahrbuch der bildenden Kunst
ÖJh	Jahreshefte des Österreichischen Archäologischen Instituts in Wien
OlBer	Bericht über die Ausgrabungen in Olympia
OlForsch	Olympische Forschungen
OpAth	Opuscula atheniensia
Paralipomena	J. D. Beazley, *Paralipomena* (Oxford, 1971)
PCPS	Proceedings of the Cambridge Philological Society
PM	Arthur Evans, *Palace of Minos* (London, 1921–1935)
PP	La parola del passato
ProcBritAc	Proceedings of the British Academy

RA	Revue archéologique
RBN	Revue belge de numismatique et de sigillographie
RE	Pauly-Wissowa, *Real-Encyclopädie der klassischen Altertumswissenschaft*
REG	Revue des études grecques
RhM	Rheinisches Museum für Philologie
Richter, *Korai*	G.M.A. Richter, *Korai, Archaic Greek Maidens* (London, 1968)
RM	Mitteilungen des Deutschen Archäologischen Instituts, Römische Abteilung
Rolley, *Greek Bronzes*	C. Rolley, *Greek Bronzes* (London, 1986)
RVAp	A. D. Trendall and A. Cambitoglou, *The Red-figured Vases of Apulia* (Oxford, 1978–)
SBHeid	Sitzungsberichte der Heidelberger Akademie der Wissenschaften, Philosophisch-historische Klasse
SEG	Supplementum Epigraphicum Graecum
SMEA	Studi micenei ed egeo-anatolici
SNR	Schweizerische numismatische Rundschau. Revue suisse de numismatique
SwCyprusExp	The Swedish Cyprus Expedition
TAPA	Transactions of the American Philological Association
TrWPr	Trierer Winckelmannsprogramme
WS	Wiener Studien
ZPE	Zeitschrift für Papyrologie und Epigraphik

Contributors

Alan L. Boegehold is professor of classics and director of the ancient studies program at Brown University. He also serves as chairman of the managing committee of the American School of Classical Studies at Athens. Recently he has completed a study of Athenian law courts in antiquity.

Walter Burkert received his Ph.D. from the University of Erlangen and honorary doctorates from the University of Toronto (1988) and the University of Fribourg (1989). Since 1969 he has held the post of professor of classics at the University of Zurich. He has lectured and published widely on Greek religion and is the author of half a dozen books.

Bernard C. Dietrich was appointed to the chair of classics at the University College of Wales, Aberystwyth, in 1978. Previously he served as professor of classics and head of the classics department at Rhodes University, Grahamstown, South Africa, from 1963 to 1978. He has published articles on Greek and Roman language and literature and on Greek religion, and books on Homeric religion and the origins and traditions of Greek religion. His monographs are *The Semantics of the Soul* and *A Sense of Guilt in Greek Tragedy*.

Evelyn B. Harrison, a classical archaeologist, has taught at Columbia and Princeton universities and the Institute of Fine Arts, New York University, where she is professor emerita. She has written on Archaic and Classical Greek sculpture and is publishing the sculpture found in the excavations of the Athenian Agora by the American School of Classical Studies at Athens.

Jeffrey M. Hurwit, professor of art history and classics at the University of Oregon, has written on Bronze Age Aegean, Archaic, and Early Classical Greek vase-painting and sculpture. He is the author of *The Art and Culture of Early Greece, 1100–480 B.C.* He received his Ph.D. in Classical art and archaeology from Yale University in 1975 and was assistant professor of classics there until 1980.

Bernard Knox is director emeritus of the Center for Hellenic Studies. He is a member of the American Philosophical Society and a corresponding member of the British Academy. His awards include a Guggenheim Fellowship, the George Jean Nathan Award for Drama Criticism, the PEN/Spielvogel-Diamonstein Award, and the National Endowment for the Humanities Frankel Prize. He is the author of several books, including *Oedipus at Thebes, The Heroic Temper, Word and Action,* and *Essays Ancient and Modern.*

Vassilis C. Lambrinoudakis is professor of classical archaeology at the University of Athens. He has excavated in Naxos, Chios, Marathon, and Epidauros, where he organized the conservation of the monuments in the Sanctuary of Asklepios. He has published books and articles on ancient Greek art and iconography, ancient topography, epigraphy, and religion, many of which reflect his special interest in the Argolid and the Cyclades.

Mabel L. Lang is professor emerita of Greek at Bryn Mawr College. She has written extensively on ancient Greek history and literature. She is

the author of *The Palace of Nestor II: The Frescoes* and has published material from the Athenian Agora in both *Hesperia* and the *Agora* series.

Oswyn Murray is fellow and tutor in ancient history at Balliol College, Oxford, and lecturer in ancient history at Oxford University. He is a former senior research fellow of the Warburg Institute, London, and was a British Academy research reader from 1988 to 1990. He is the author of *Early Greece* and editor of *Sympotica: A Symposium on the Symposion.*

Richard V. Nicholls, a New Zealander educated at Auckland University, was a student at the British School at Athens in 1947–1950 and 1952–1954 when he took part in the Anglo-Turkish excavations at Old Smyrna that are the subject of his essay in this volume. From 1958 to 1983 he was keeper of antiquities at the Fitzwilliam Museum and from 1975 to 1983 was also senior keeper of the museum. Currently he is concentrating on the study and classification of Attic terracottas.

Mando Oeconomides has served as director of the Numismatic Museum of Athens since 1964. She received her Ph.D. from the University of Athens and is a life-fellow and member of the Council of the Athens Archaeological Society, as well as a member of the German Archaeological Institute, the Austrian Archaeological Institute, the American Numismatic Society, and other learned institutions. She is the author of many scholarly publications and has lectured widely.

H. A. Shapiro is associate professor of humanities at Stevens Institute of Technology. He has written on Attic iconography and vase-painting, and is the author of *Art and Cult under the Tyrants in Athens.* He was formerly a fellow of the American School of Classical Studies at Athens and the Alexander von Humboldt-Stiftung.

Evi Touloupa received her Ph.D. at the University of Ioannina following studies in Athens, Rome, and Berlin. She has excavated at the Palace of Kadmos at Thebes and at the site of Lefkandi in Euboea. She has been director of the Ephoreias of Euboea, Ioannina, and until 1989, the Acropolis at Athens. Among her publications is a monograph, *Pedimental Sculptures of the Apollo Daphnephoros Temple at Eretria.*

Olga Tzahou-Alexandri is the director of the National Archaeological Museum in Athens where she is working on the reinstallation of the vase collection. She received her doctorate from the Sorbonne and has excavated sites in Corinthia, Argolid, Attica, Boeotia, and central Macedonia. She is the author of numerous excavation reports and other articles on aspects of Geometric, Archaic, and Classical art.

Emily Vermeule teaches Greek, and Bronze Age and Classical archaeology at Harvard University. Her most recent book, edited jointly with Florence Wolsky, is *Toumba tou Skourou: A Bronze Age Potters' Quarter on Morphou Bay in Cyprus.*

Dyfri Williams received his doctorate from Oxford University in 1978 and joined the staff of the Greek and Roman department at the British Museum in the following year. He took part in the British excavations of the Unexplored Mansion at Knossos on Crete, and since 1976 has been part of the German team excavating the Sanctuary of Aphaia on Aigina. His publications include *Greek Vases* and articles on Greek pottery, jewelry, and bronzes.